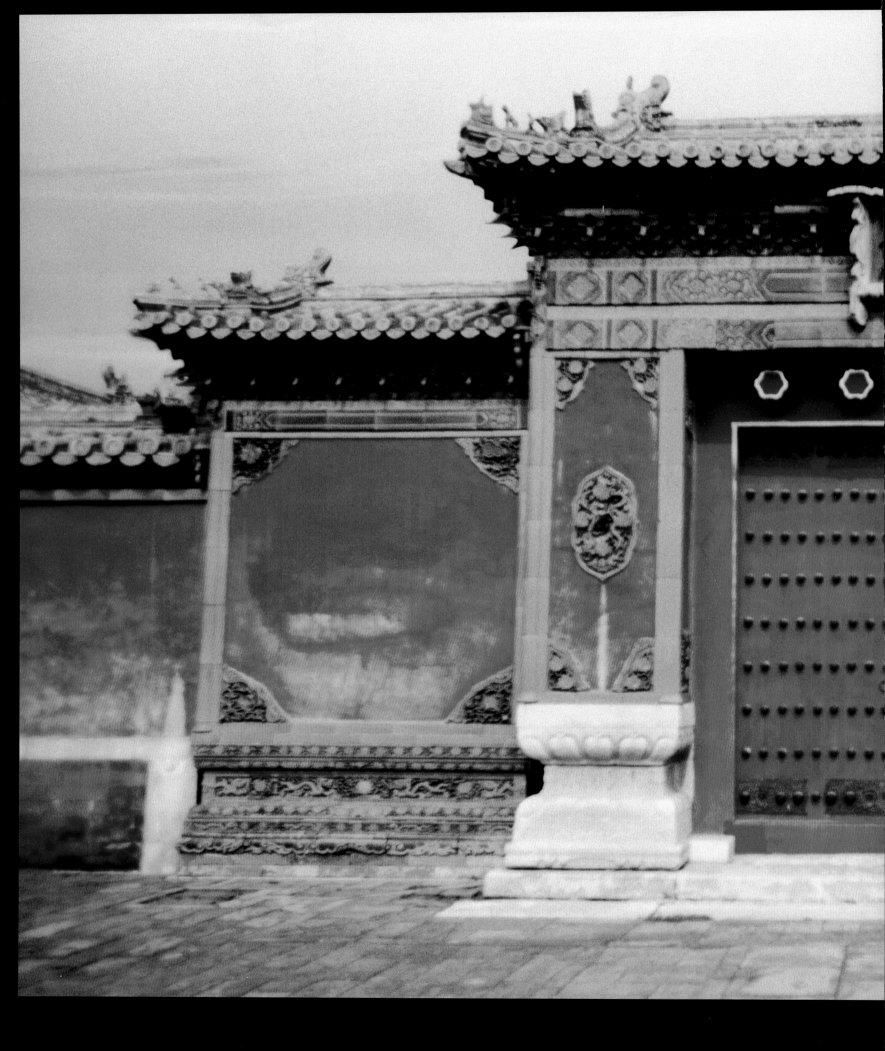

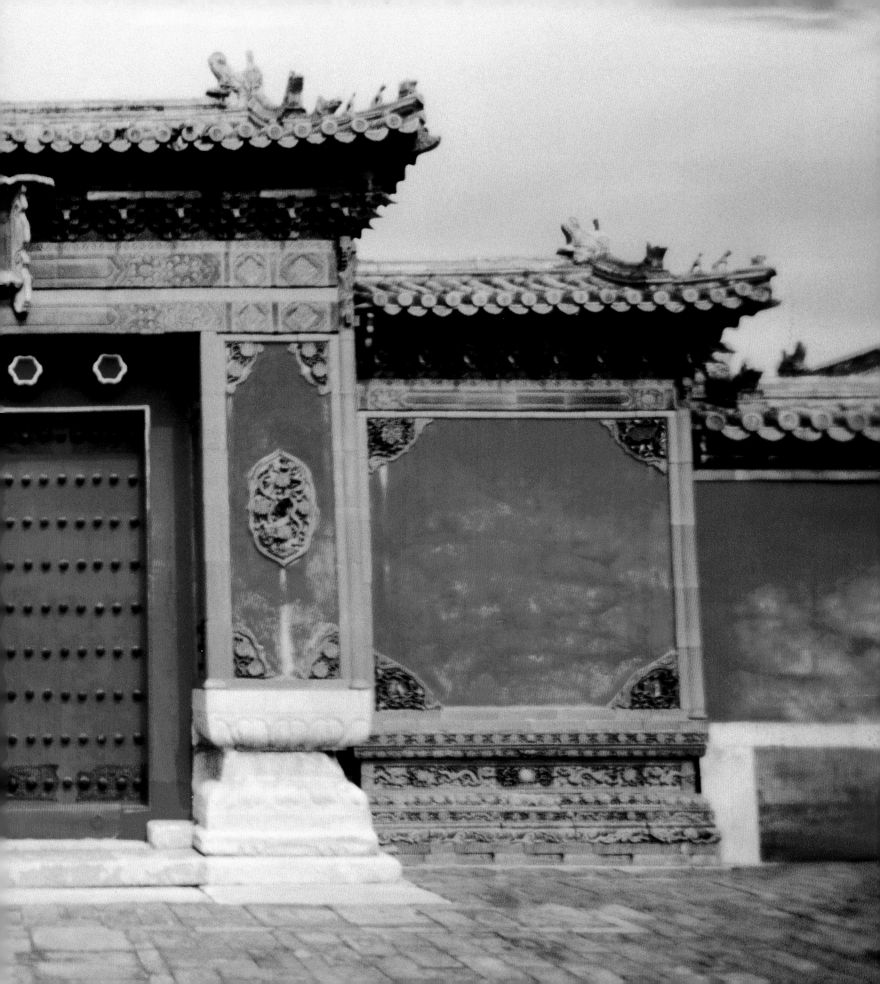

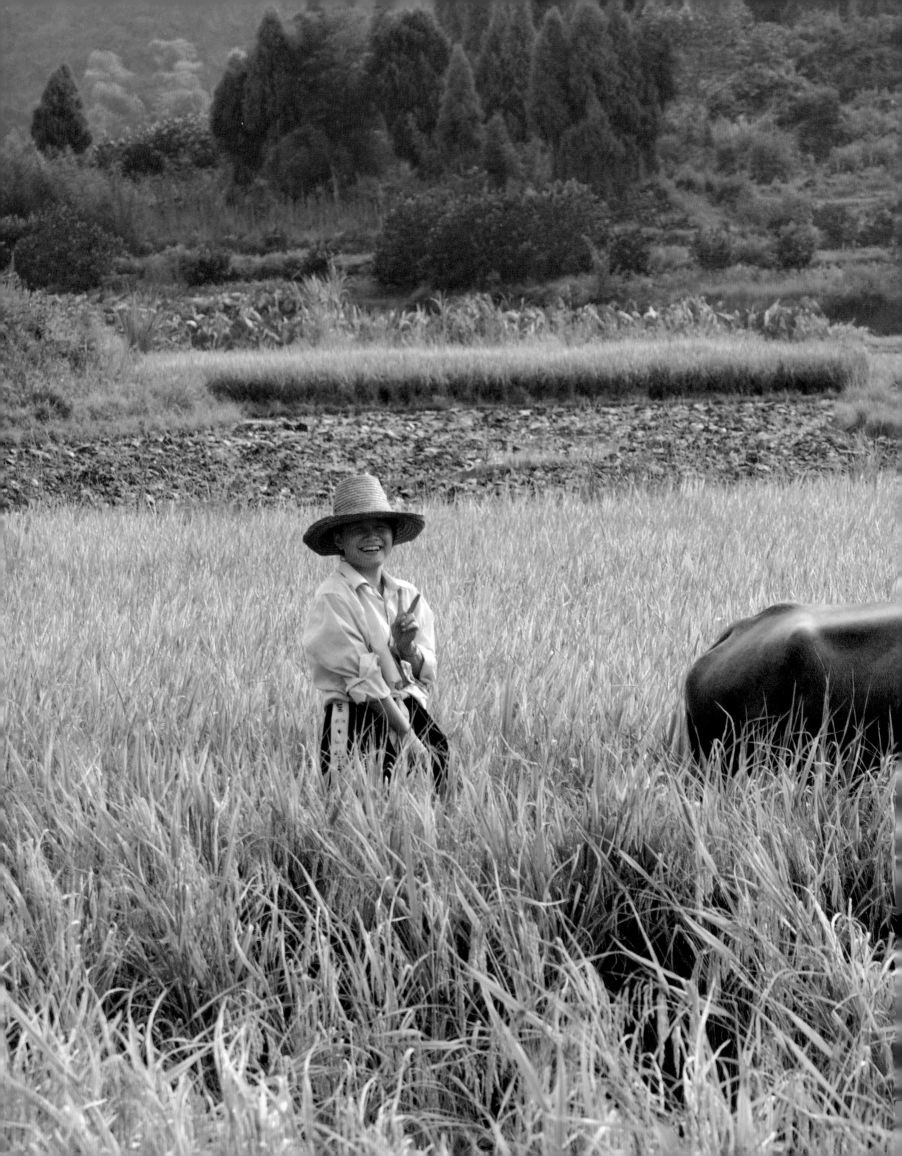

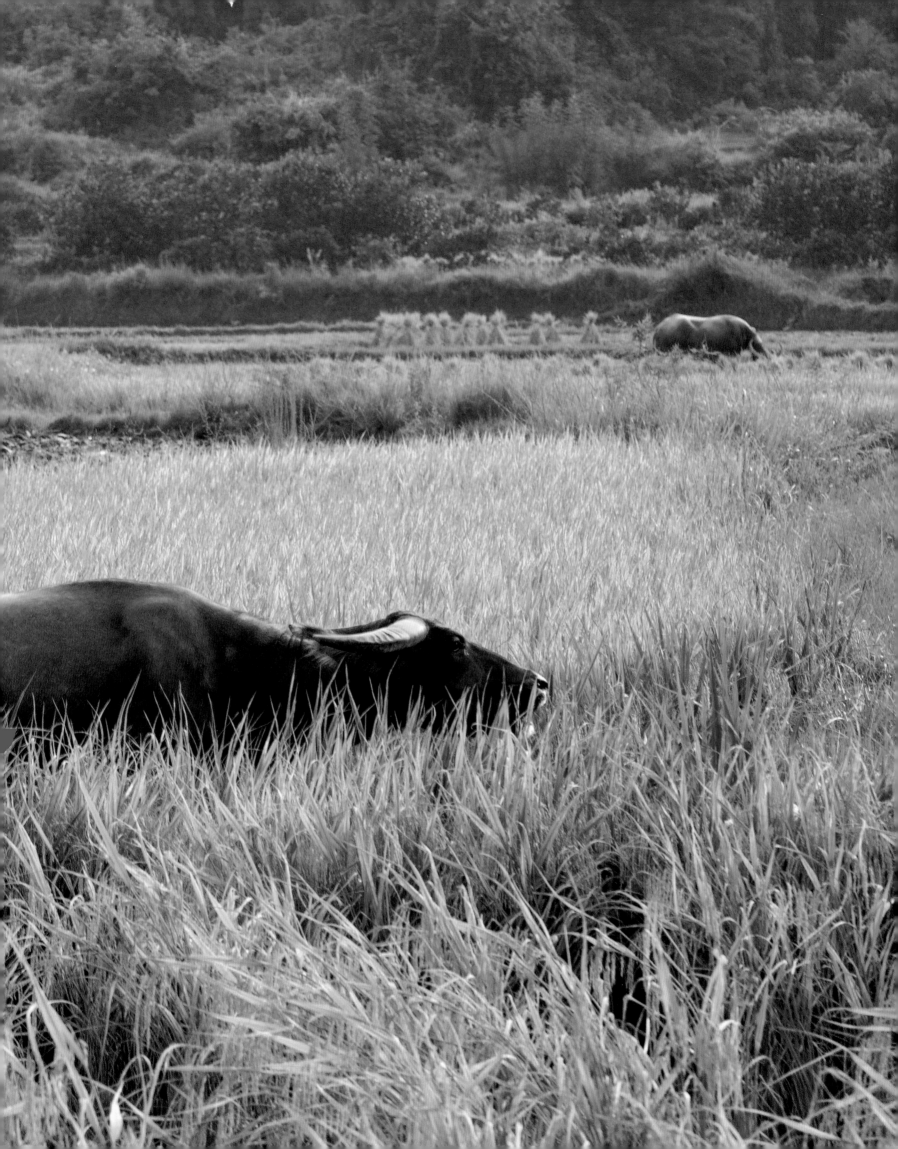

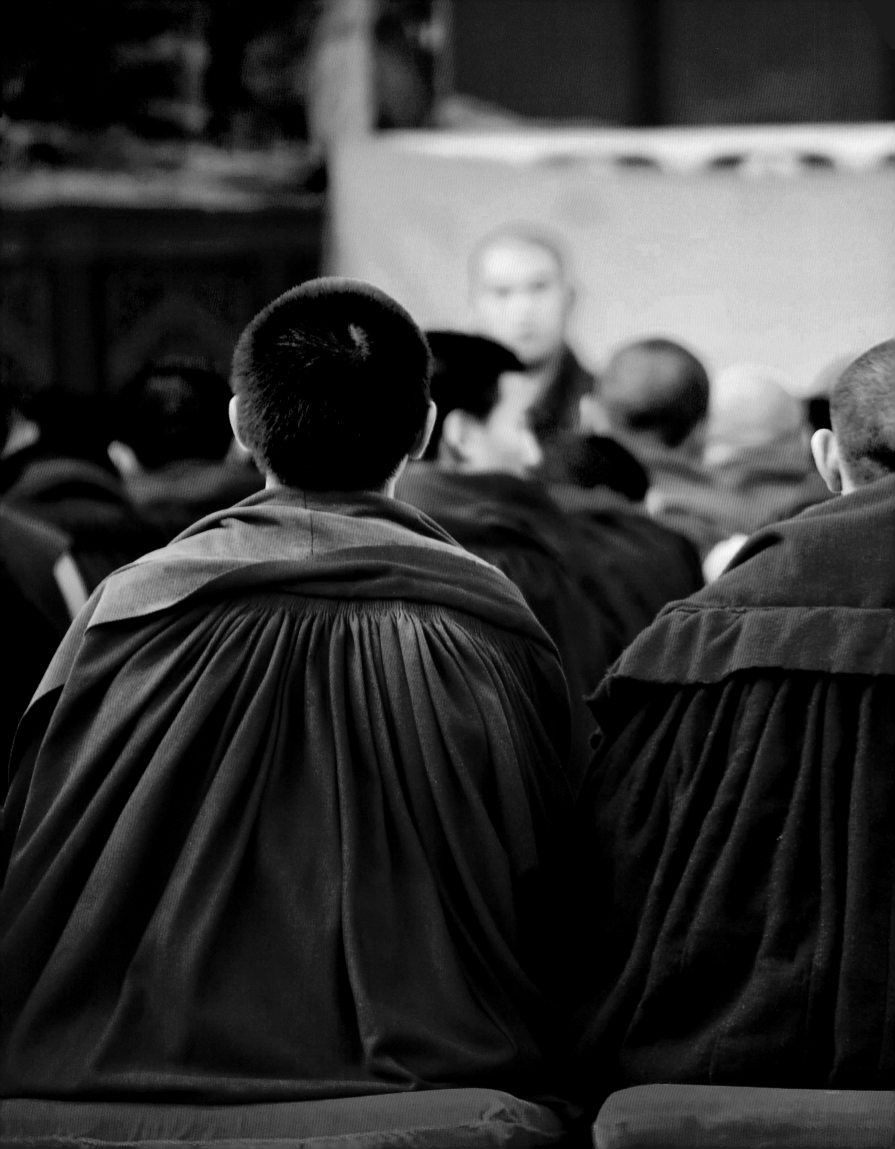

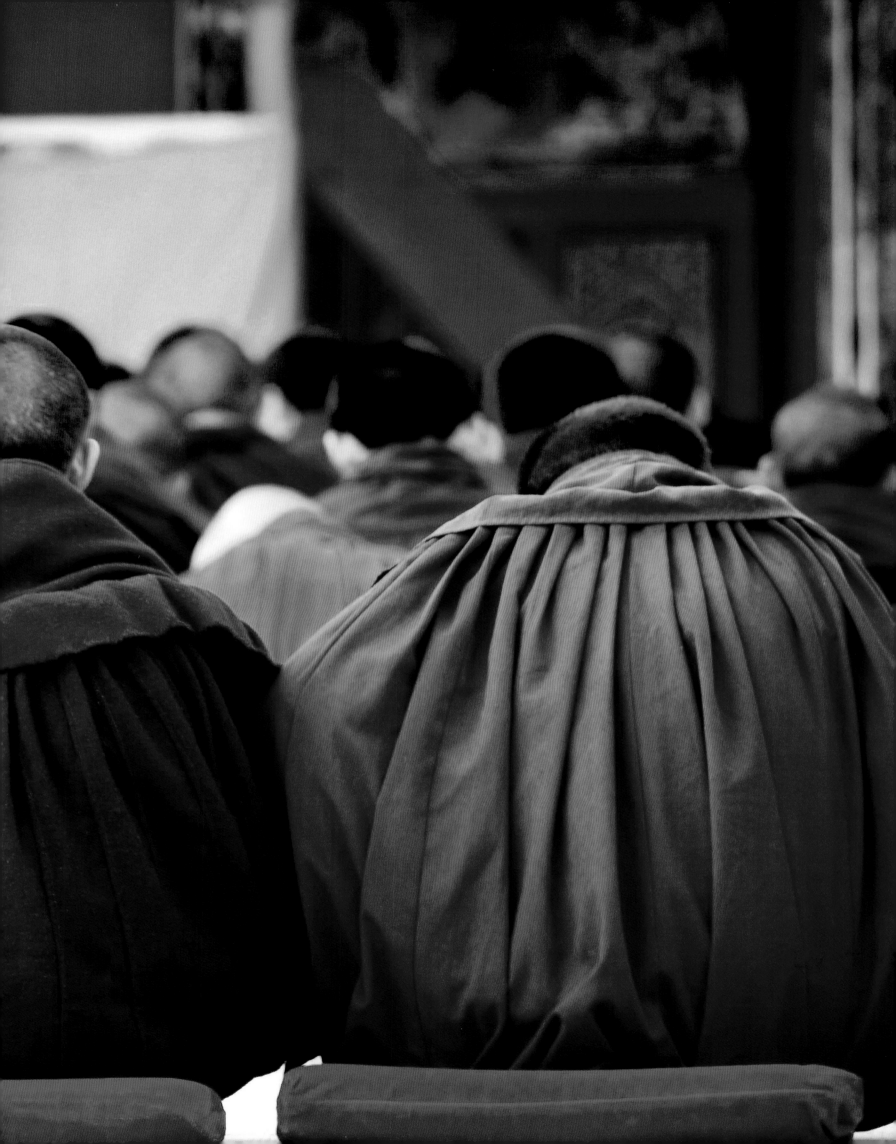

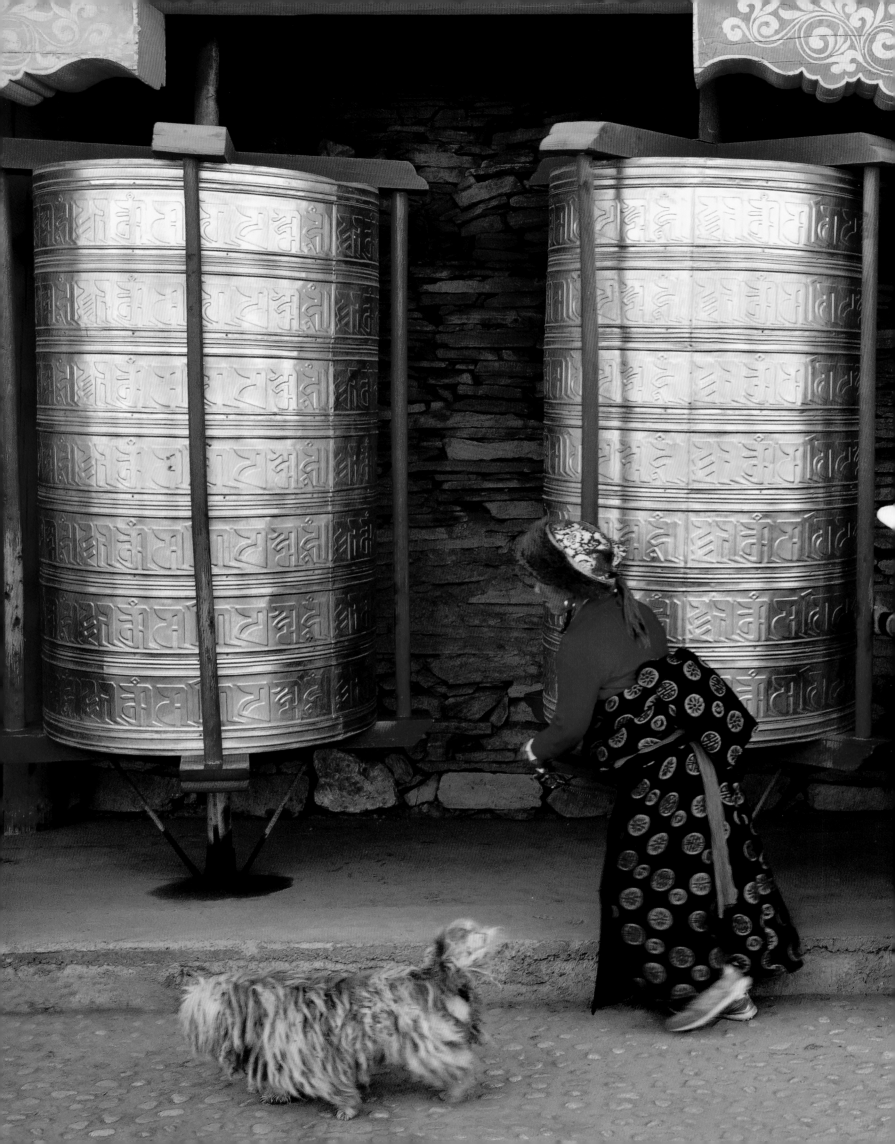

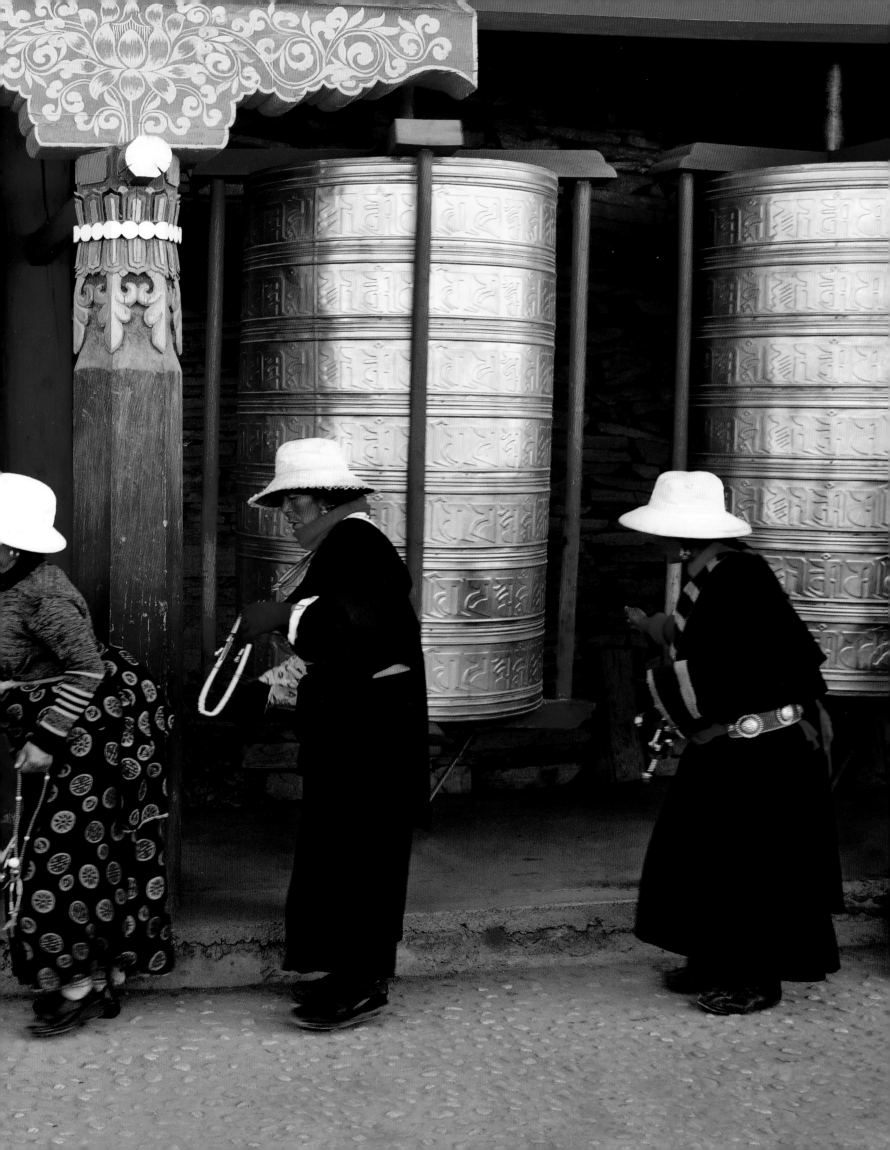

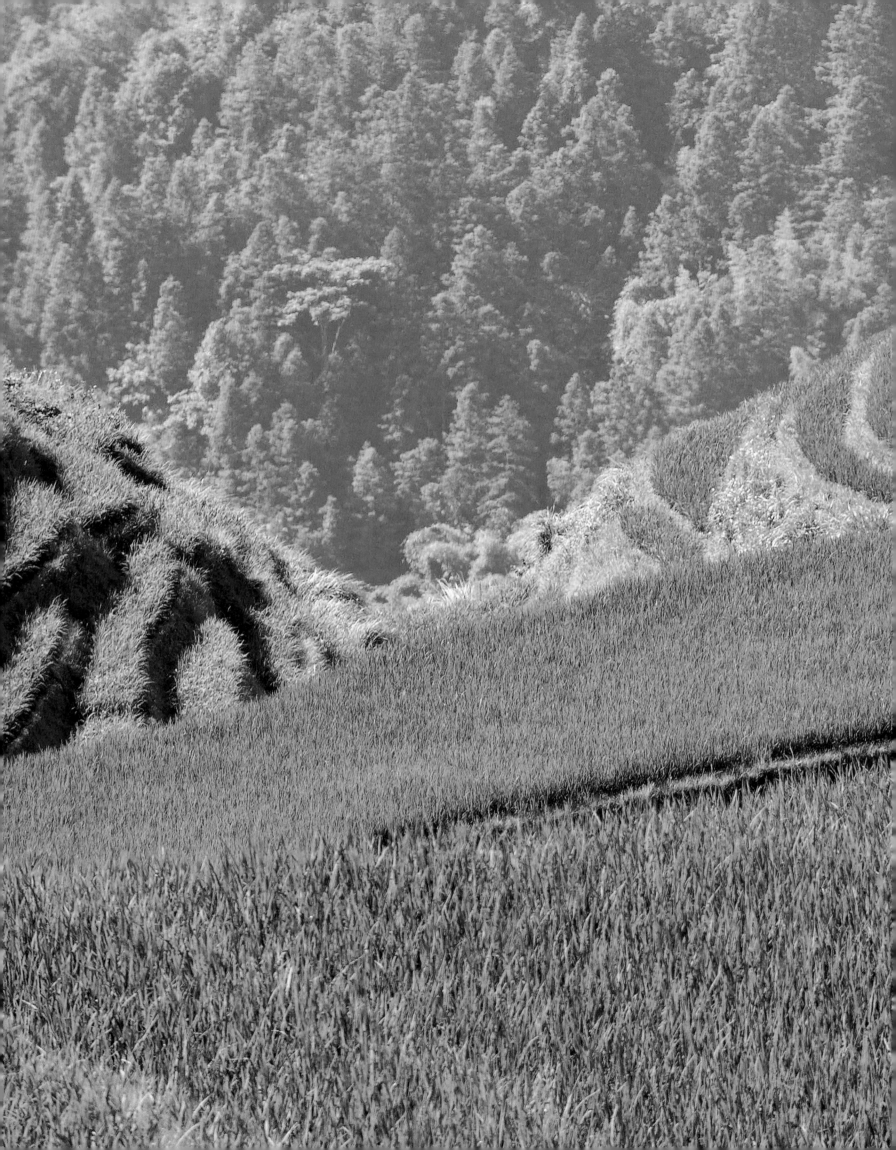

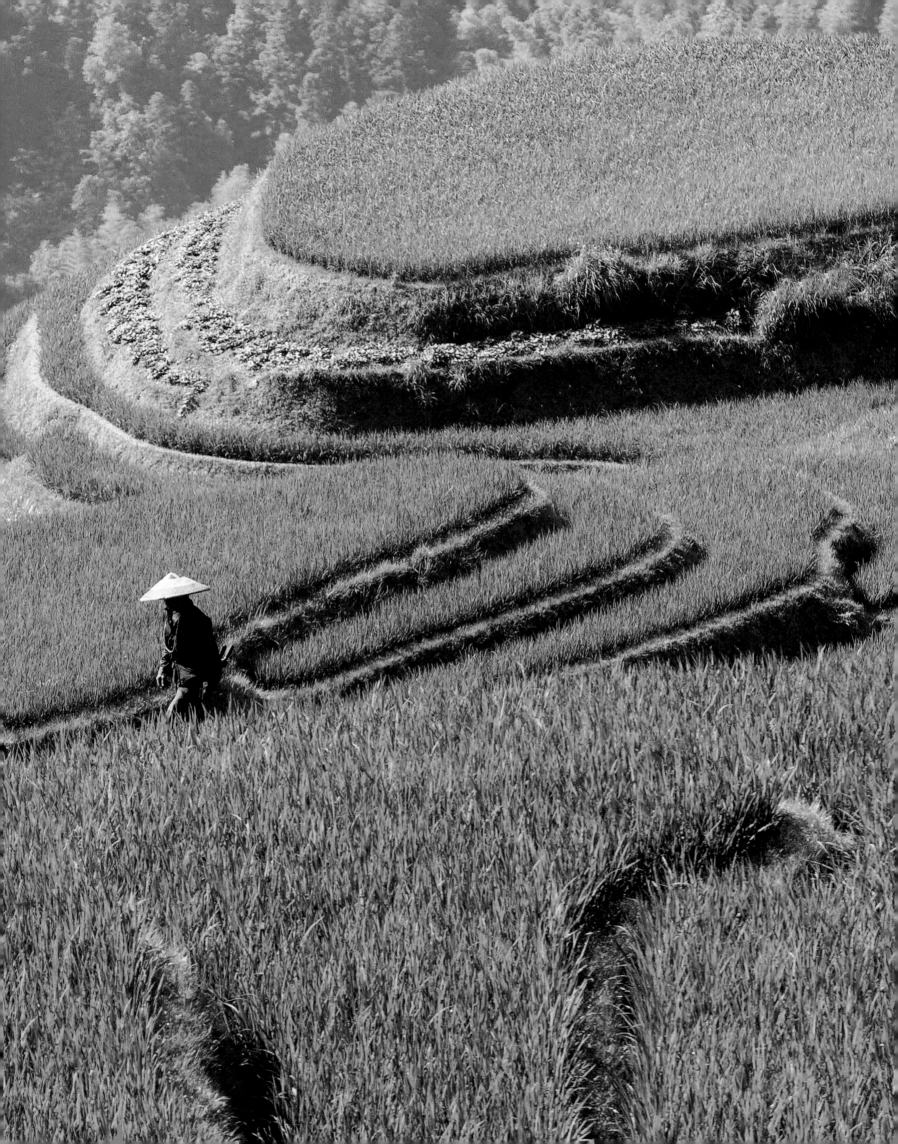

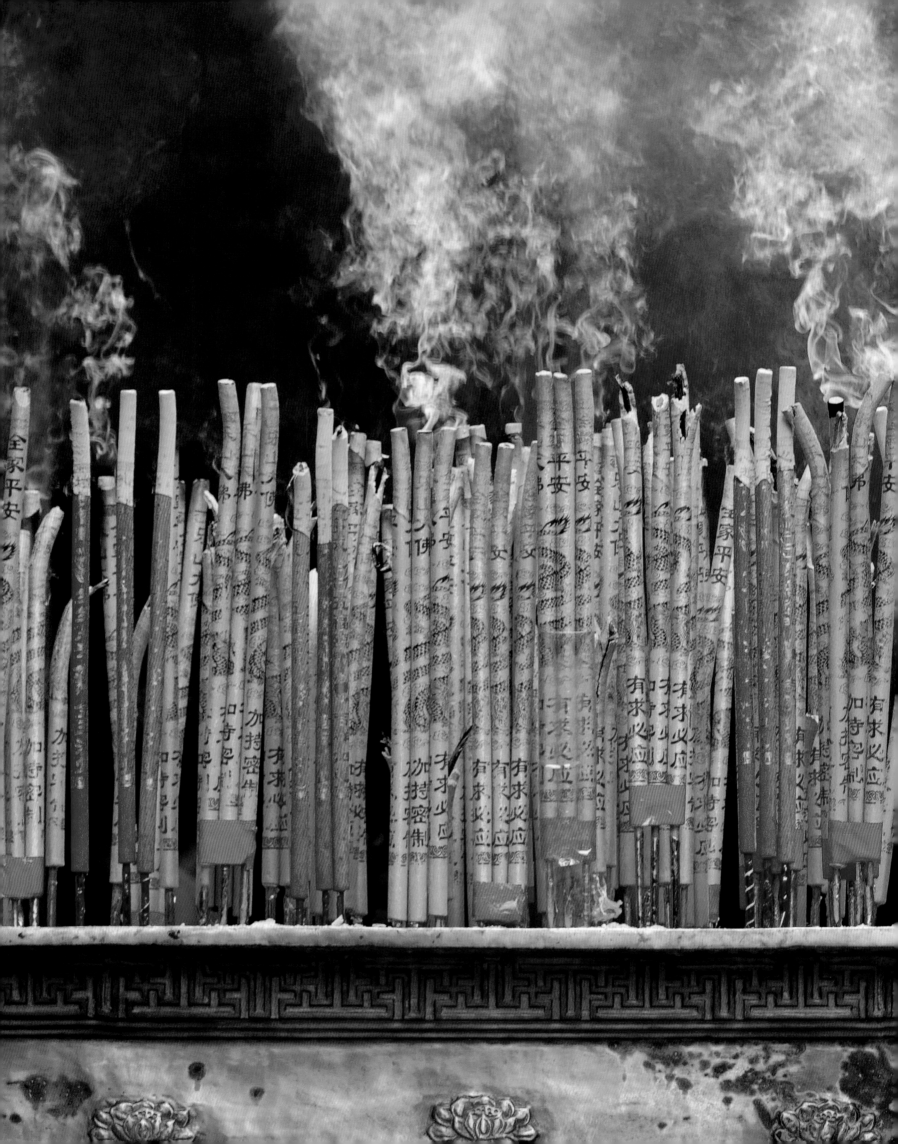

SIMPLY CHINA
本色中国

IMAGES & WORDS BY NANCY BROWN
文/图　南希·布朗

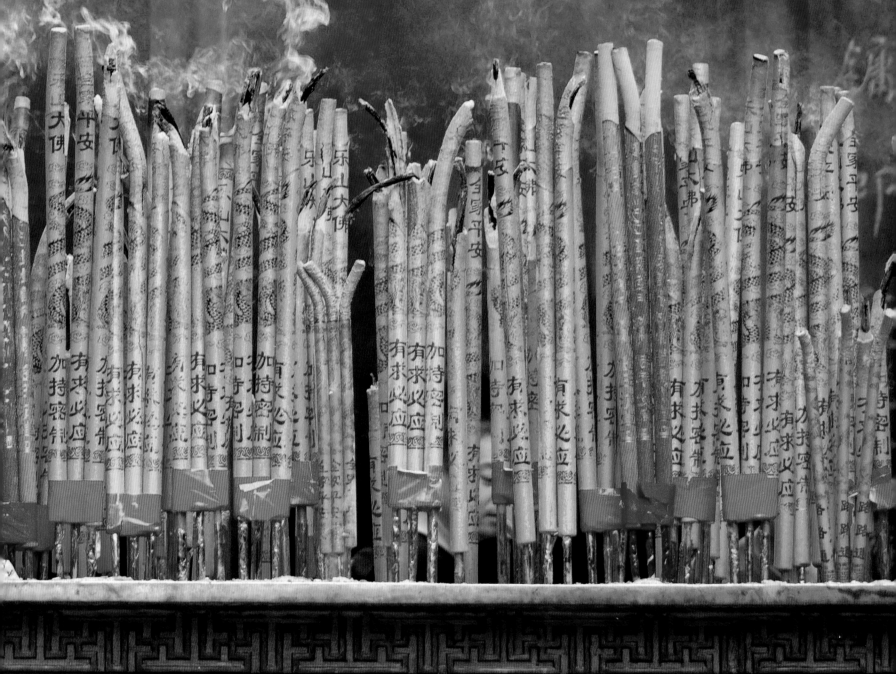

图书在版编目（CIP）数据

本色中国：汉英对照 / 南希著．—北京：中国民族
摄影艺术出版社，2011.2
ISBN 978-7-5122-0114-9

Ⅰ.①本… Ⅱ.①南… Ⅲ.①摄影集-美国-现代②
中国-摄影集 Ⅳ.①J431

中国版本图书馆CIP数据核字（2011）第008620号

--

SIMPLY CHINA

Images & Words By **Nancy Brown**

ISBN 978-0-615-42824-6

Published in 2011 by
China Nationality Art Photographic Publishing House

Copyright © 2011 Nancy Brown
www.simplychinabynancybrown.com
www.nancybrown.com
www.nancybrownschina.com

Chinese translation by Ms. Qin Di
Design by Janae Thuma

Printed in China

书　名：本色中国
作　者：南希·布朗
责任编辑：白弋　萨社旗
出　版：中国民族摄影艺术出版社
地　址：北京东城区和平里北街14号　邮编：100013
发行部：010-64211754　84250639
网　址：www.chinamzsy.com
印　刷：北京雅昌彩色印刷有限公司
开　本：700×1000mm　1/16
印　张：18.25
字　数：5千
版　次：2011年7月第1版第1次印刷
印　数：3000册
I S B N　978-7-5122-0114-9
定　价：280.00元

Title：SIMPLY CHINA
Author：Nancy Brown
Executive Editor：Bai Yi　Sa she qi
Publisher：China Nationality Art Photographic Publishing House
Address：No.14 Hepingli Beijie, Dongcheng District Beijing, China 100013
Distributing Departmemt：010-64211754　84250639
Website：www.chinamzsy.com
Printing：BEIJING ARTRON COLOUR PRINTING CO., LTD.
Format：700×1000mm　1/16
Sheet：18.25
Word number：5000
Order of the edition：First printing in first edition, May 2011
Impression：3000
I S B N　978-7-5122-0114-9
Price：RMB 280 yuan

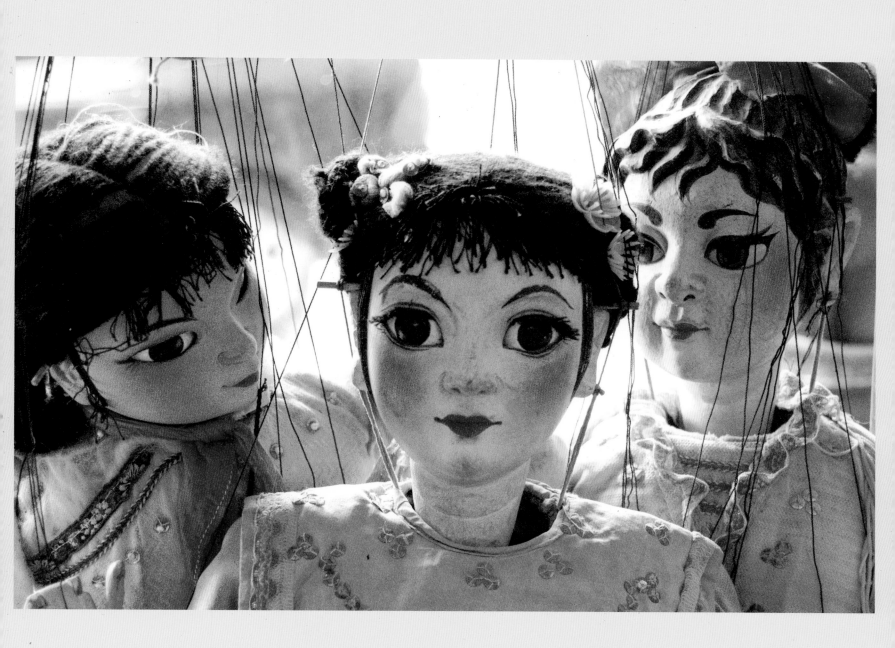

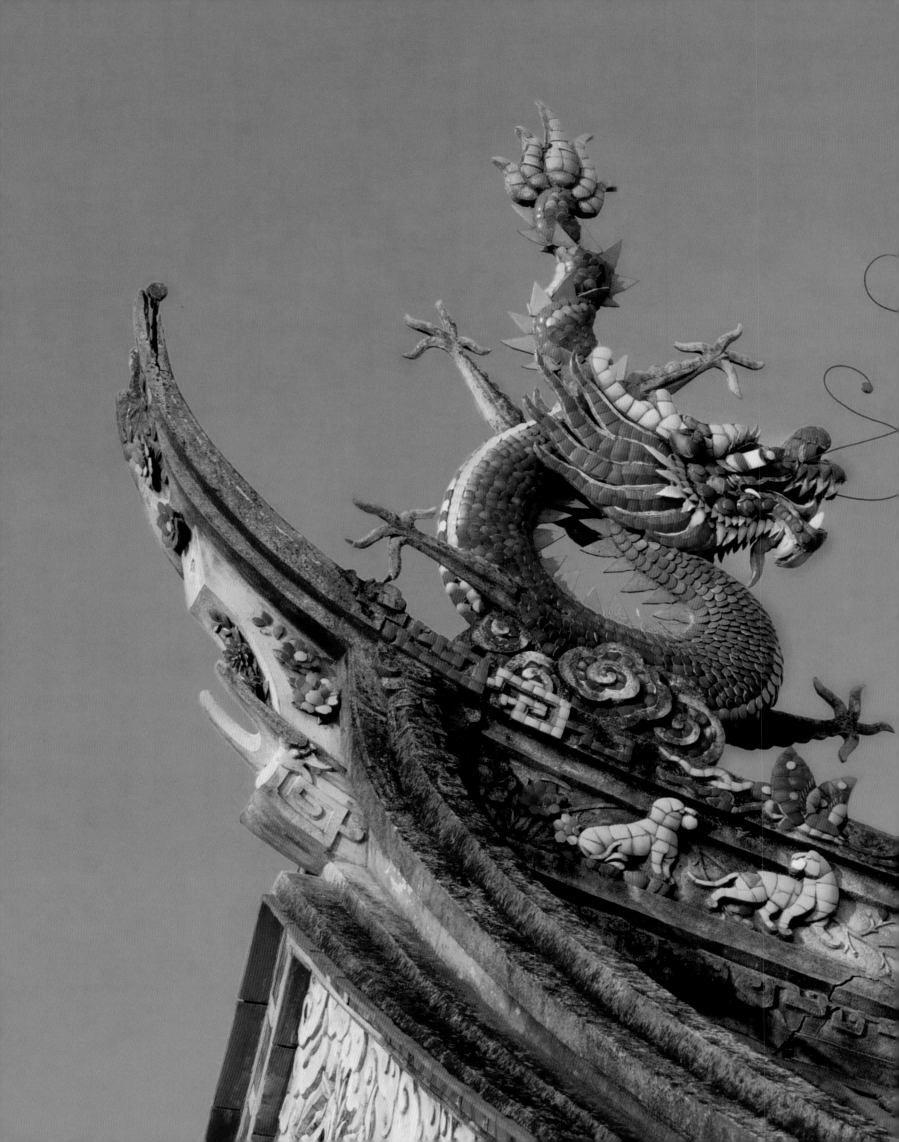

With thanks to:

Ms. Yancong Sun who introduced me to the real soul of China.

Ms. Qin Di for putting my English words into Chinese and for being a good friend.

I also would like to thank Glenn McLaughlin and Tom Sayler, two wonderful photographers and great China traveling companions.

感谢孙燕聪女士，在她的帮助下我了解了真正的中国精神，

感谢我的朋友秦镝女士把我的文字译成中文，

还要感谢两位优秀的摄影家戈兰和汤姆，他们在我的中国之行中一直陪伴着我。

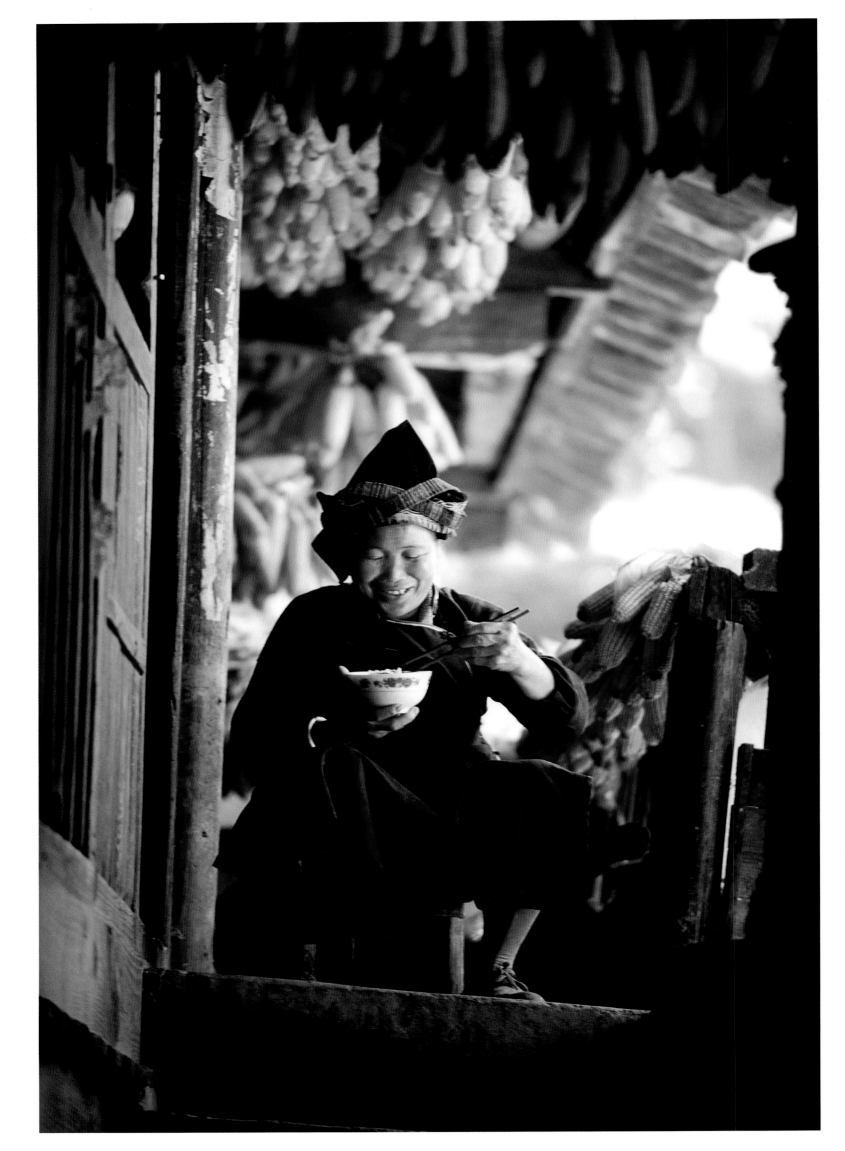

MY PHOTOGRAPHIC JOURNEY THROUGH CHINA

我的中国摄影之旅

First and most important is that I love China and the Chinese people. I have been a photographer for over thirty years and when I stepped off the plane for my first visit to China in 2005 I began my photographic love affair with China and its people. I wish I had gone to China many years ago. Since my first trip I have been back many times and I hope to go many more. My photography specialty has always been making beauty and lifestyle images. China immediately became my new beauty subject. It is heaven for me to be wandering around villages and remote areas of China with my cameras around my neck.

The Chinese people make me feel very much at home. I have gone back to several areas in China to photograph them in different seasons and have run into familiar faces that give me big smiles of recognition. This recognition has occurred in places that don't see many non-Chinese people. I will admit being a light haired woman with three cameras around her neck photographing their village probably is not hard to forget!

The air trip to China is 17-plus hours and then it can be two to four more hours to the final destination. I always use this time to relax and get ready for my next adventure in China and I have never been disappointed. I do a little research on the areas where I am going to, but I usually do most of my research when I get back. For me it is more fun that way and I don't have any preconceived ideas of what I am going to find to photograph.

The big cities in China are certainly worth going to but I spend very little time in them. I head

首先，最重要的是我热爱中国和中国人民，我从事摄影已经40多年了，2005年当我迈出机舱第一次来到中国的那一刻起，我就深深的爱上了中国和她的人民。我只是希望很多年之前就去该有多好。第一次到中国后又去了很多次，还希望能有机会再去。我摄影的专题是美和生活方式，中国成为我新的美的主题。对于我来说脖子上挂着照相机徜徉在中国的小村庄和人烟稀少的地方就像到了天堂一样。

中国人民使我感到在中国就像在我自己家里一样，我曾经在不同的季节回到中国我去过的一些地方进行拍摄，碰到一些熟悉的面孔，当他们认出我来后都报以微笑。这事发生在很少看见外国人的地区。我承认作为一个脖子上挂着3台相机的有着浅色头发的女士在他们村里拍摄照片是很令人难忘的一件事。

到中国旅行，乘飞机需要17个小时，然后还要乘2—4个小时甚至更长时间的车才能到达目的地。我总是利用这段时间放松自己，为在中国的下次拍摄做好准备。对此，我从来没有失望过。我对要去的地区要做一些小小的调查，但通常更多的是在回来后对所去的地区再做大量的调查，我认为这样做更有趣，我对所要拍摄的地方和内容没有偏见。

for the rural areas where not many non-Chinese go. To me that is the real China. The Forbidden City in Beijing is the exception. Ever since I saw the movie The Last Emperor many years ago (and several times since), I have been fascinated with The Forbidden City with all its history and mystery. My most recent trip to China ended in Beijing in late October and to everyone's amazement Beijing got a heavy snowfall. We had just been in West Sichuan for two weeks hoping for snow and got very little. When I saw the snow coming down in Beijing I quickly ran over to The Forbidden City and was like a kid in a candy store photographing it. It was a magical few hours for me. Some of those images are my favorites in the book. After The Forbidden City we got a car and headed to The Great Wall hoping to get snow there too. We got to the Wall near sunset and photographed it in the snow and then again at sunrise. I had photographed the wall before but the snow made it even more beautiful. Ms. Sun, our guide on most of our trips, said it snowed just for me!

My visits to China have brought tears of joy to my eyes several times because I was caught off guard with the kindness of the people. This happened to me in Inner Mongolia when I was photographing a group of yurts in the grasslands. Yurts are the tent like houses that the nomad Inner Mongolians live in and move with the seasons. All of a sudden a woman came from the yurts and took me firmly by the arm into her yurt. She put a blue sash around my neck and sat me down on a rug on the ground by her table. The table was the only furniture in the yurt. She just smiled at me and then served me horse milk and cheese that they had made. Since we could not talk we just sat and smiled at each other and it was actually very relaxing. They have very little but she wanted to welcome me in her home

中国的大城市当然值得去看，但我只在这上面花费很少的时间，而是直奔人烟稀少的农村地区。对我来说那才是真实的中国。但北京的故宫不在此列。自从多年前看了电影（末代皇帝）后（此后又看过好几遍）我被故宫的历史和神秘深深吸引，最近一次的中国之行于去年十月底在北京结束，令大家惊奇的是的北京下了大雪，两周前我们还在四川希望能看到雪，但遗憾的是在那儿只有一点点小雪。我很快地冲到故宫像小孩在糖果店里那样兴奋地在雪中拍摄起来。那真是无比美妙的几个小时。在那些照片中我把最喜欢的几幅收集到了本书中。故宫拍摄完后，我们找了一辆车向长城出发，希望在那里能拍到雪。我们在快日落时到达长城并在雪中拍照，第二天日出时继续拍。以前我也拍过长城，但是大雪使长城变得更美丽。一路上陪伴我们的导游孙女士说这雪就是为我下的！

在我的中国之行中，人民的善良淳朴多次让我感动的热泪盈眶。这事发生在内蒙古，我正在拍摄一组蒙古包的照片。蒙古包是像房子一样，供内蒙的游牧民族居住和随季节迁徙时使用的帐篷。突然一名妇女从蒙古包里出来紧紧地抓住我的胳膊把我拉进包里，将一条蓝色的哈达围在我的脖子上，让我坐在桌边的地毯上。这张桌子是包里唯一的家具。她只是微笑的看着我，用自制的马奶和奶酪招待我，由于语言不通，我们无法交谈，我们只能坐着微笑的看着对方。这实际上是一种休息。他们的东西很少，但她想在她的家里欢

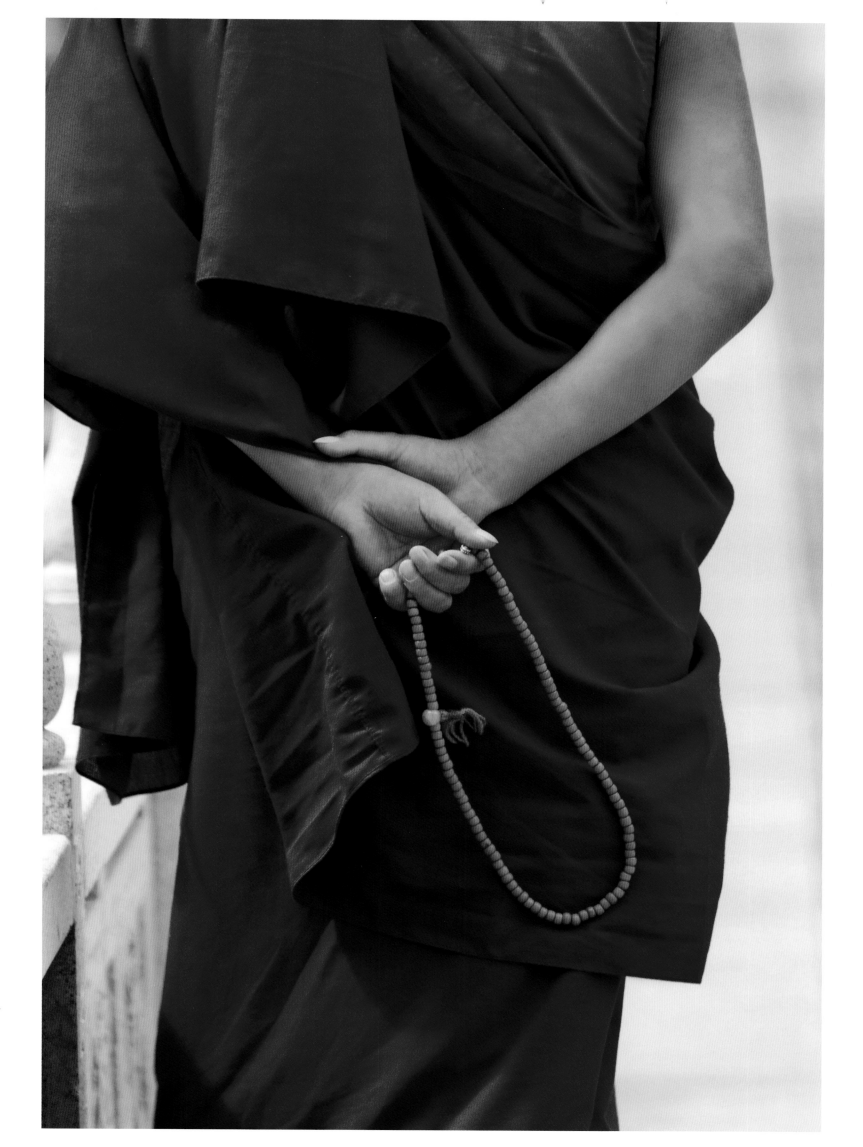

and share what she had. This experience was overwhelming but it got even better. The sun was setting outside the yurt and I pointed to my camera and pointed outside to the sunset trying to make her understand that I wanted to go outside. She said something to some of the women outside and we sat for a while longer just smiling at each other. I finished my milk and cheese and then we got up and went out of the yurt. To my surprise the woman and young girls had changed into their traditional dresses that they wear for special occasions. That must have been what she told them to do when she was talking to them. They got dressed for me! I photographed them until sunset and showed them what we were getting on the back of the camera. They were all laughing and smiling and did not seem to want me to leave. As I walked back to the van down the road I felt tears in my eyes. What wonderful people! The images of the woman who took me in the yurt and some of the women and girls in the dresses are in the Inner Mongolian section of the book. The woman holding the baby is the one who took me in her home.

Another time when I was photographing in Guangxi Province near Guilin our guide asked me if I wanted to go to a 400 year old village off the beaten path. Off we went and when we got there she introduced me to a 90 year old Chinese woman. The woman had lived in the village all her life and she spent all morning taking me around with the guide interpreting for us. She was so proud of her village. It still had a well for water and her little house was very basic. She had a wonderful face and smile and I asked if she goes into the nearest city very often and she said, "No." I met her husband too and as we left she was going into the garden by her house to get vegetables for their lunch. They both were very thin but looked very healthy and happy. In the

迎我，与他们分享她有的东西。这种经历令人难以置信，而且越来越令人称奇。蒙古包外面太阳正在落山，我指指我的相机，指指外面的落日，想让她明白我要出去。她对外面的妇女说了些什么，我们又在蒙古包里多坐了一会，什么也不说只是微笑的看着对方。我喝完奶茶，吃完奶酪后站了起来，来到了蒙古包的外面，令我惊奇的是，这名妇女和姑娘们都换上了只有在特殊场合才穿的传统服装，这肯定是她跟她们说话时告诉她们的。她们是为我而穿的。我为她们拍照直到太阳落山，然后给她们看所拍的照片，她们都高兴地笑起来，似乎不想让我离开。当我走向路边的马车，我感到眼里充满泪水。多好的人民啊！把我领进蒙古包的妇女、穿着盛装的妇女和姑娘们的照片都收在本书的内蒙古单元里，抱孩子的妇女是领我去她家的那个人。另一次是在广西桂林附近拍摄时，导游问我想不想去小路那边的一个有400年历史的村子，我们到了那里以后，她向我介绍了一位90岁的中国妇女。这位妇女在村子里住了一辈子。她带我转了一上午，导游做我们的翻译。她为她的村子自豪，村子里有口井供应日常用水，她的房子很小很简单，她慈祥的脸上挂着微笑。我问她是否经常到附近的镇上去，她说不去。我还见到了她的丈夫。当我们离开时，他正要到屋子旁边的菜园摘些青菜做午餐。他们两个都很瘦，但看起来很健康、快乐。在本书的广西单元里她就是手托腮站在房前拱廊（archway）里的那名妇女。在我所有的中国照片里，我最喜欢的

section on Guangxi Province she is the woman in the archway with her hand by her face and also standing in front of her home. Of all the images of me in China my favorite is the one when I am hugging her. I used it in the snapshot section in the back of the book. I think of her often and wonder how they are doing.

On my West Sichuan trip we went to many very remote monasteries and photographed many monks. My favorite monastery was the Juli Monastery near a town called Xinduqiao. A monk who had lived in the Monastery since he was a little boy (he was thirty years old now) became friendly with me. He then invited Ms. Sun and me to his room and served us hot water. He shared with us his life story and showed us pictures of his family who still visit him. There is a picture of me with him in his room in my snapshot section. In all my trips to China I had never been in a monk's room and had the opportunity to learn so much about their daily life. The monk was a very happy person and loved telling us his story. I got his address and sent him many images of his Monastery. In the West Sichuan section that Monastery is the one with the monk looking out the window and the collage of all the happy monks.

When putting this book together the only way I could do it was by areas where I had been. It was hard because I have so many images and I wanted to give the reader the feeling that I got from each area. Inner Mongolian was an ocean of greens and when the wind blew the grass was like the ocean changing colors. I had always heard about the wild horses and was so happy that it was true---they are everywhere. The image of the two wild black horses running in the green field, says Inner Mongolia to me. I was shooting the field and mountains, when the horses ran through--

一张就是我与她拥抱的那张。我把它用做作者的照片放在书后的抓拍单元里。我常常想起她，不知道他们现在怎么样。

在川西旅行时，我们去了很多偏僻的寺庙，拍了很多僧人的照片。我最喜欢的寺庙是西渡桥小镇附近的居里寺。一个很小就在寺里的僧人（他现在30岁了）对我非常友好，邀请我和孙女士到他的房间并请我们喝热水。他给我们讲他的故事，给我们看他家人的照片，他的家人现在还经常来看他。在本书后面的抓拍单元里有一张我和他在他的房间里的合影，在我所有的中国之行中，从来没有进过僧人的房间，对他们的日常生活了解的这么多。他是个非常快乐的人，愿意把他的故事讲给我们听。我要了他的地址给他寄了很多他们寺庙的照片。在川西单元里，这个寺庙就是有他望着窗外，上面有所有僧人愉快微笑的那个。

当我编辑这本书时，我唯一能做的就是按我到过的中国地区来编排。做起来太困难了，因为我有那么多的照片，而且想让读者了解我在每个地区的感受。内蒙古是绿色的海洋，当风吹过时，草原像海洋一样变换着颜色。我总是听到关于野马的故事，我太高兴了，那都是真的，我看到了，到处都有。那张在绿色草原上向我奔驰而来两匹野马的照片对我说这就是内蒙古。我拍大地、拍山川、拍奔驰而过的野马——我仍然不敢相信这是真的！！！在内蒙古，我们下榻在锡林浩特，我

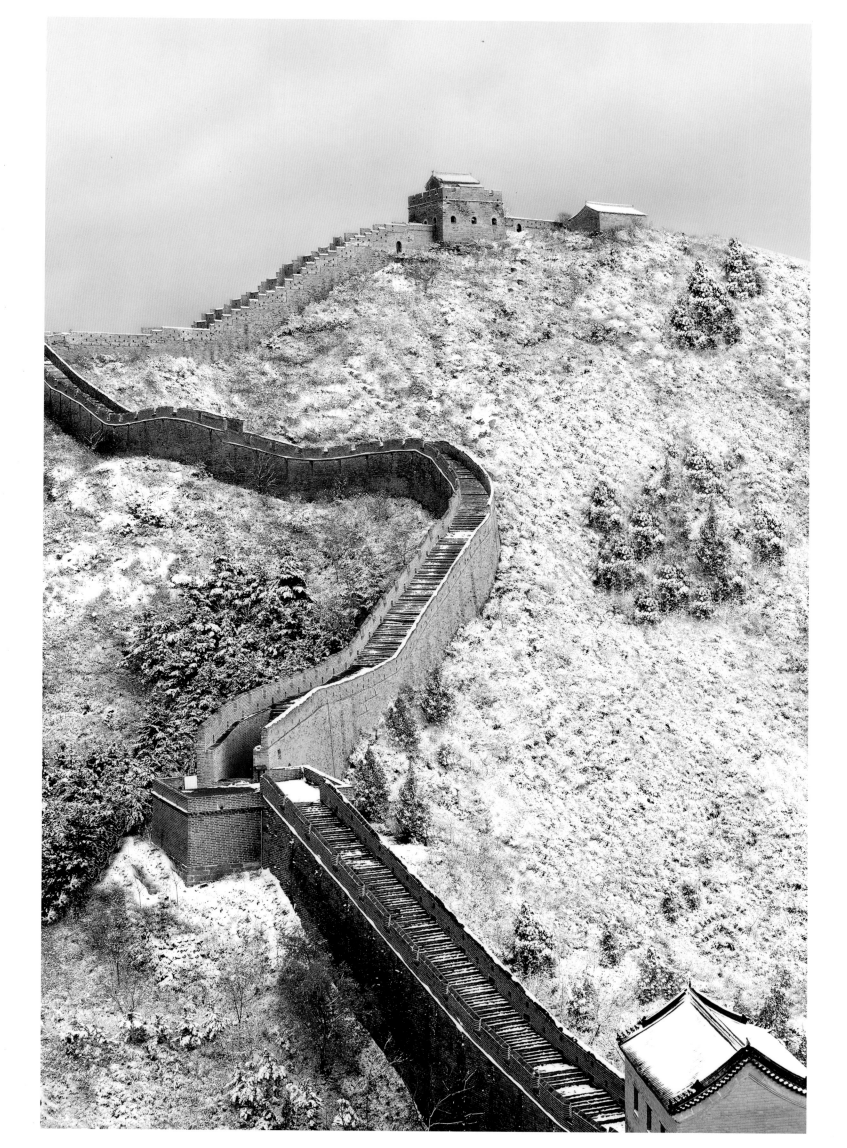

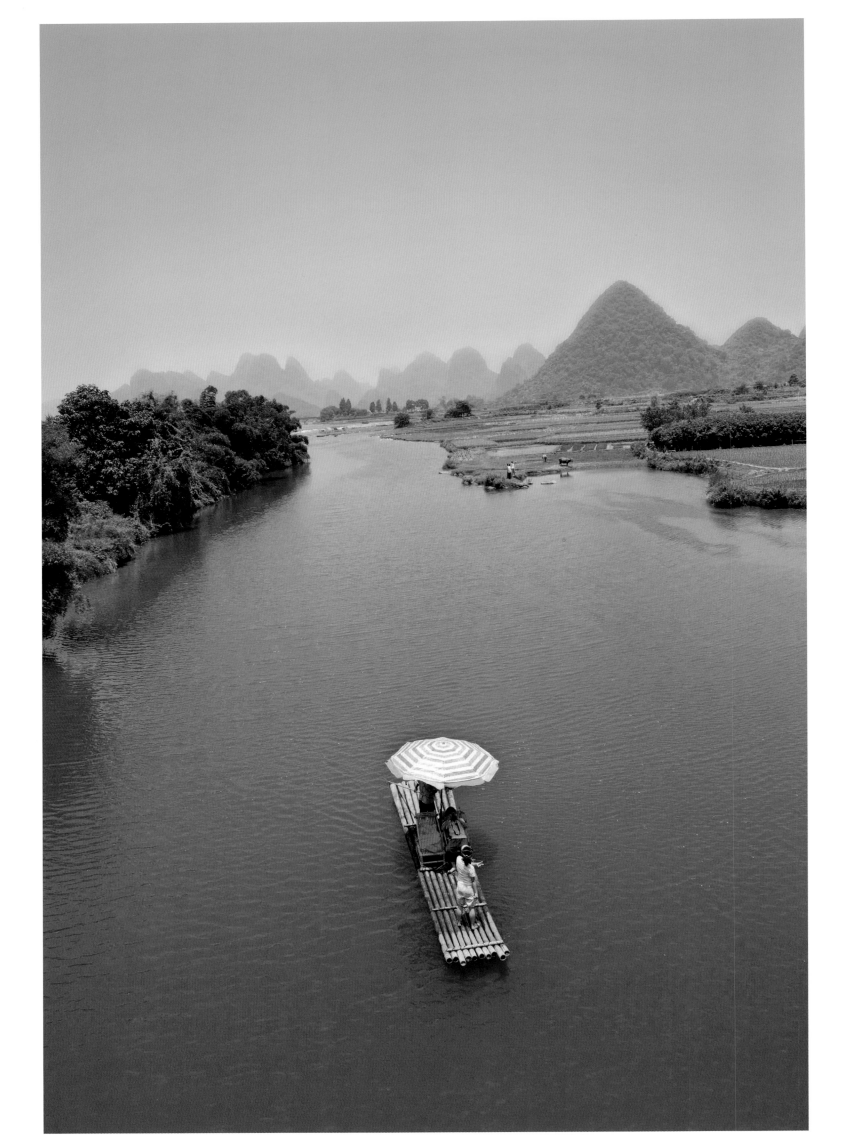

-I still can't believe it!!! In Inner Mongolia we were based in the town of Xilinhot. We went to different areas everyday and were lucky because this was the time of the year when there were many festivals going on. At these festivals the big activity was horse racing and in the Inner Mongolian section you can see how intense they become. The little boy in the traditional clothing on the horse shows how much it means to race and try to win. I definitely want to go back to Inner Mongolia in the winter to the area where they ride camels. I have seen photos of that area and it looks amazing.

Guangxi, and especially the area around Guilin, is known for the wonderful mountain-like limestone peaks that just rise out of the ground (Karst Formations) and the Yulong and Li Rivers. The rivers are very busy with the locals and tourist on raft like boats. This area is also the home of the famous Cormorant Fishermen which I photographed. The farmland between the mountains and rivers is very fertile and beautiful. The land is always being worked by the Chinese farmers and their water buffaloes. The image of the woman with the water buffalo giving me big smile and friendship sign was taken in this province. I did two trips to this area to get the change of seasons and to be able to spend more time in the Longhi Rice Terraces. The terraces are a photographer's dream location. The second time I was there it was fall and I lived three days in a local inn in Ping An. Ping An is one of the villages up in the Longhi Terraces. That is one of the places where I saw many familiar faces. This is also where I learned to really appreciate the strength of the Chinese woman. They climb the rice terraces all day with baskets on their backs filled with everything they need. They also carried my bags and cameras up the terraces on their backs and I am sure the load on their backs weighted

们每天都去一个不同的地方。 我们非常幸运，因为在每年的这个季节总是举办很多节日， 在这些节日中，大的活动就是赛马。 在我的内蒙古单元中你们可以看到赛马是多么的紧张。那个穿传统服装骑在马背上的男孩向我们展示了赛马意味着什么并争取获胜的信心。我一定要在冬天的时候再回到内蒙古，到骑骆驼的地区。我在照片上看到过那个地区，看起来真美。

广西，特别是桂林的周边地区以拔地而起的峰林石山（喀斯特地貌）、玉龙雪山和丽江而闻名于世。丽江上航行着载满当地居民和游客的像船一样的筏子。这里也是利用鸬鹚钓鱼的渔夫们的家乡。 我拍了很多他们的照片。山下河边的土地肥沃而美丽。中国农民带着他们的水牛在此耕作。 那张一个妇女牵着水牛向我友好微笑的照片就是在这个地区拍摄的。为了拍摄不同季节的景色，也是为了有更多的时间拍摄龙脊梯田 我曾经两次来到这里。它是摄影家梦寐以求的地方。我第二次到那里是在秋天的时候， 住在龙脊梯田上面的一个叫平安镇的村子里，在那里呆了三天， 又看到了很多熟悉的面孔。也是在这里， 我真正感受到了中国妇女的力量，她们每天身背装满日用品的背包来到梯田上。上梯田的时候她们也帮我背相机和摄影包。我敢肯定她们背负的重量要比她们本身的体重大得多。啊，和老乡住在一起， 早上听公鸡把你从梦中唤醒的感觉真是太妙了！

我的川西之行是在去年十月底到11月初

more than they did. It was a wonderful experience to live with the locals and it was also wonderful to have roosters wake you up in the morning!

I did my West Sichuan trip late in October and into November hoping to get snow. We started in Chengdu, my favorite city in China, and began our trip up the mountains near Tibet. We photographed the Mt. Emei area which included "The Giant Buddha". He is truly a giant and amazing. The weather being so cold on this trip had one great advantage for photography. To stay warm the people in the area were dressed in very colorful layers and had great colorful head covers and scarves. Also, being so close to Tibet most of the people were Chinese Tibetans and their normal attire is the most colorful in all of China. Besides the Juli Monastery that I talked about earlier my favorite town in West Sichuan was Tagong Town. It was very small and was like a Western movie set. The men in this town were like our cowboys with hats, boots, and turquoise jewelry. In this section there is a man standing in a doorway that says it all. The young monks in the wheelbarrow were also in Tagong Town. I also shot a lot more scenics in West Sichuan than I usually do because next to Tibet the mountains in this area blew me away.

The largest section of the book is the section on Tibet. I have never taken so many photographs in any period of time as I did in Tibet. The people, the colors, and the light was like no other place I had ever been. You are very high and the air is very clear and the sky is very blue. There is an image in this section of a scene looking down on a lake and road from above that took my breath away when we came upon it. It looked fake because it was so perfect. I was as close to heaven, altitude wise, as I was ever going to be. We spent three days in the city of Lasha and then

进行的。 我希望能在那里见到雪。我们从成都——我最喜欢的中国城市之一—— 出发来到了峨眉山拍摄，拍到了峨眉山的大佛，大佛真是令人惊奇的大啊。这次旅行时天气很冷但好处是利于拍摄。为了保暖， 这里的人们穿着五颜六色的外套、头戴五颜六色的大毡帽和围巾。同样，由于该地区临近西藏，这里大部分都是藏族人， 她们的服饰在中国是最丰富多彩的。 除了前面提到的居里寺， 在川西， 我最喜欢的城镇是塔公镇。它很小， 很有点像西部电影中的样子。这里的男人像我们的牛仔那样戴帽子、穿靴子、佩戴镶宝石的首饰。在这个单元中，站在门口的那个人向我们完美的展示了塔公镇男人们的穿着打扮。那个在独轮车中的年轻僧人也是塔公镇的。我在川西拍摄的风光照片比我通常在其他地方拍摄的要多得多，因为这个地区临近西藏的山脉简直是太让人着迷了，尤其是被雪覆盖时更是如此

本书最大的单元是西藏之行。 我从来没有在任何时候像在西藏那样拍过那么多的照片， 那里的人、色彩、光线都是我在其他地方所没有见过的。 在这里， 你是那么高、空气是如此的清澈、 天空是那么的蓝。有一张从上往下观看湖泊山脉的照片，当我们爬上去观看的时候，我简直是惊呆了，他看起来就跟假的一样，但却是那么的完美，这里美丽宁静的景色使我感到好像来到了天堂，我们在拉萨市呆了三天，然后沿着友谊公路向日喀则出发，途中在甘孜停留了一下，在路上经常是边走边

took the Friendship Highway to Shigatse. We stopped at the town of Gyangtse and often along the way. The image of the monk from above and the young monk smiling at me in this section was taken in Gyangtse. They are two of my favorite images from Tibet. I did not see anyone but Tibetans after we left Lasha.

There is a very small section on a very magical town in China. The town is Zhouzhuang also known as The Venice of China. We were on our way to Shanghai and stopped overnight in Zhouzhuang. We got there very late in the afternoon and it was very crowded with Chinese tourist. I got up early the next morning and photographed the town. It was covered in an early morning mist over the canals and the only people up were the locals getting ready for the day. It was so peaceful and quiet. It is one hundred miles from Shanghai so I would tell anyone going to Shanghai not to miss Zhouzhuang.

After my third trip to China I knew I wanted to do a photographic book on China. I wanted people to see China as I do. After my fifth trip I realized I could never get to all of China but I definitely wanted to go to the area where the Yellow Sect Monks were. They are the monks that wear the wonderful large yellow hats. There aren't nearly as many now as there once was. When an opportunity came up to go to Qinghai Province I was excited to go. This area of China is known for monasteries of the Yellow Sects Monks. We started in the city Xining at the Kumbum Monastery where there was at one time 3,600 Yellow Sect Monks. Now there are 400 monks but it is a very active monastery. I spent three weeks in Qinghai Province and photographed many monasteries and "yellow hats". For the first time in China I went through a Chinese Muslim area. To be able to photograph

拍，那张从上往下拍的僧人的照片和冲我微笑的年轻僧人的照片就是在甘孜拍的，这两张是我在西藏拍摄的所有照片中最喜欢的照片。离开拉萨后除了藏民再没有见到其他人。

本书中有个小单元是关于一个被誉为中国威尼斯的神奇小镇 —— 周庄。我们是在去上海的途中在周庄停留了一夜。我们到那里时已经近黄昏了，人很多，到处都是游客，第二天很早起来就去拍摄，清晨的薄雾笼罩着河面，只有当地的居民早早起来为一天的生活和工作做着准备，一切都是那样的和谐宁静。周庄离上海大约100英里，我想告诉所有那些想去上海的人一定不要错过周庄。

当结束了我的第三次中国之行后，我知道我要出一本关于中国的摄影书籍，我要让人们像我那样去看看中国。当我第五次去中国后，我意识到我永远不可能走遍全中国。但是我一定要去有黄教（译者注：藏传佛教格鲁派的俗称）僧人居住的地区。他们都戴着漂亮的黄帽子，他们的数量已经不像以前那么多了。我终于有了个机会到青海去。那个地区因有黄教寺院而闻名。我们从西宁的塔尔寺开始，塔尔寺曾经有3600多名黄教僧人，现在寺中有400多名僧人，但它是一个很有生气的寺院。我在青海呆了三个星期，拍摄了很多寺庙和"黄帽子"，还去了一个穆斯林地区，这是我第一次在中国去一个穆斯林地区，拍摄到了穿着传统服装的穆斯林，他们用当地的美食款待我们！

the Chinese Muslims in their traditional clothes was an unexpected treat. Also, another treat was the great food in the area!

My best experience on this trip was meeting and photographing a monk who was only five years old. He was in the Labuleng Temple in Gansu Province on the border of Qinghai Province. I stepped into a courtyard and there he was. He was washing his robes in a water faucet while he had them on. I took many pictures of him and he loved it. Later that day when all the monks came to worship and debate I was surprised to see him among the adult monks. There is an image of him washing his robes and an image of him with the adult monks in this section. I could have taken him home he was so special! Also, being able to sit in on the debates was quite an honor. The debates were a big part of a monk's life at one time but not many monasteries do it anymore. The head monk in the Labuleng Temple let us observe and photograph the debates. He is the amazing looking monk in the yellow hat in the opening image in this section. He had a very powerful presence.

When I think about China I think about the childlike happiness of the Chinese people and how friendly they are. I am especially thankful for their willingness to share their part of the world with me. I am also always overwhelmed by the age of the villages, monasteries, art, bridges, roads, and even the paint on the walls that many times is the original. When I am home after a trip I miss that. As I am writing this I am planning my next trip to China to make more images and again absorb the spirit of the people. As I said in the beginning it is heaven for me to be wandering around China with my cameras and I hope you enjoy the images in this book as much as I did making them.

这次旅行最愉快的就是会见和拍摄一个5岁的小僧人，他住在与青海省接壤的甘肃省的拉卜楞寺，我走进一个院子，而他就在那儿，正在洗身上的僧袍。我为他拍了很多照片，他都非常喜欢。那天下午，当所有的成年僧人集合在一起做功课辩经时，我惊奇地发现他也在里面。这个单元中有一张他洗僧袍的照片和他与其他僧人在一起的照片。他太特别了，我要能把他带回家该有多好啊！同样，能够坐在辩经现场听僧人们辩经也是无上光荣的事。辩经是僧人生活中的一部分，但是现在很多寺院都没有了。拉卜楞寺的住持允许我们观看和拍摄辩经的场面。他是一个面貌奇特、带黄帽子的僧人。本单元开篇就是他的照片，在其他一些照片中也可以见到他。他外表威严。

当我想起中国，我就会想起人们孩子般的快乐以及是那么友好地与人分享他们的快乐。我总是被那些年代久远的村庄、寺庙、艺术、桥梁、道路，甚至那些壁画所倾倒。每次旅行结束回家后我都十分怀念这些东西。在我写这篇文章的时候，就已经在计划下一次的中国之行了，盼望着去拍摄更多的照片，再一次理解和汲取中国人民身上所具有的那种精神。正如我在开头所说的那样，带着相机漫步在中国的土地上对我来说就是到了天堂。我希望你们能像我喜欢拍摄这些照片那样的喜欢书中的照片。

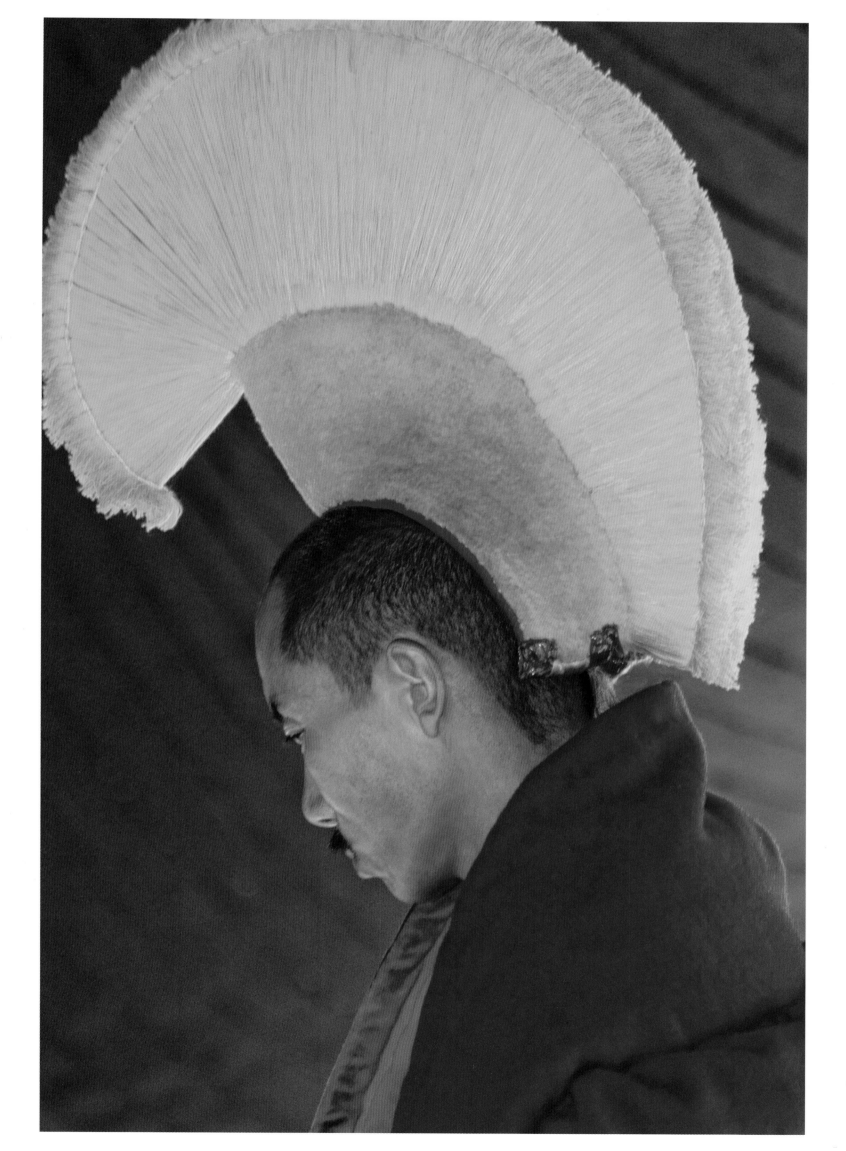

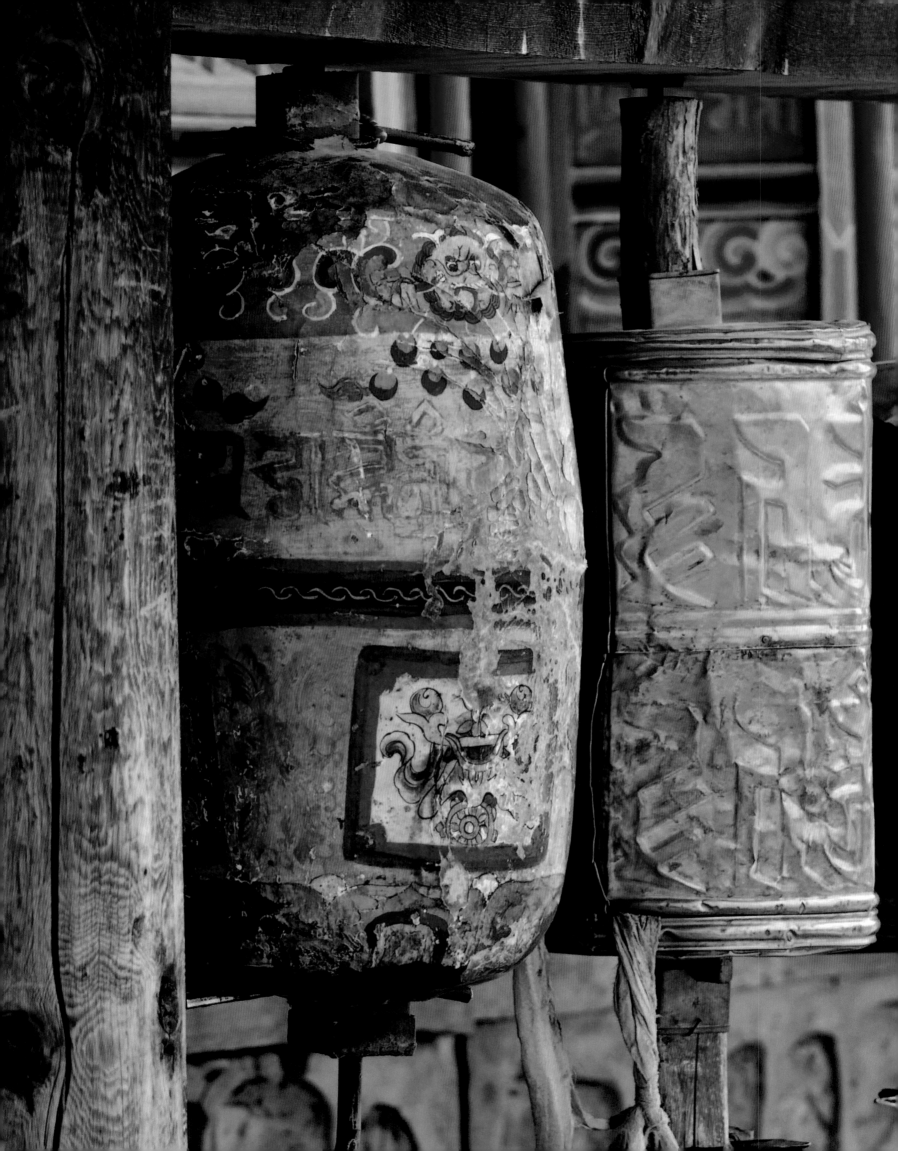

CONTENTS

目录

THE FORBIDDEN CITY

故宫

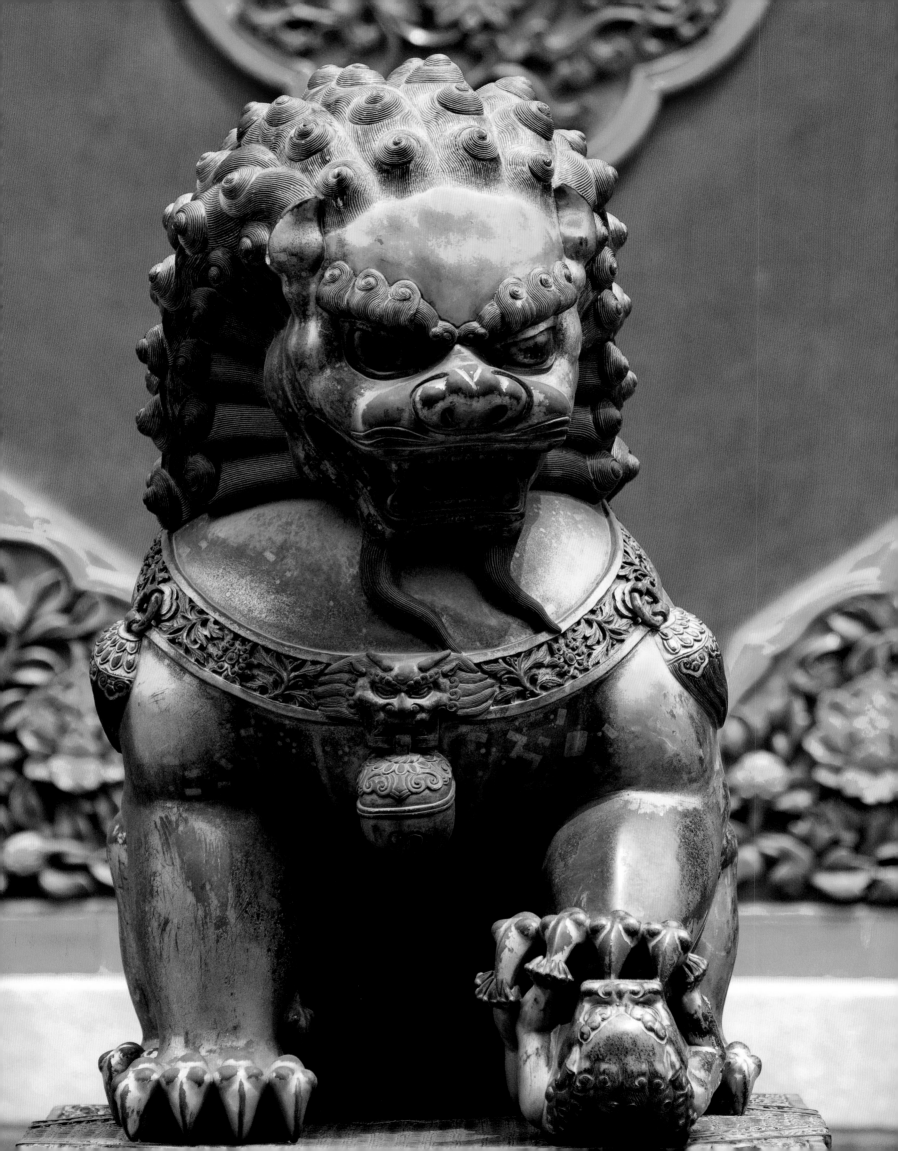

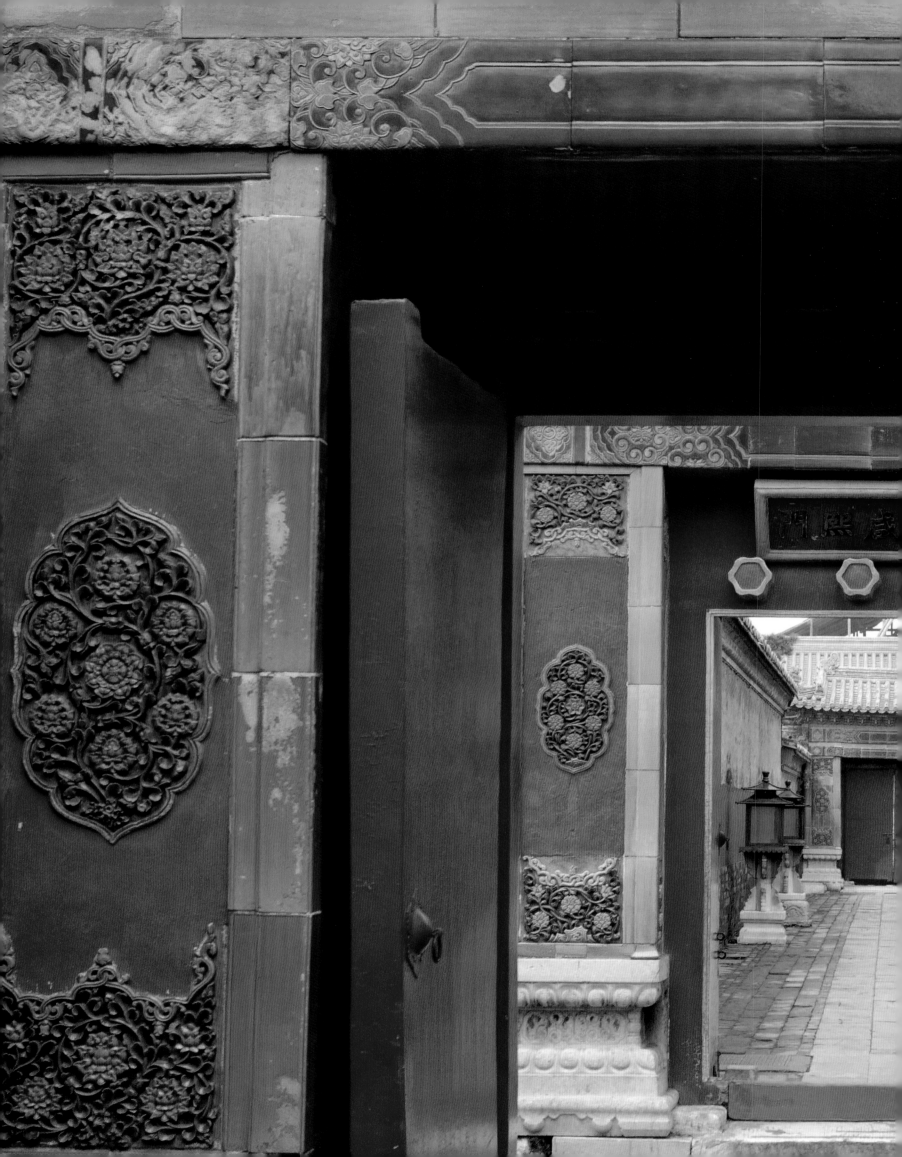

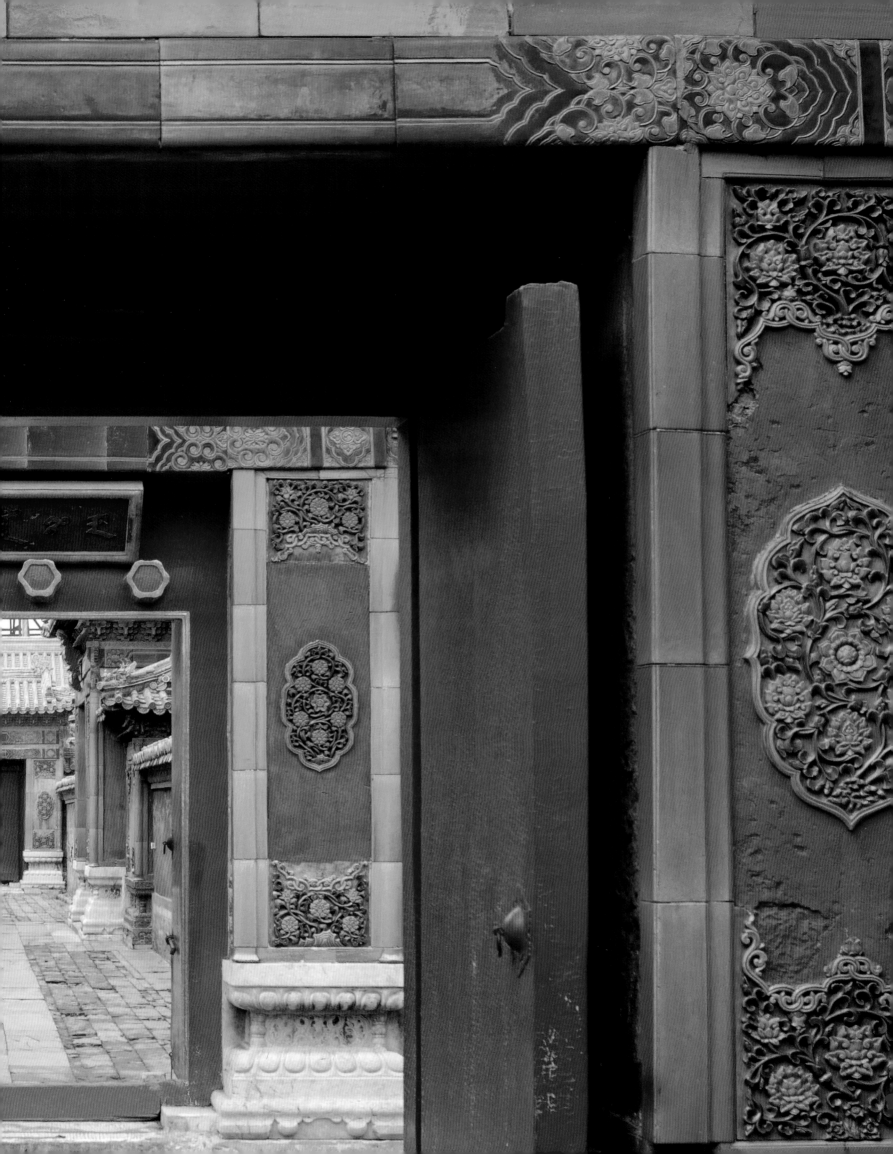

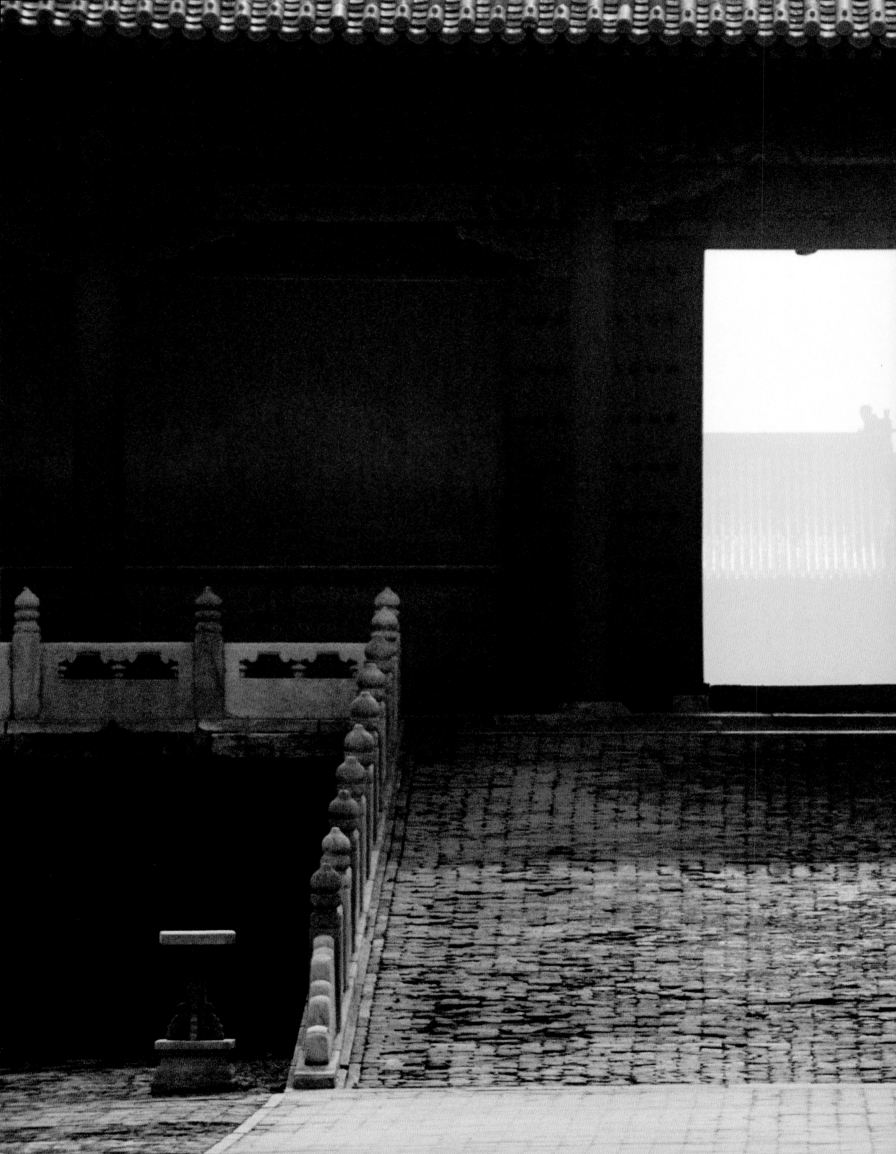

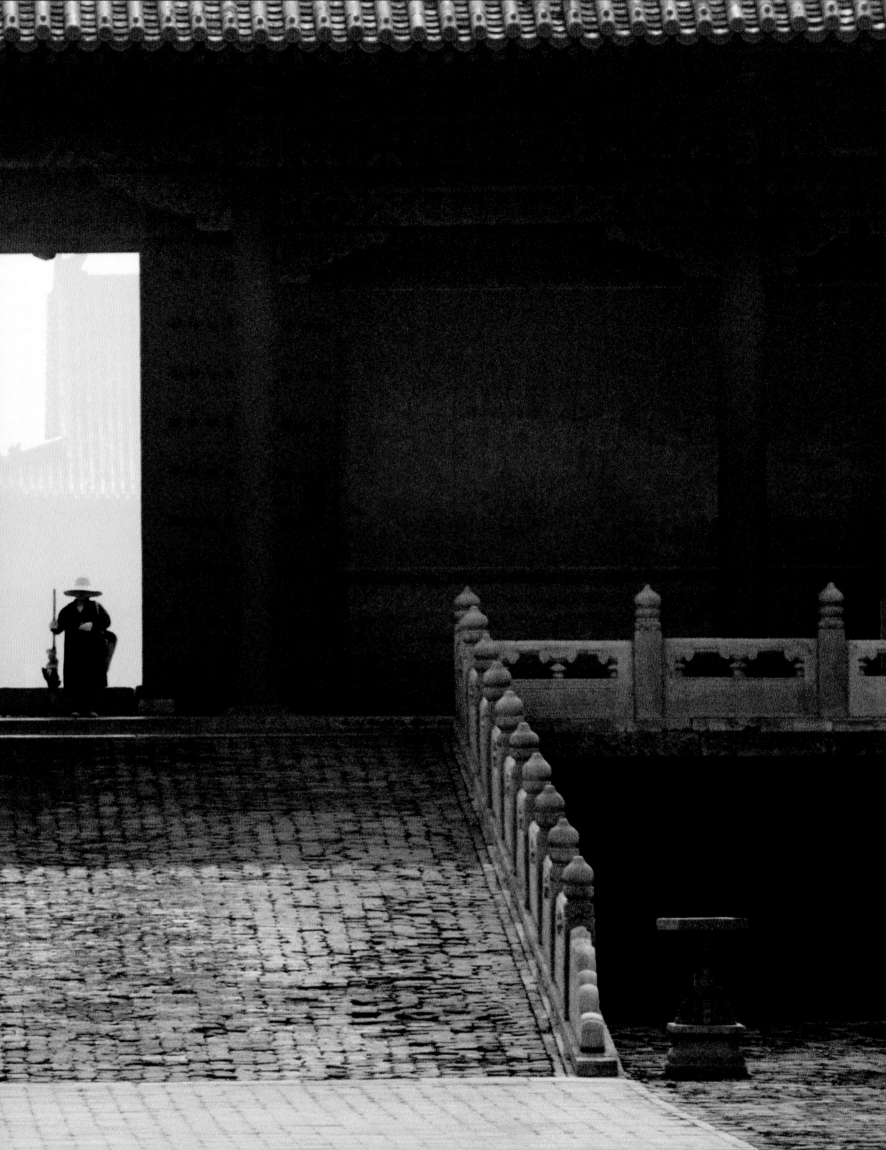

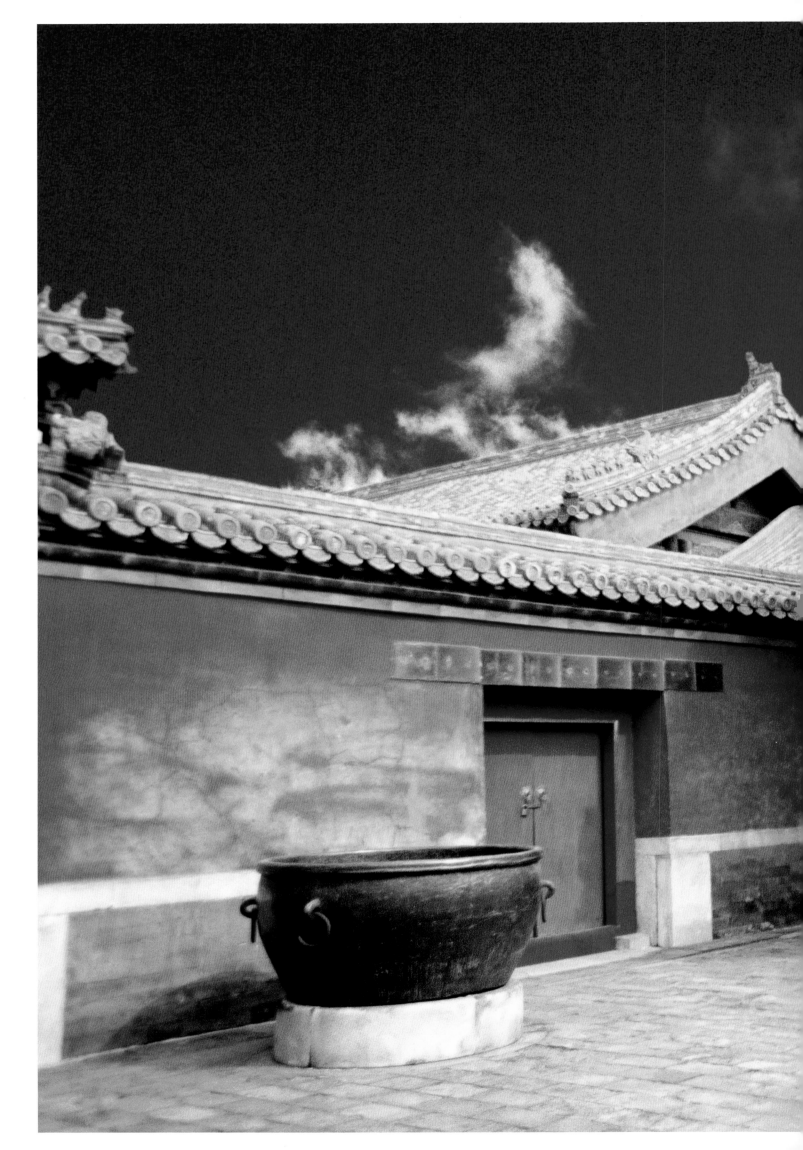

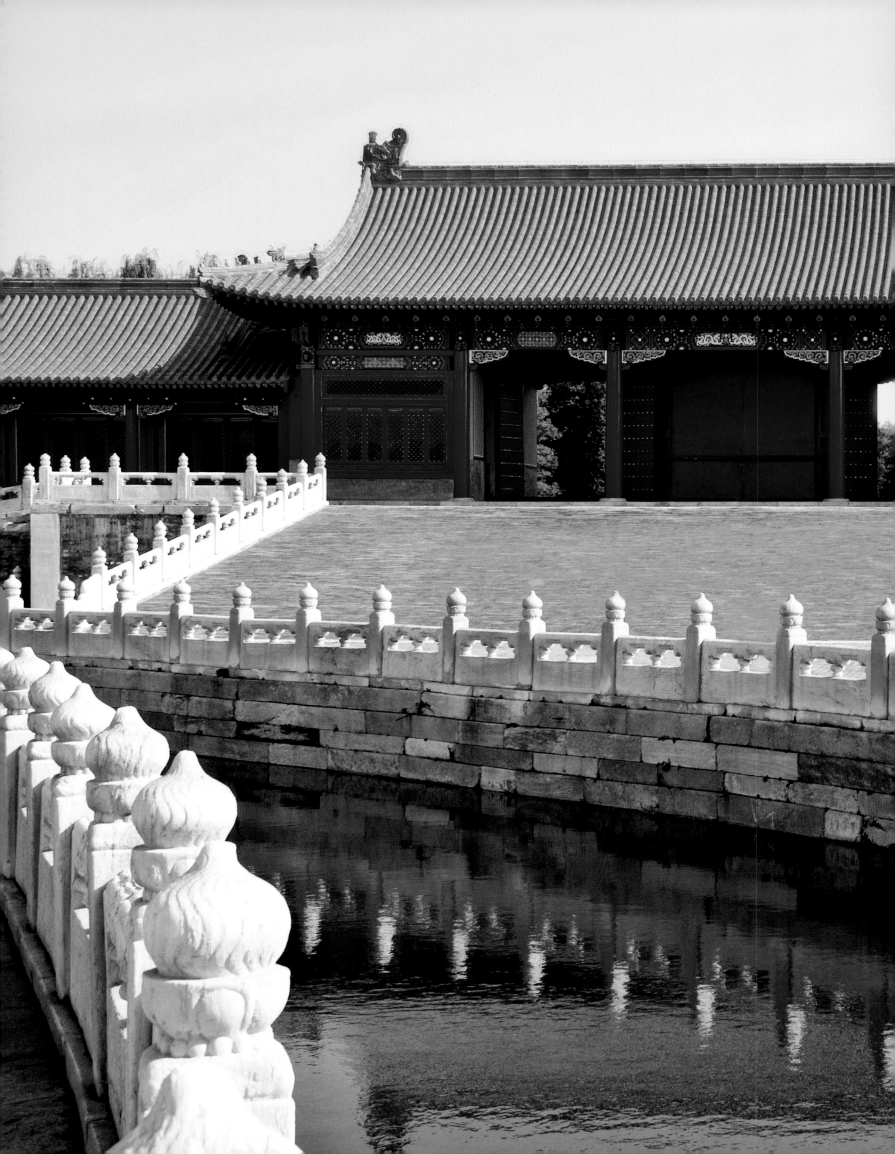

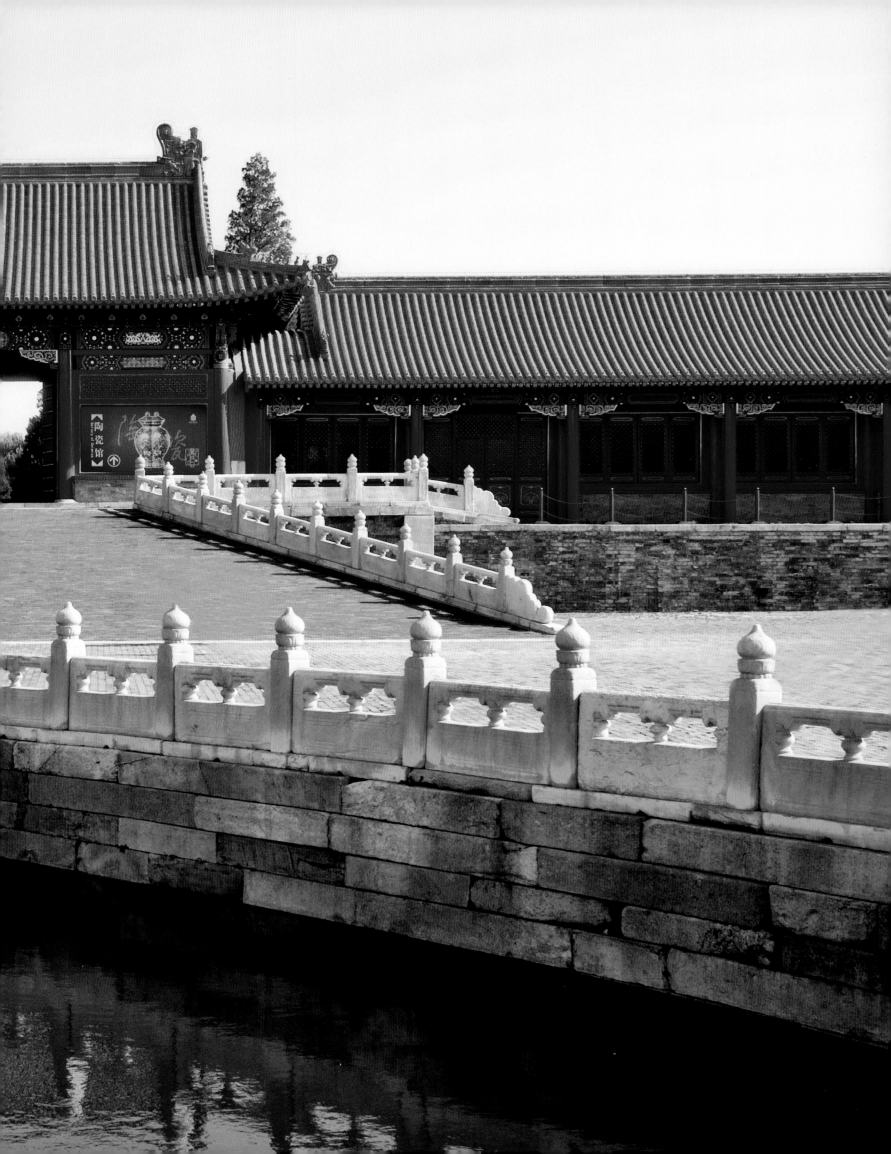

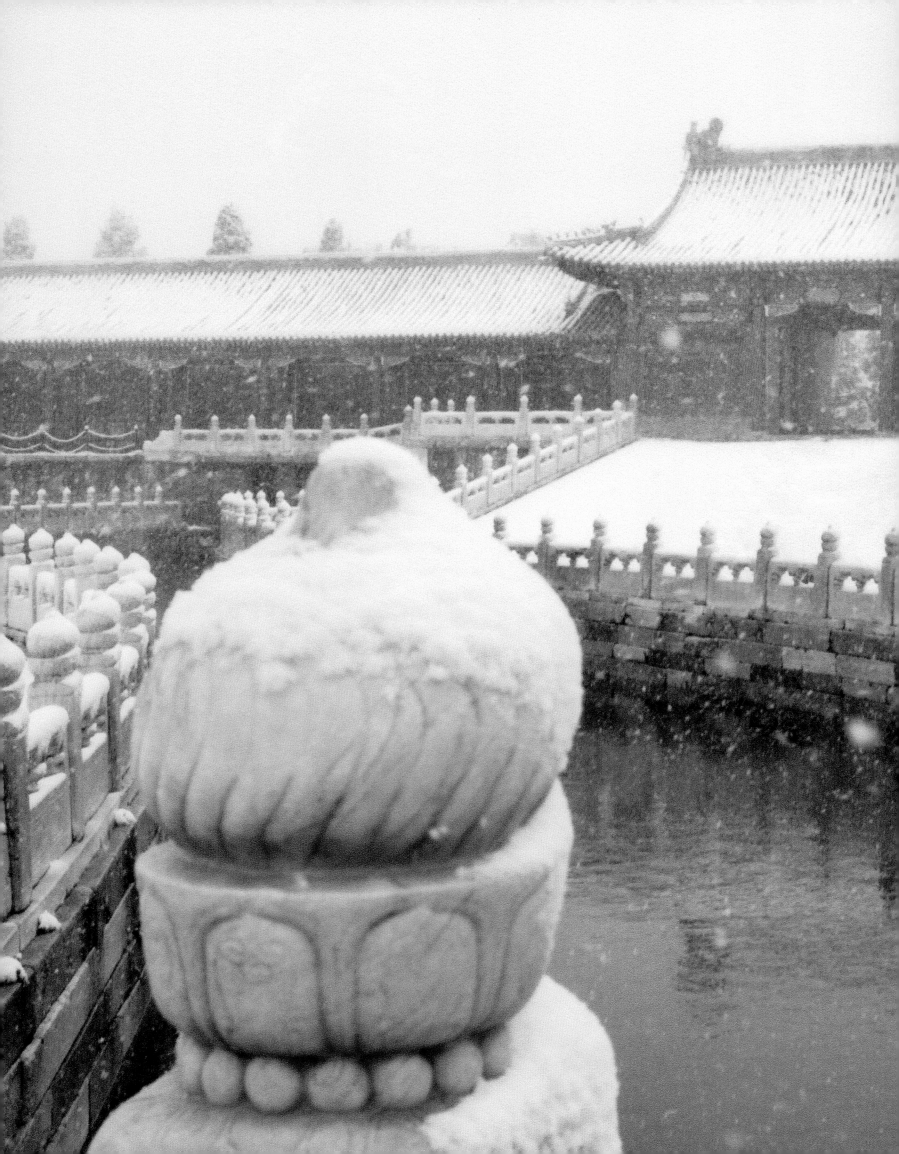

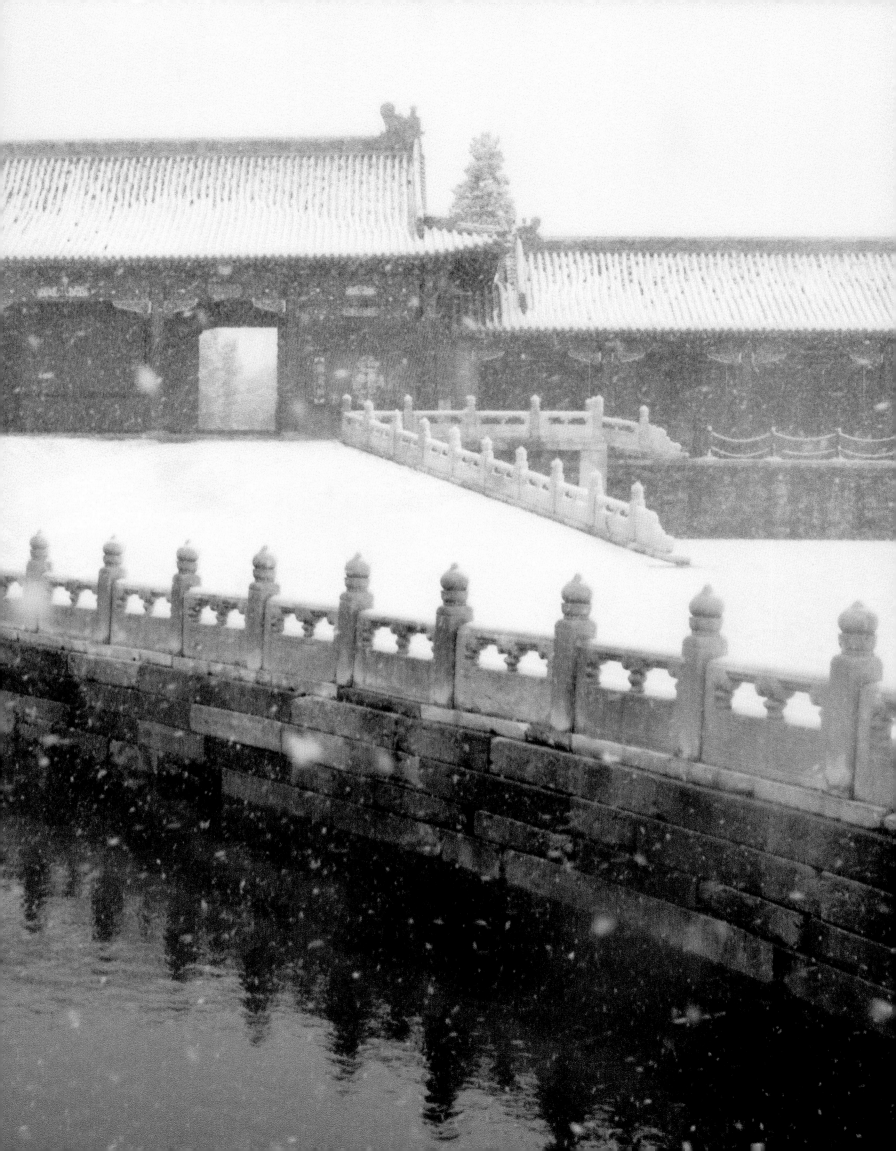

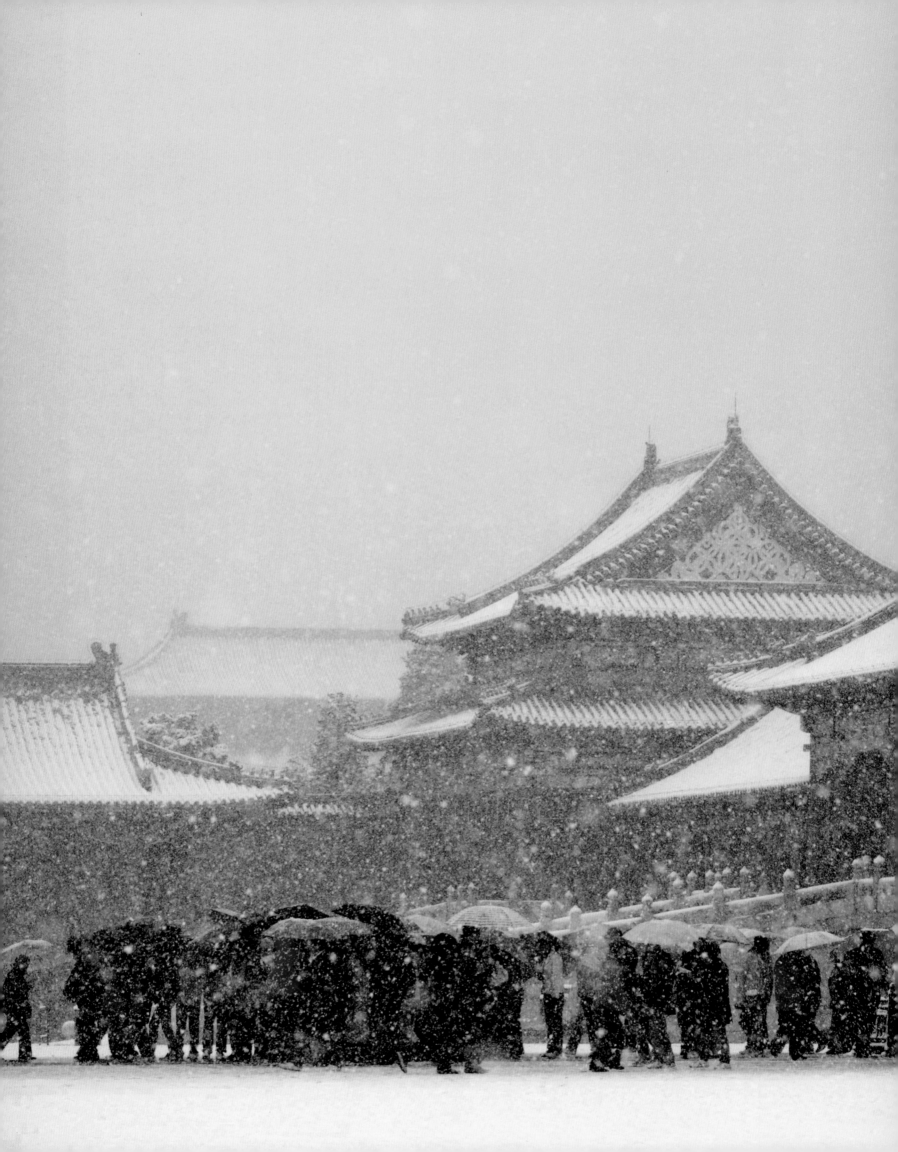

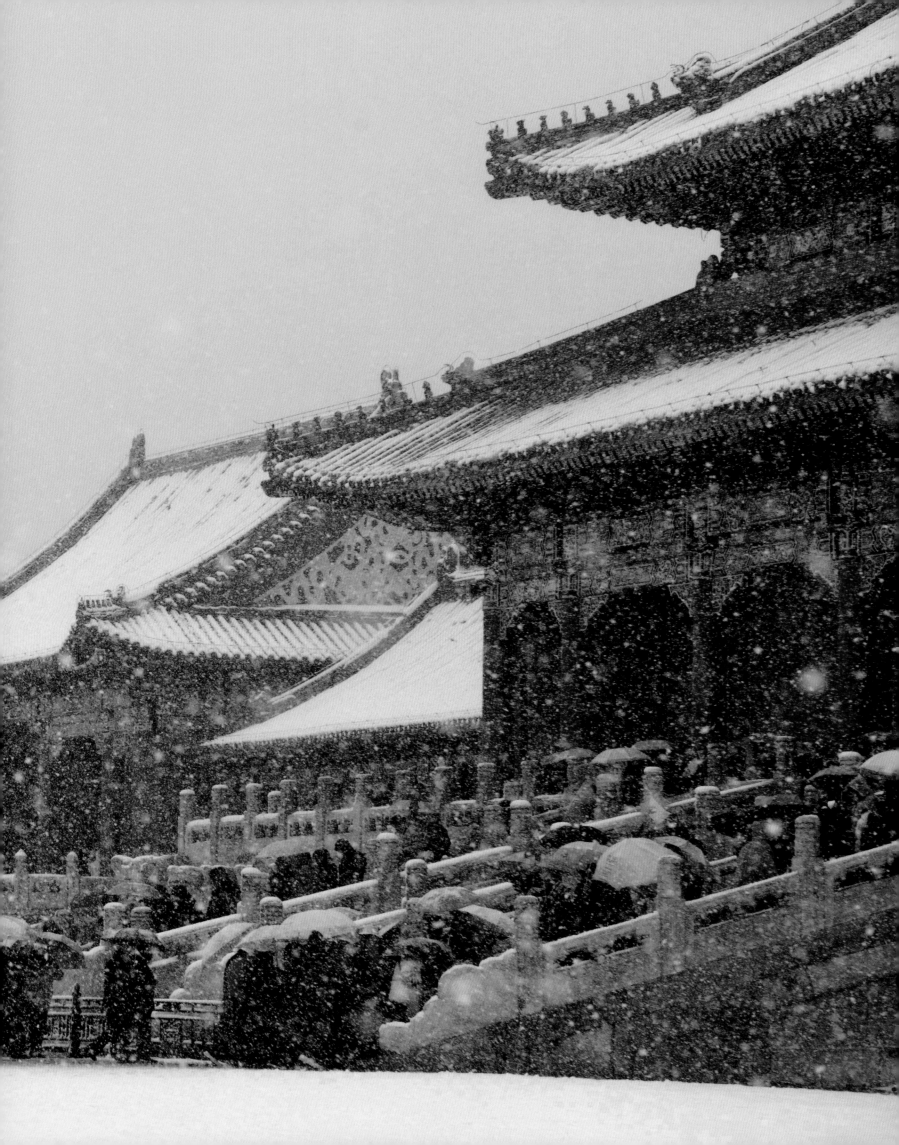

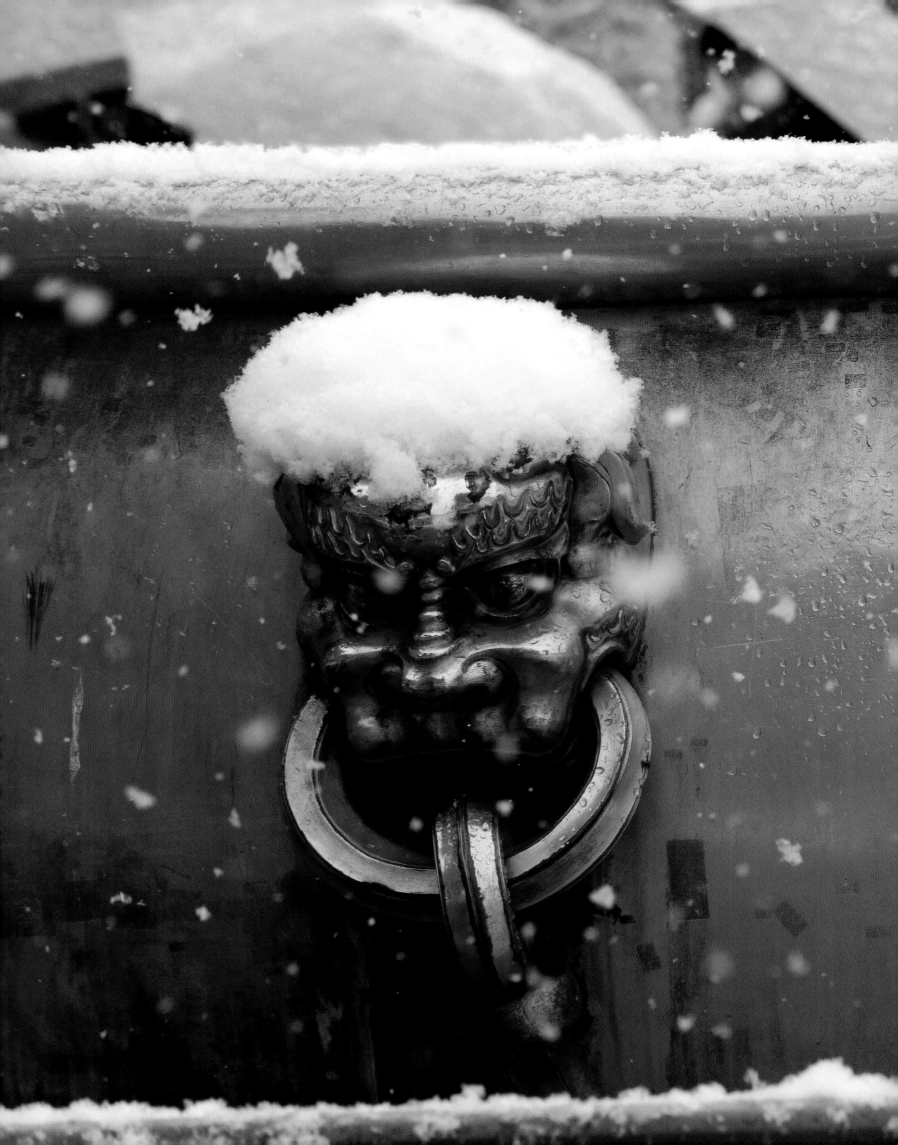

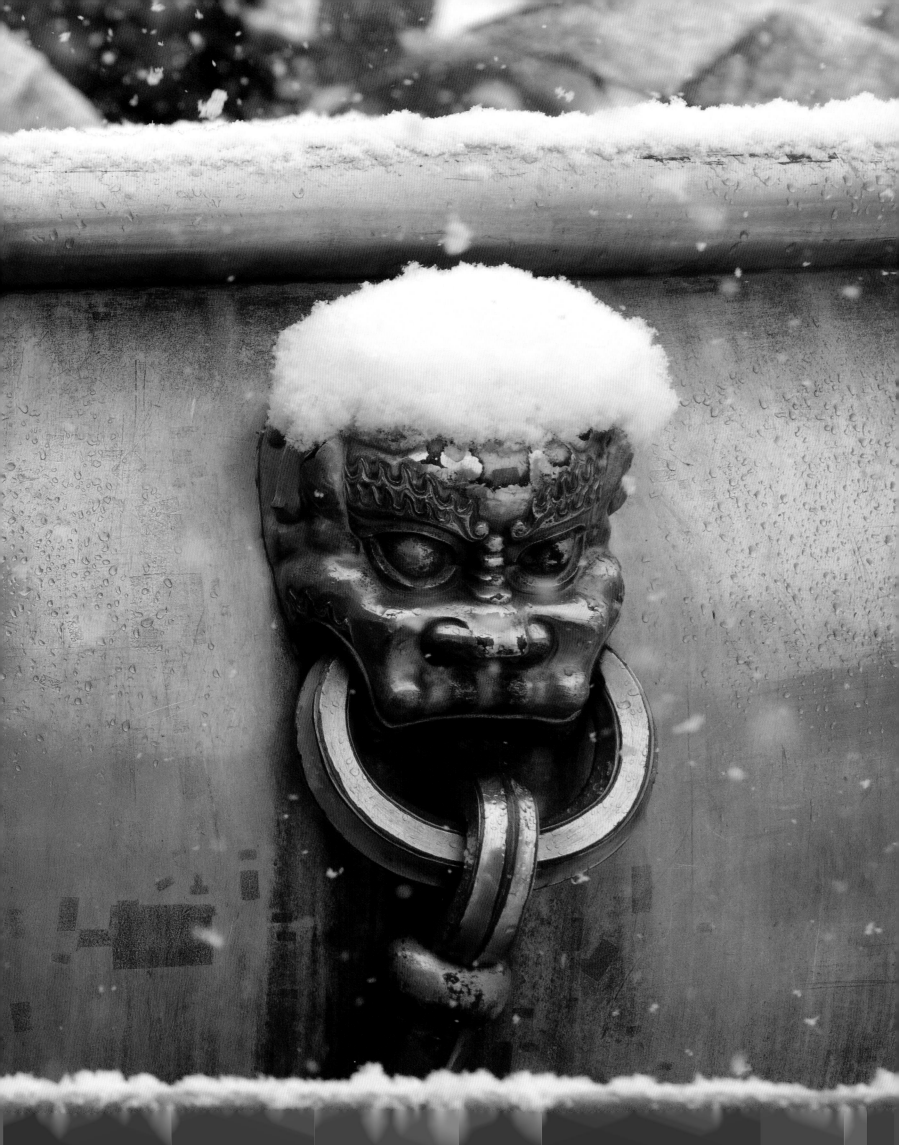

INNER MONGOLIA
THE GRASSLANDS OF CHINA

内蒙古

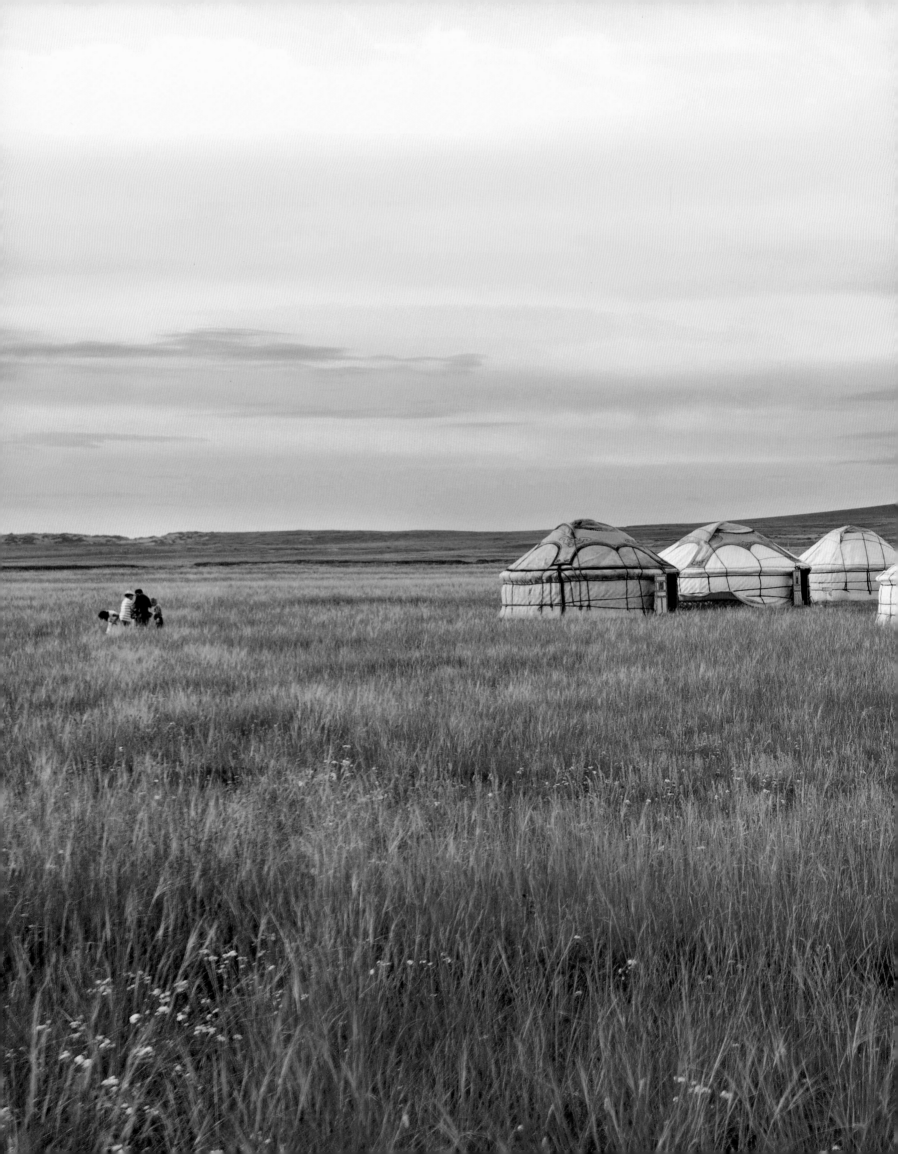

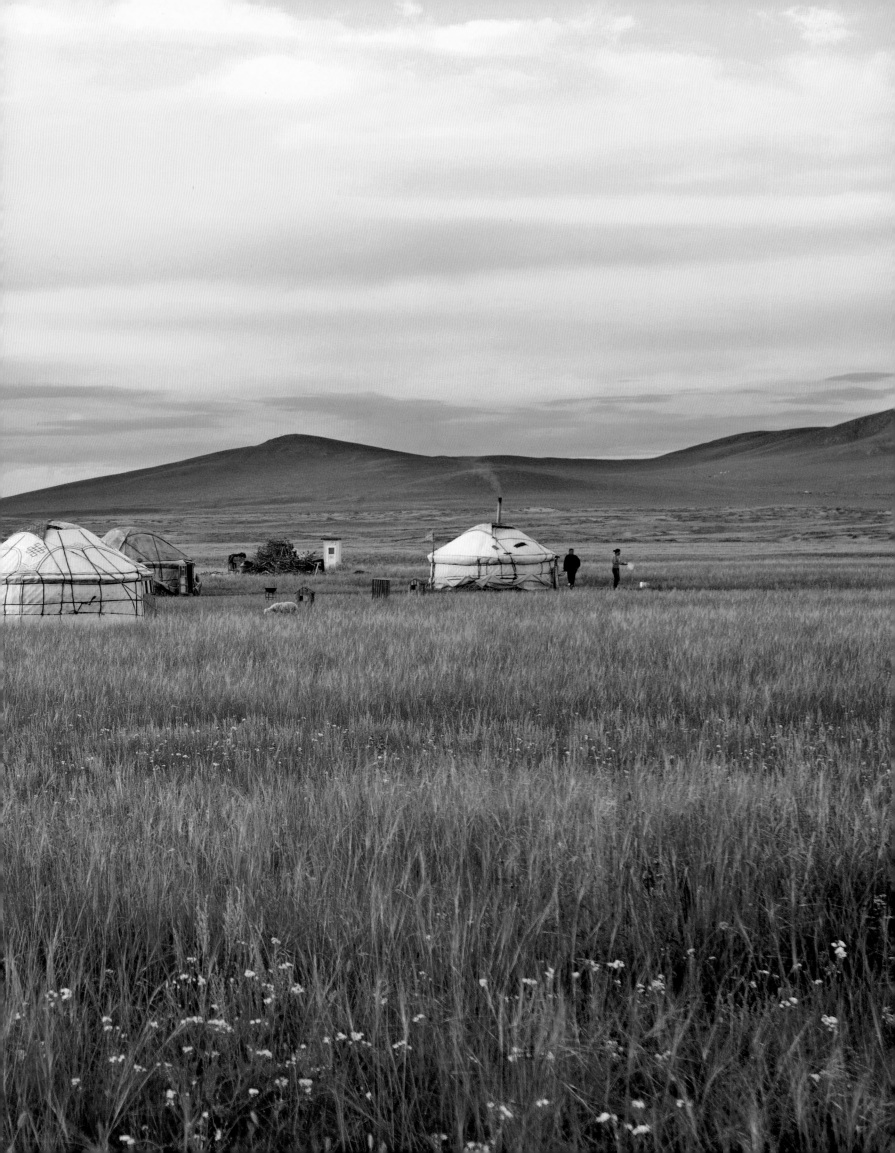

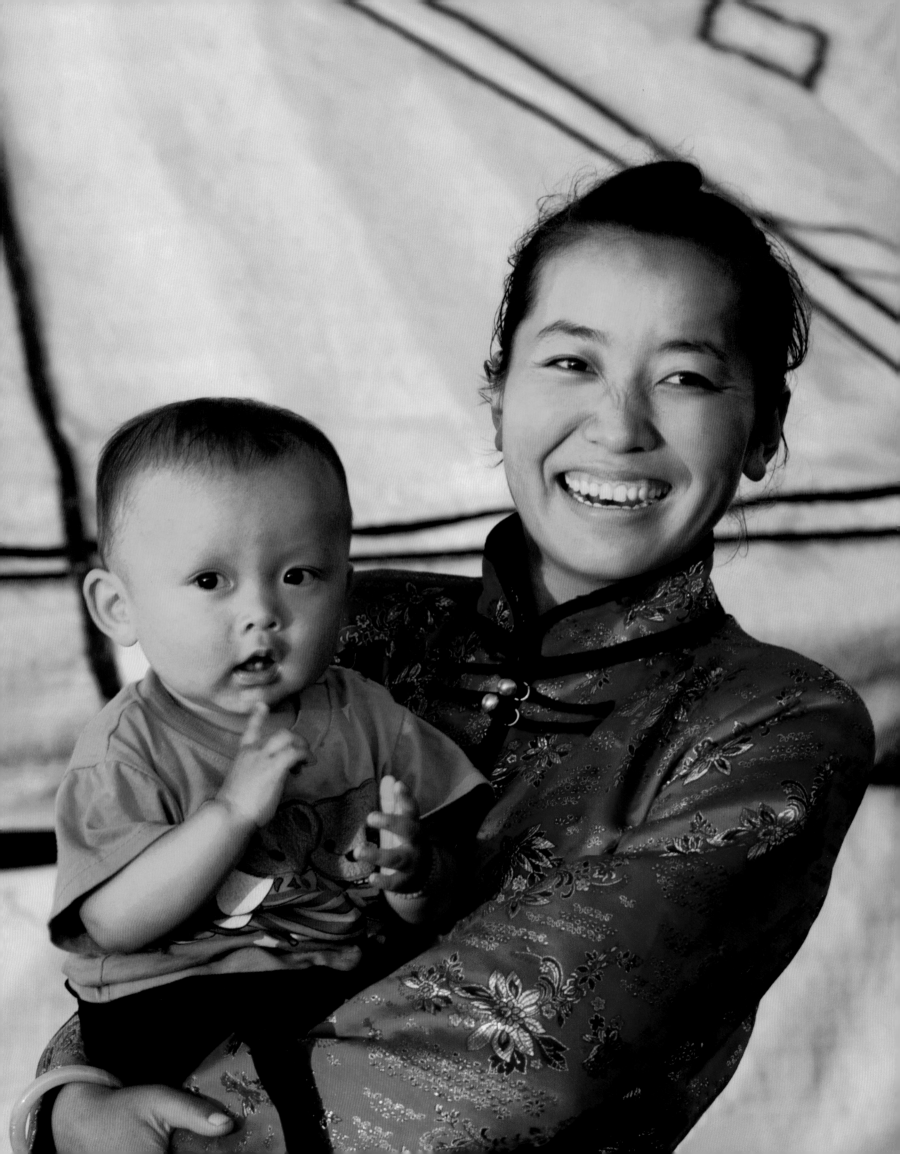

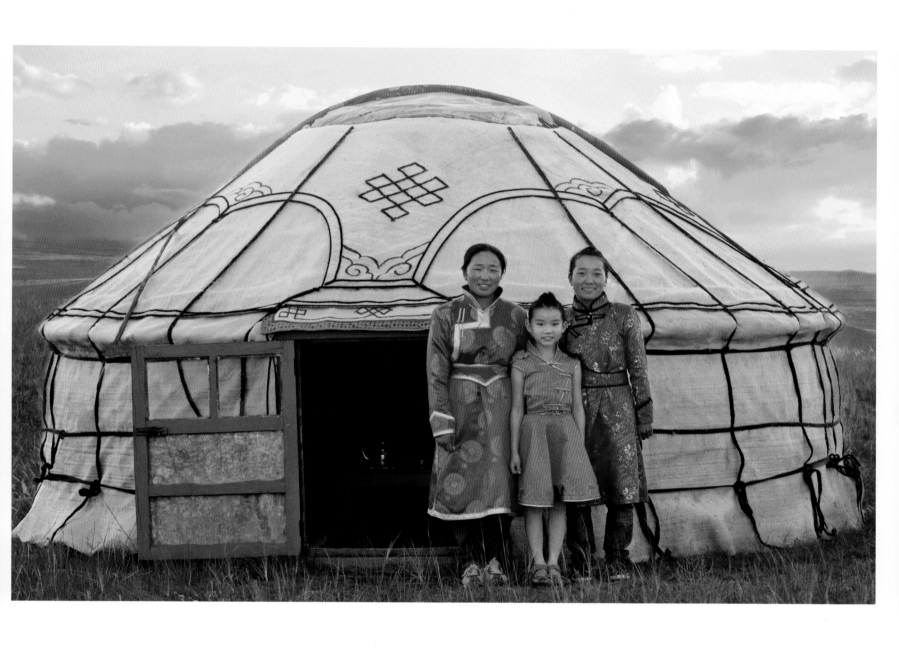

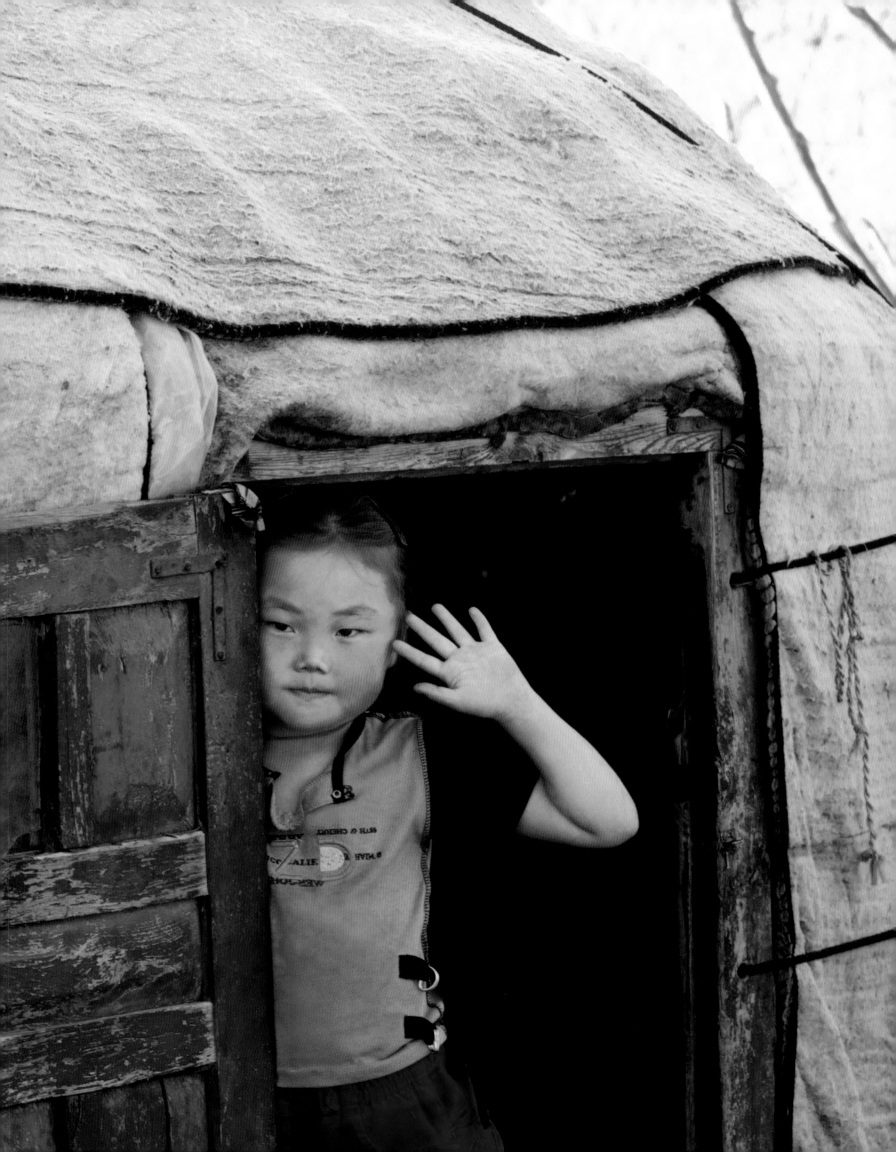

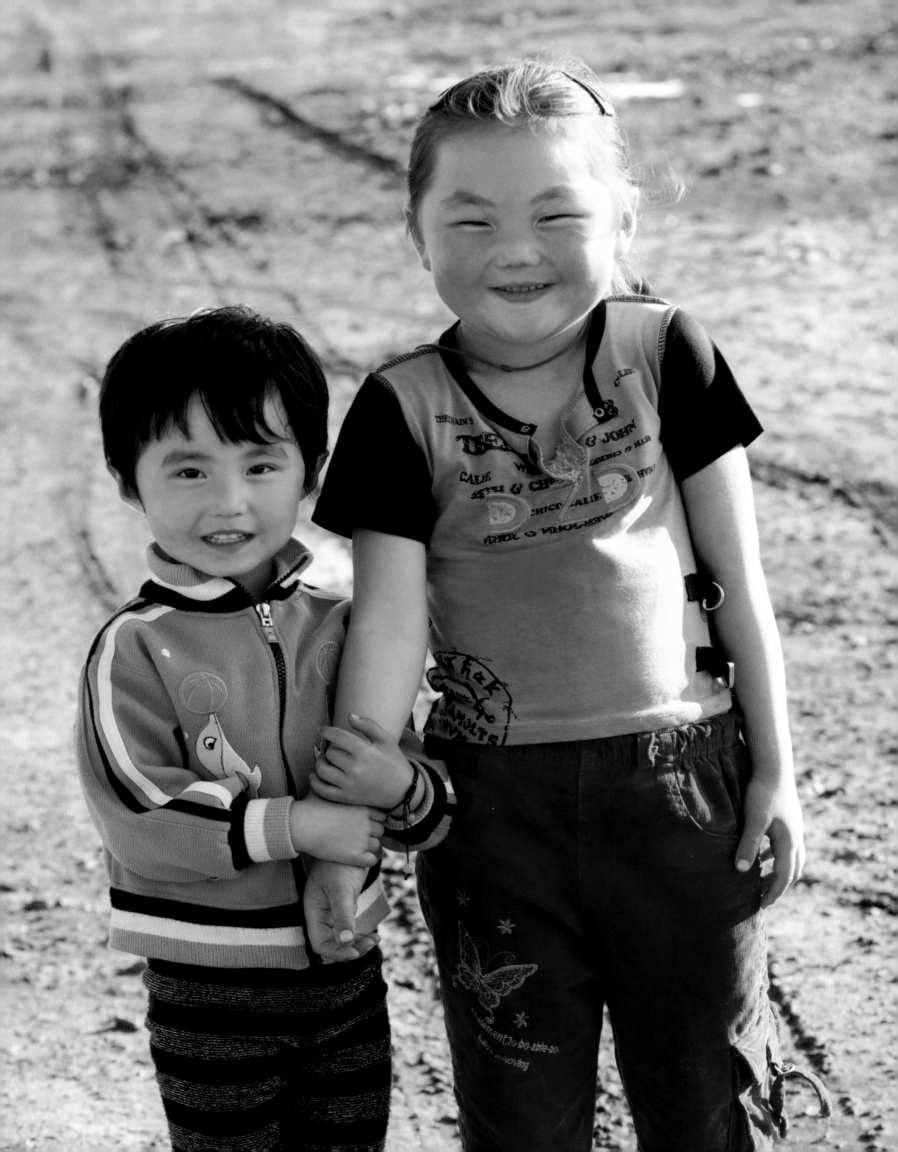

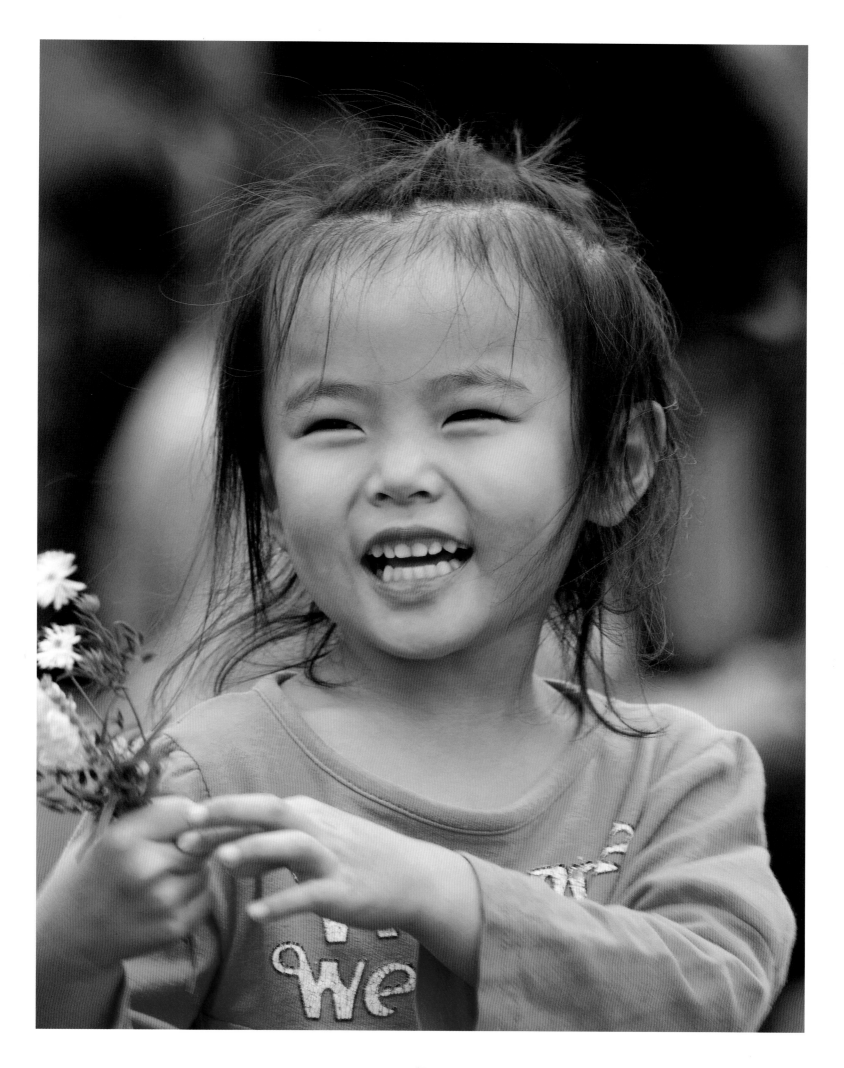

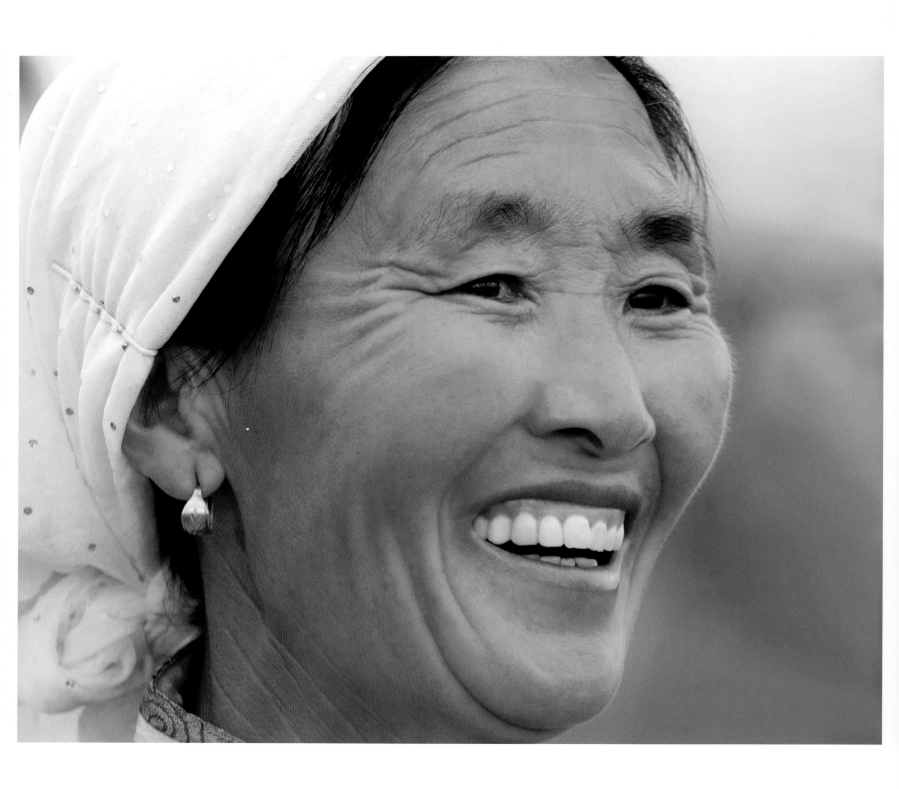

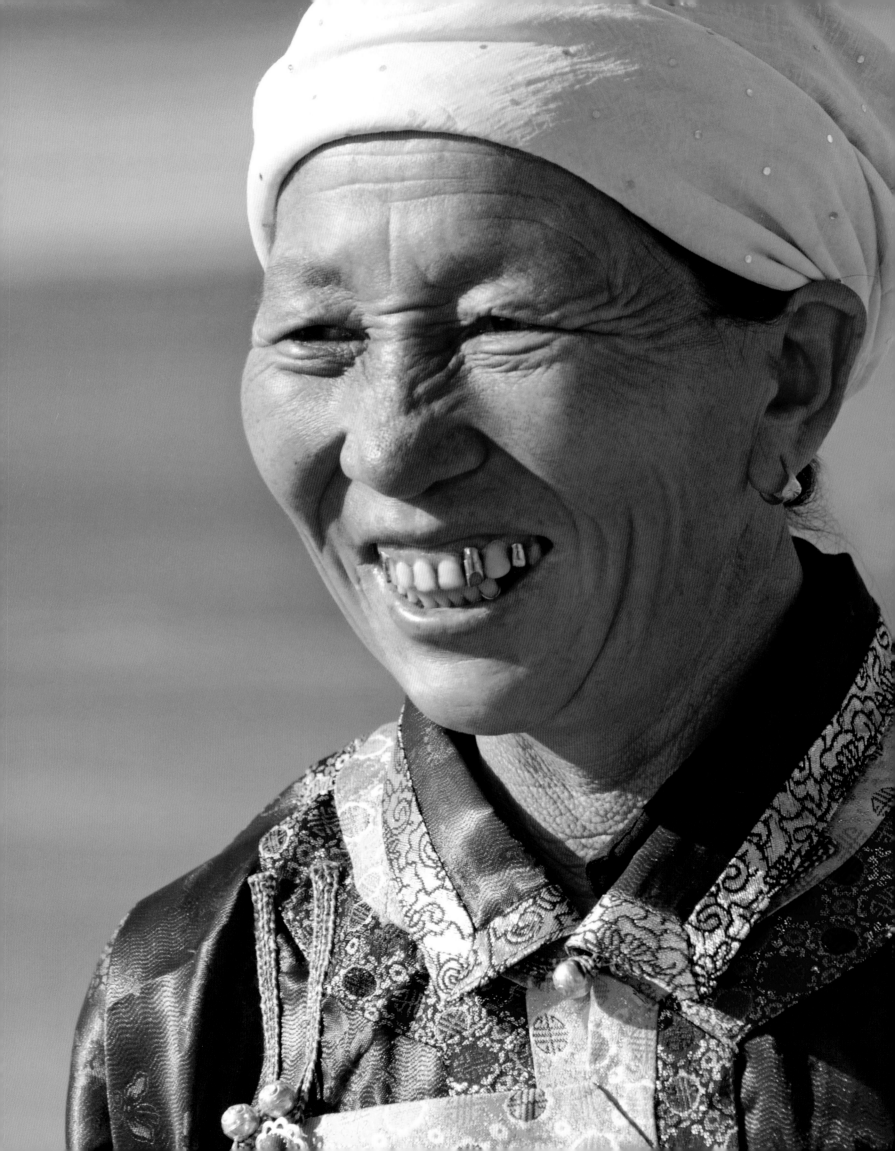

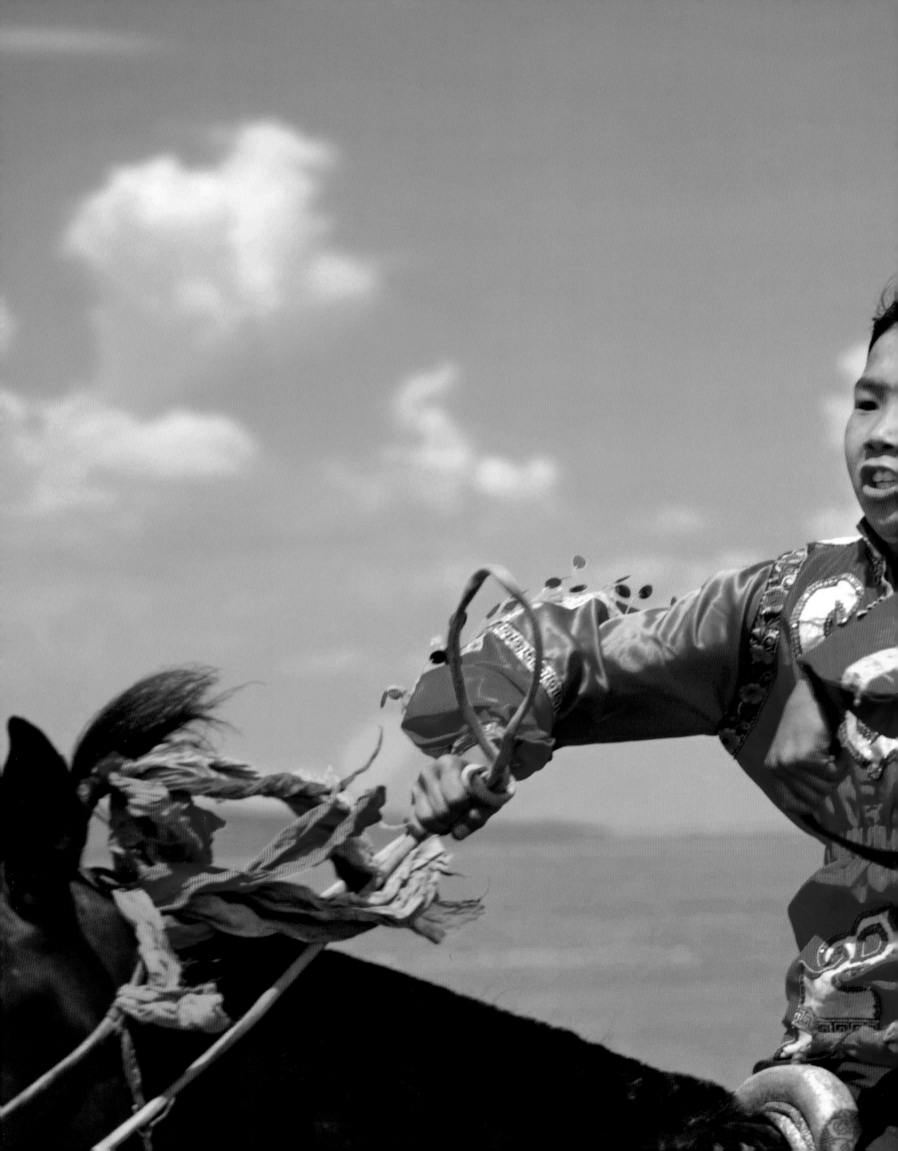

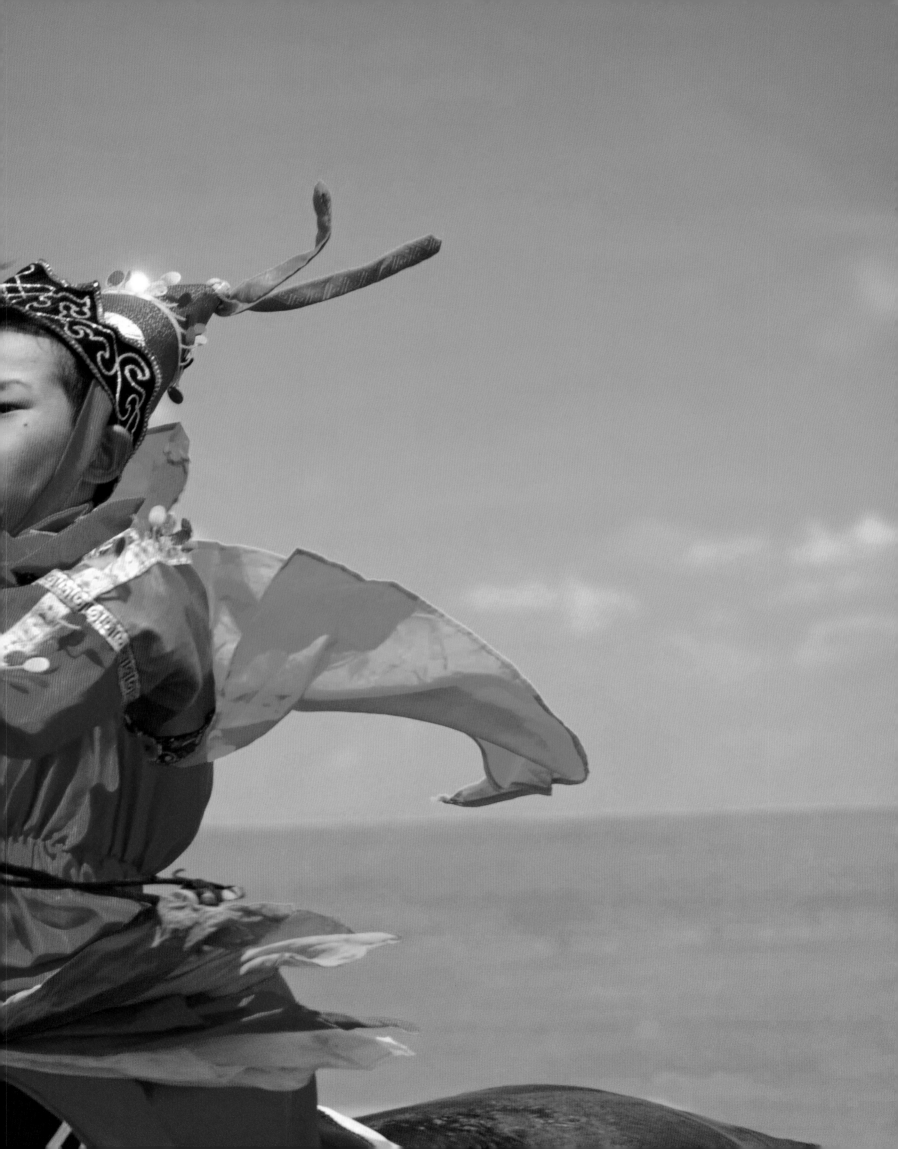

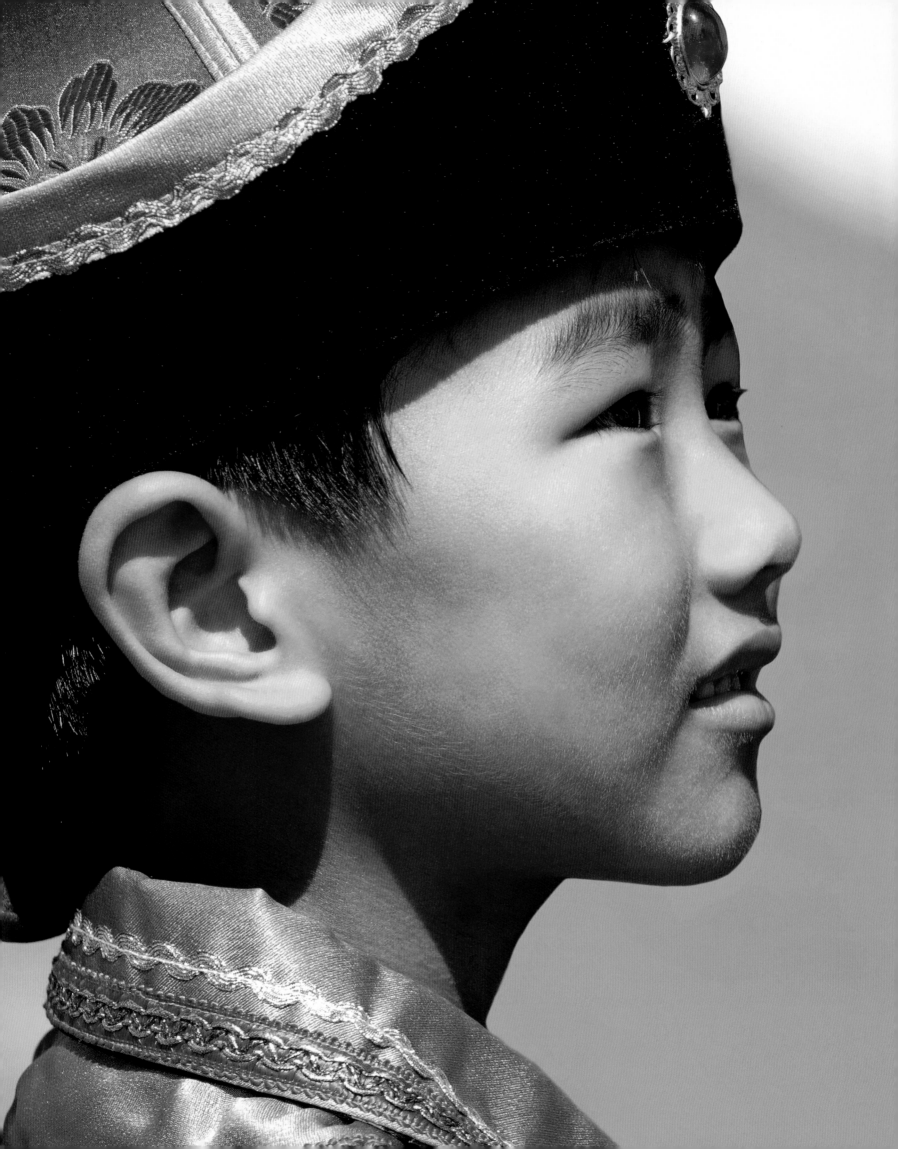

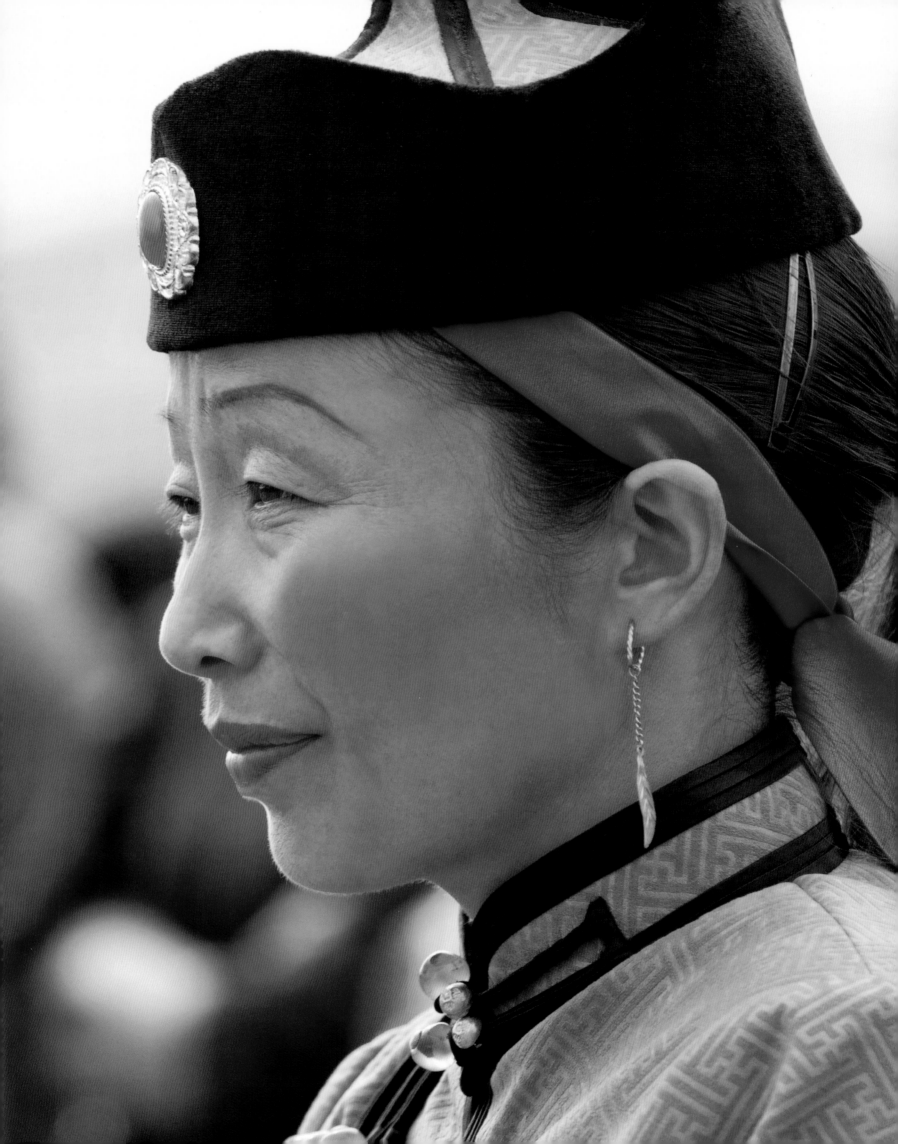

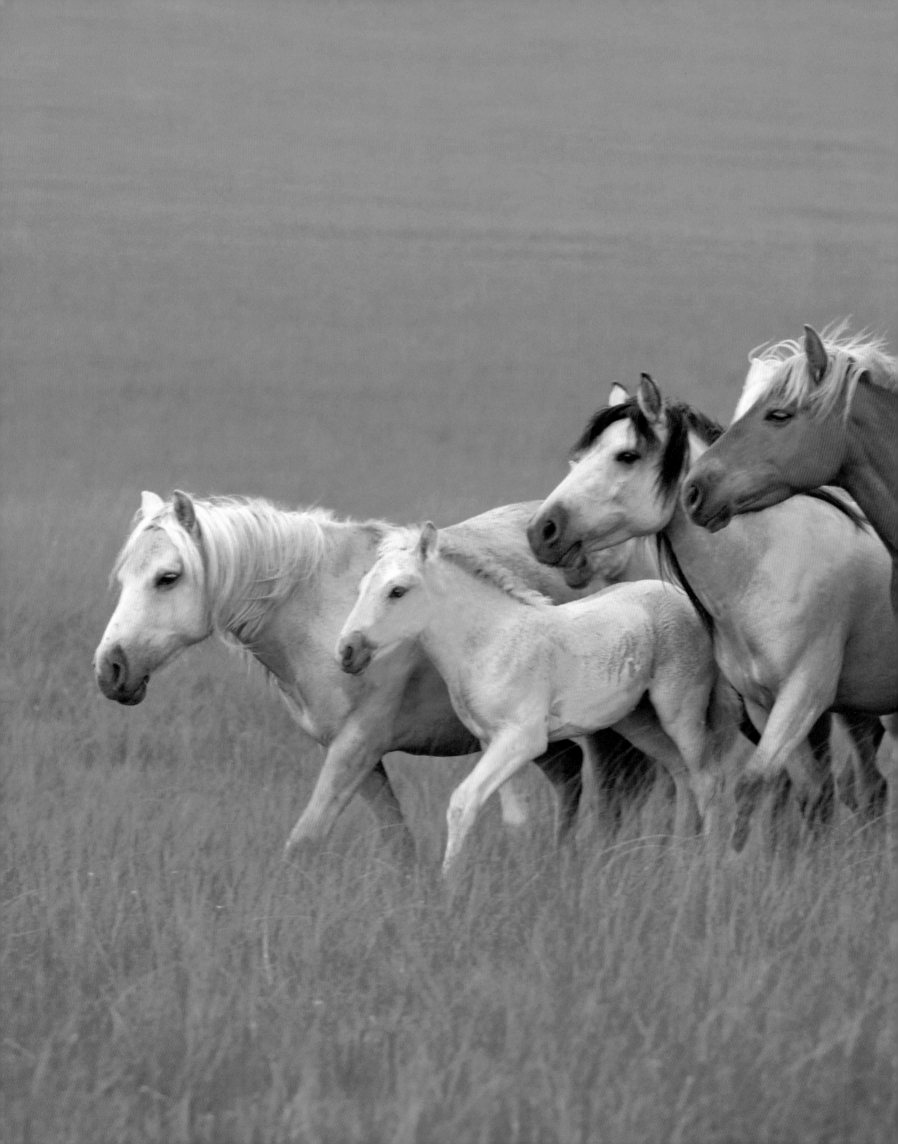

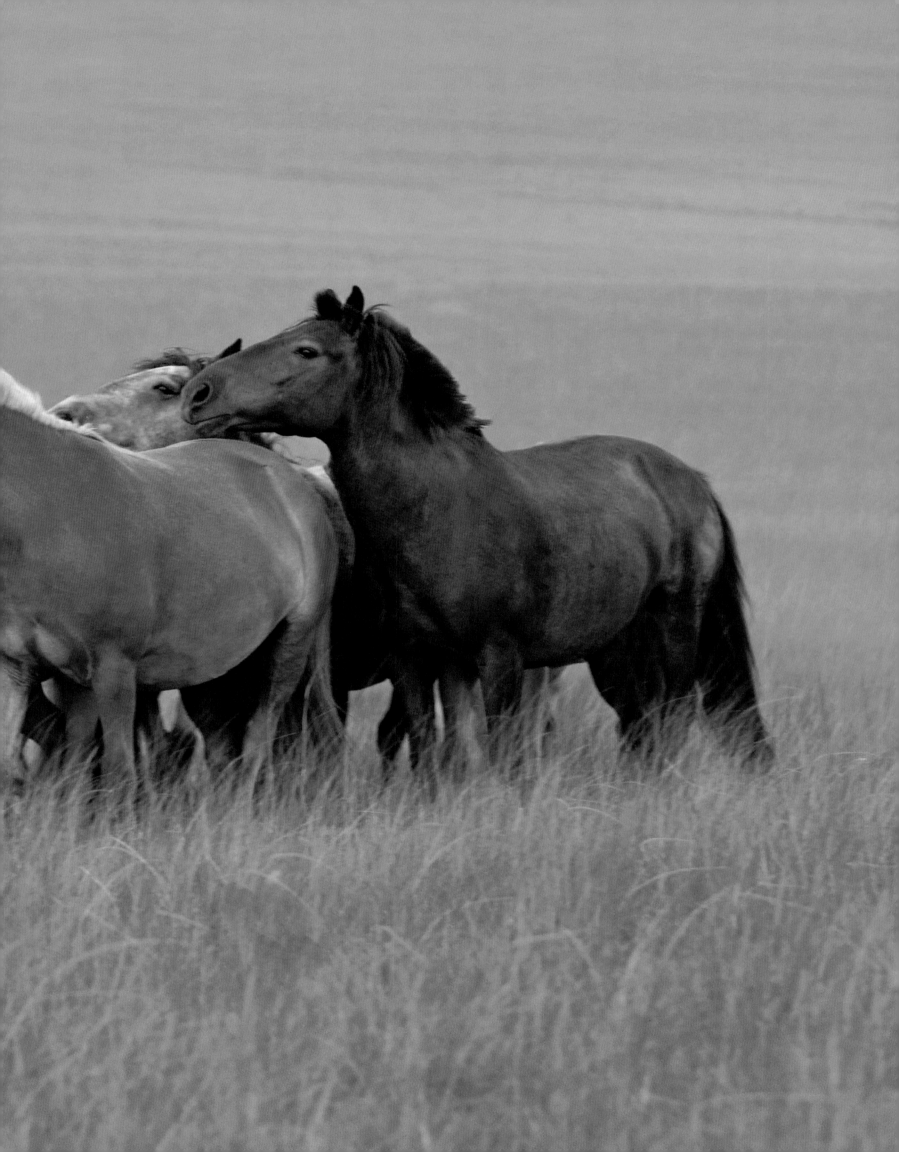

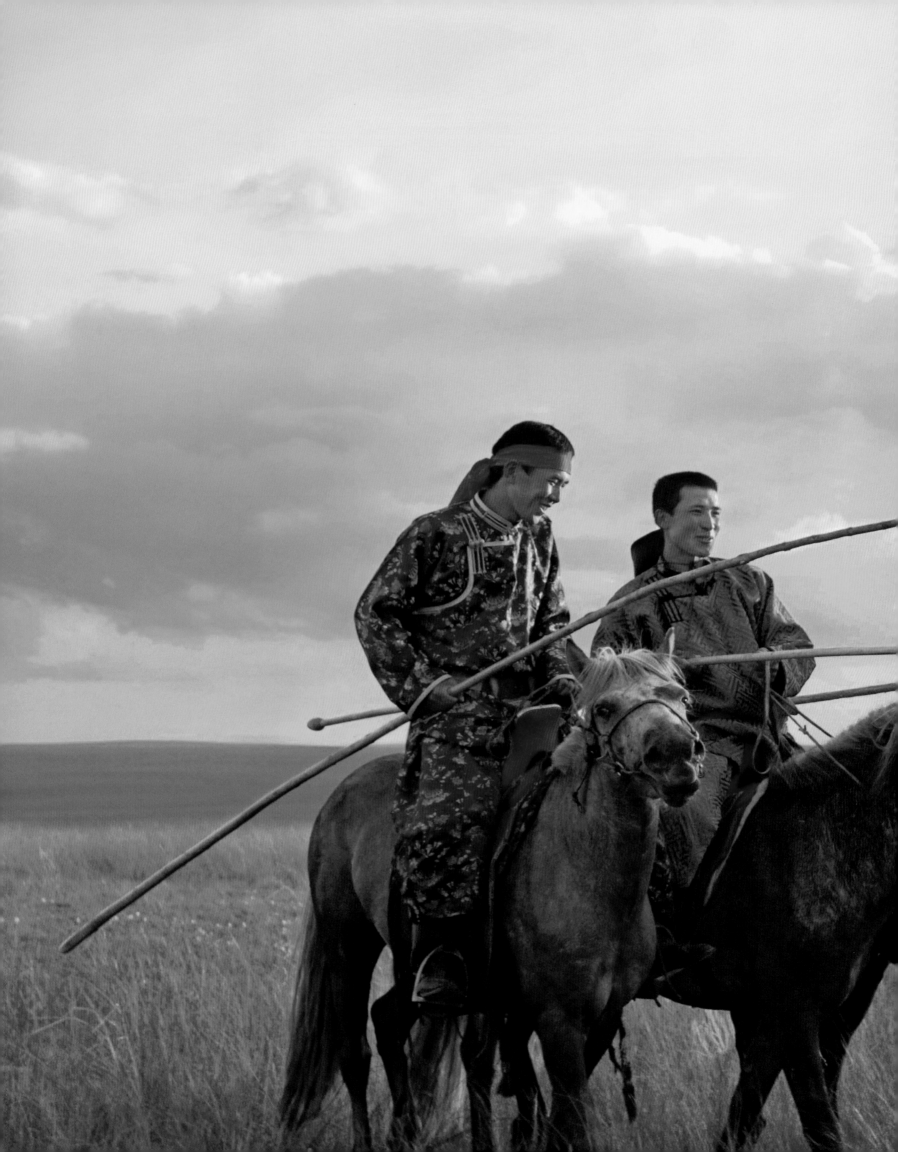

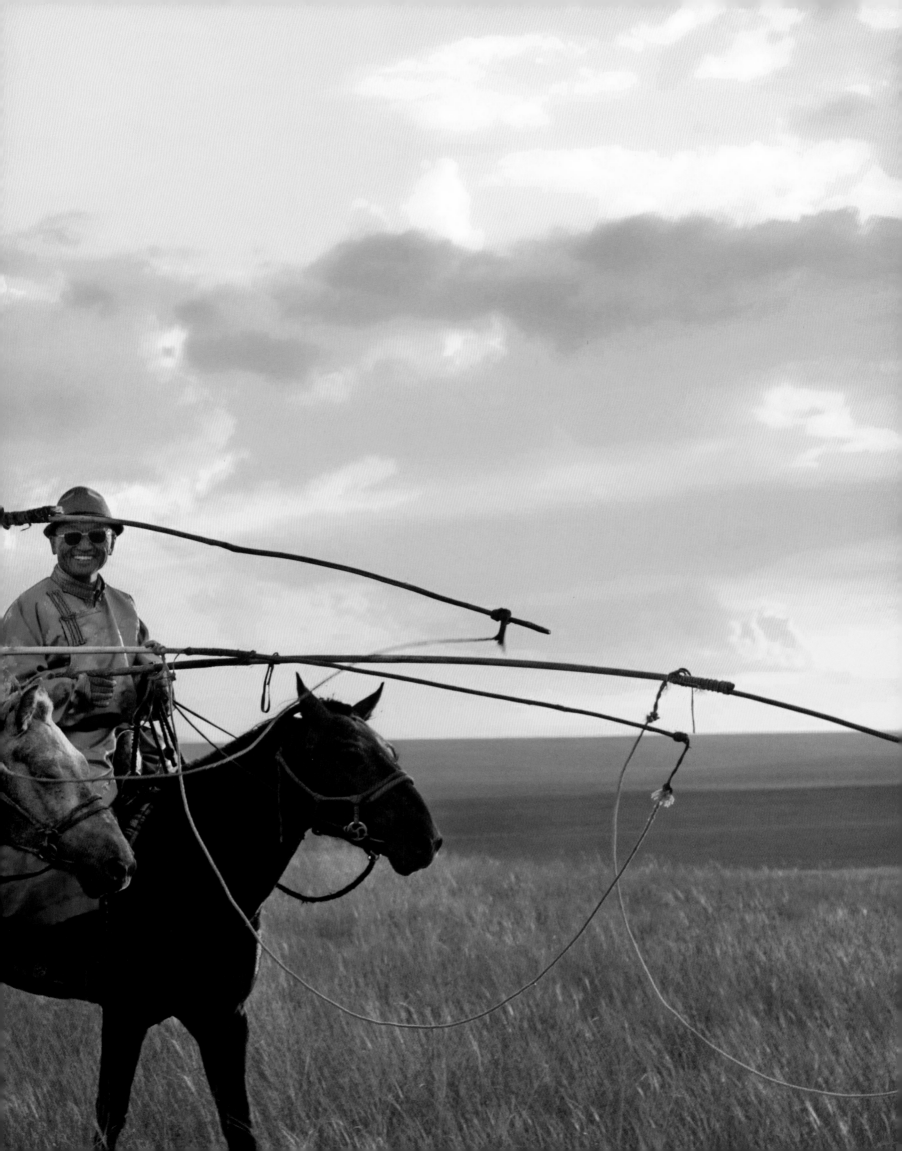

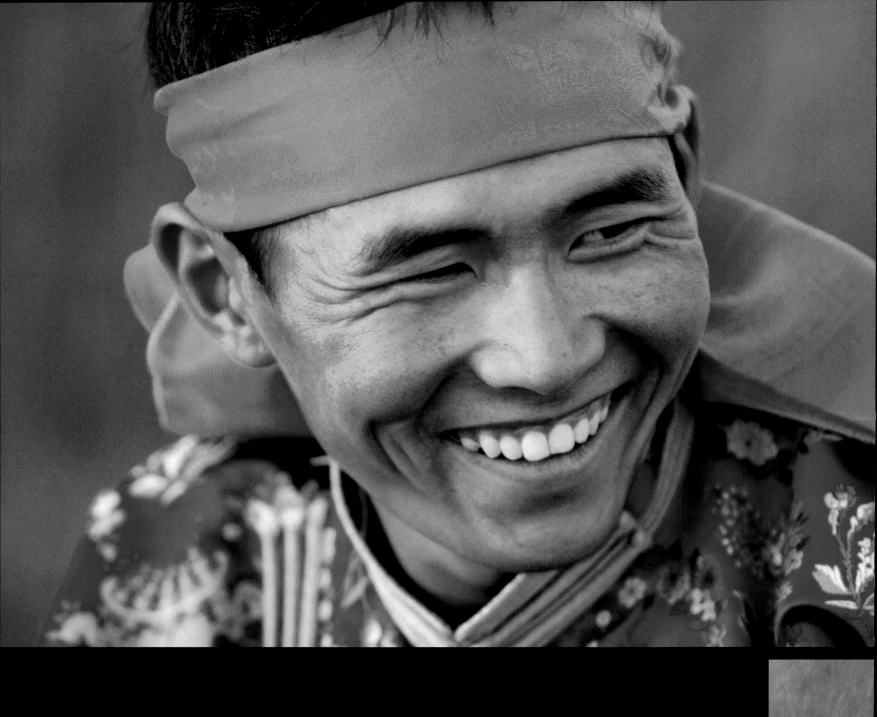

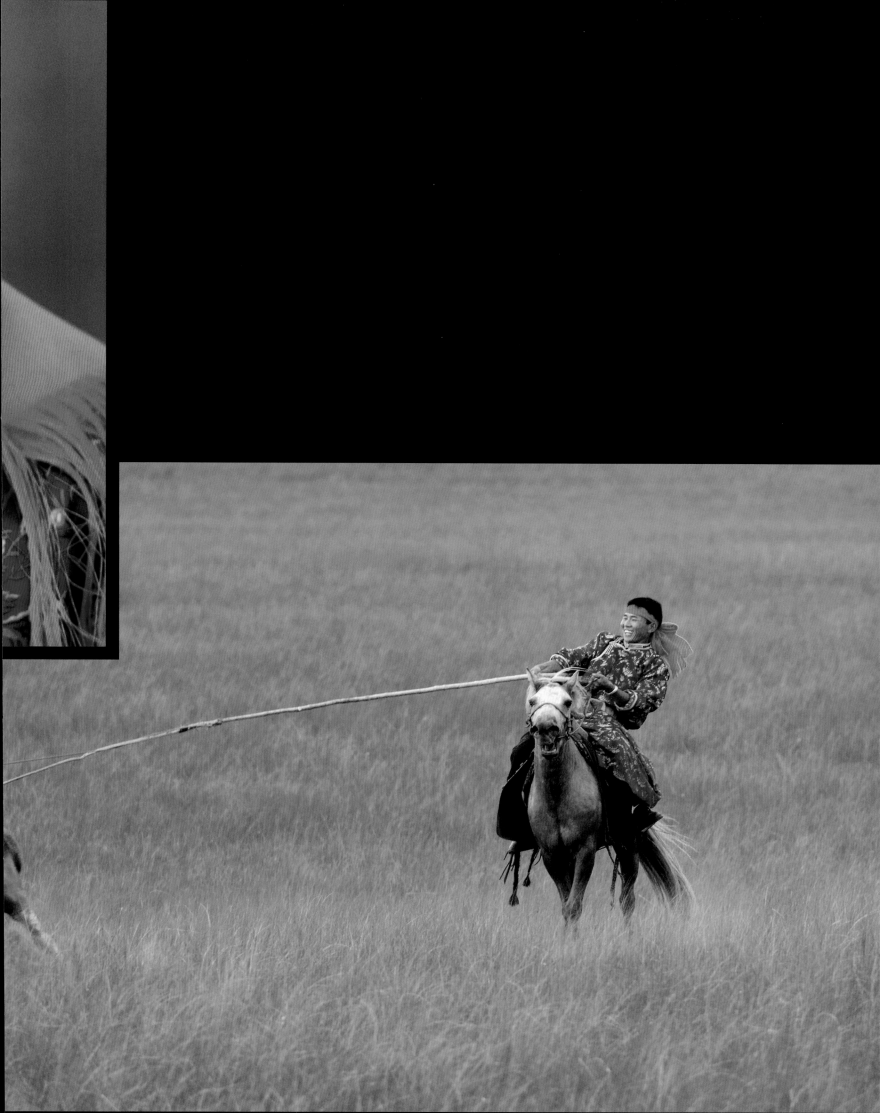

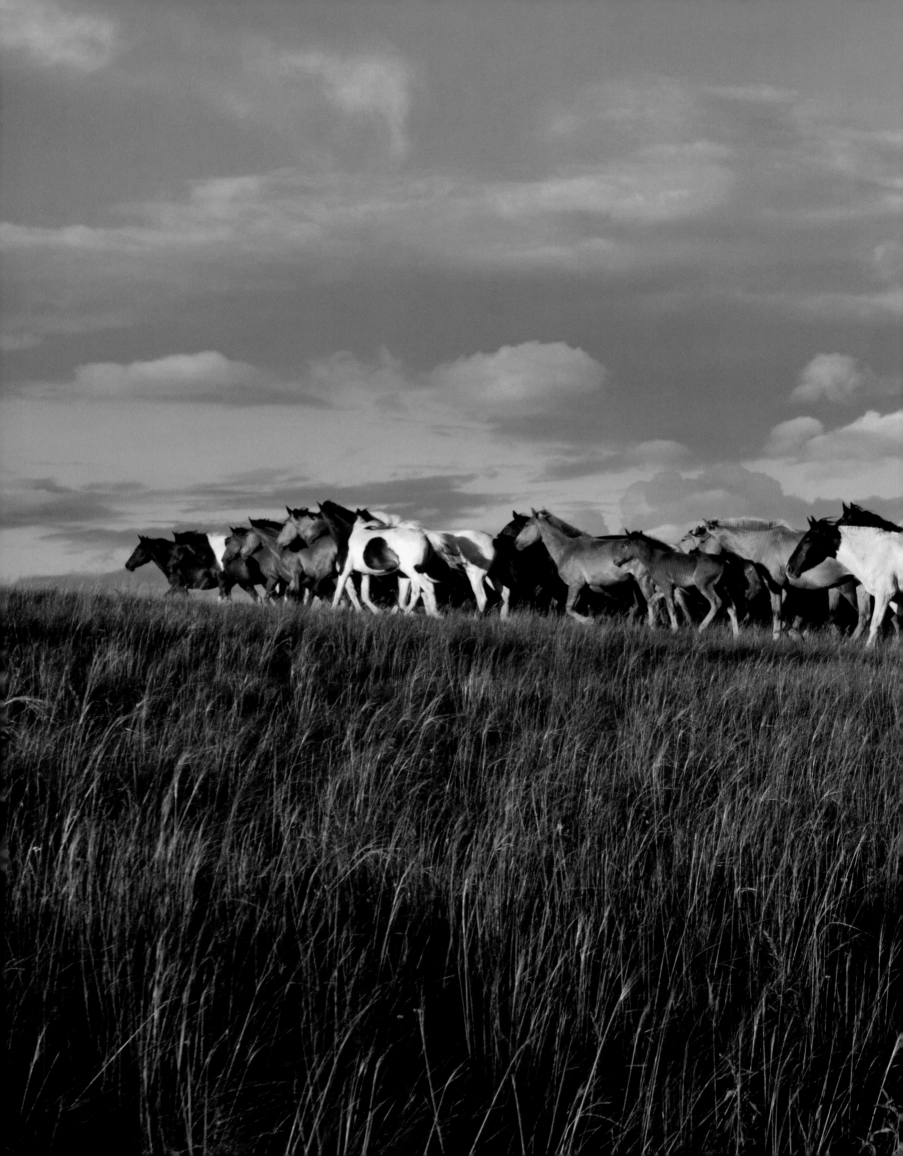

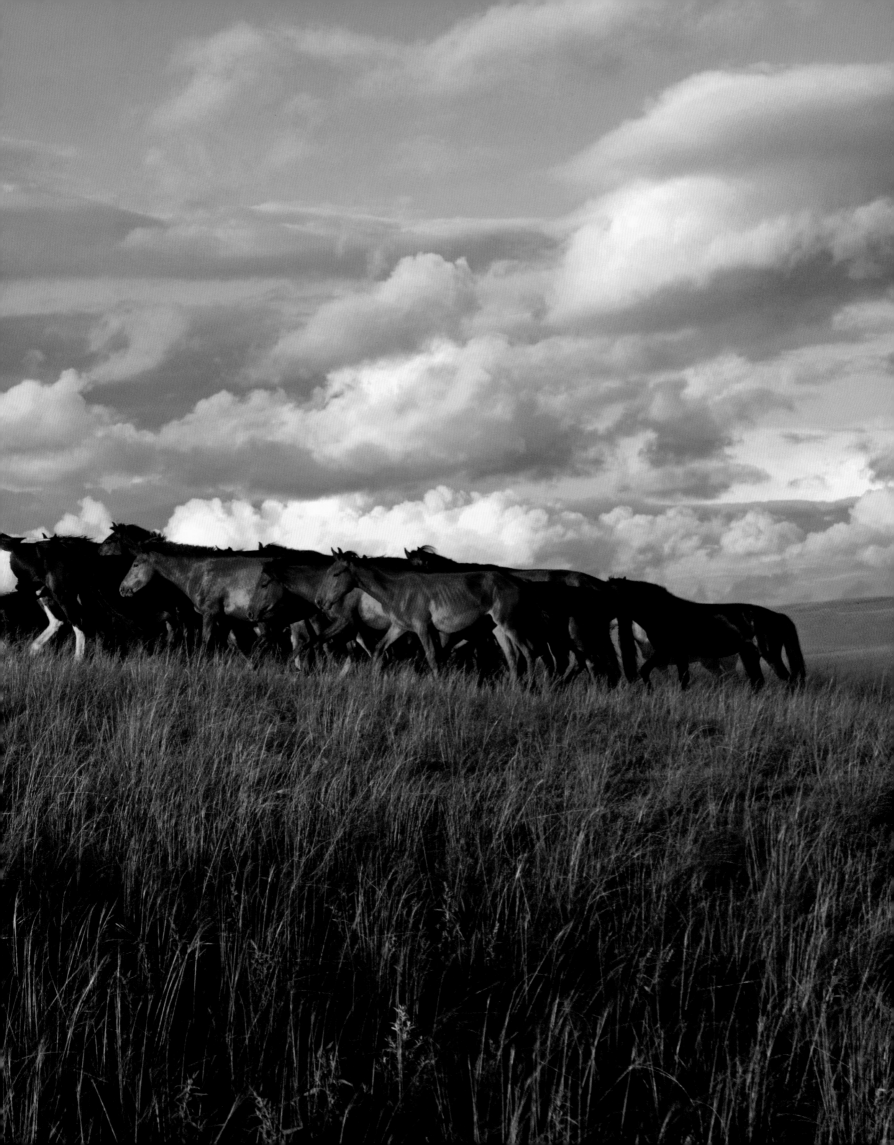

GUANGXI
GUILIN & YANGSHUO
广西

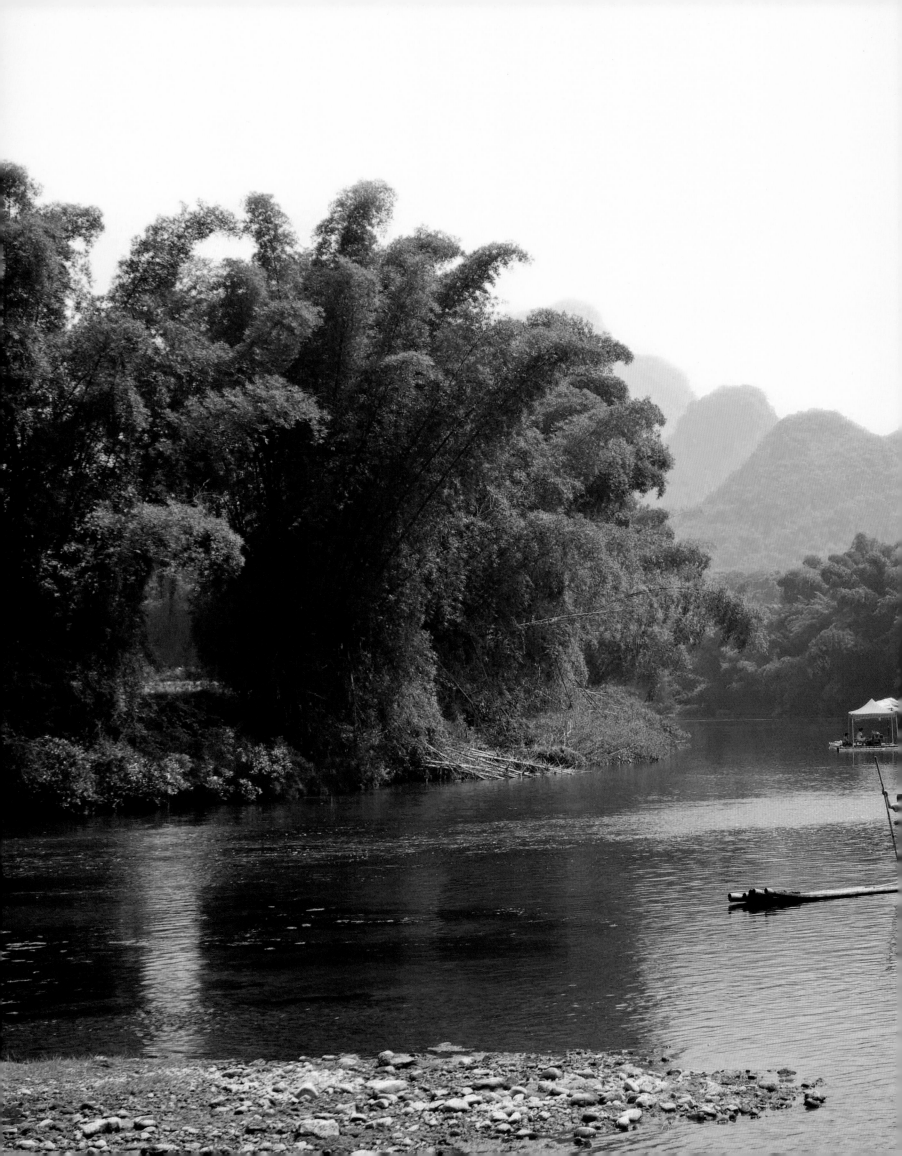

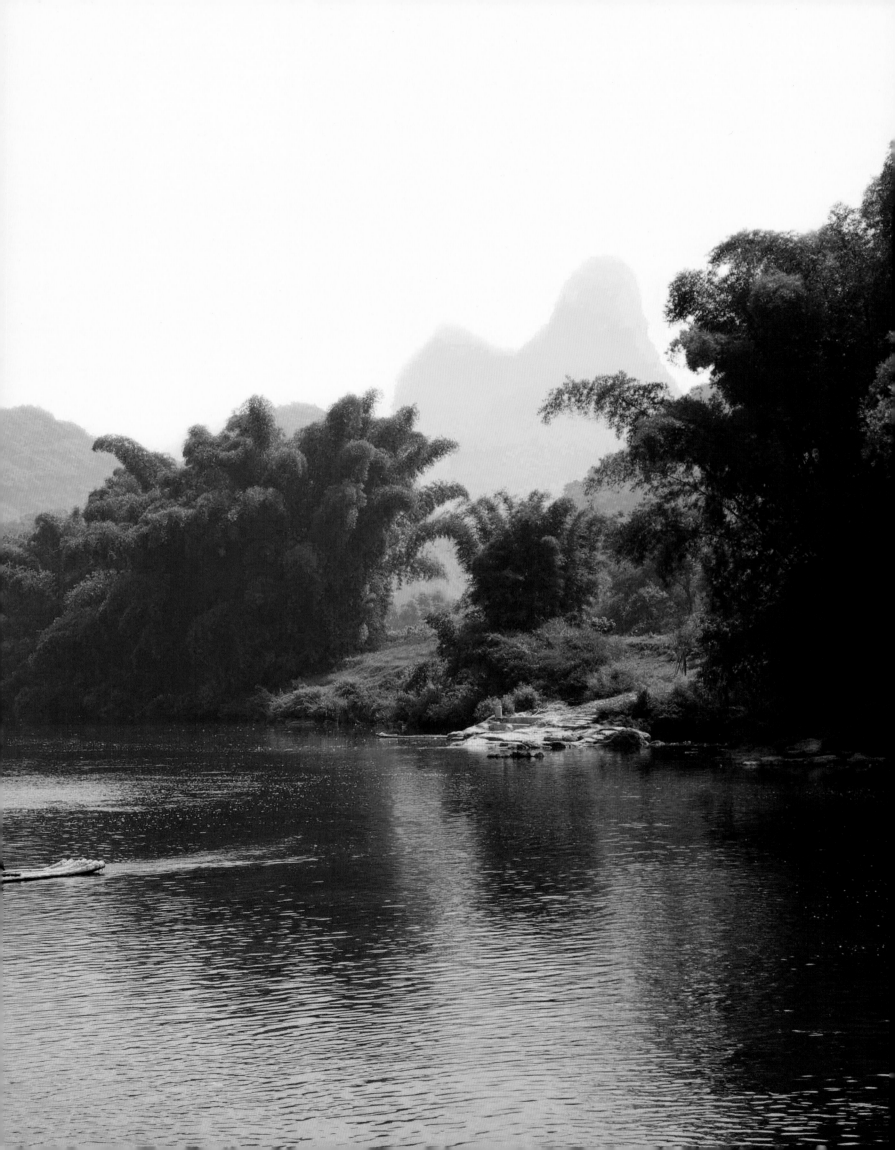

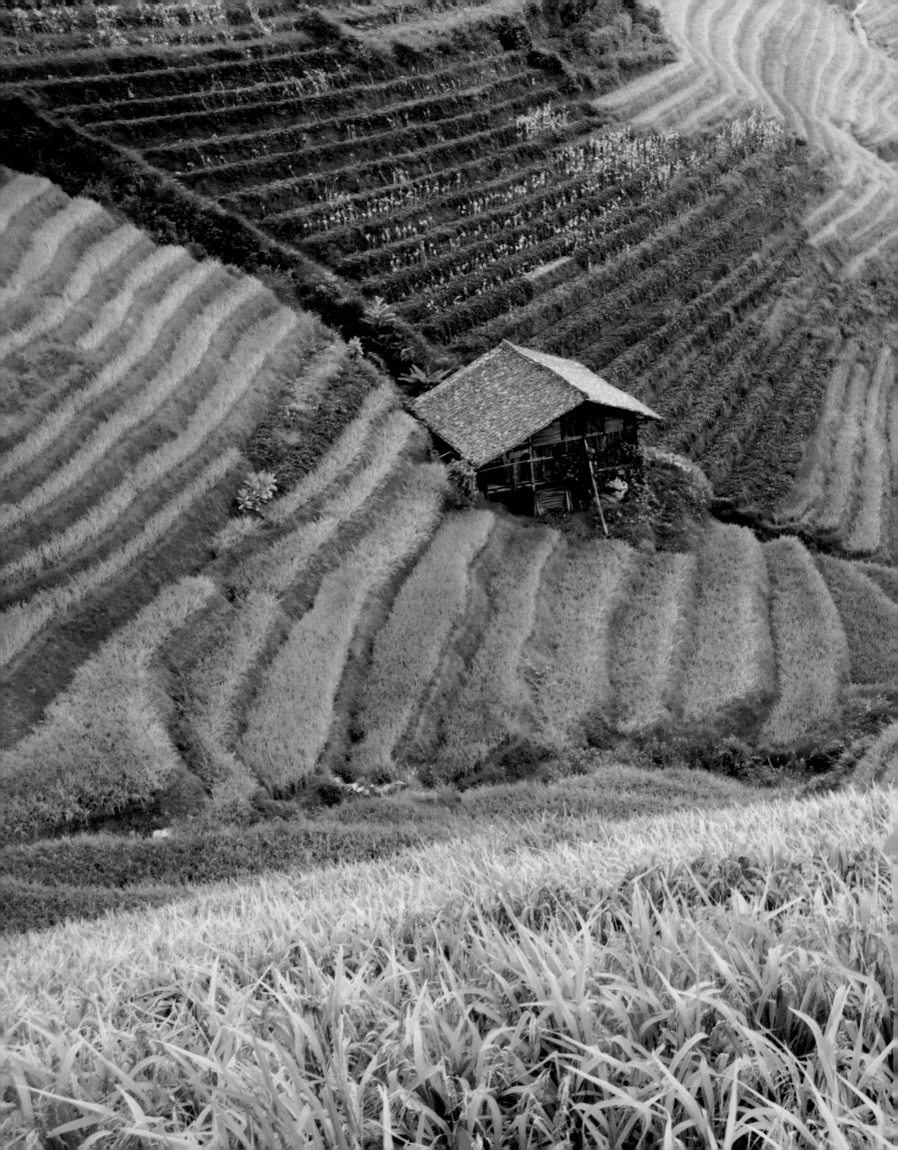

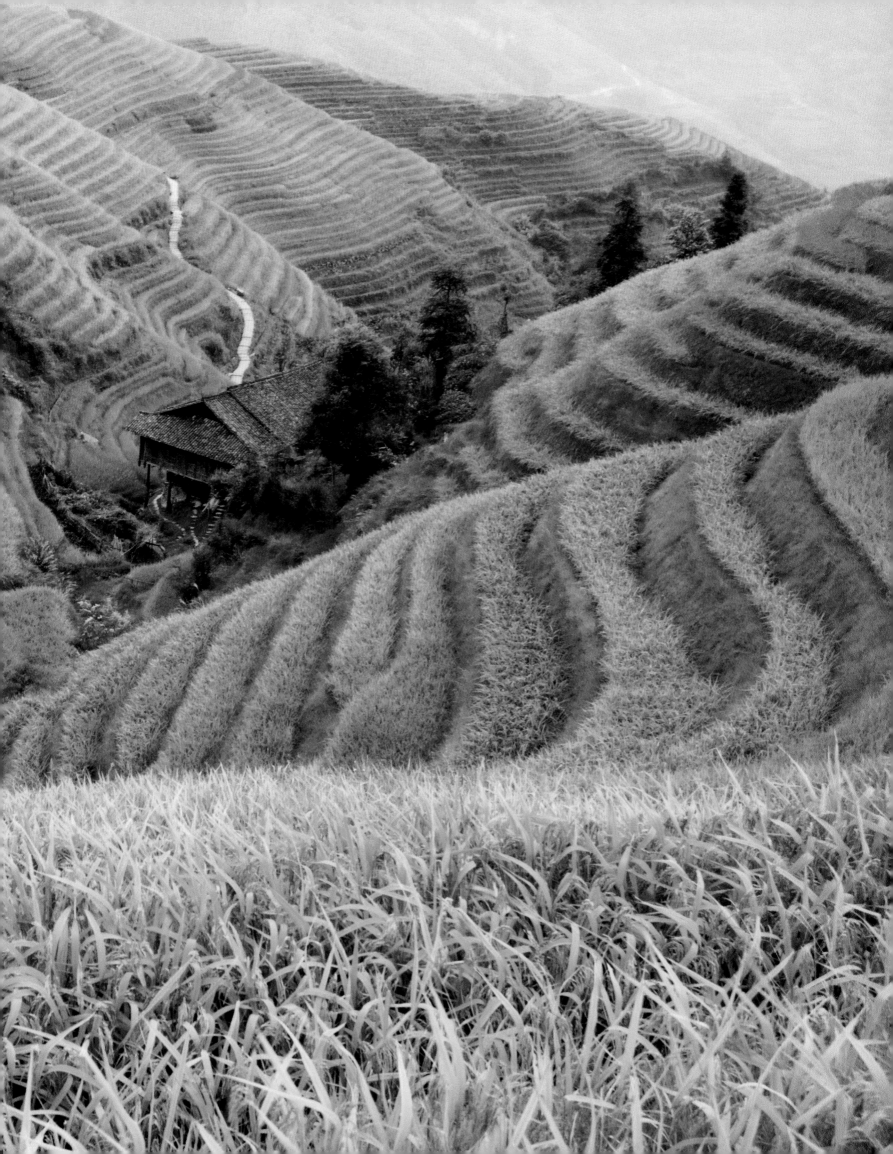

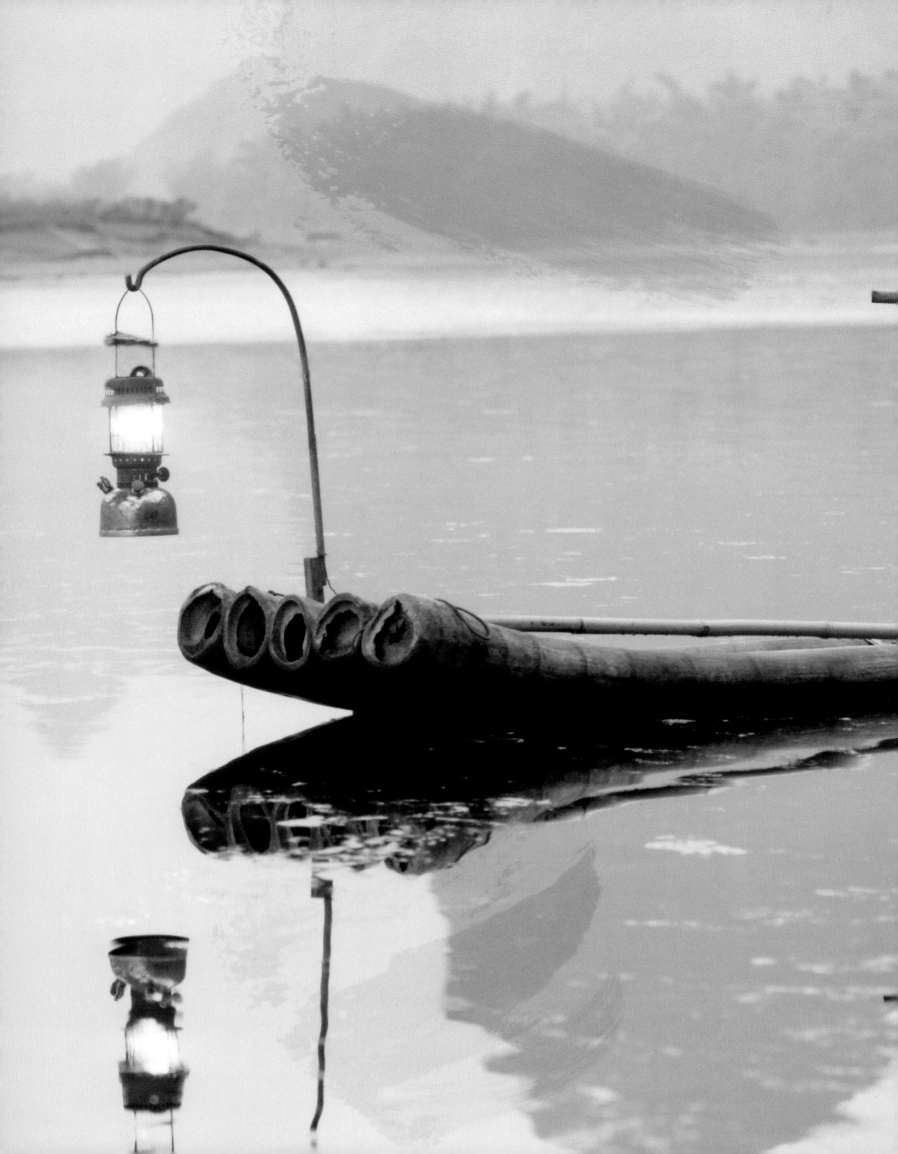

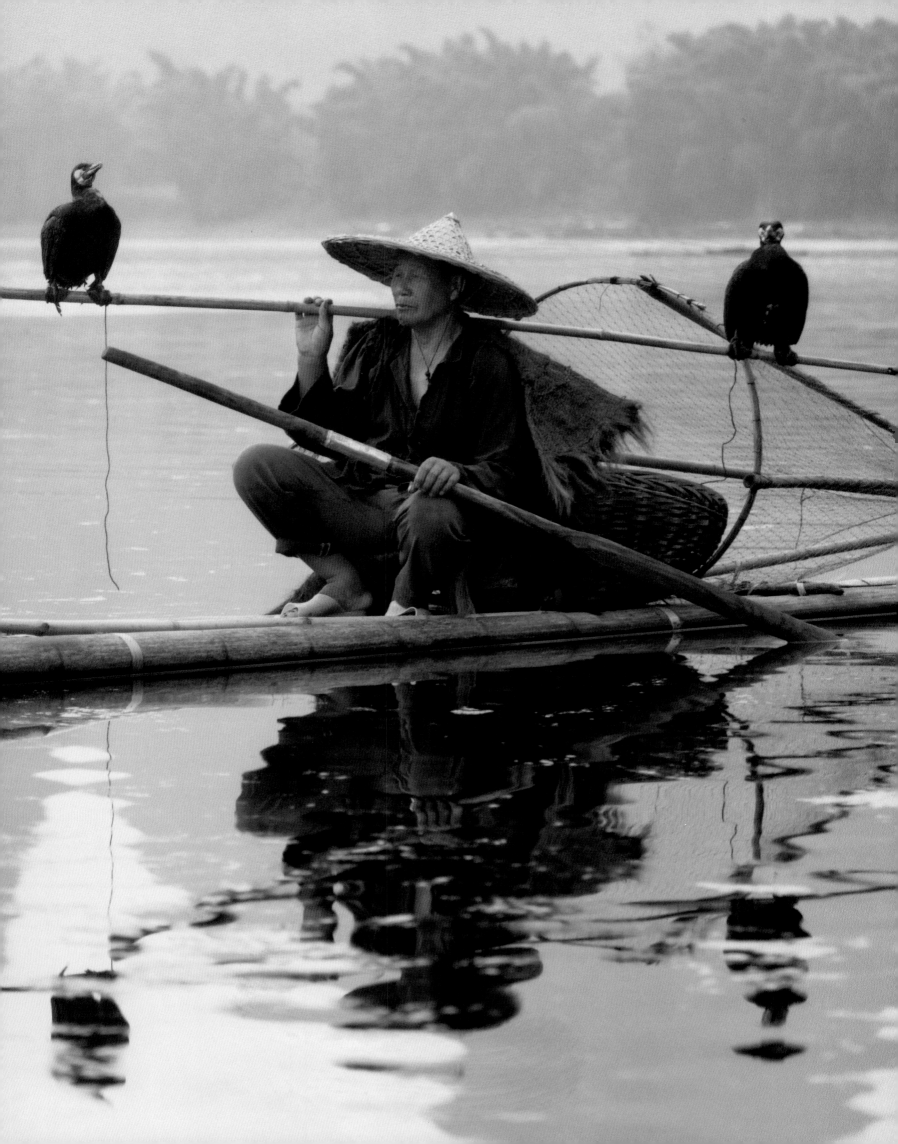

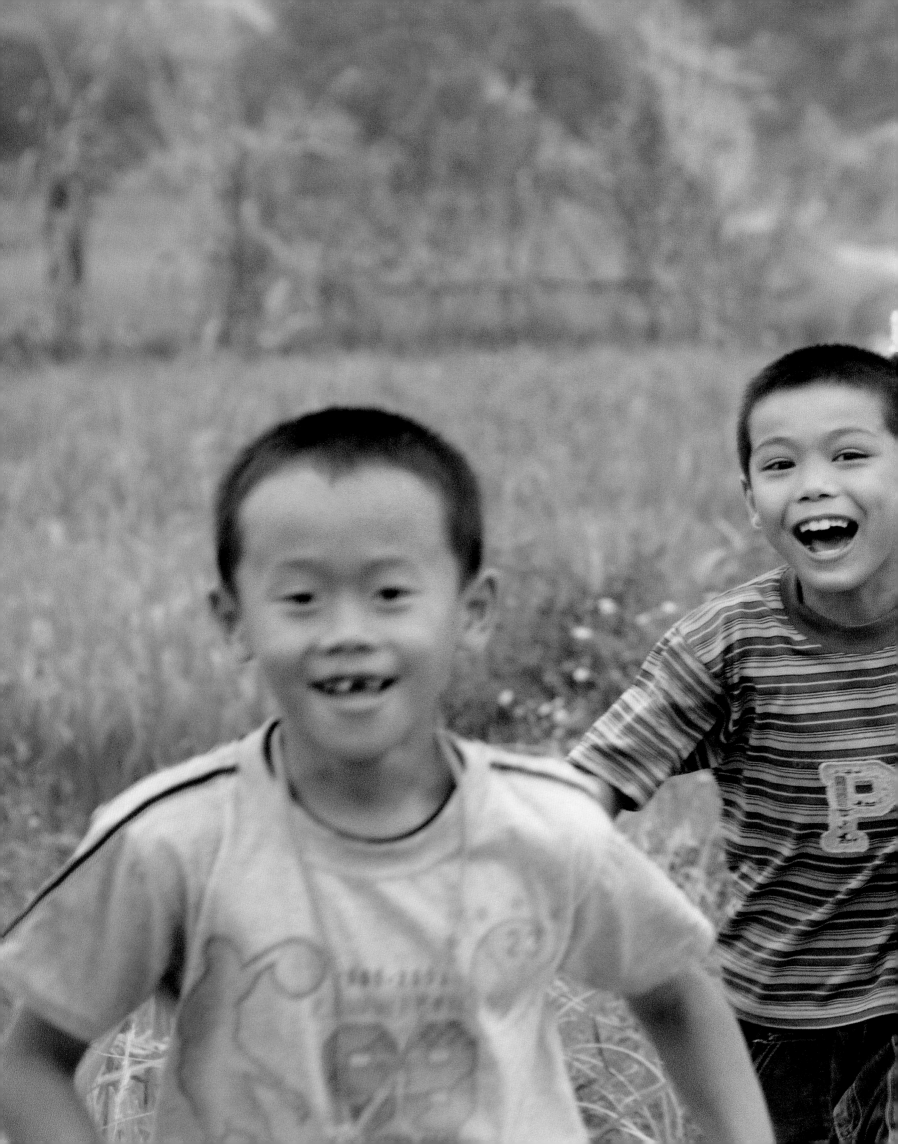

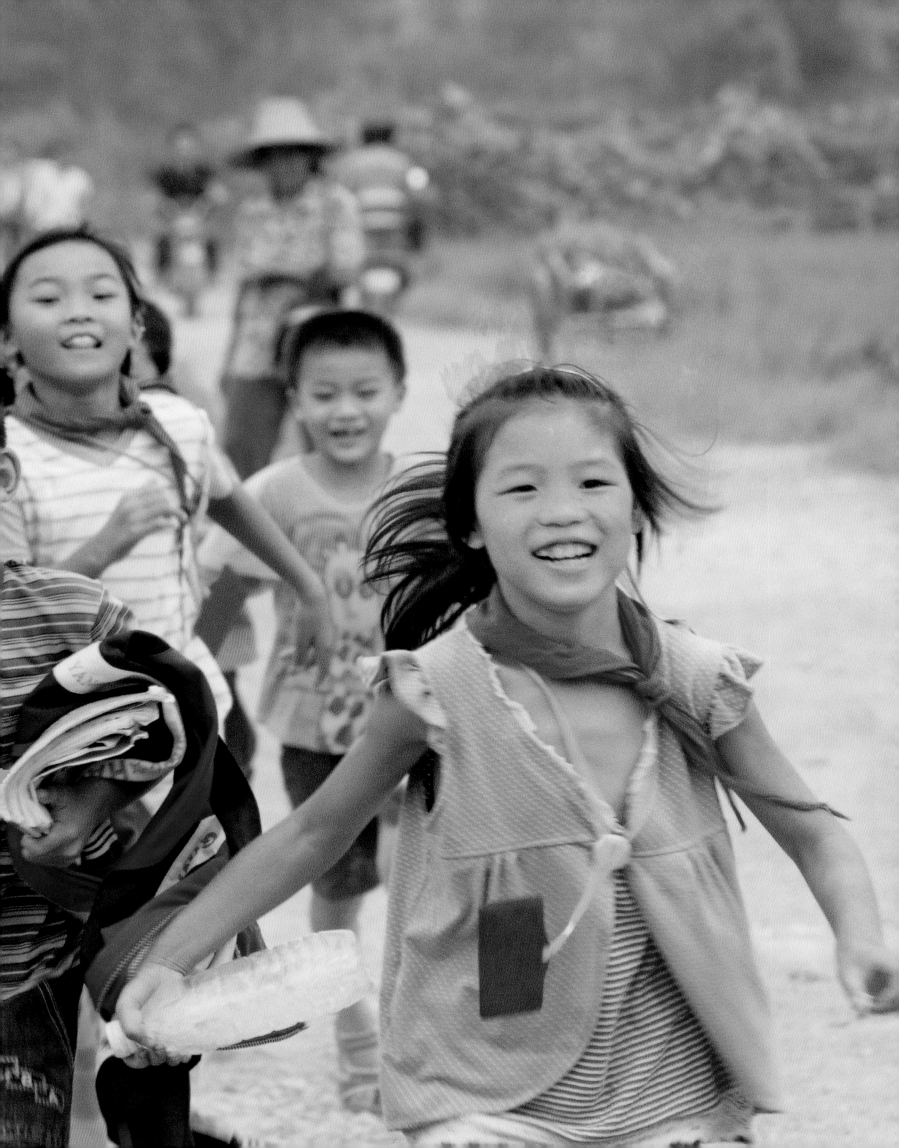

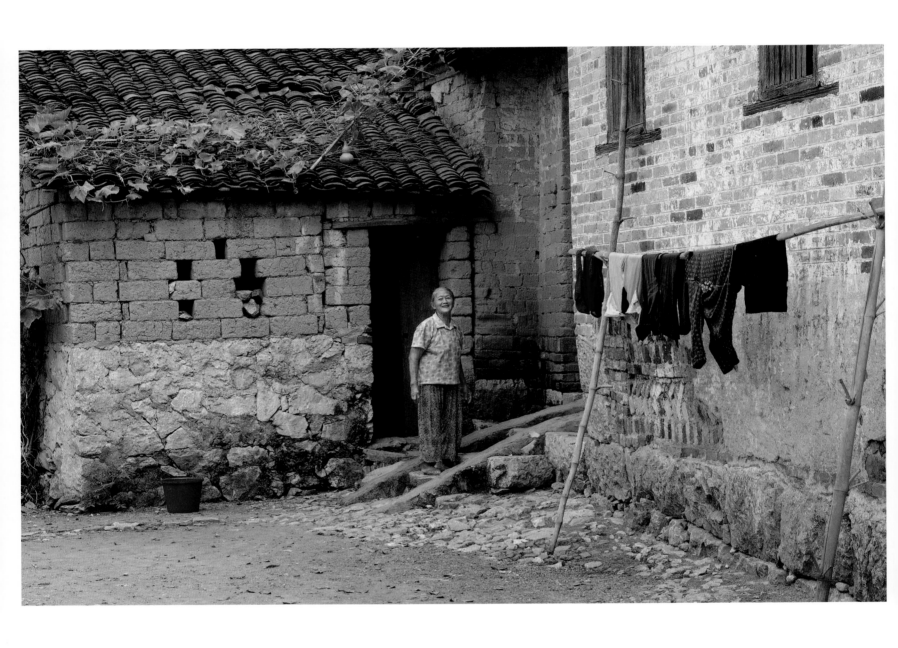

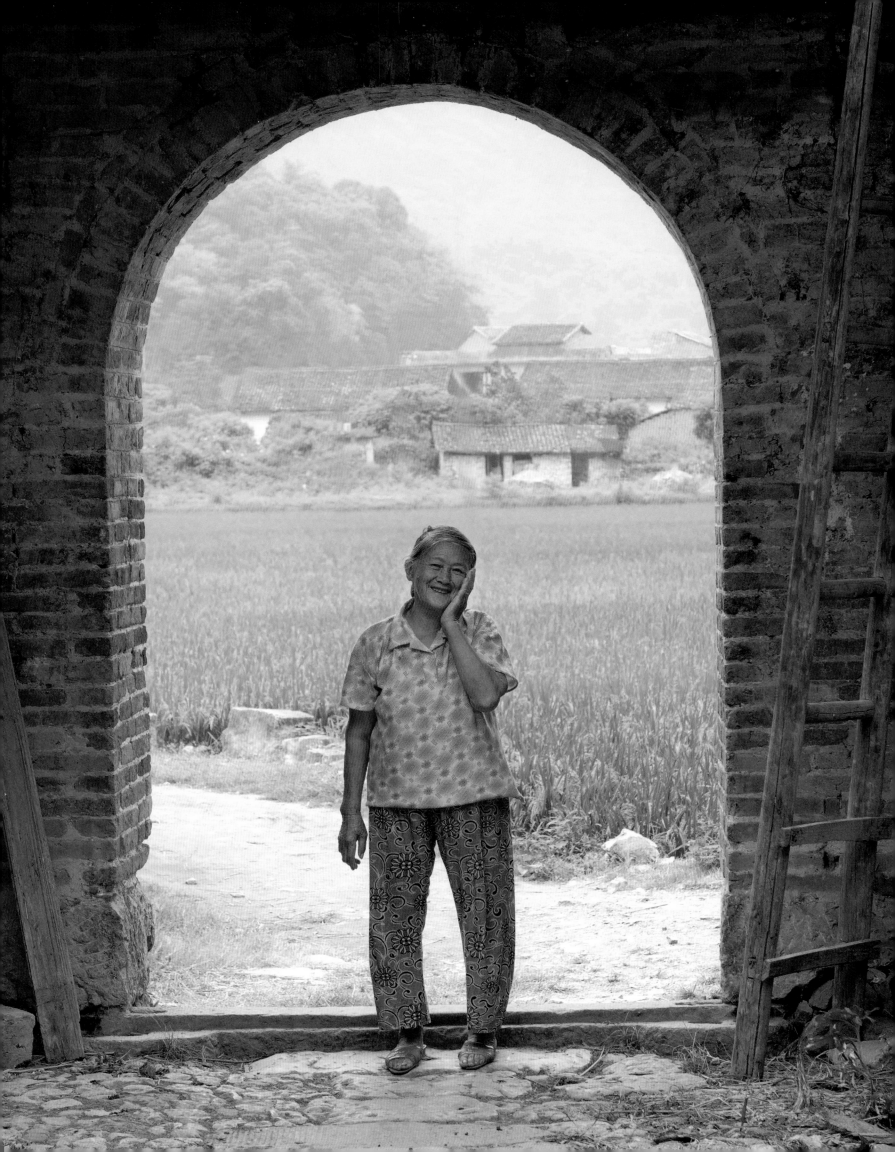

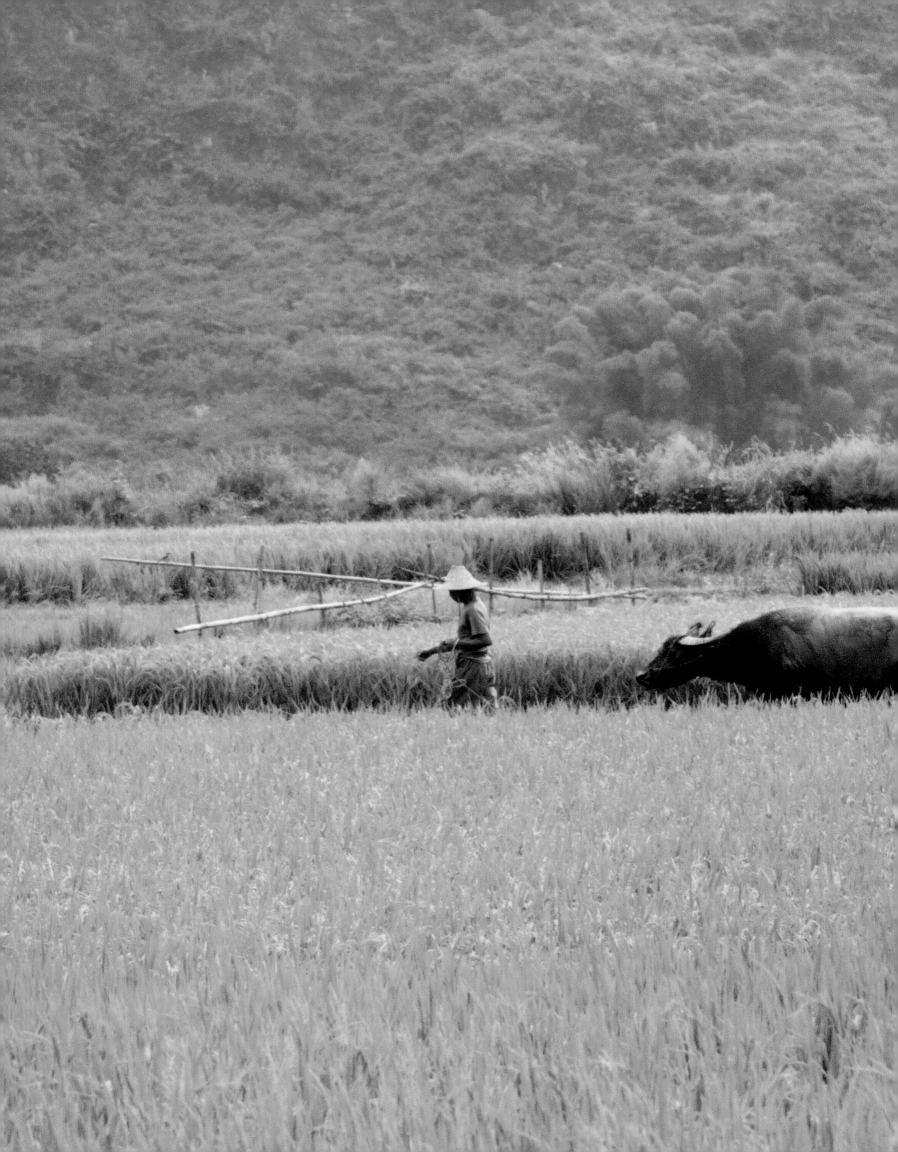

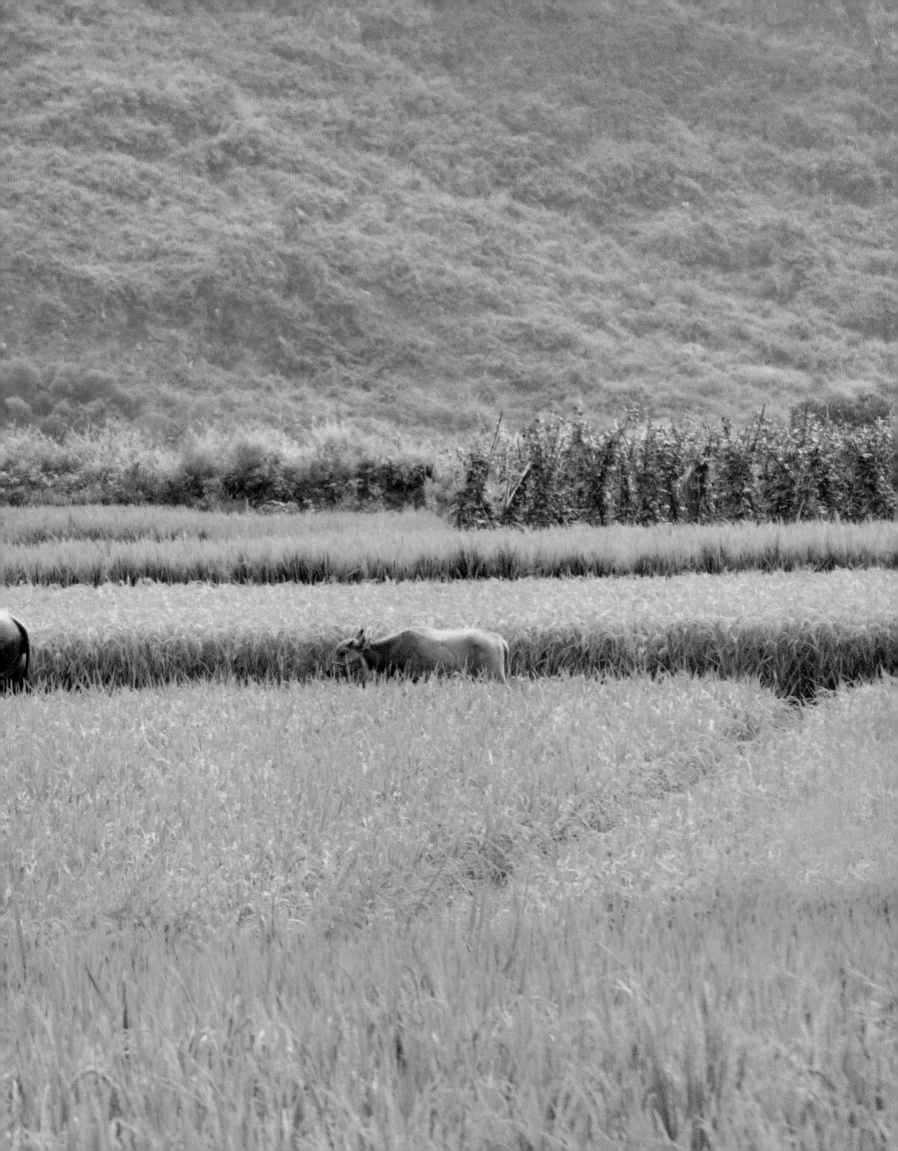

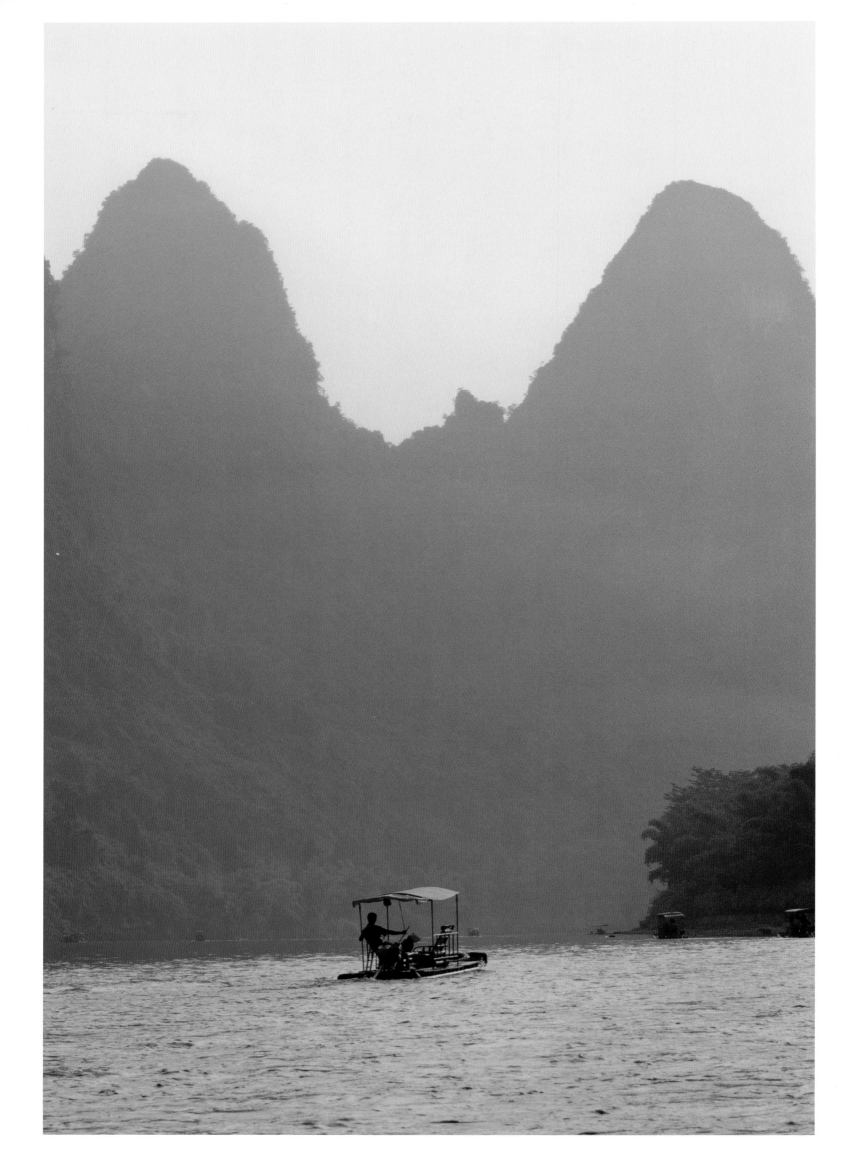

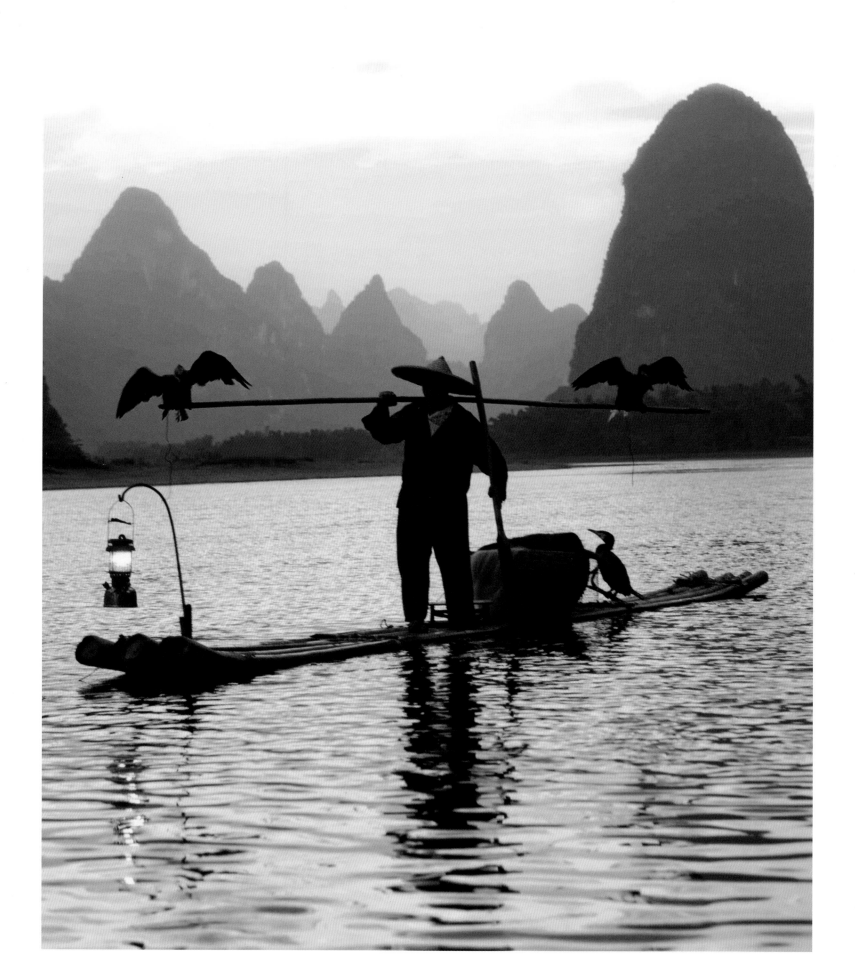

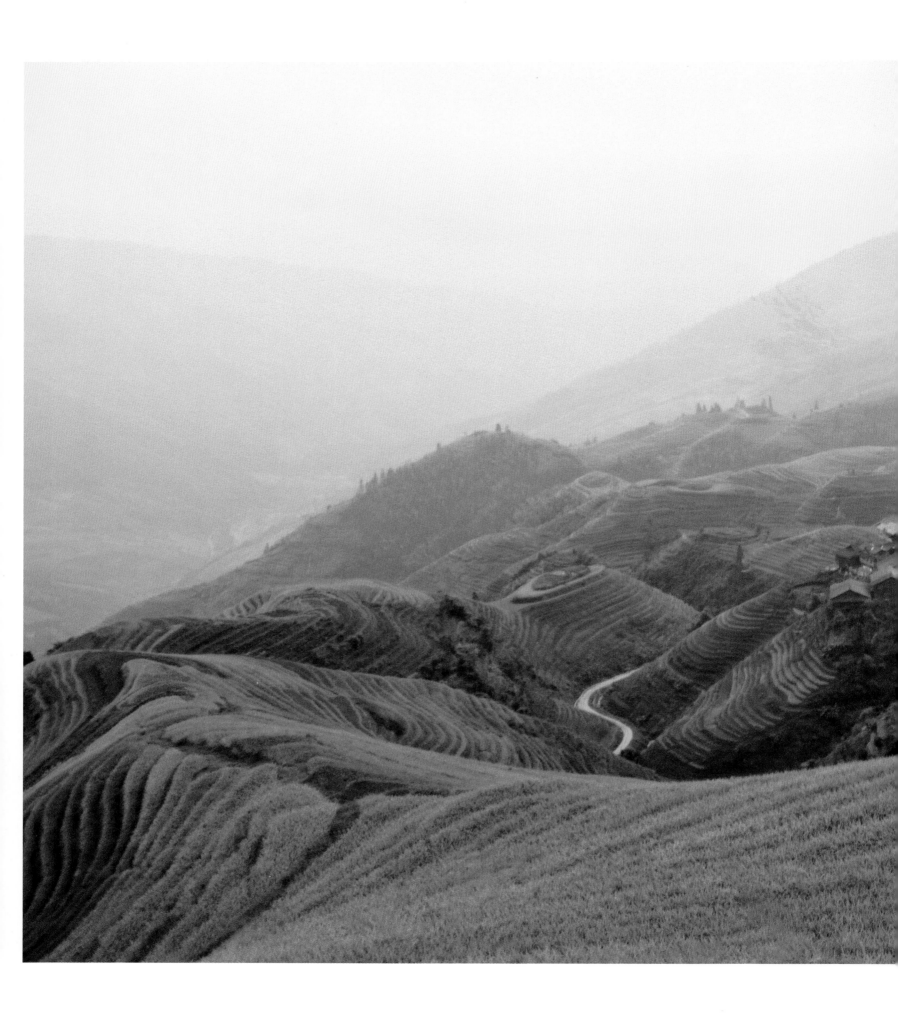

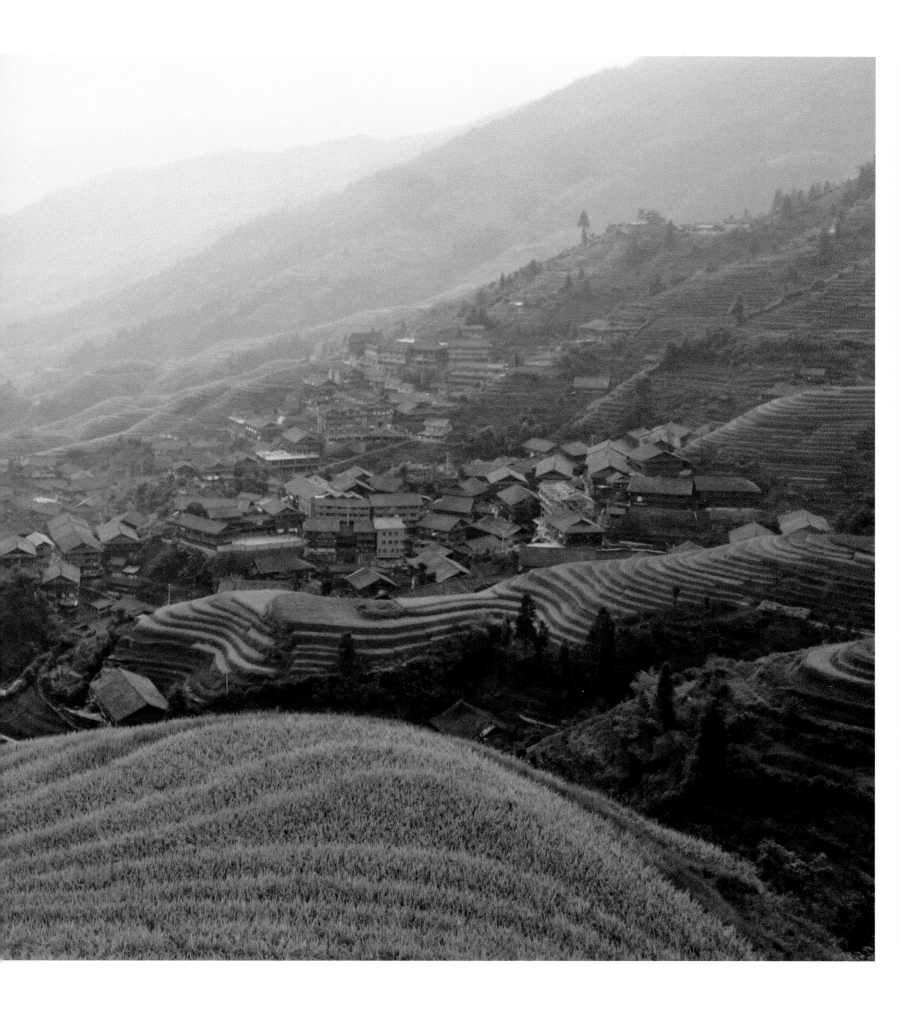

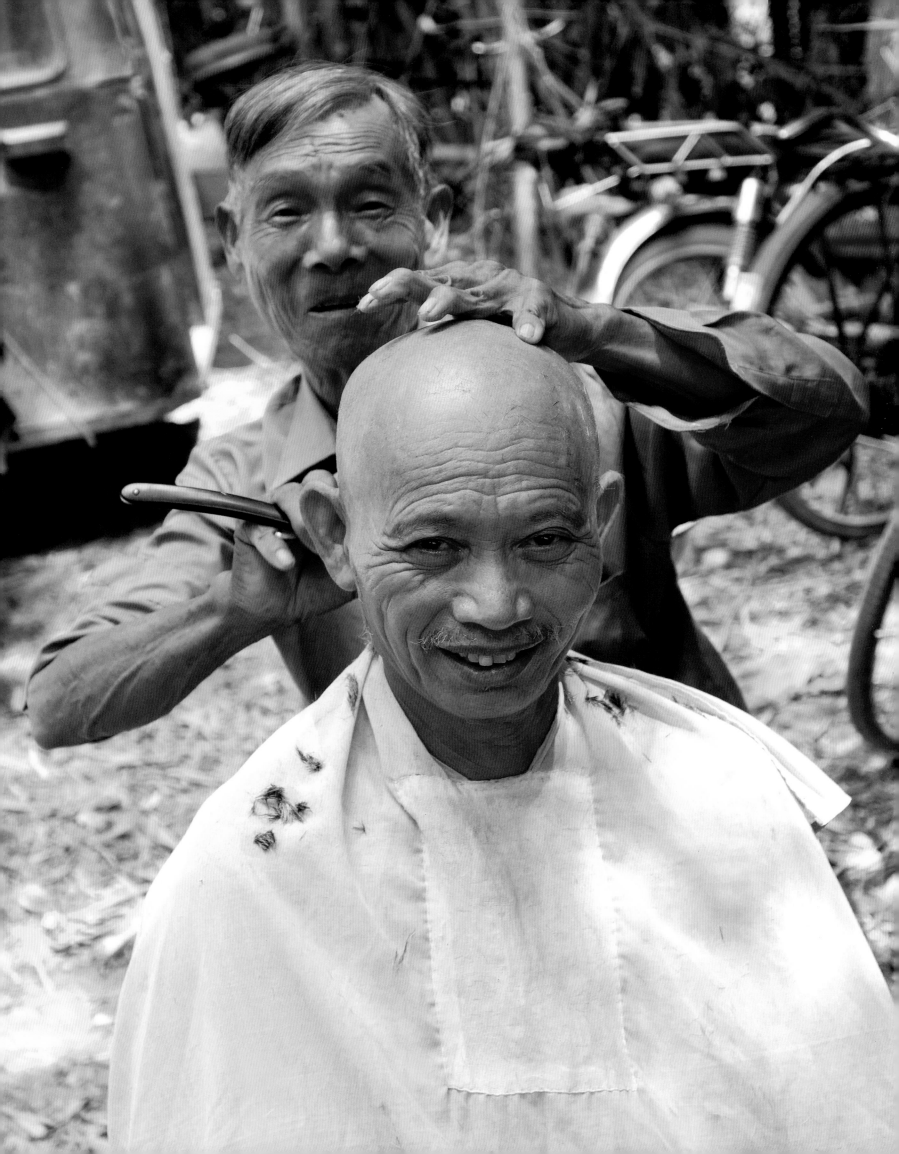

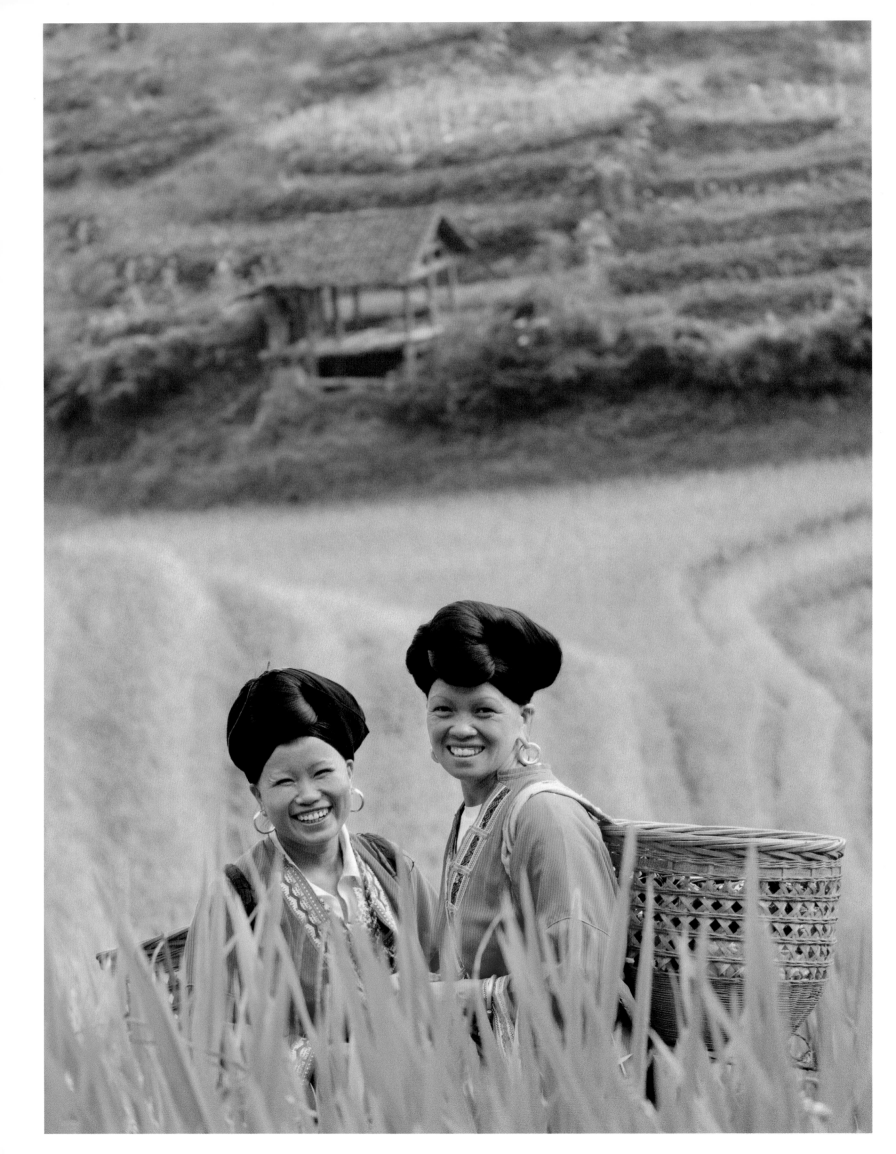

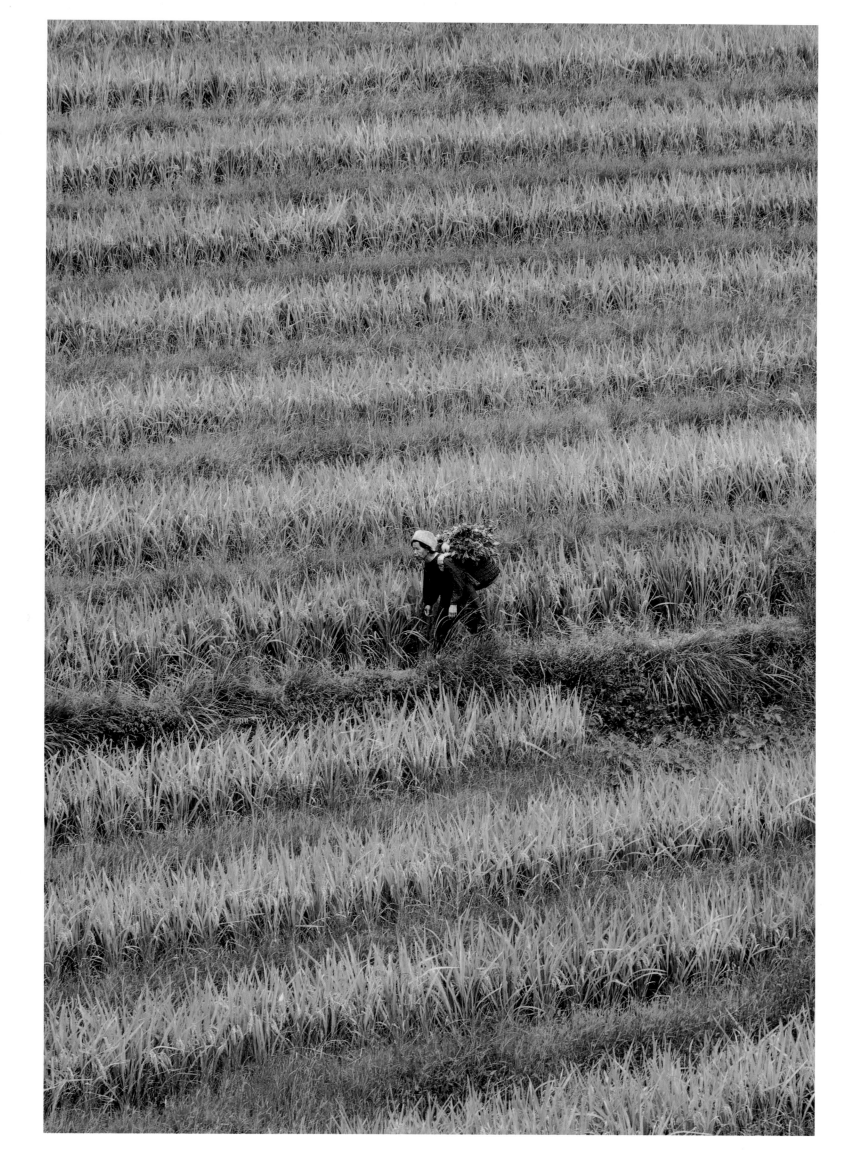

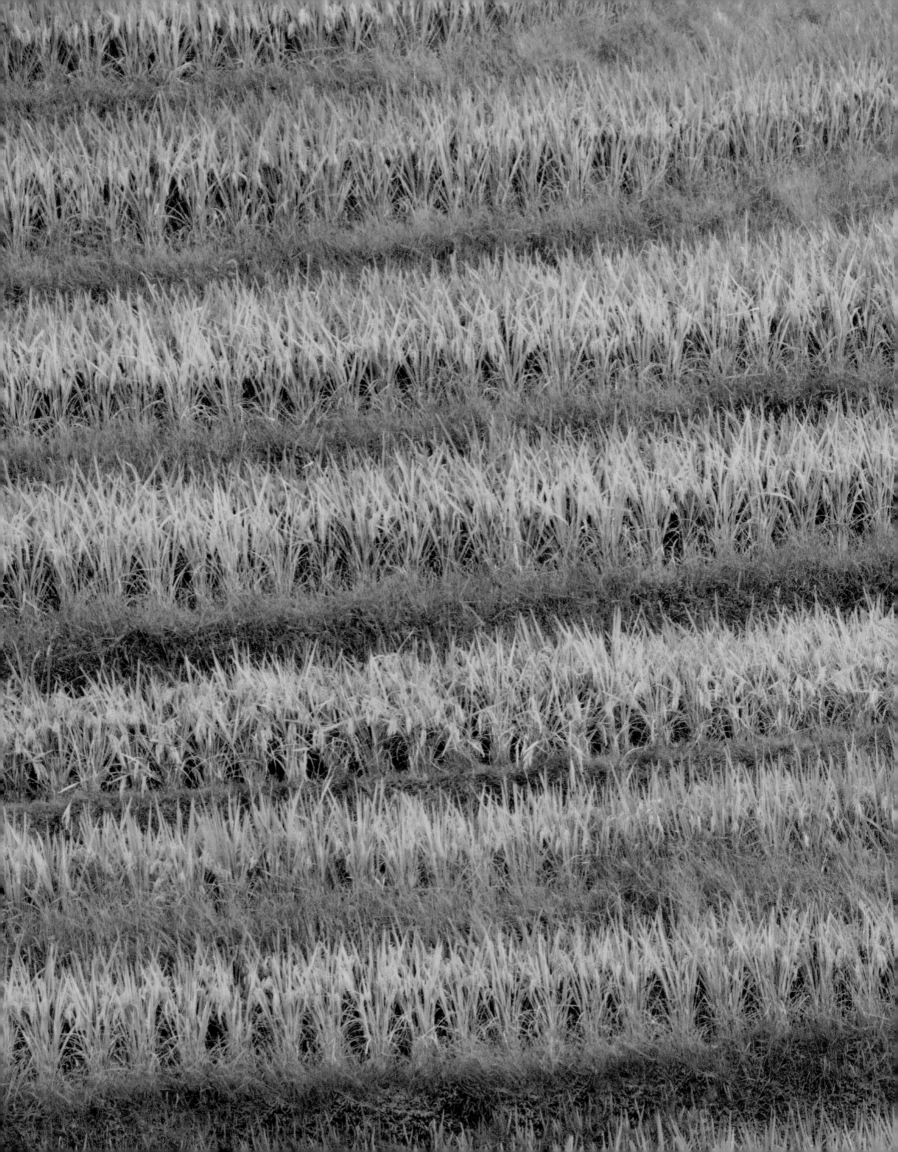

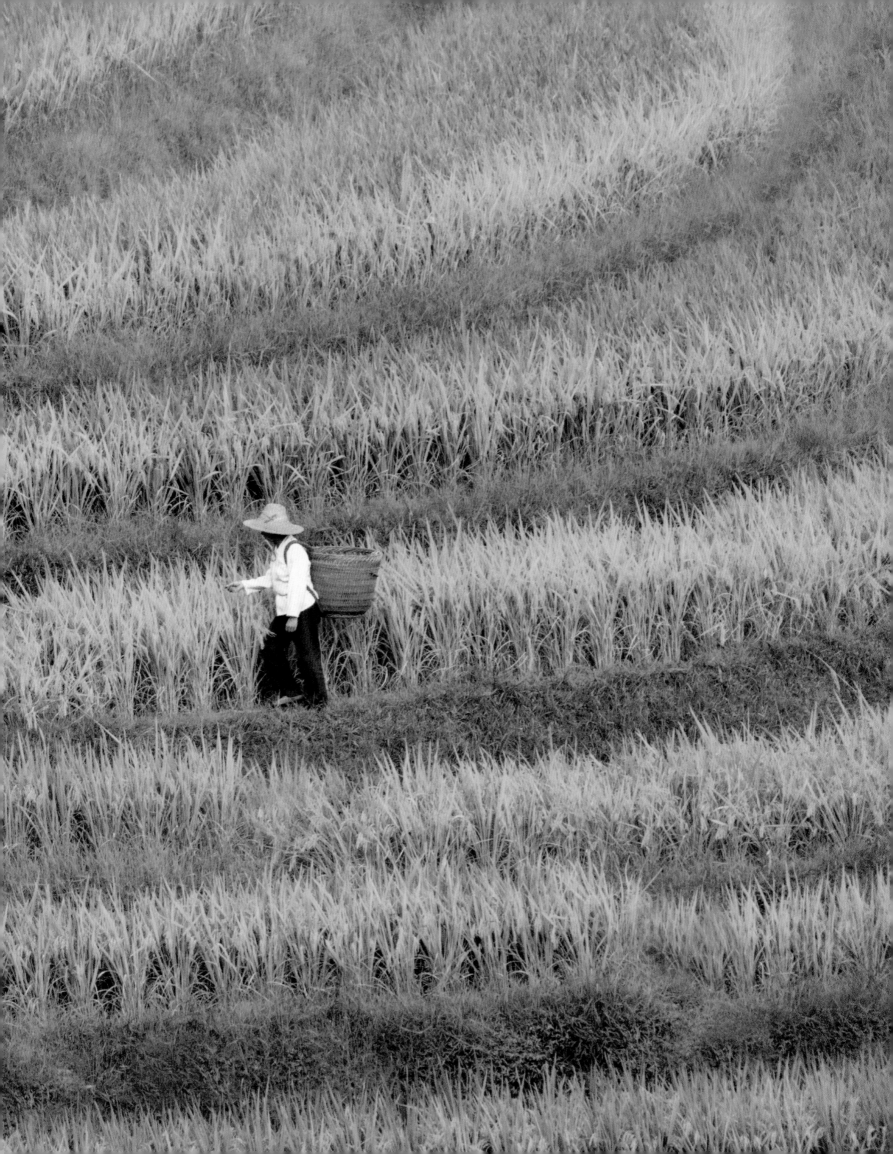

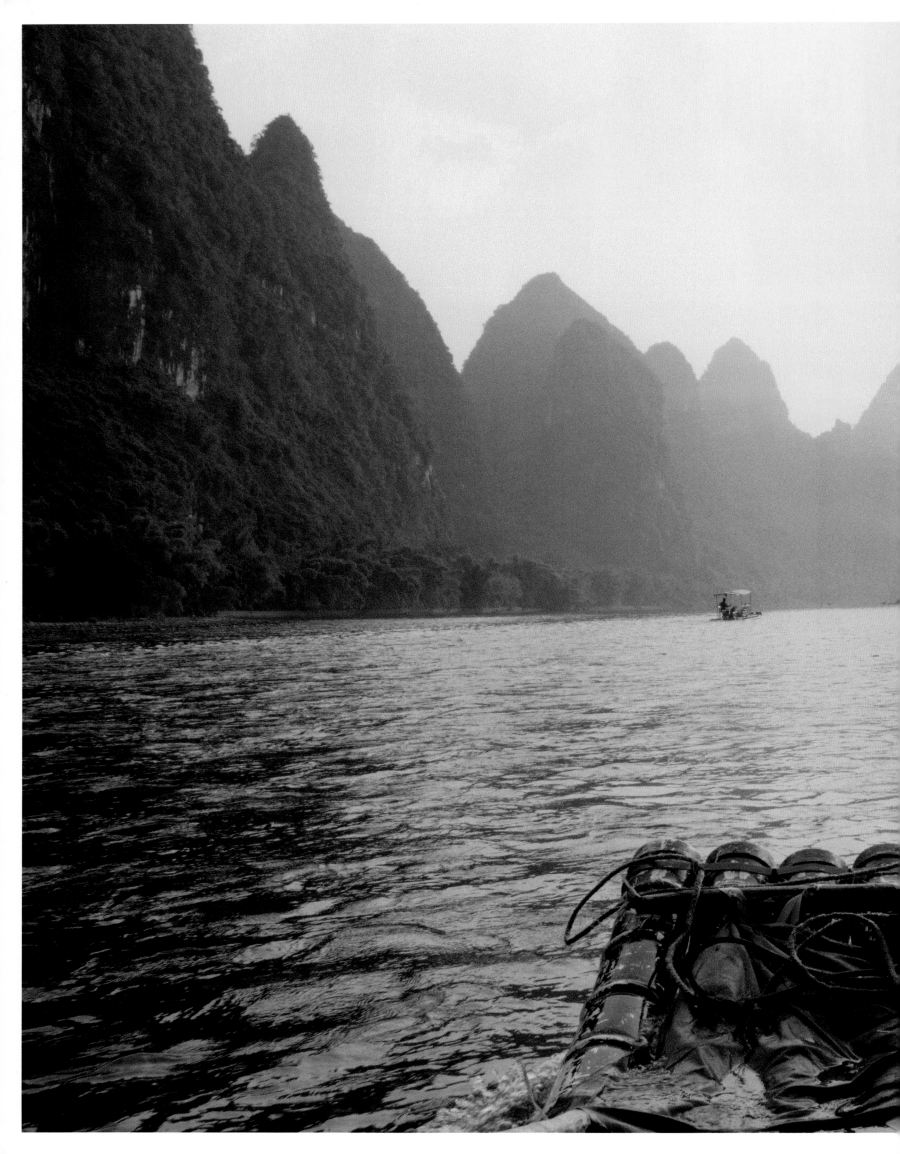

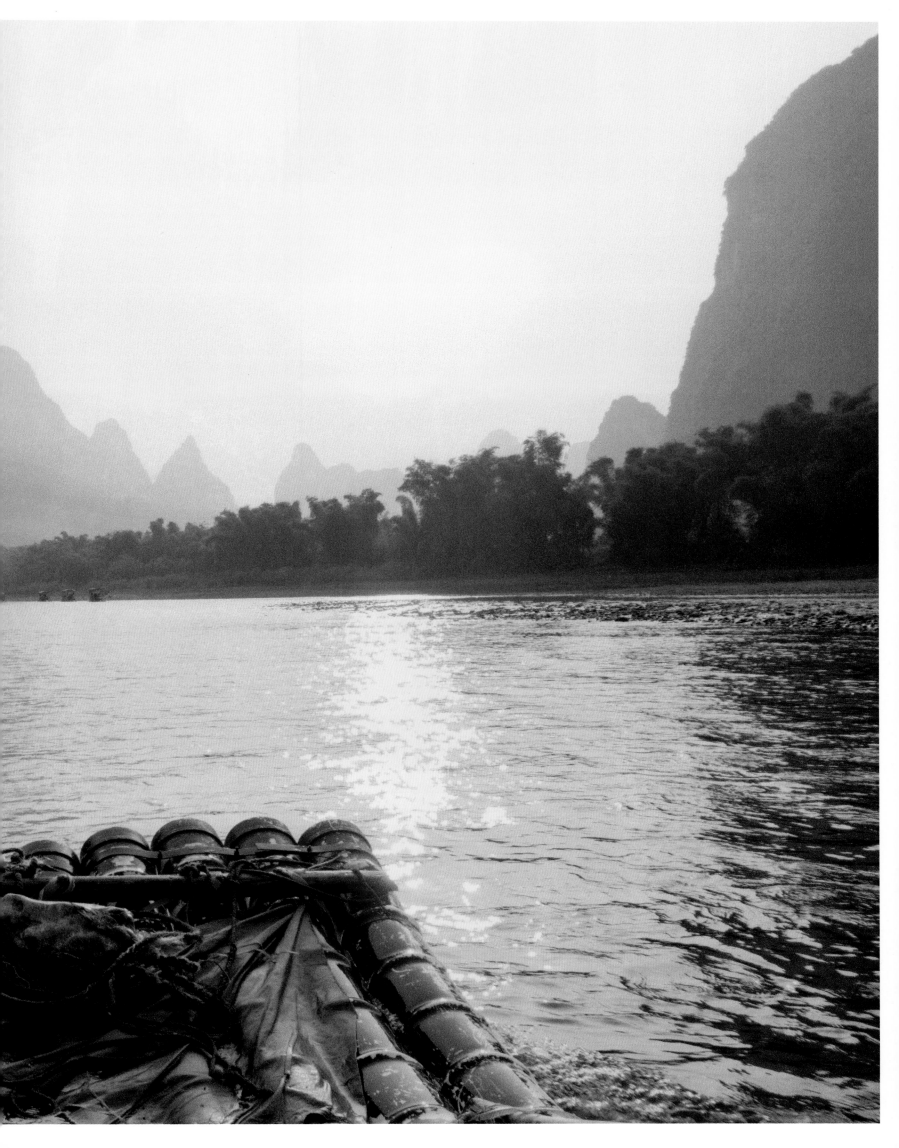

WEST SICHUAN

川西

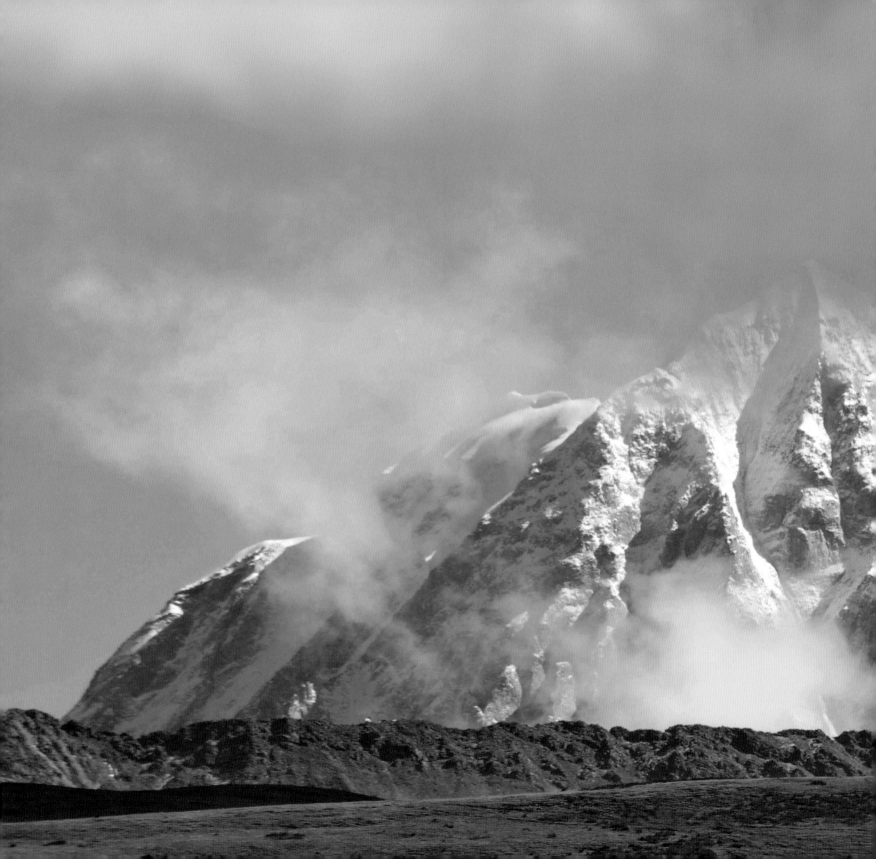

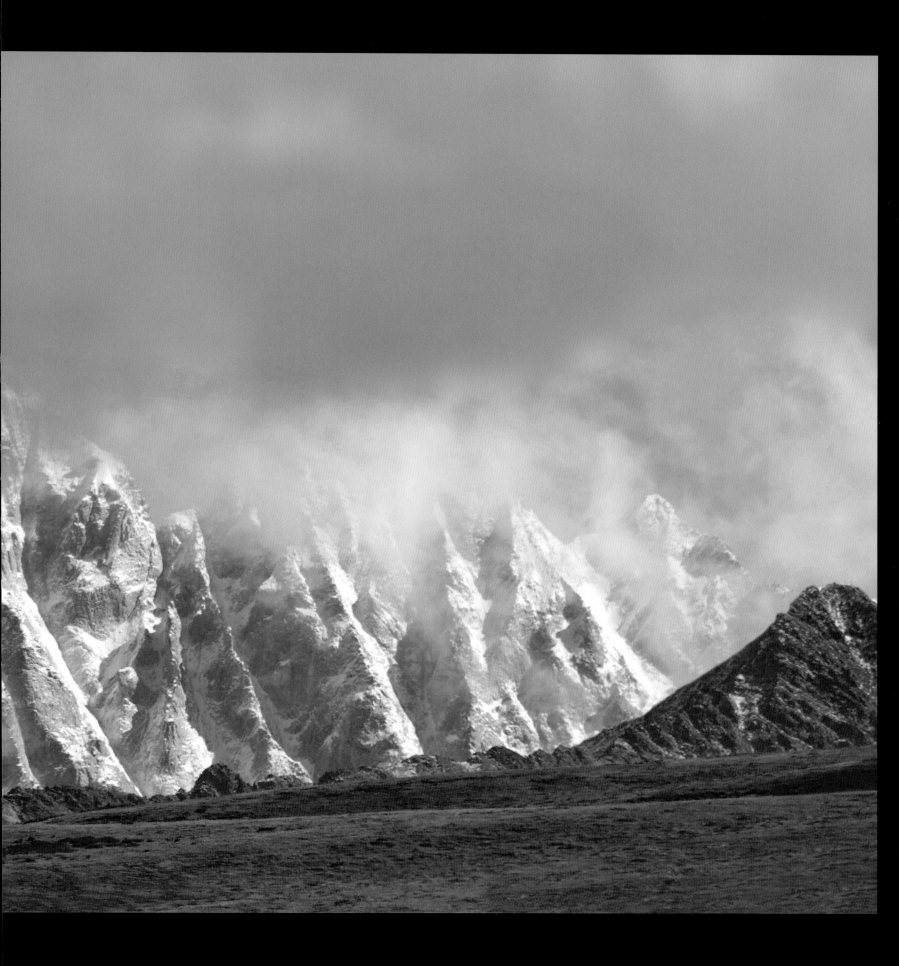

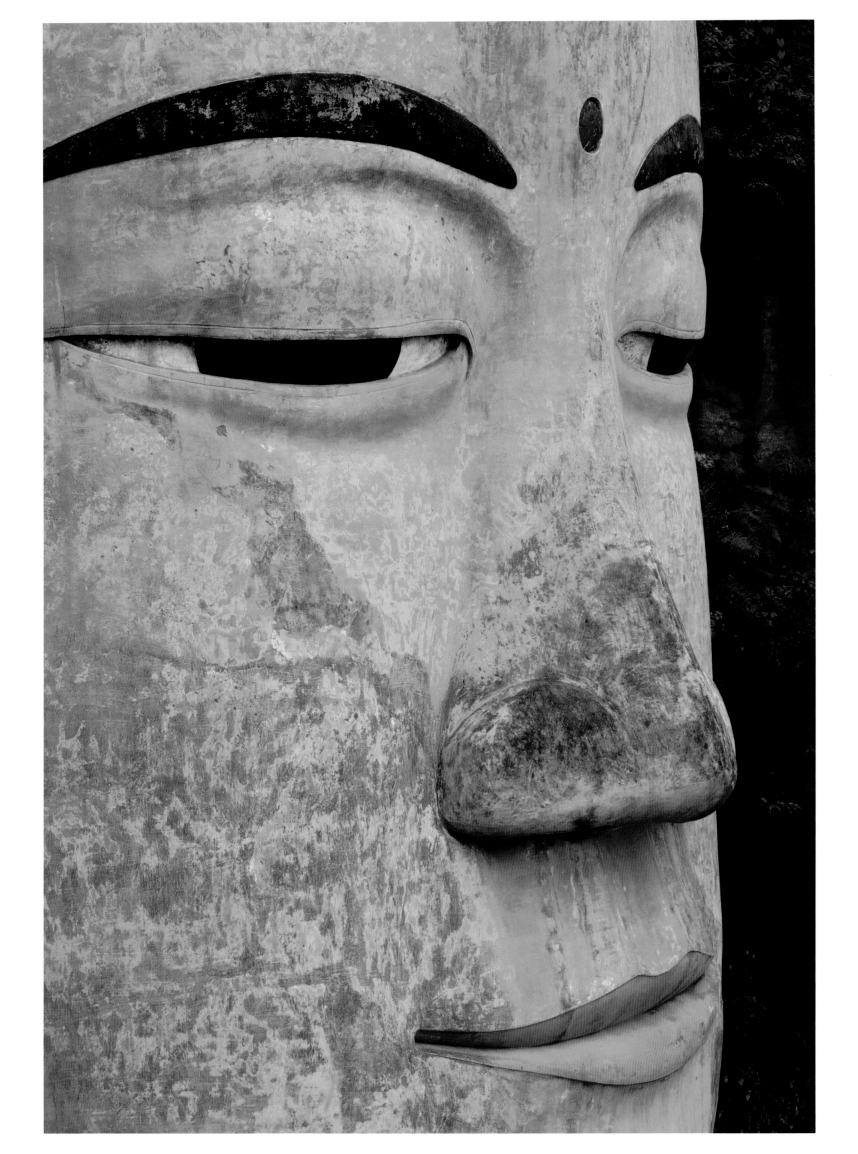

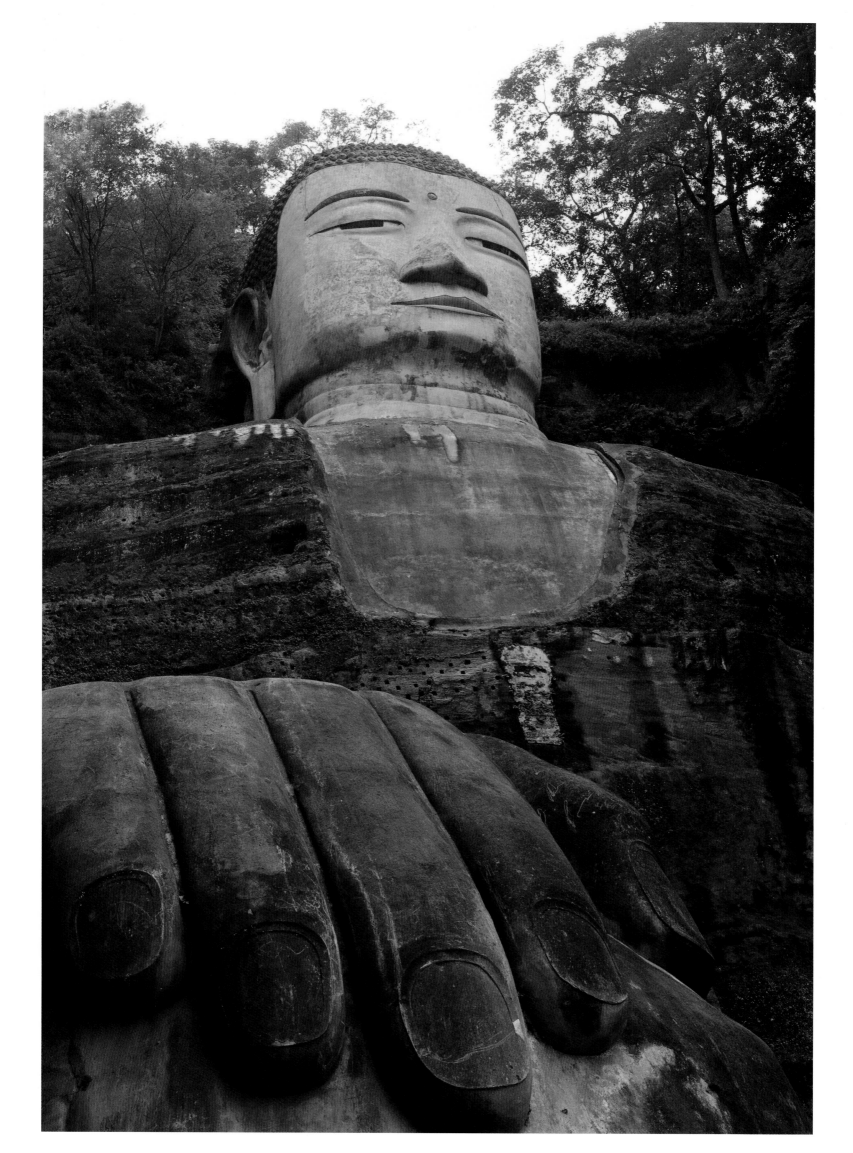

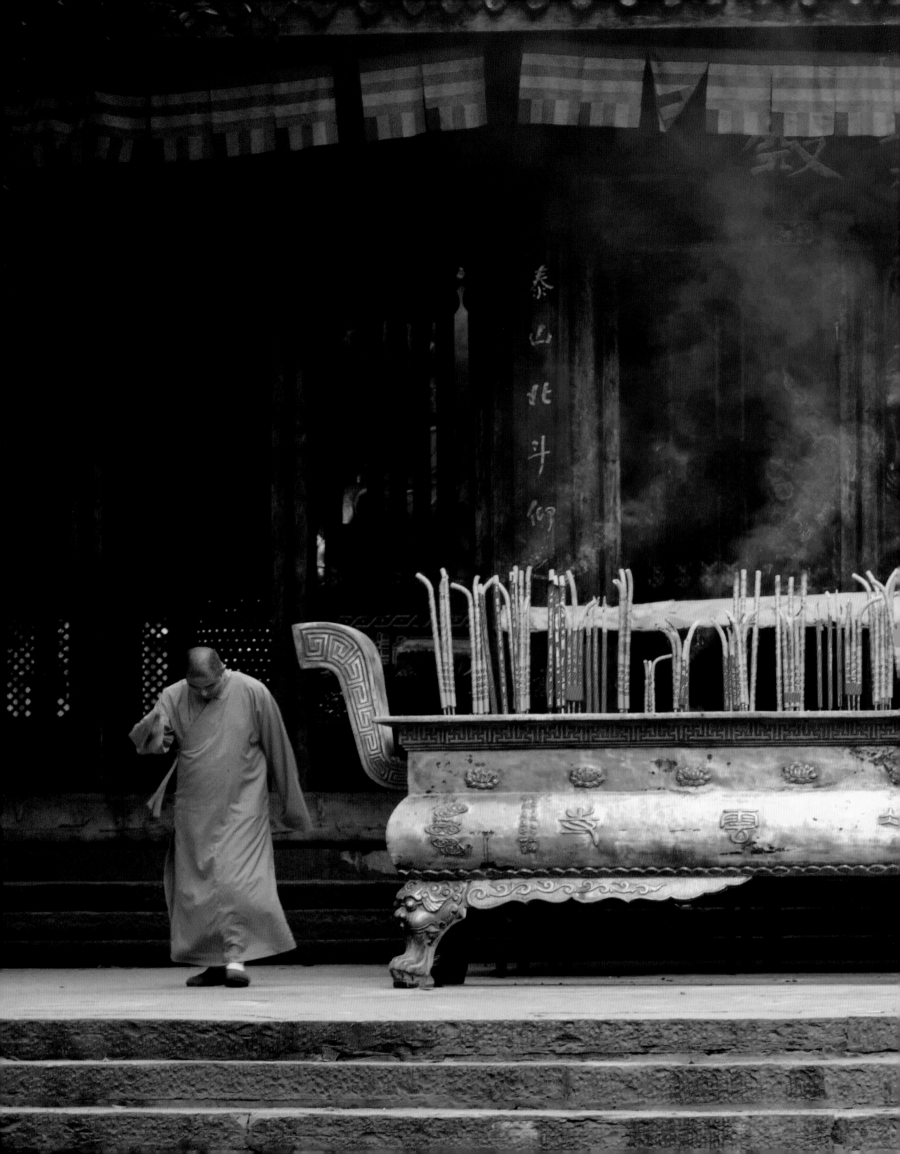

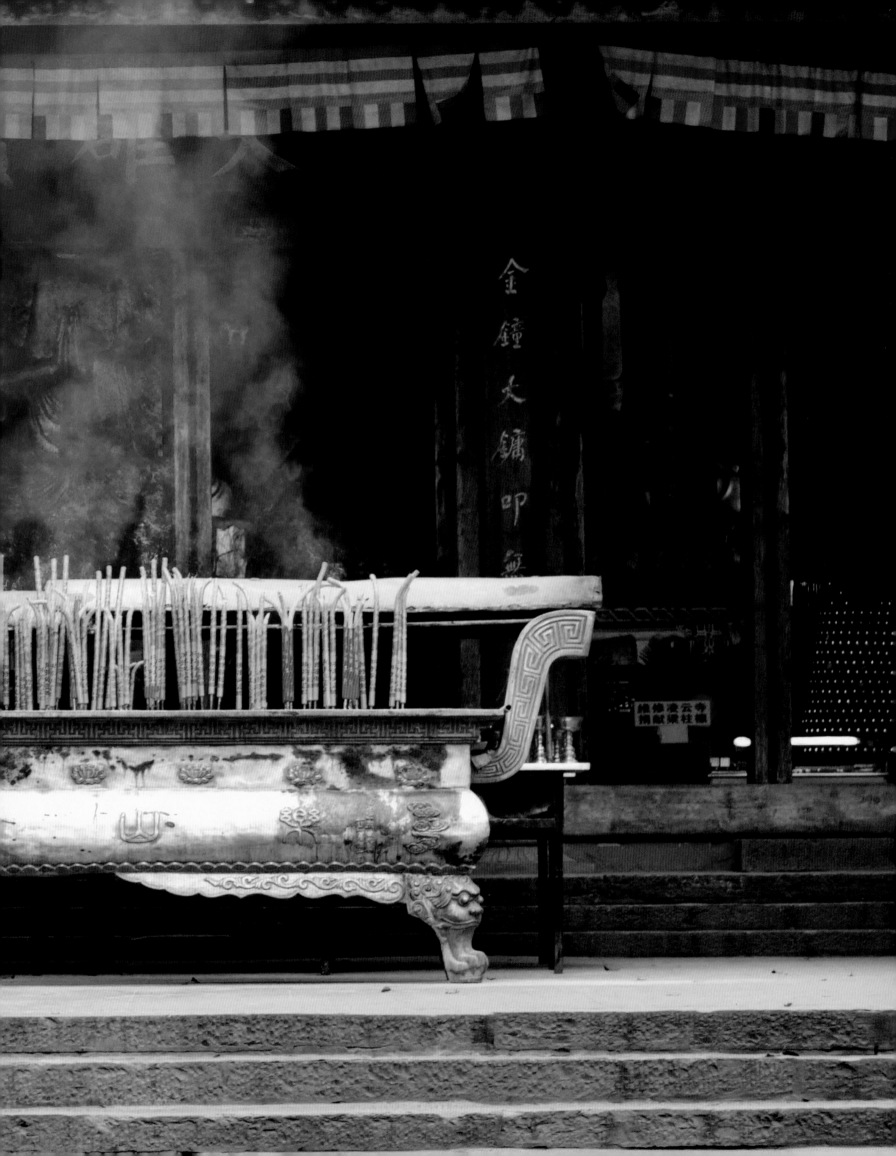

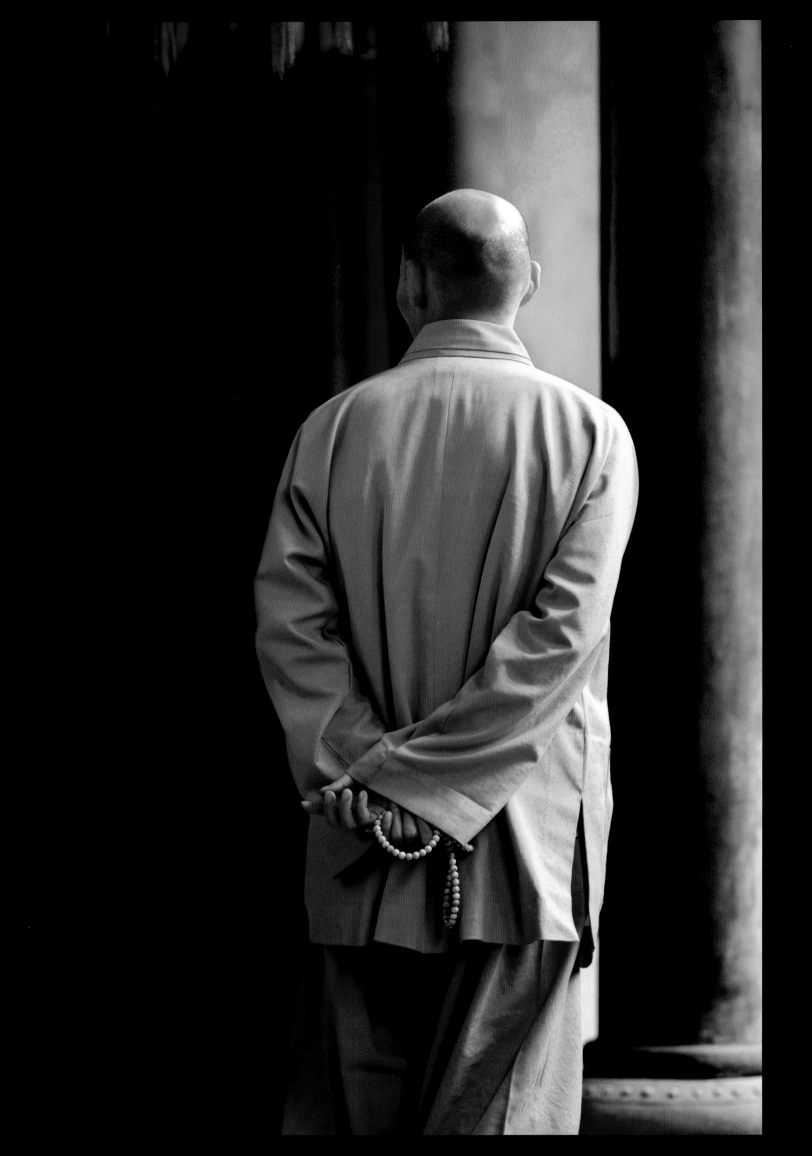

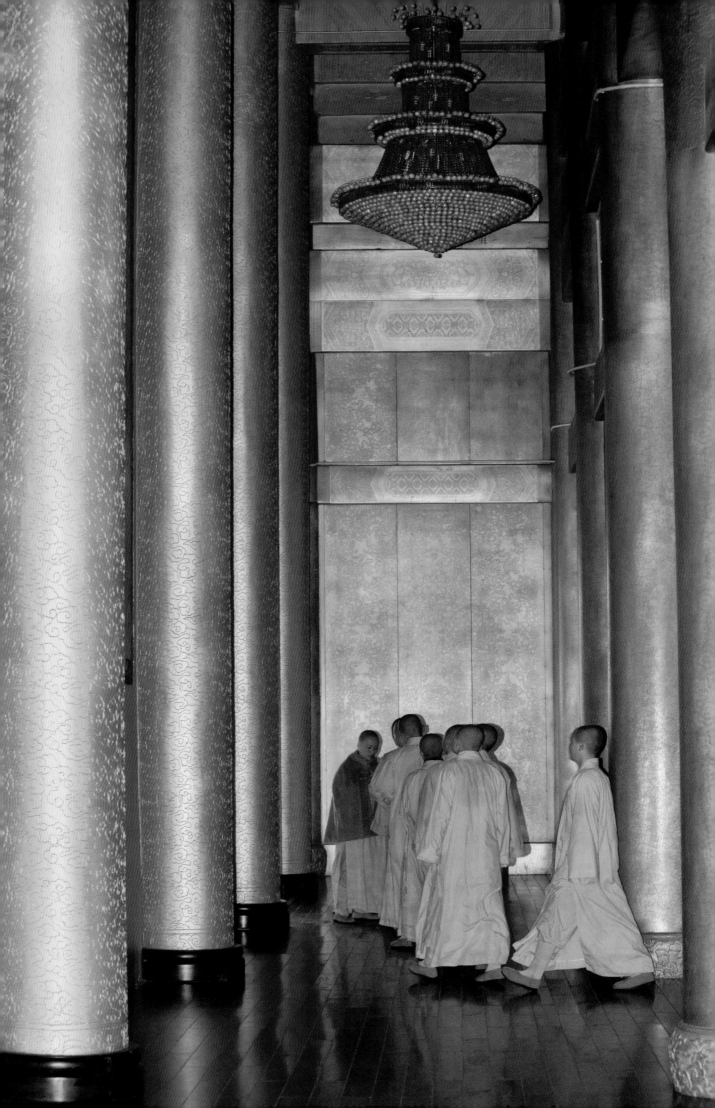

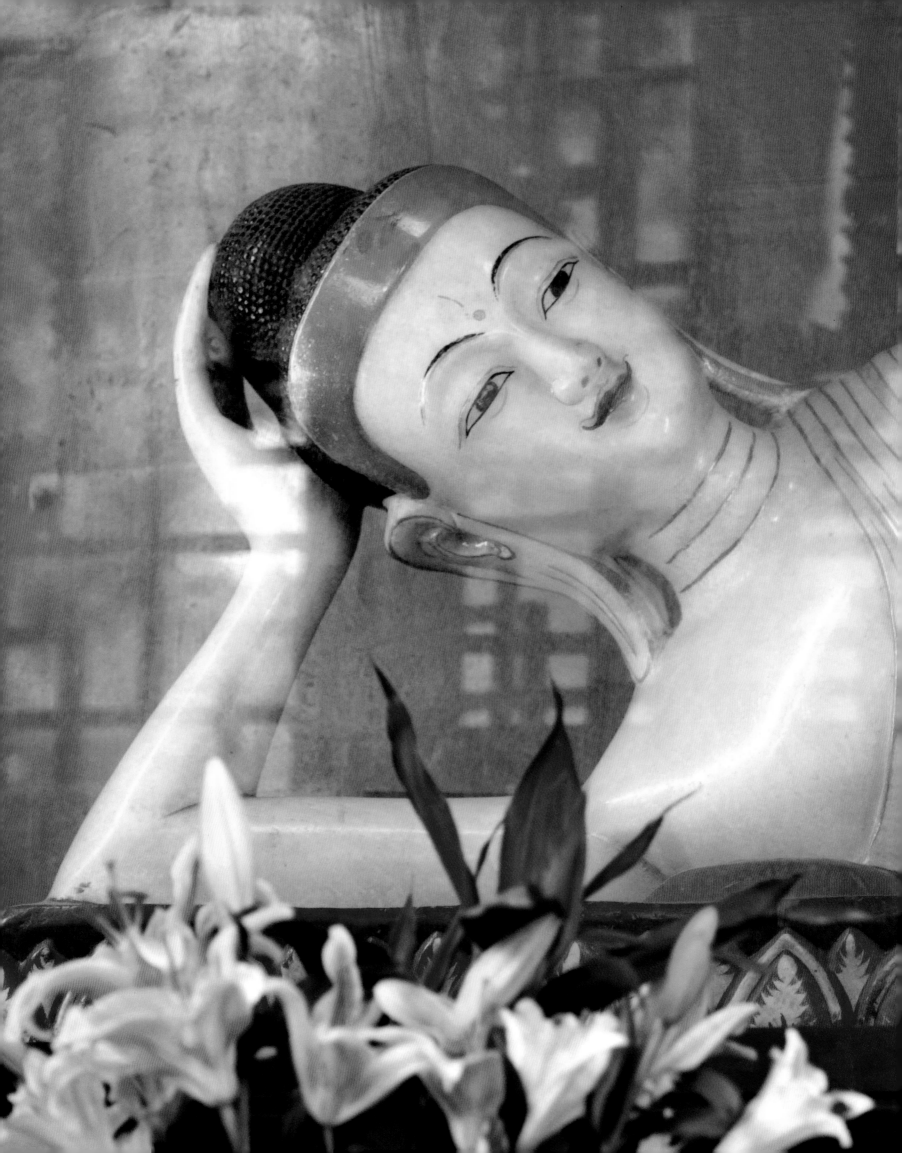

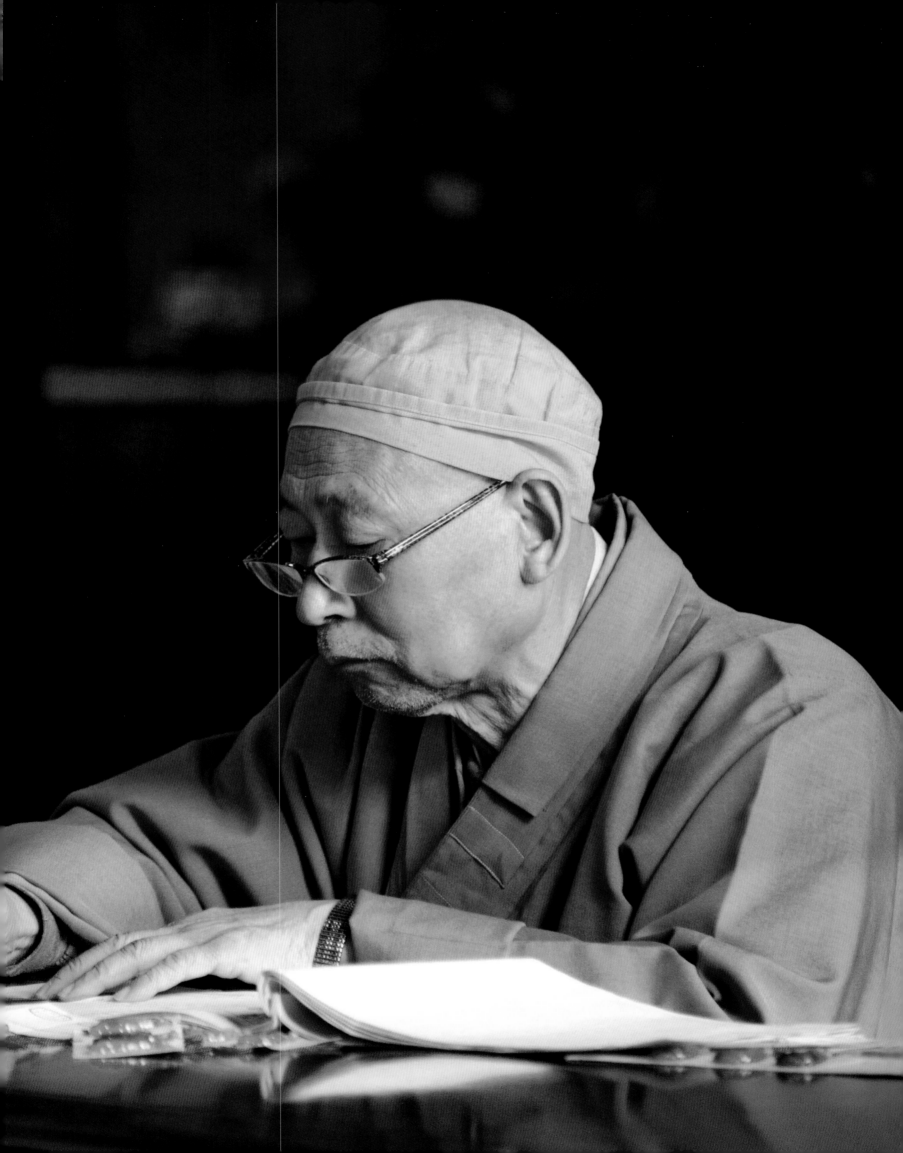

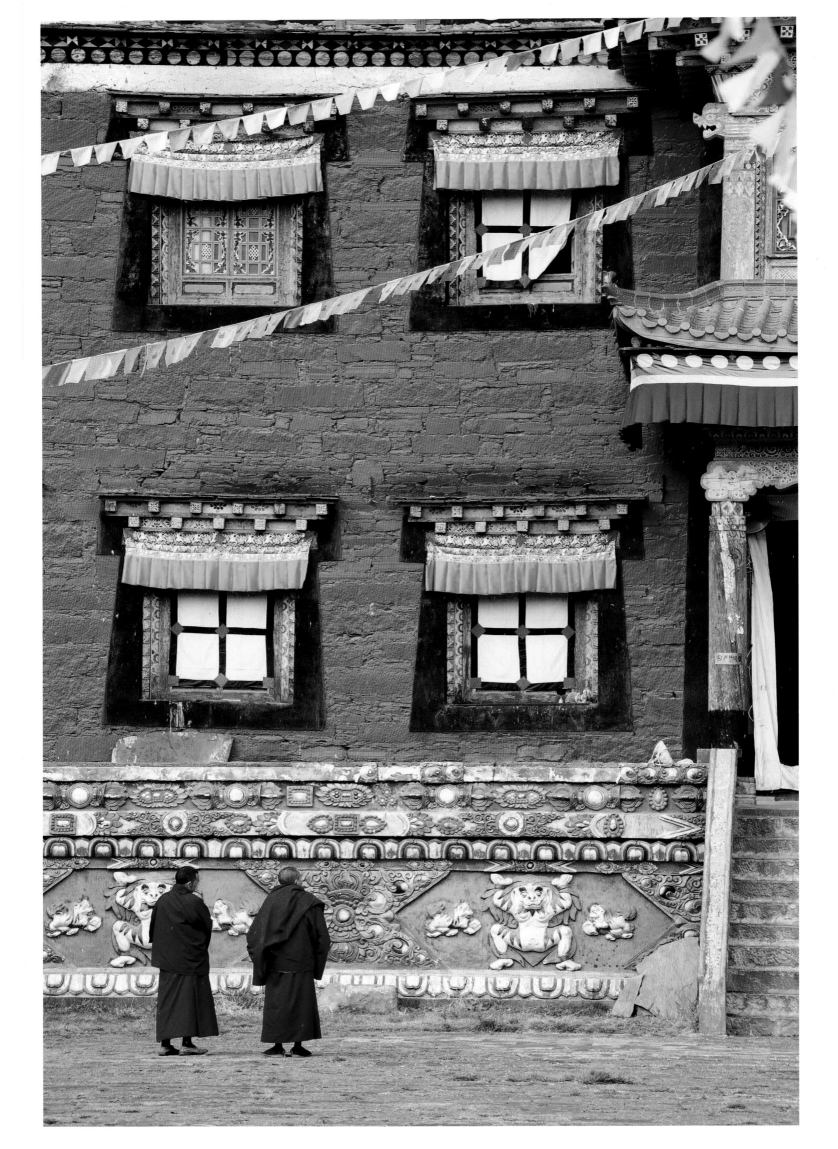

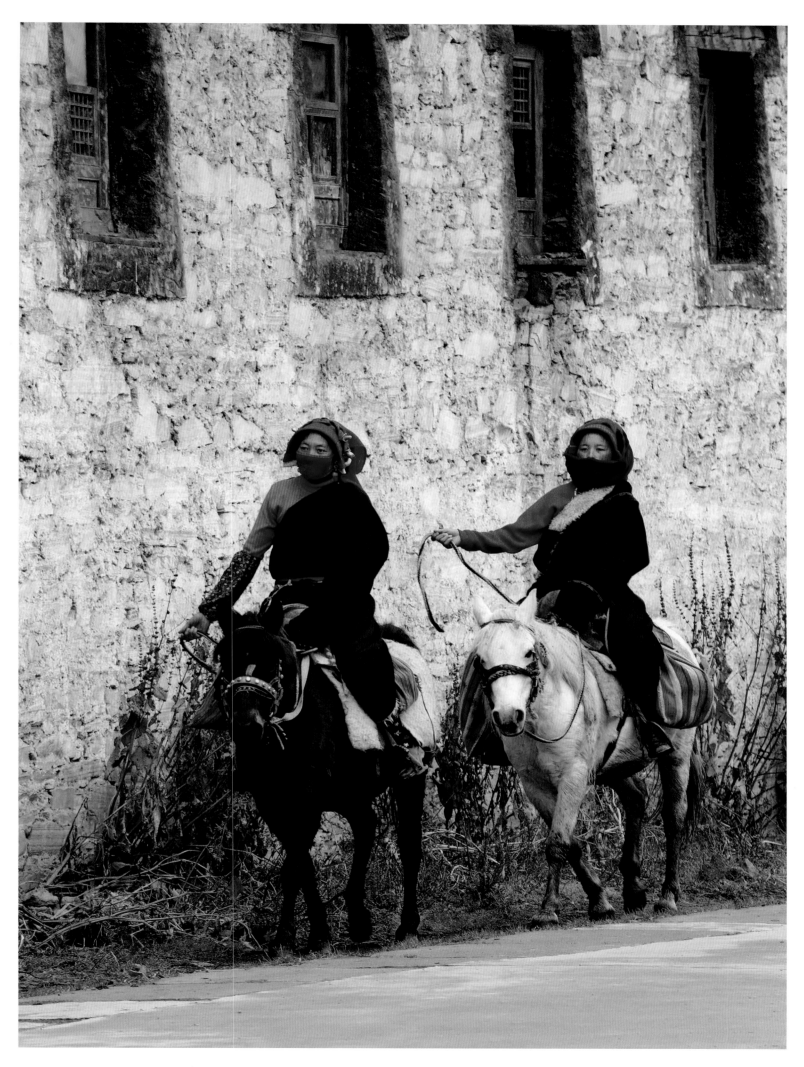

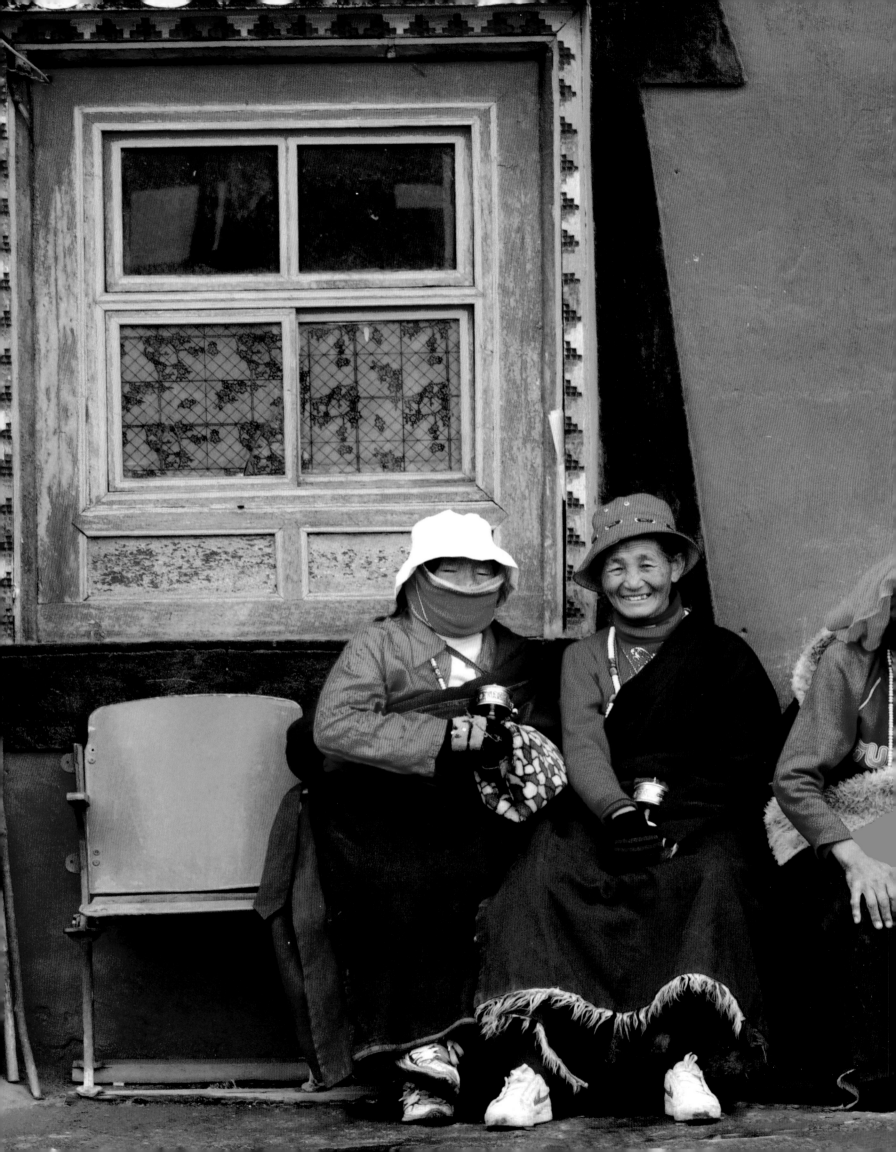

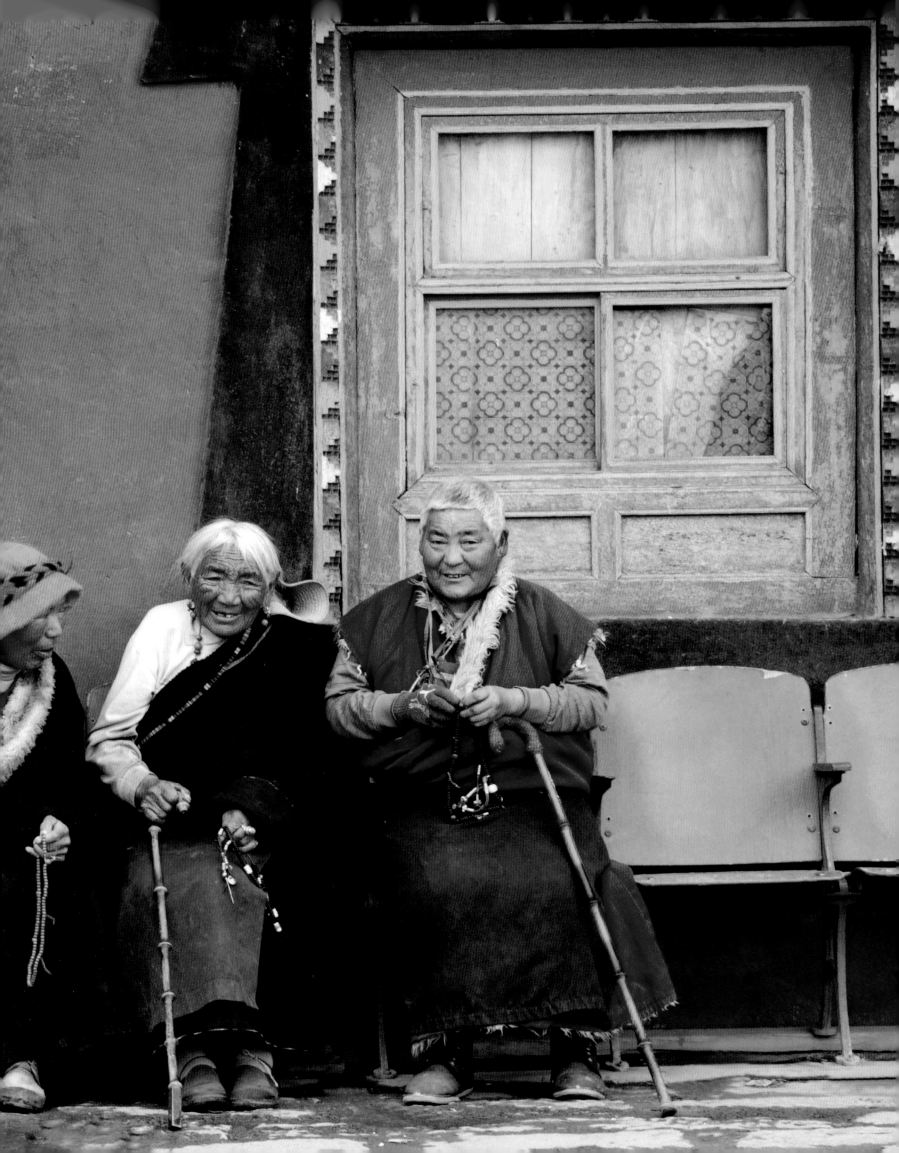

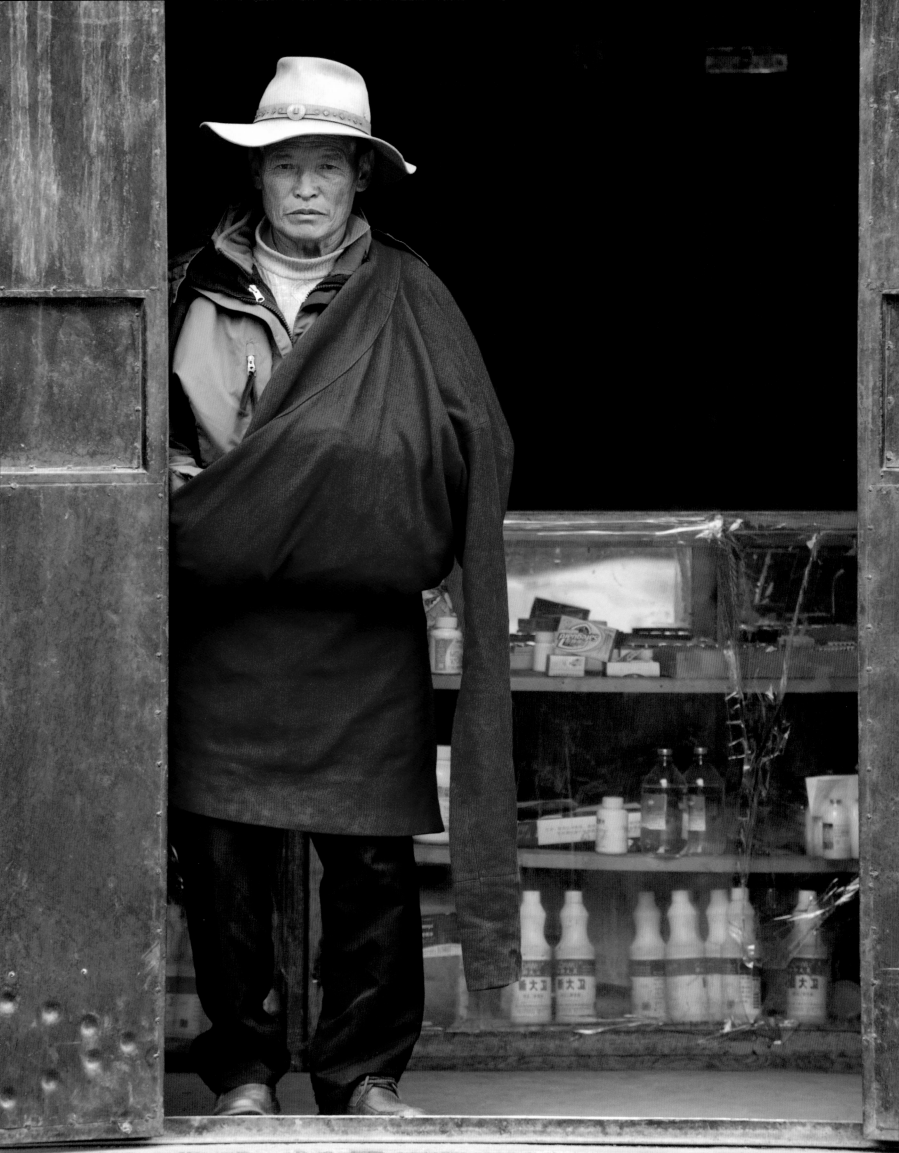

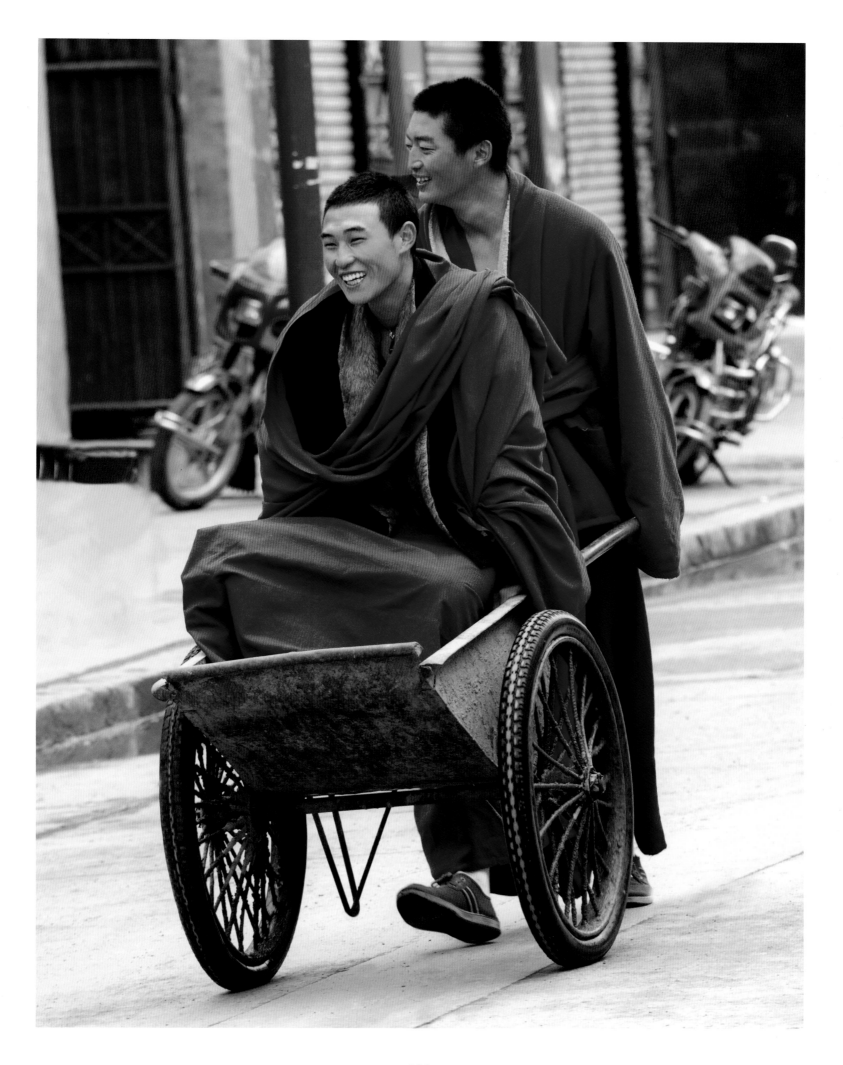

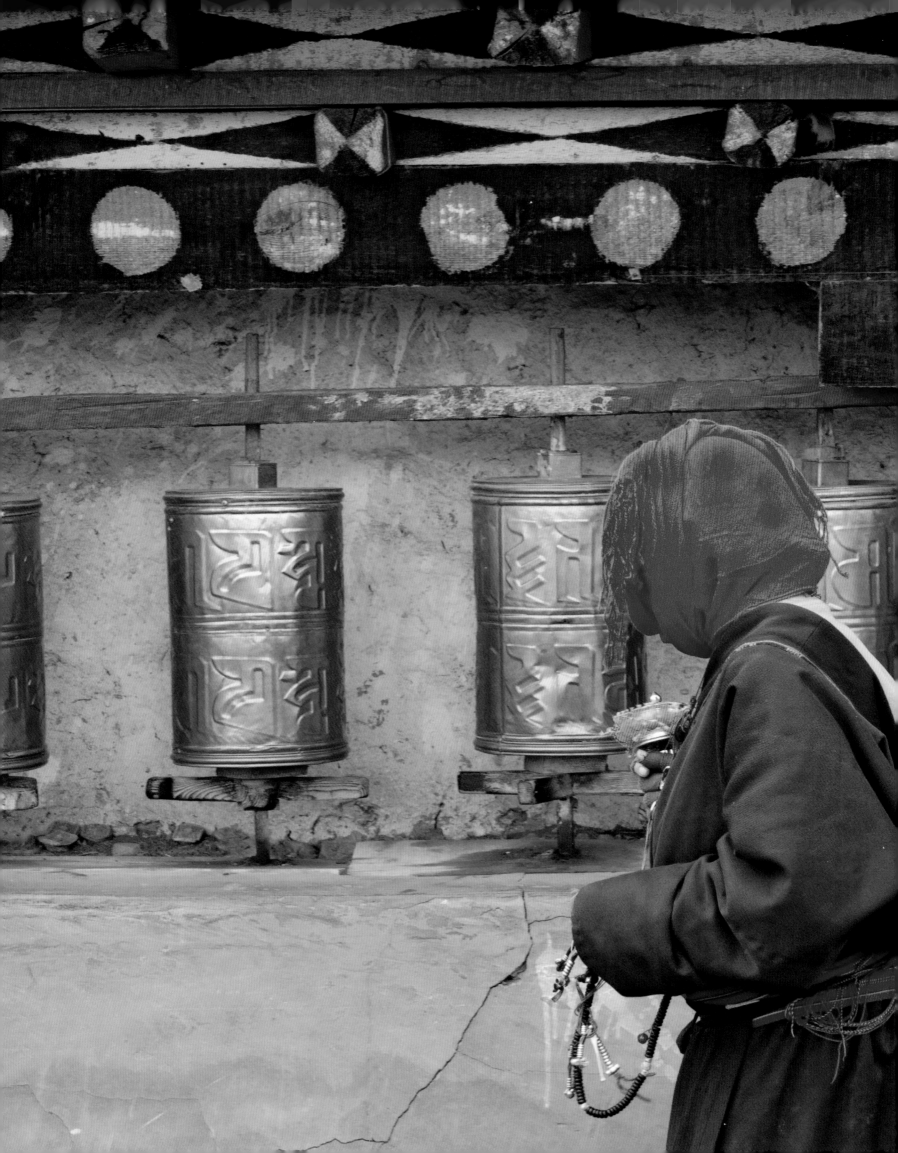

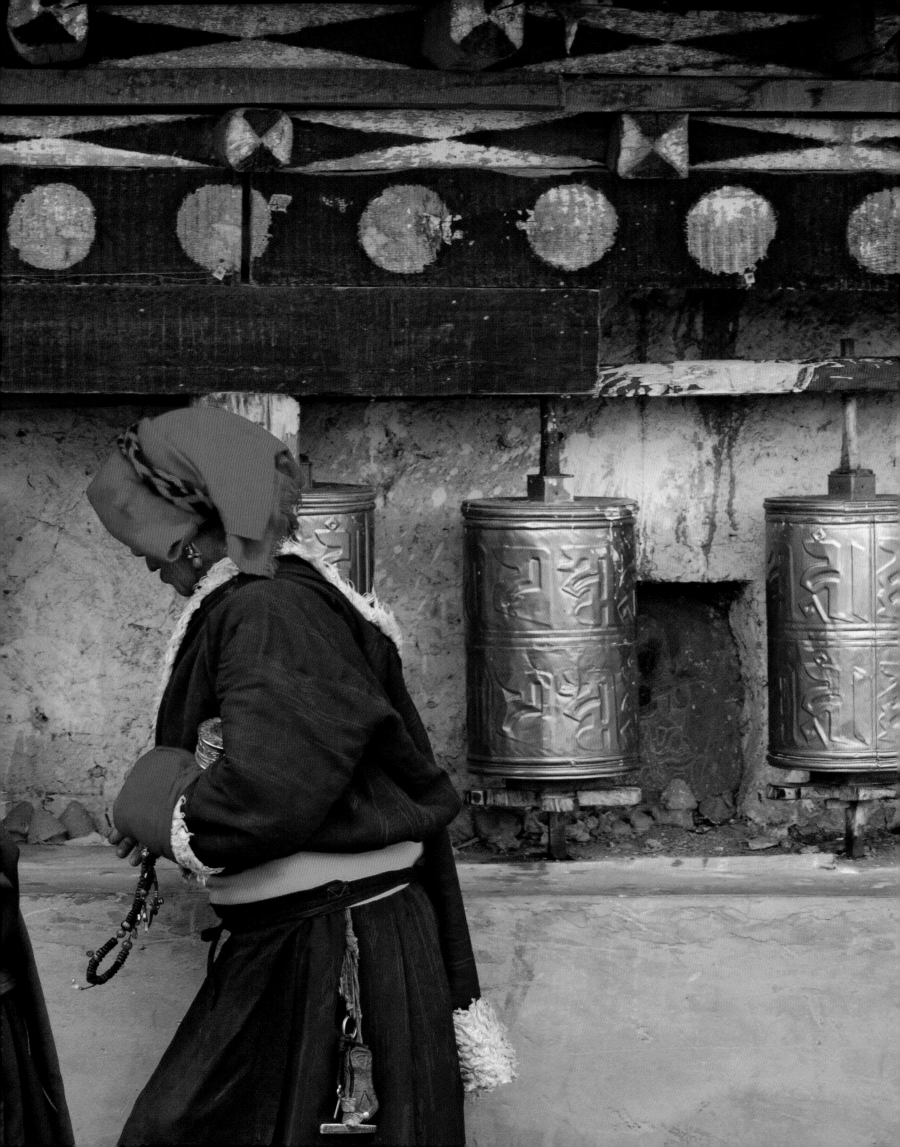

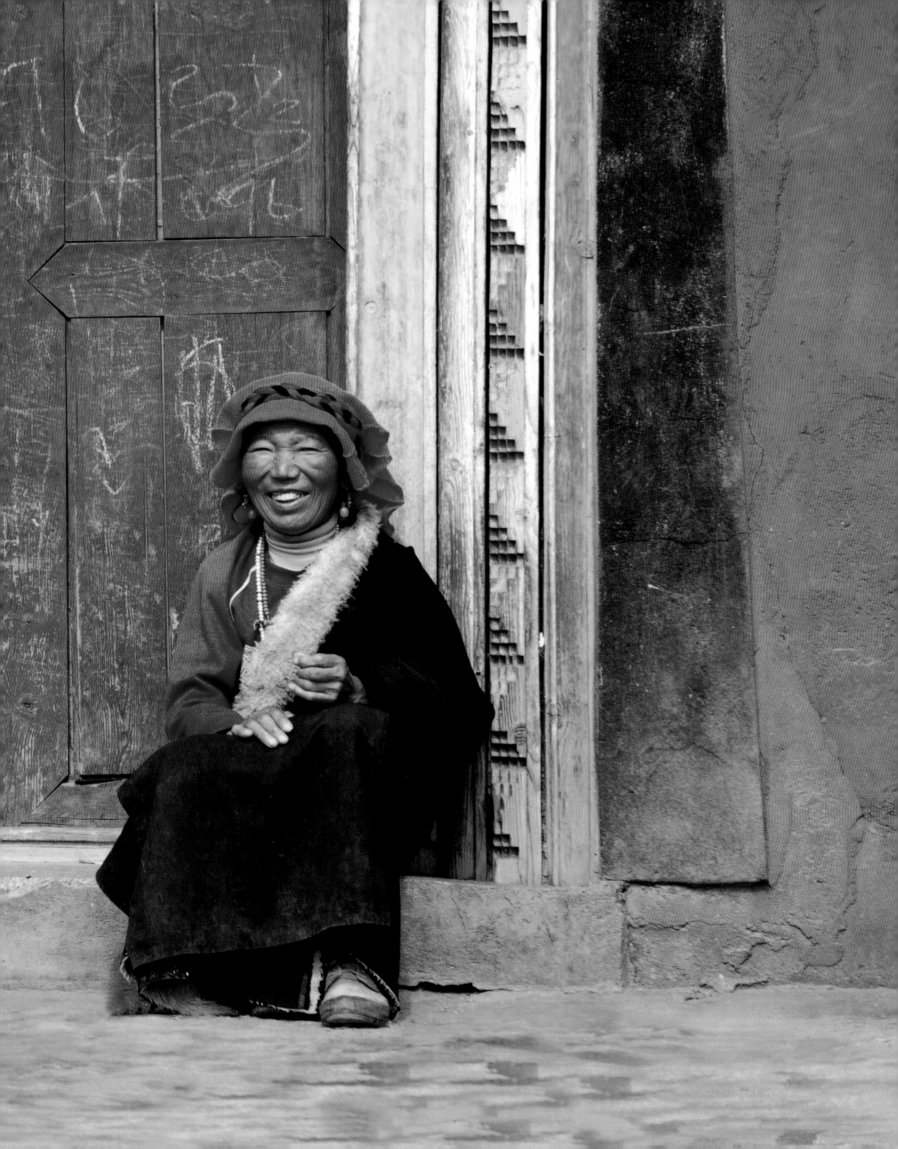

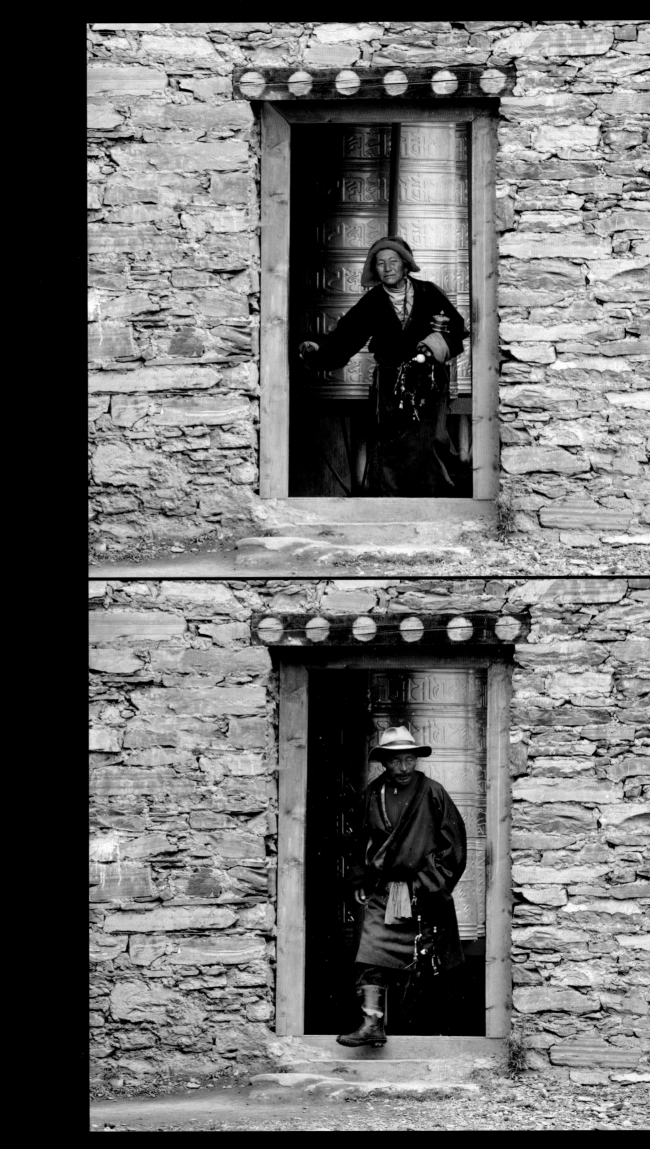

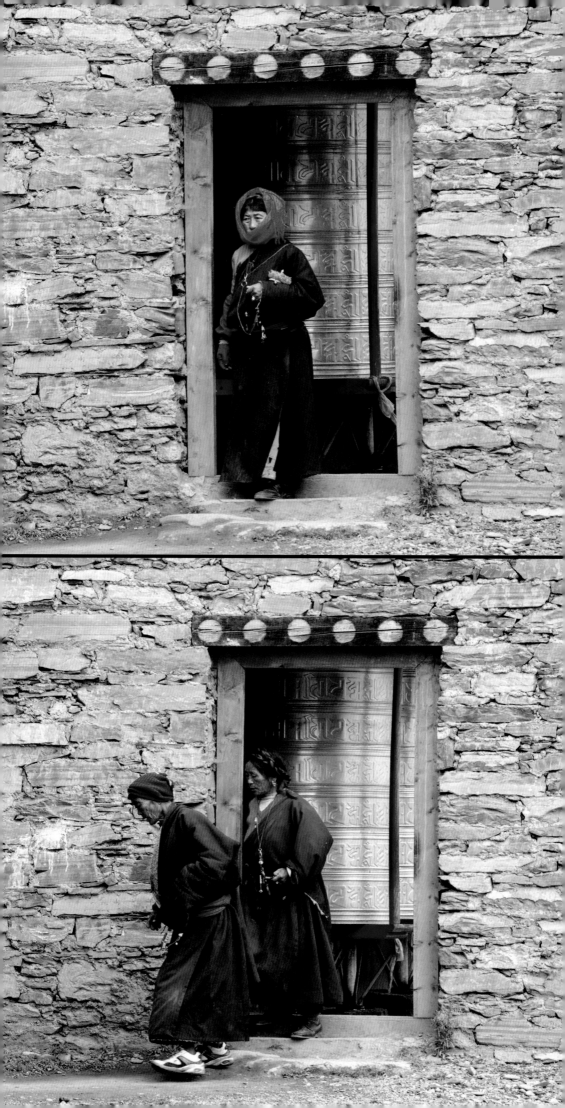

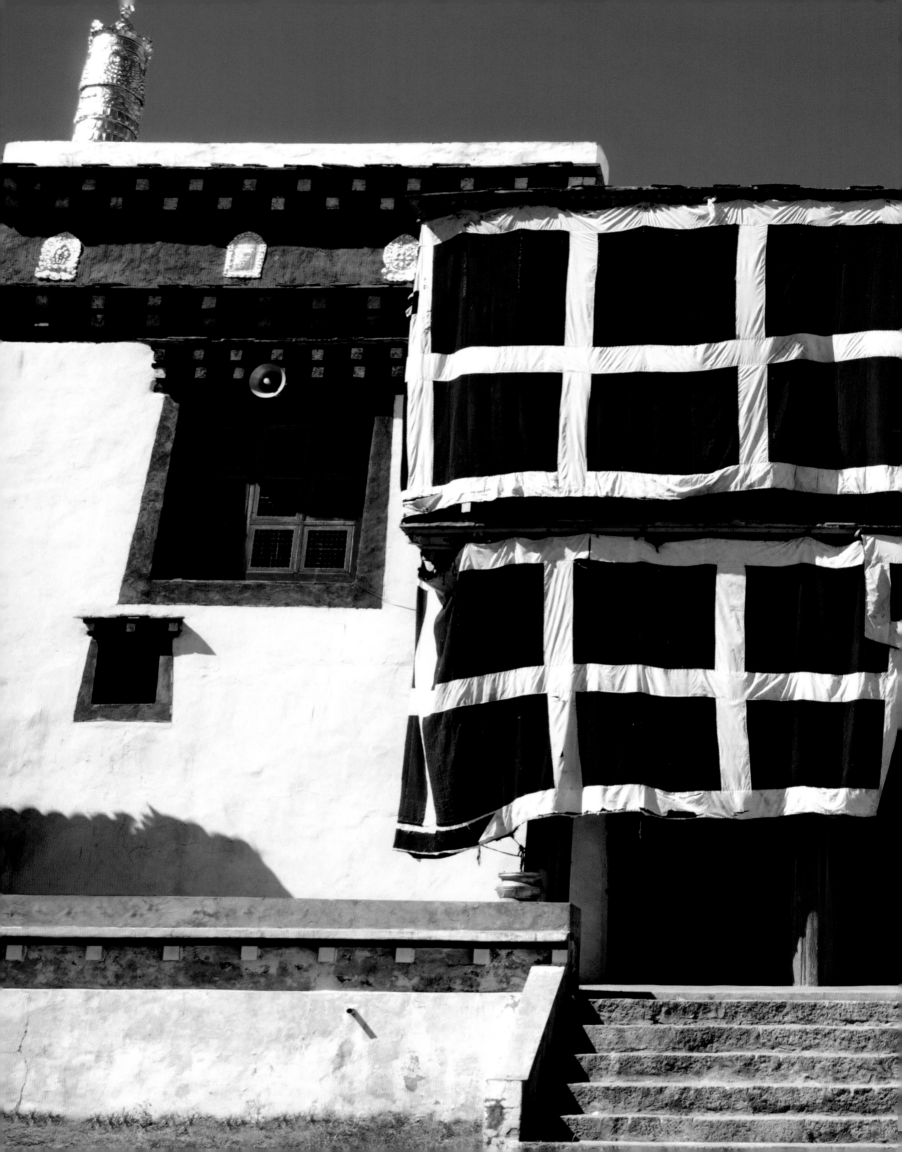

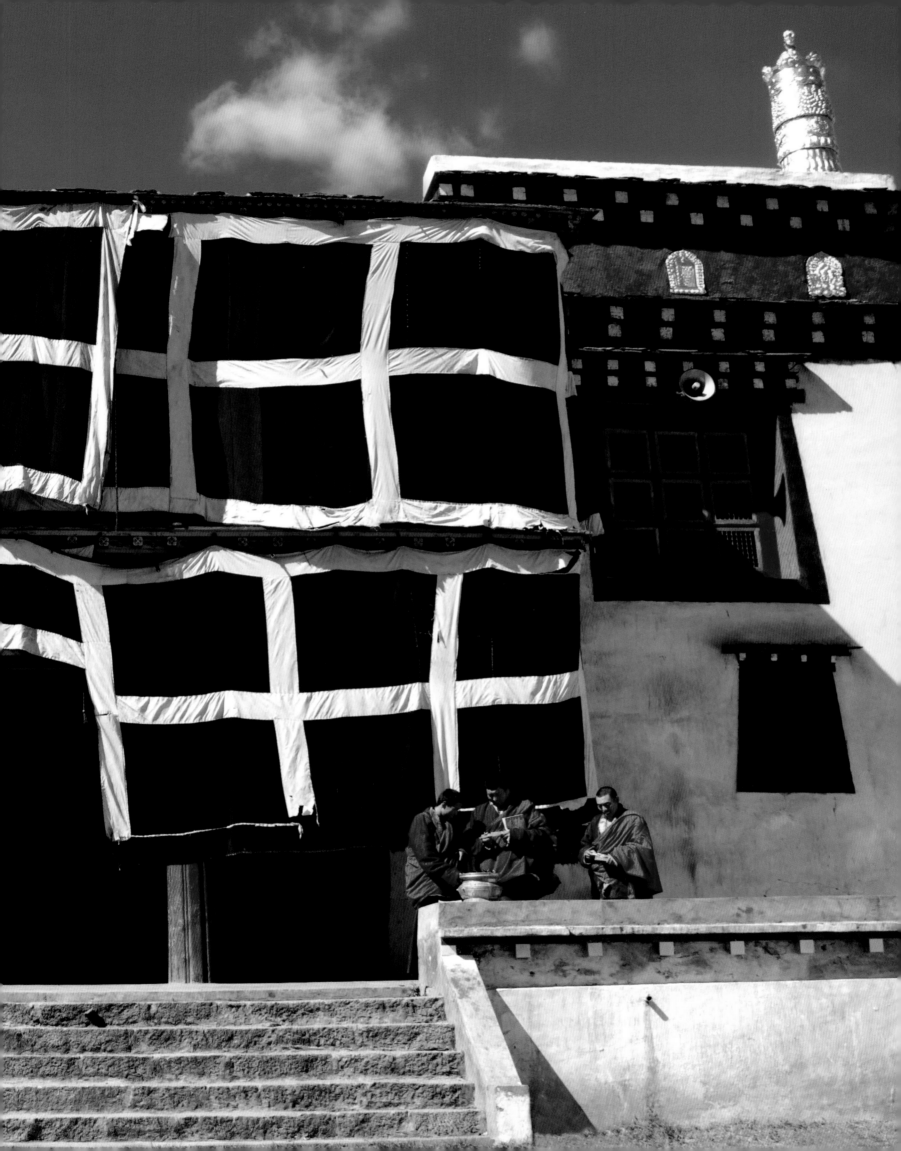

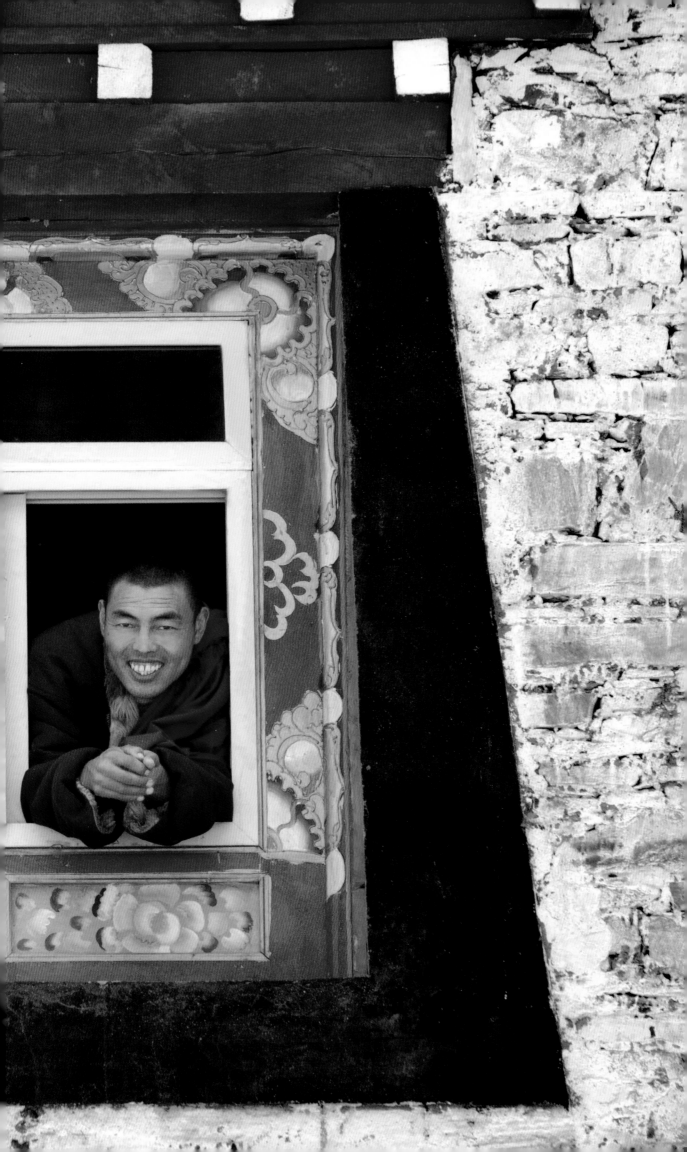

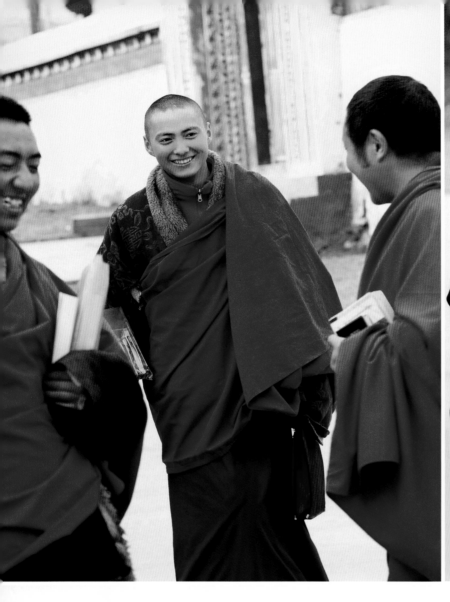
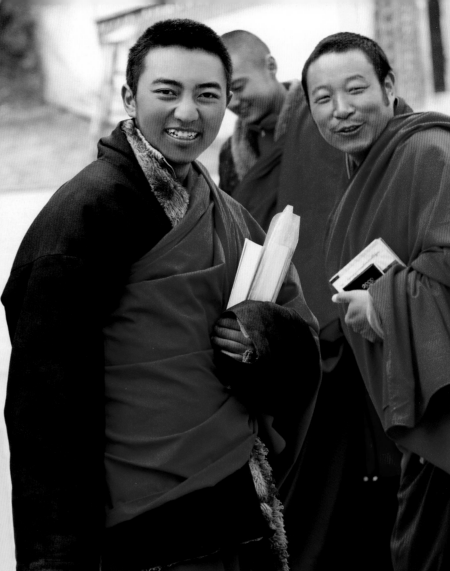
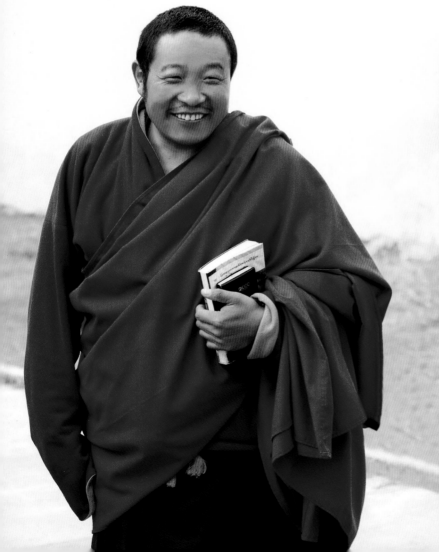
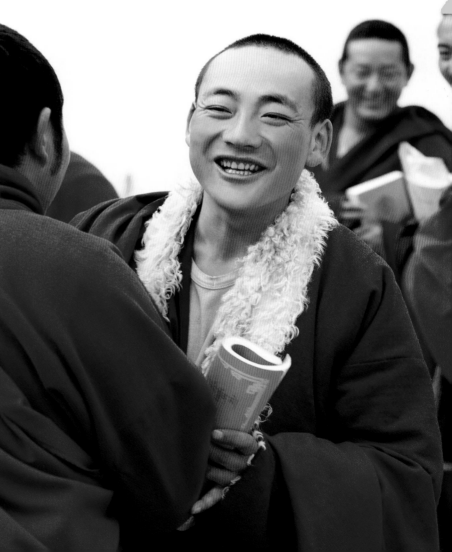

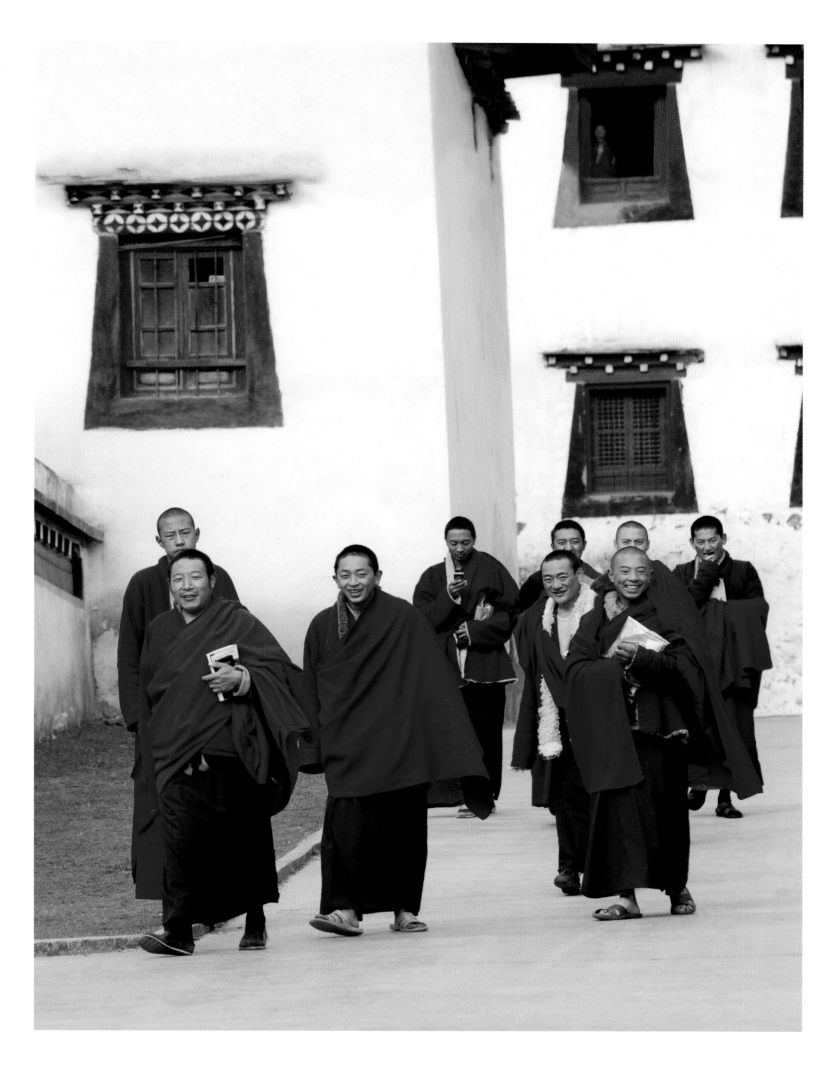

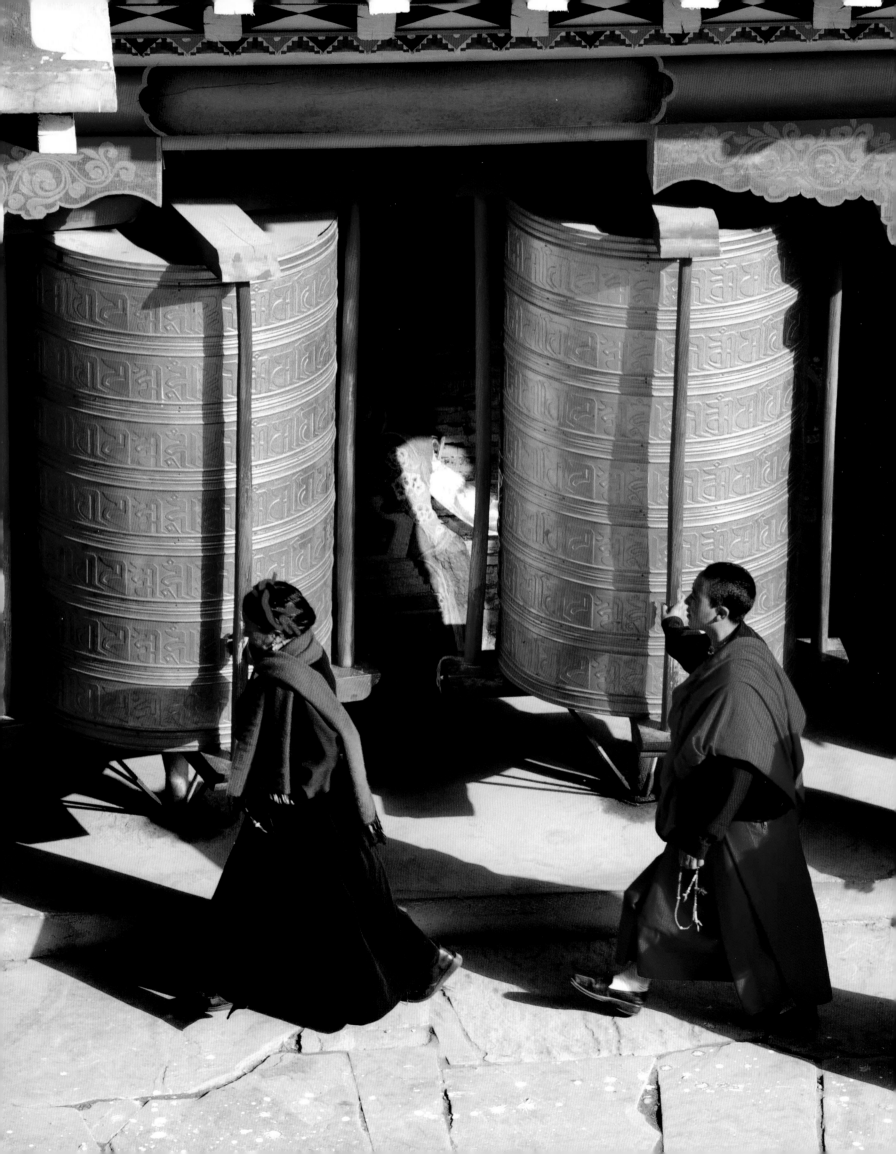

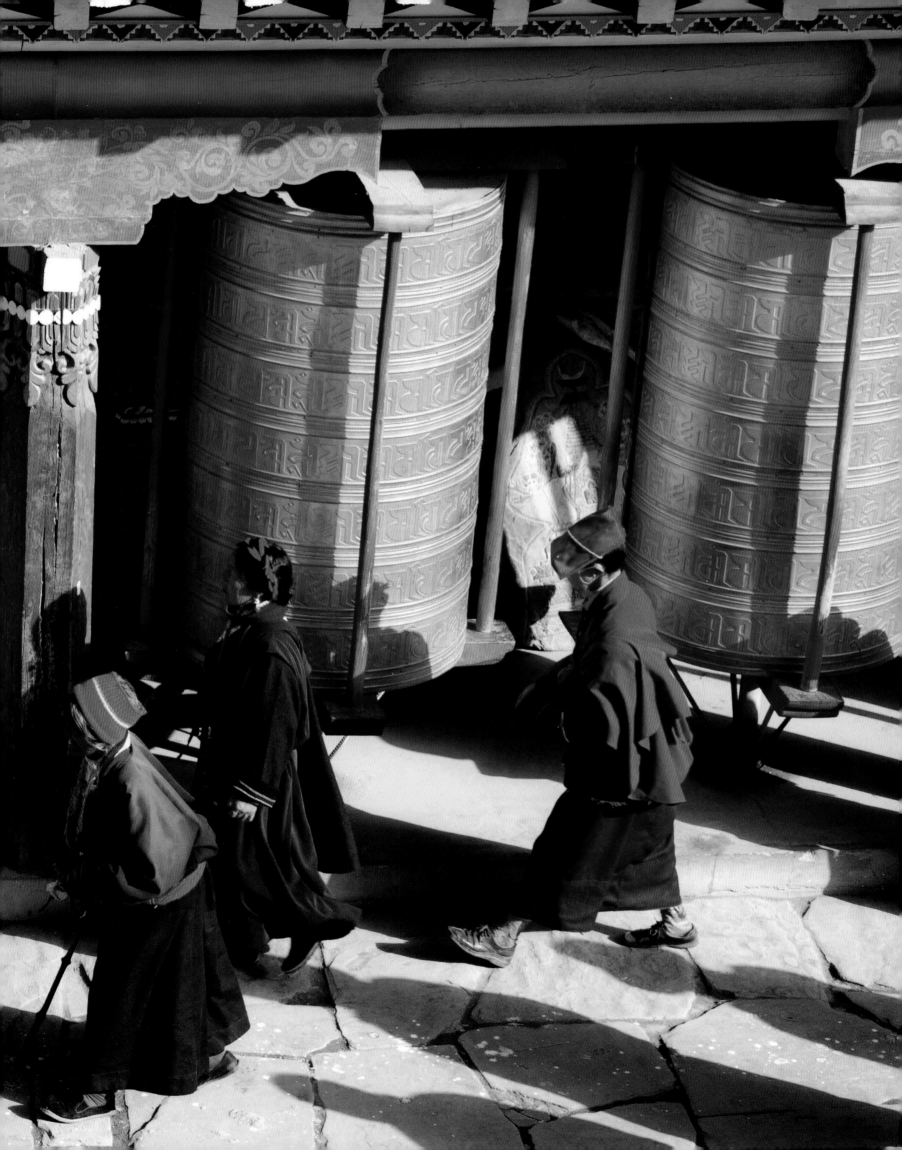

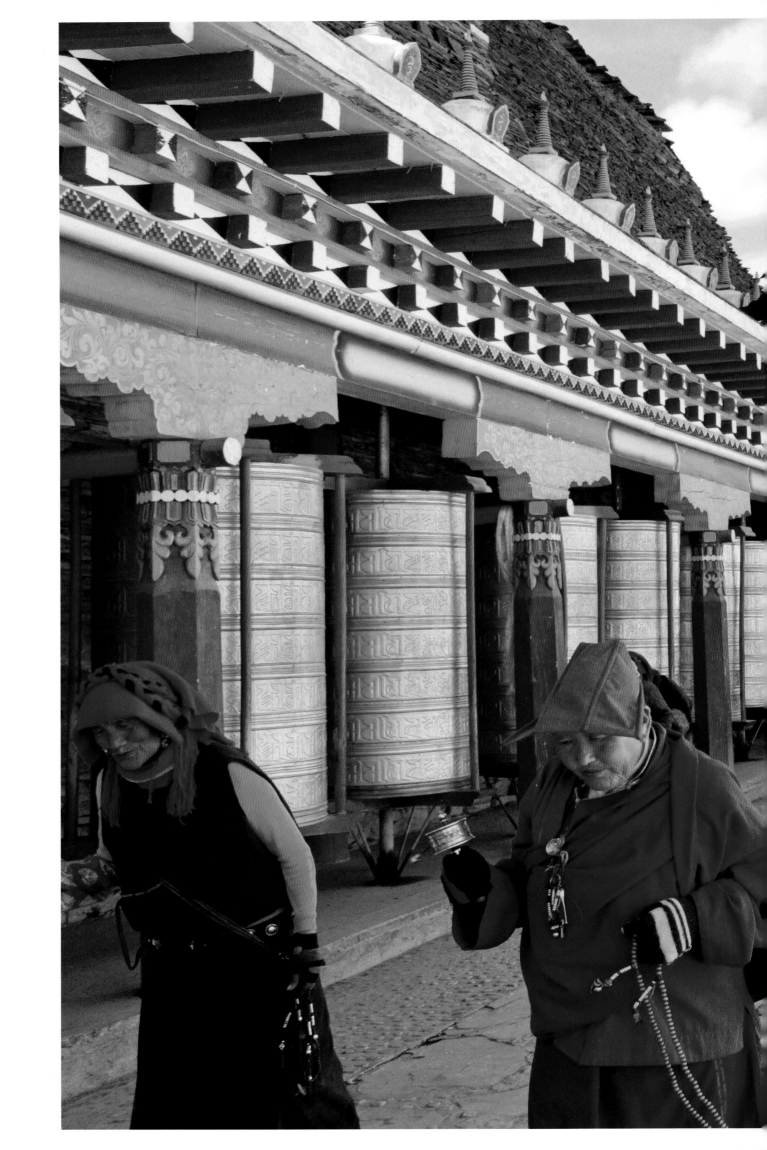

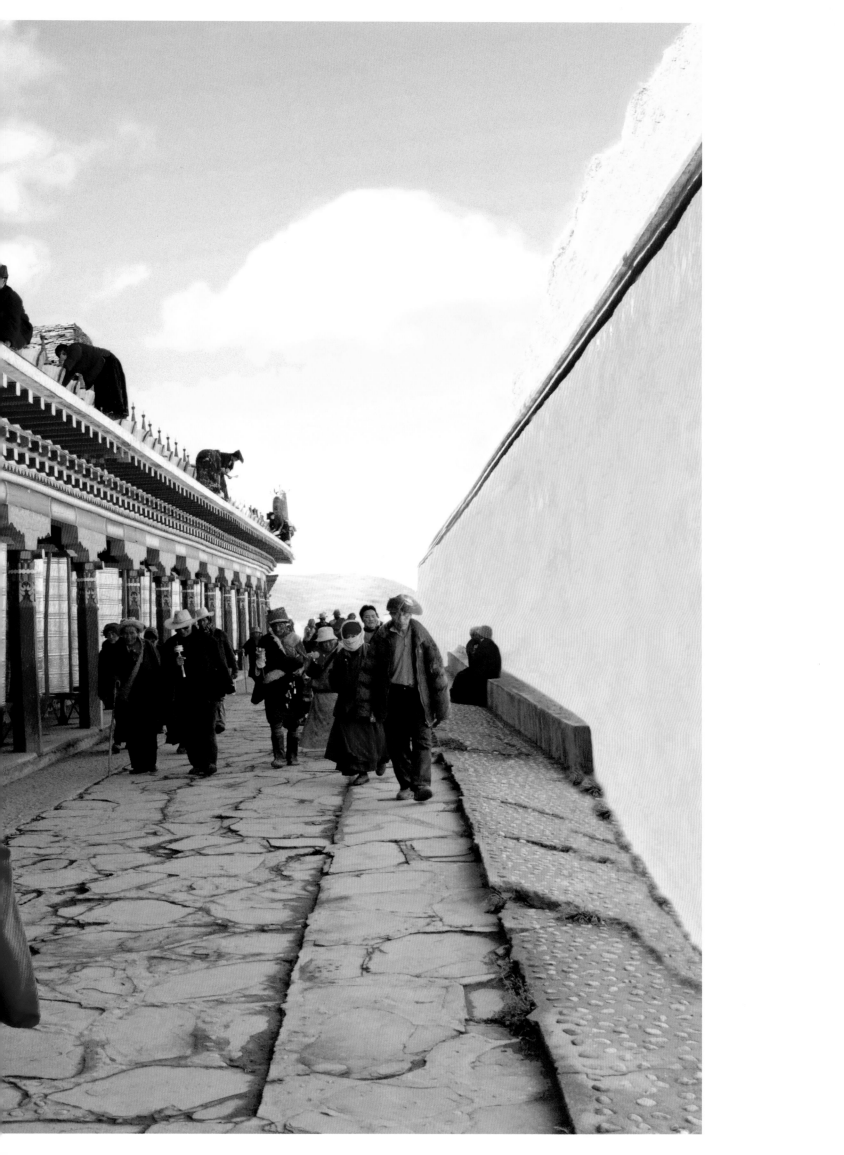

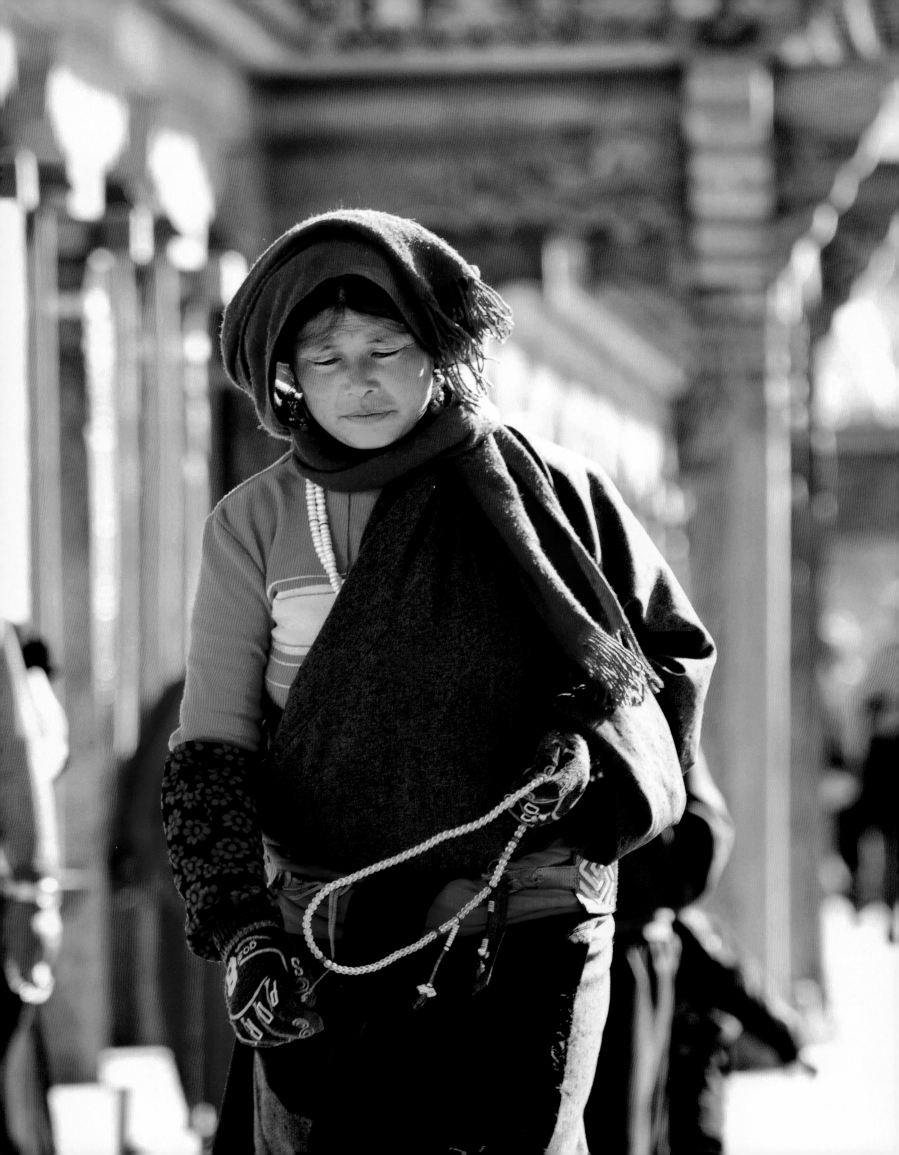

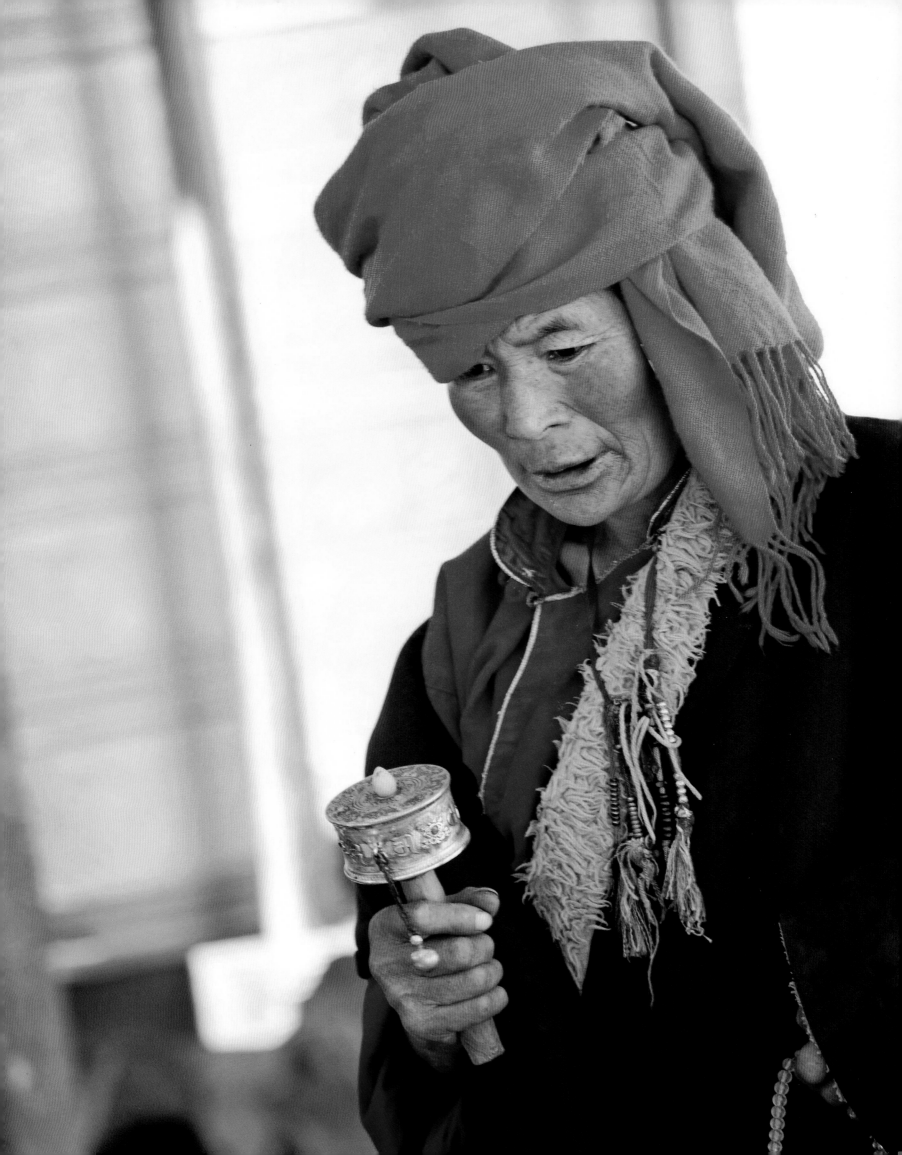

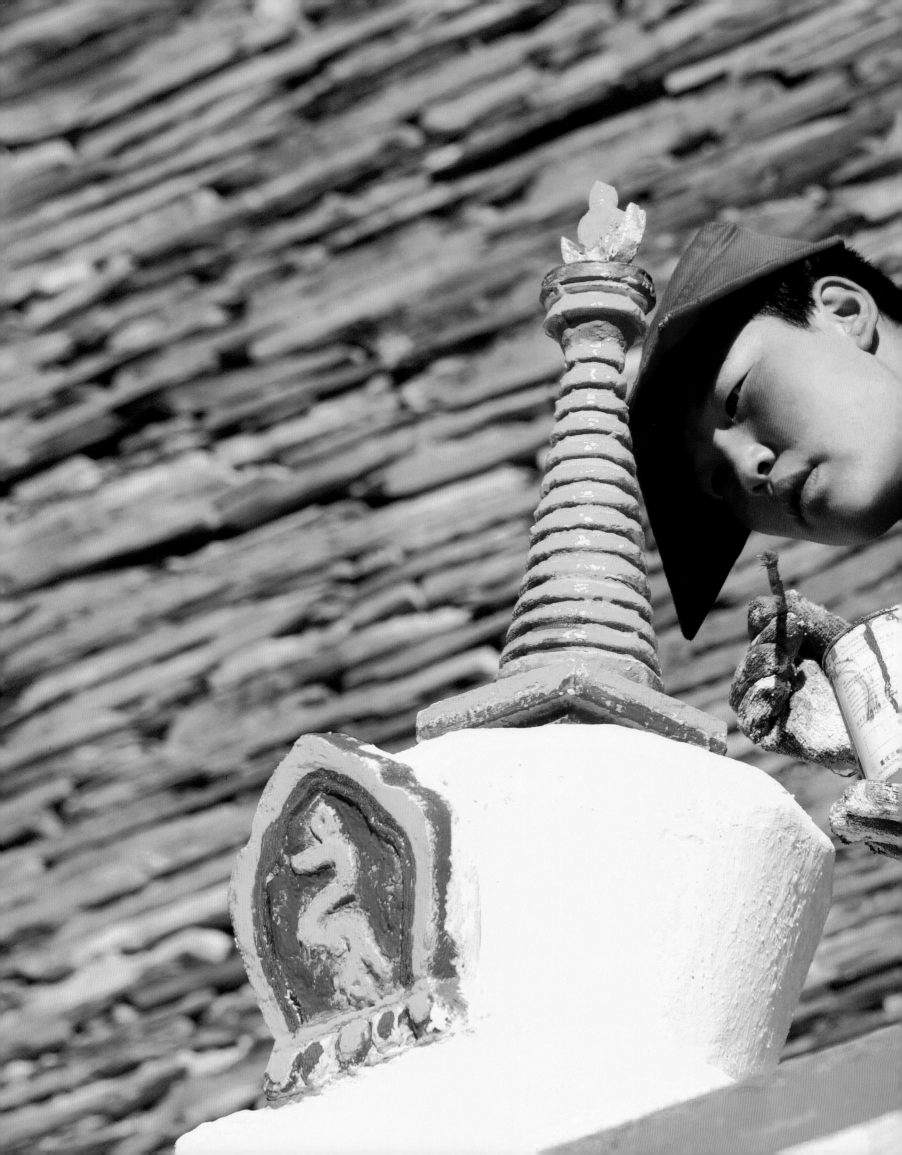

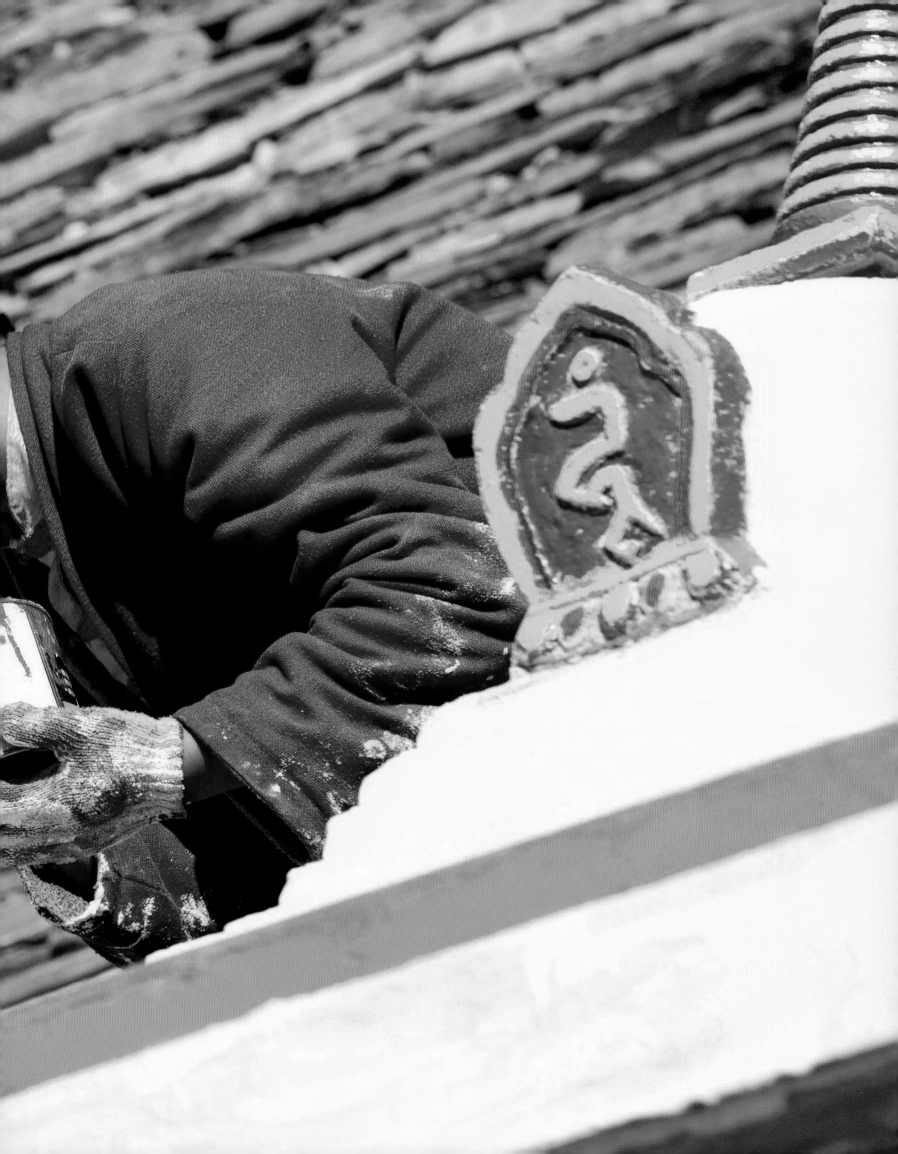

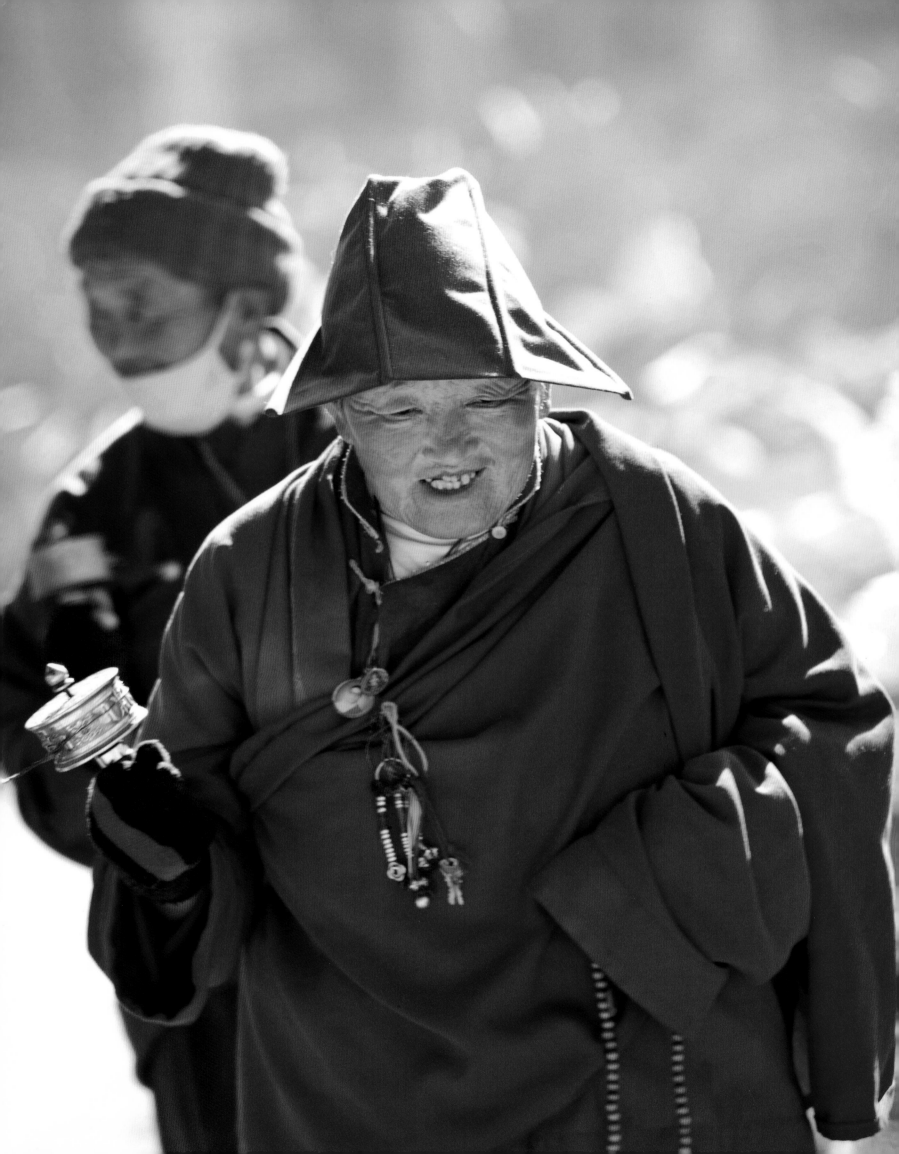

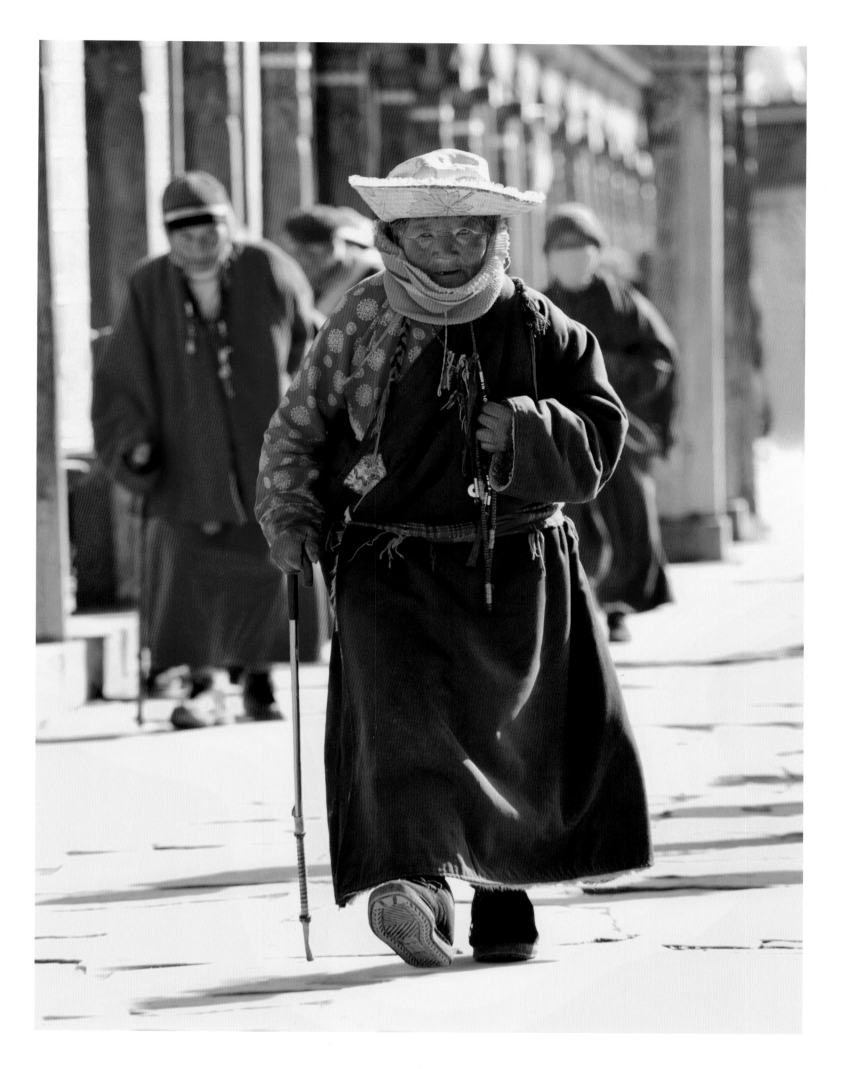

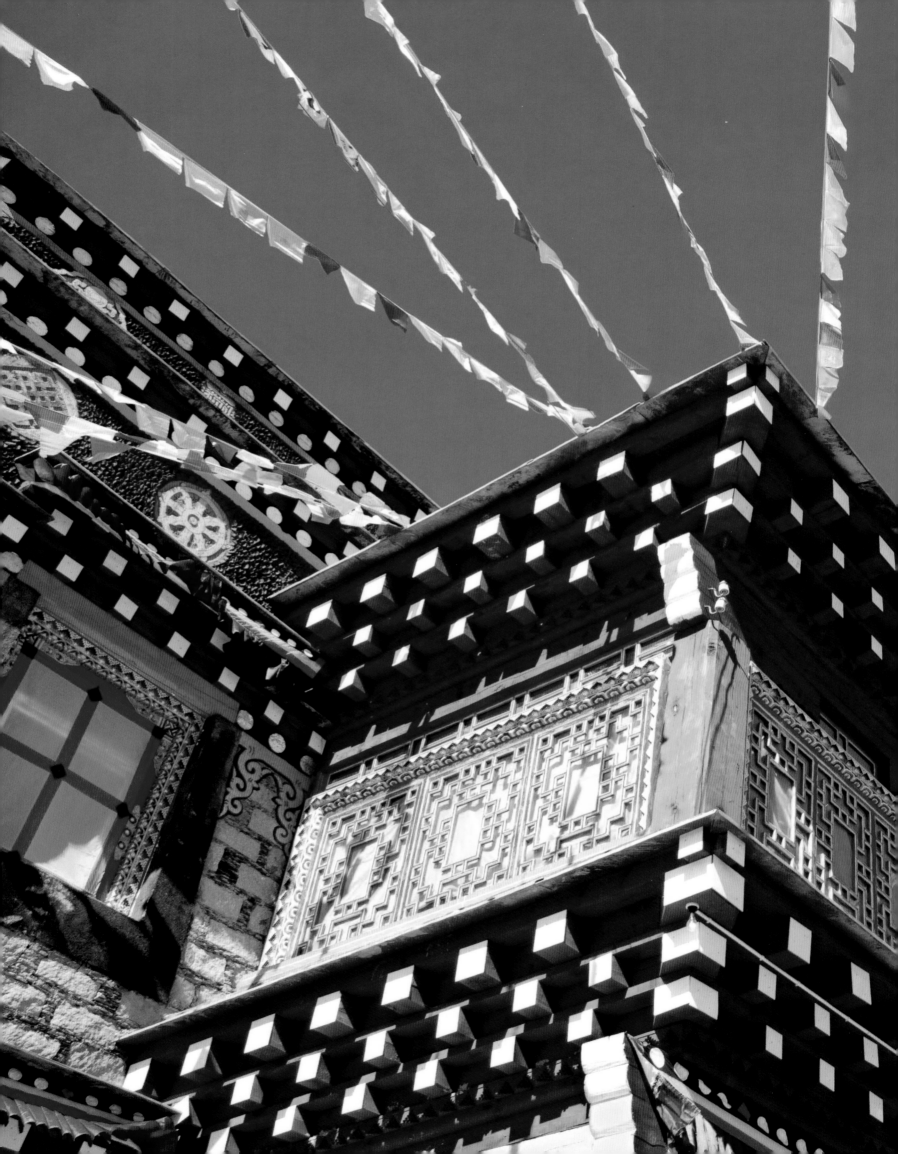

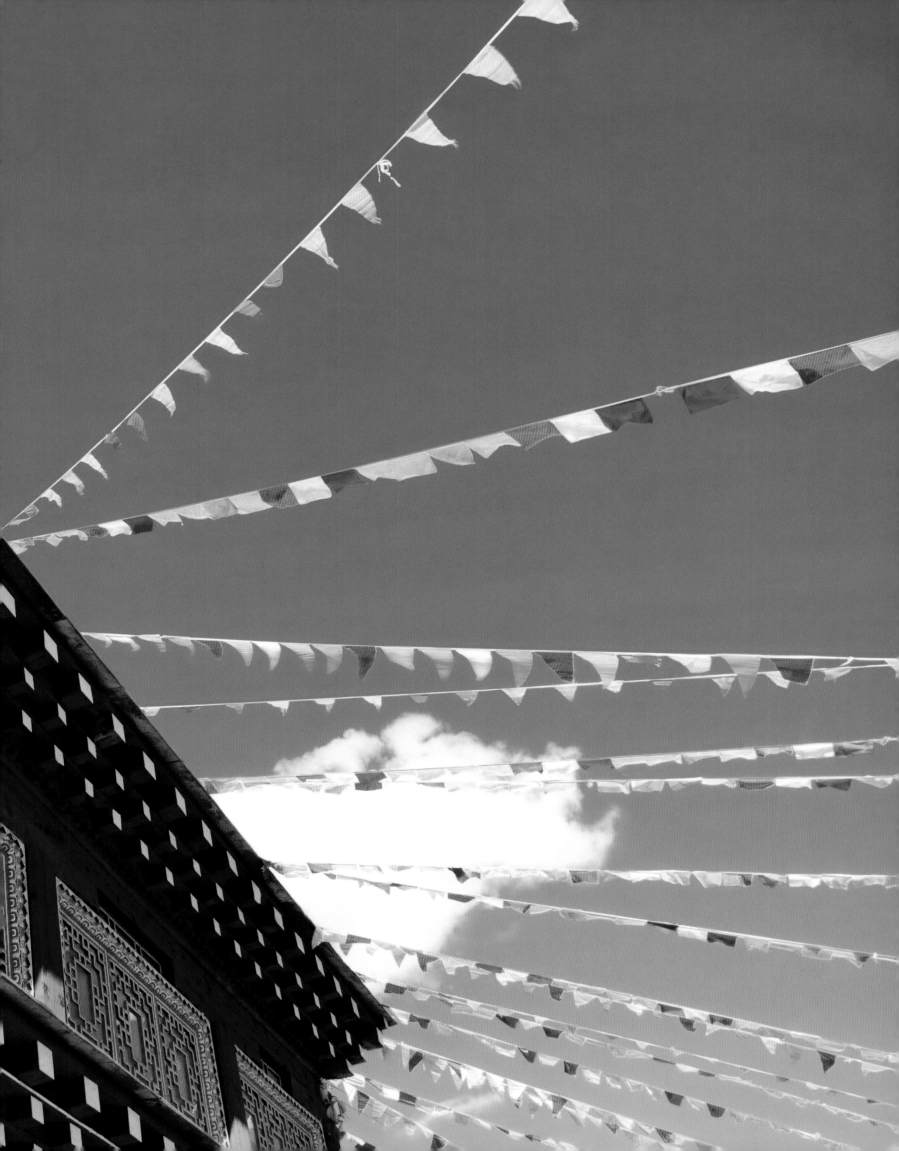

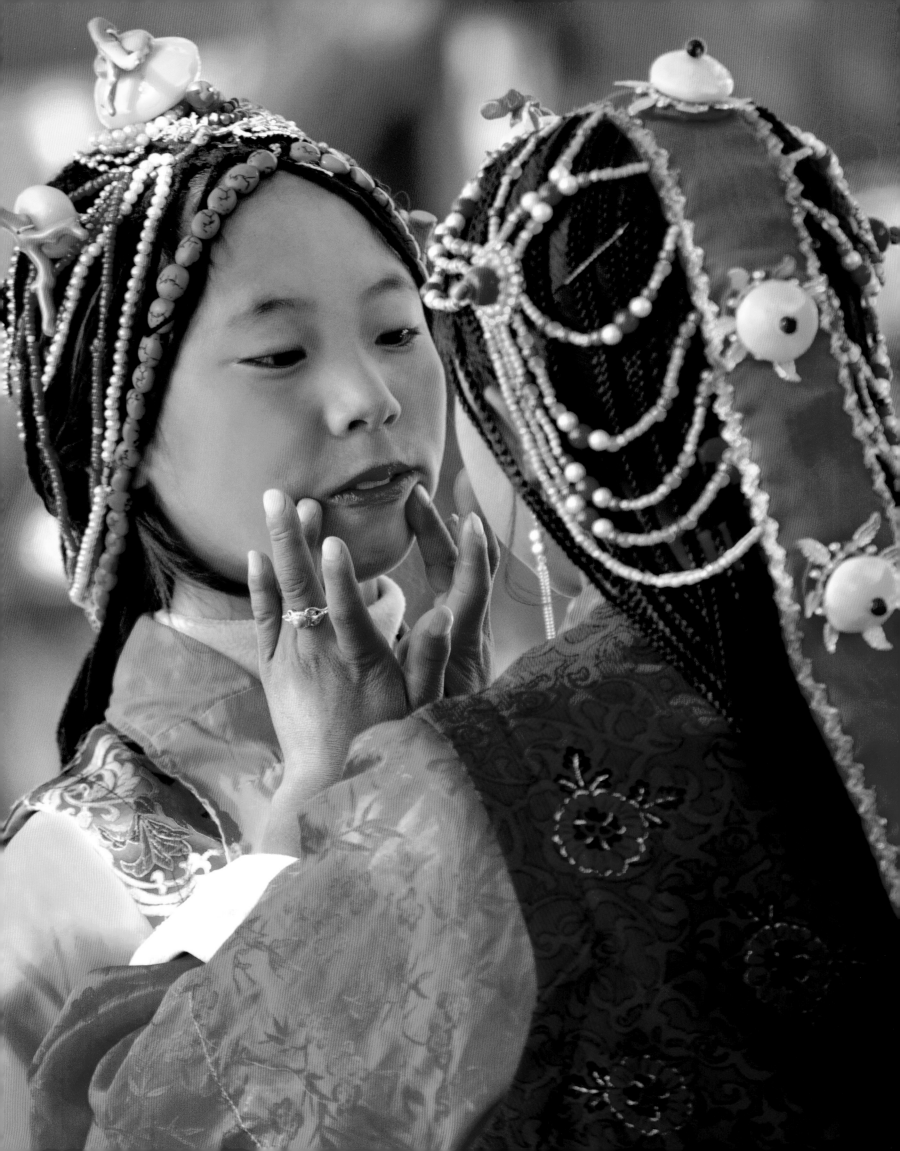

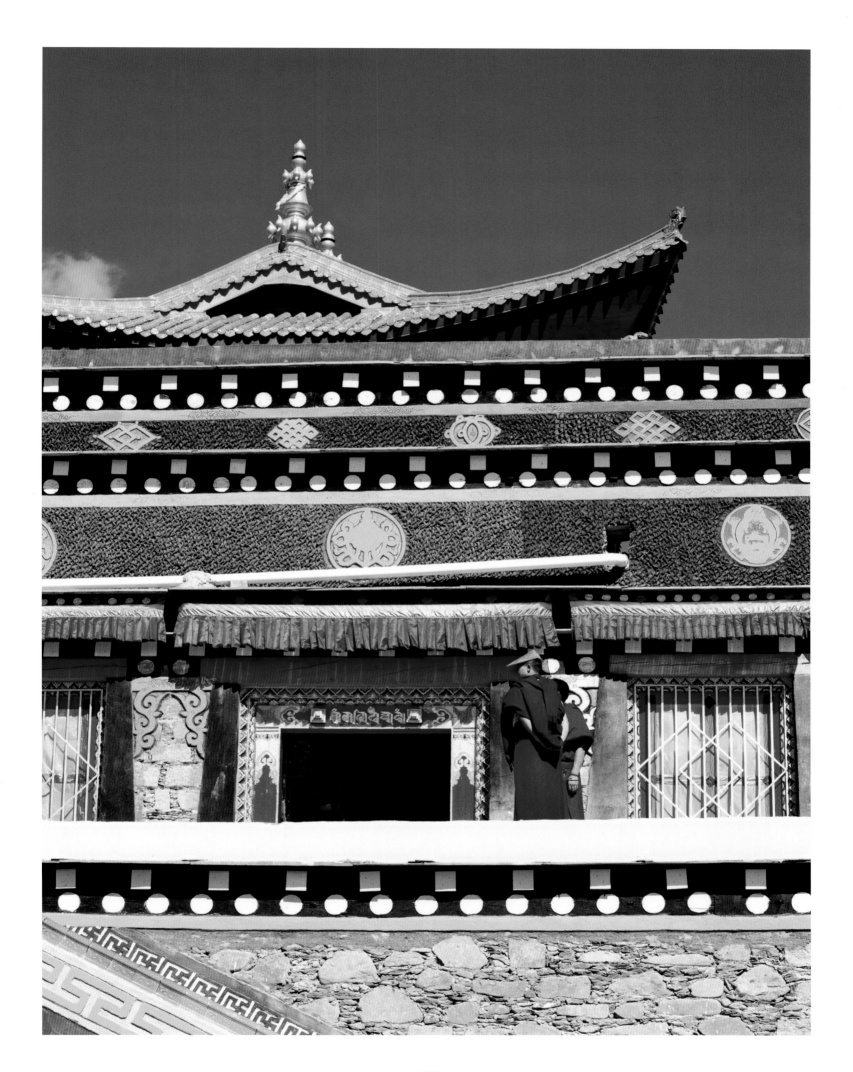

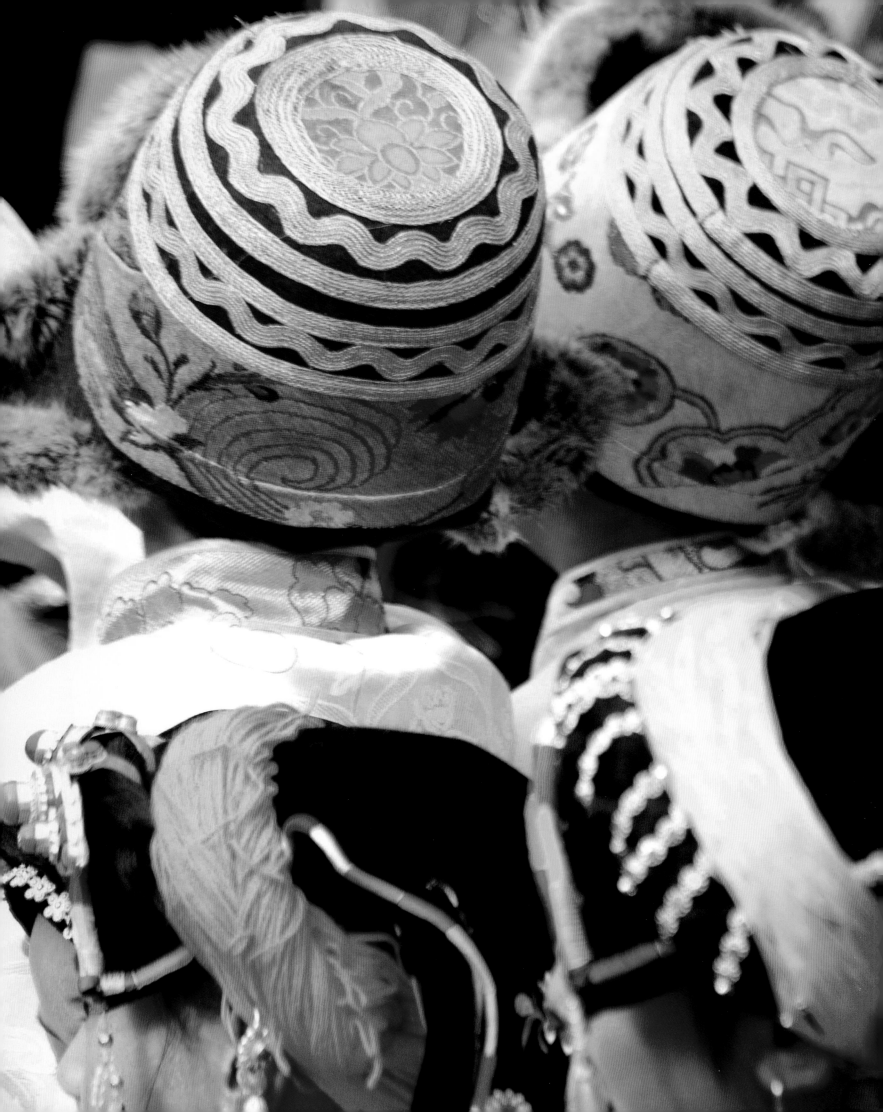

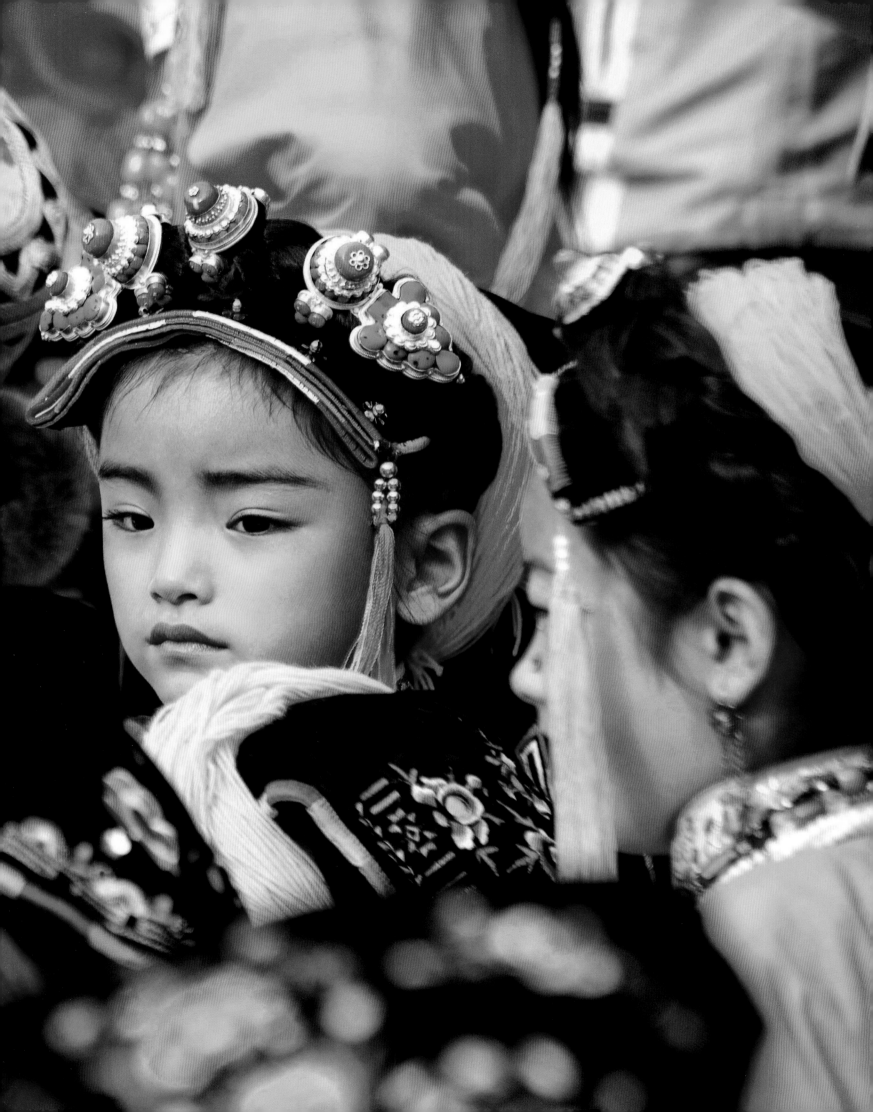

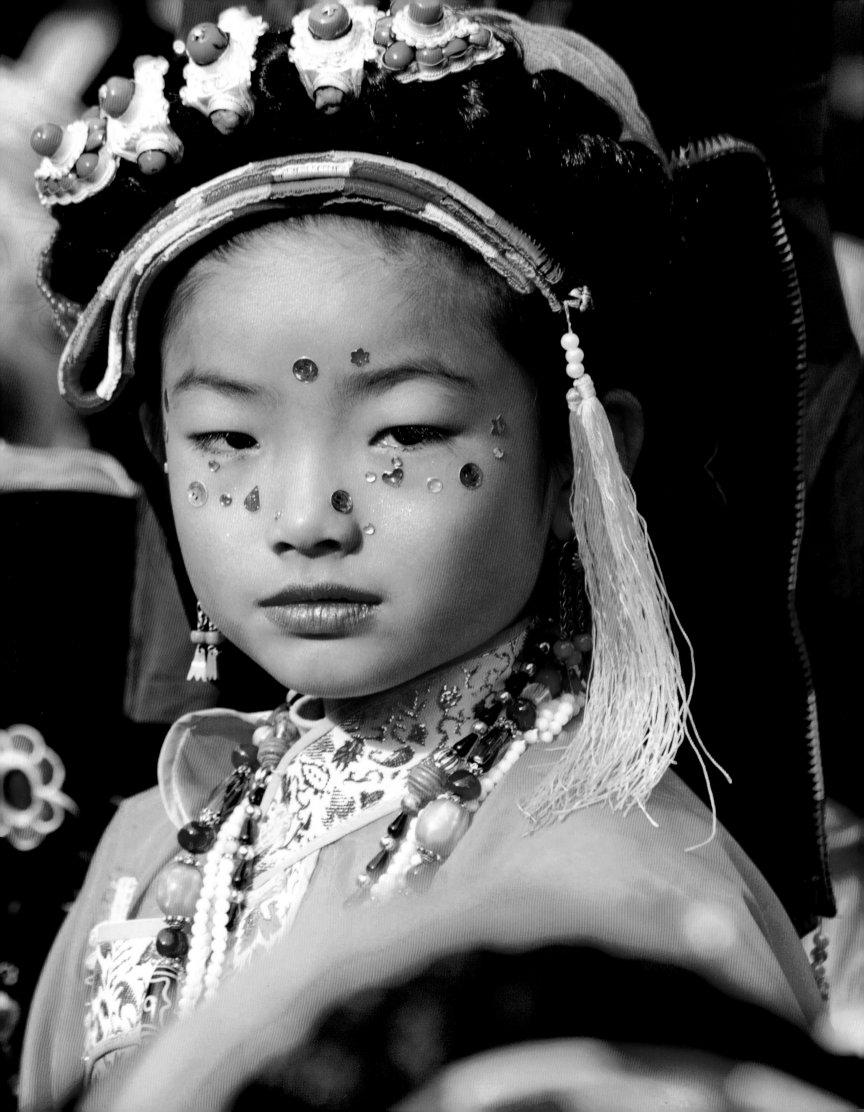

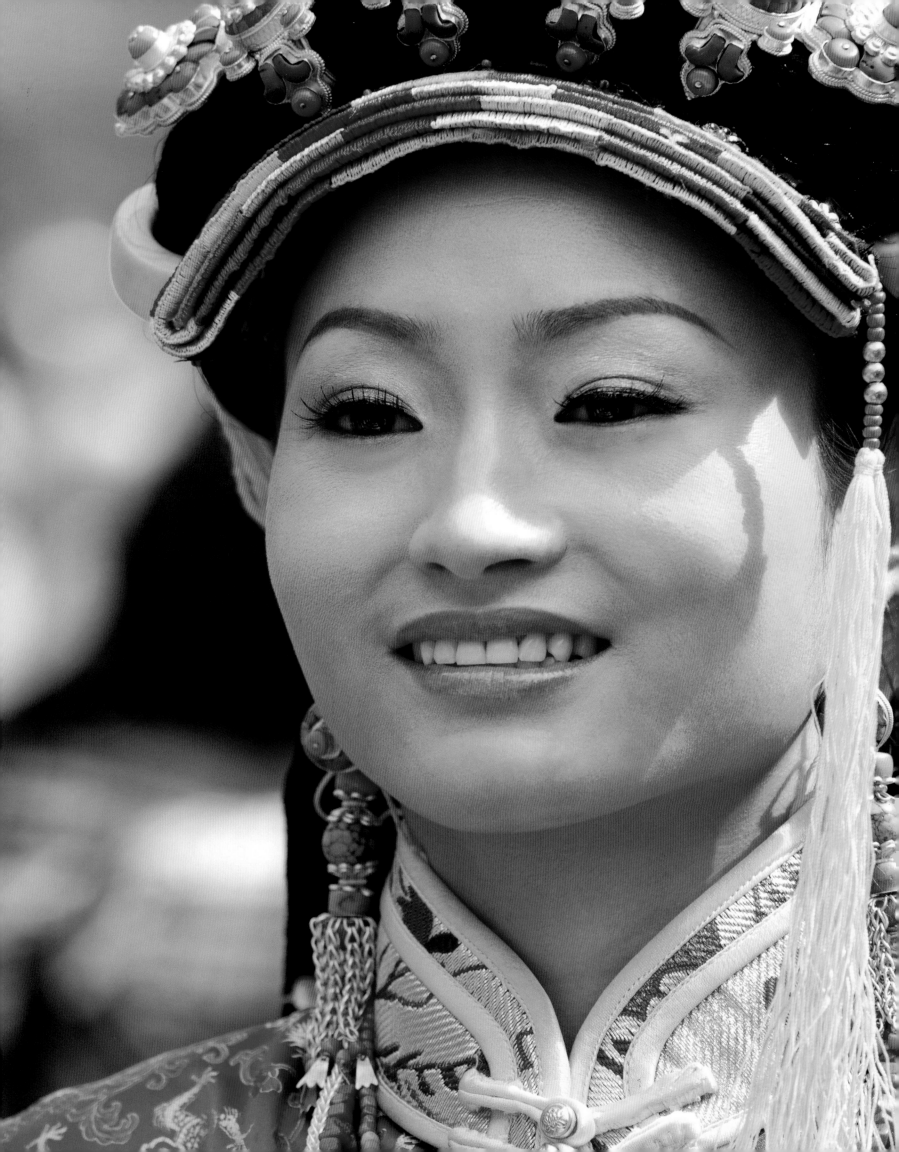

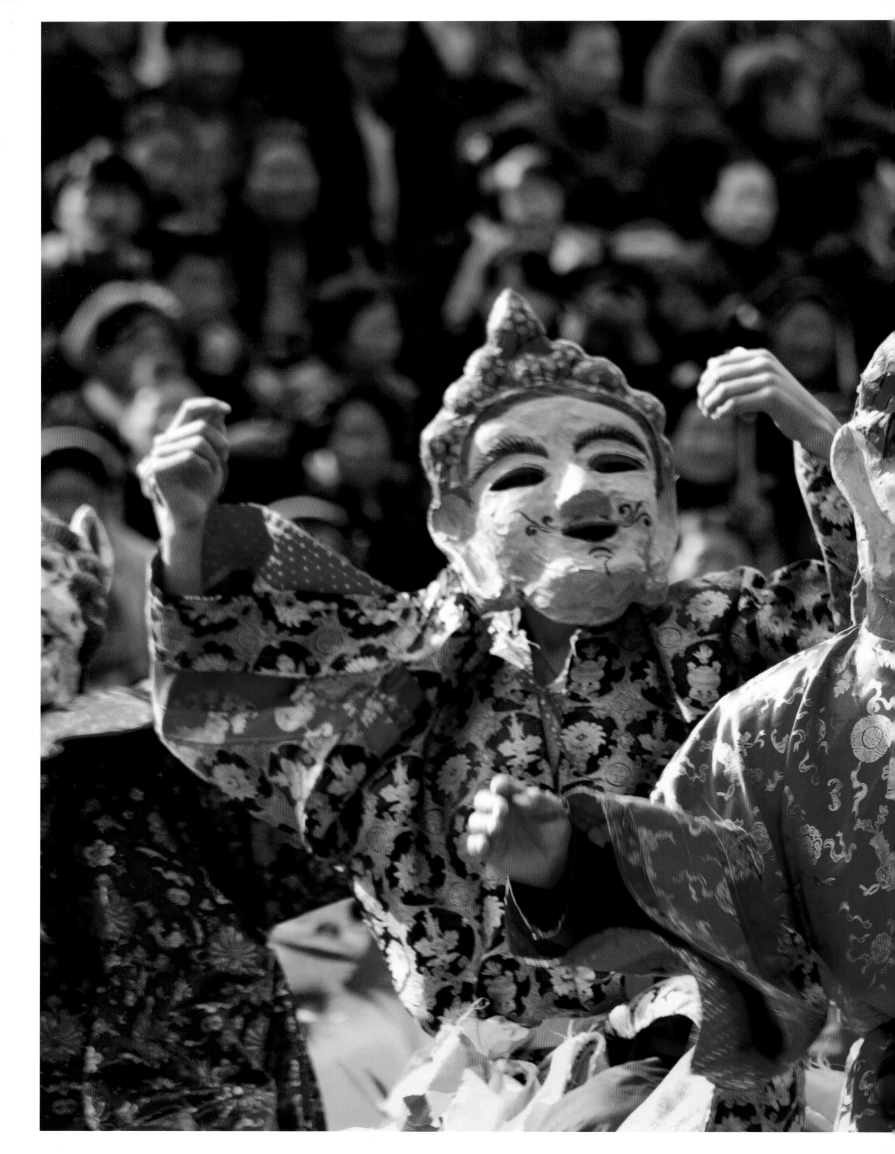

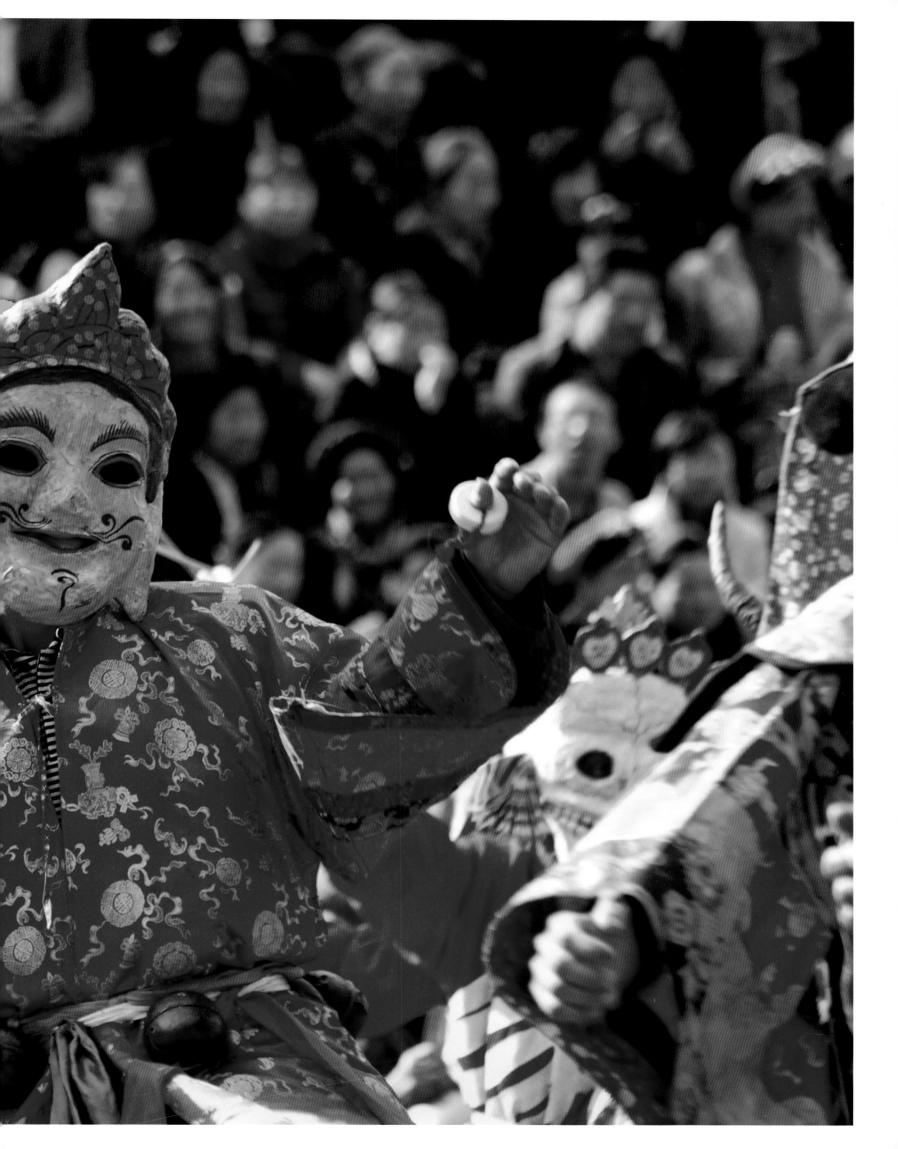

ZHOUZHUANG
THE VENICE OF CHINA

周庄

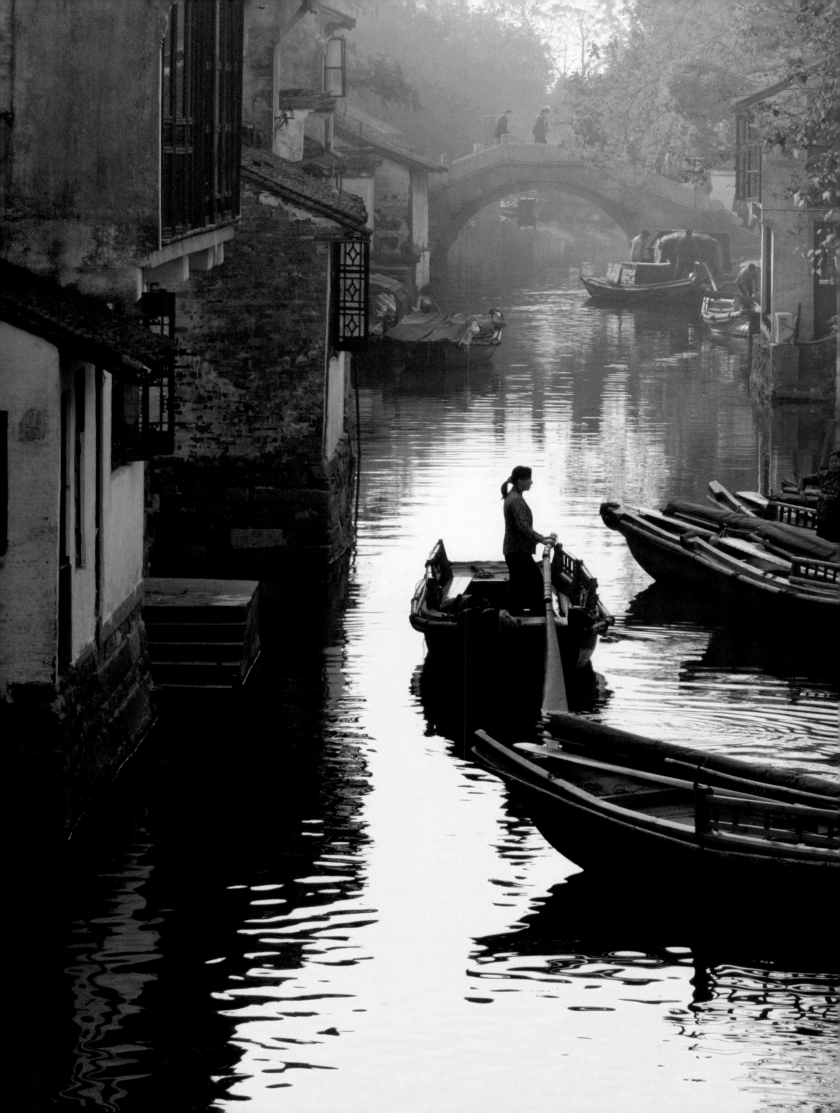

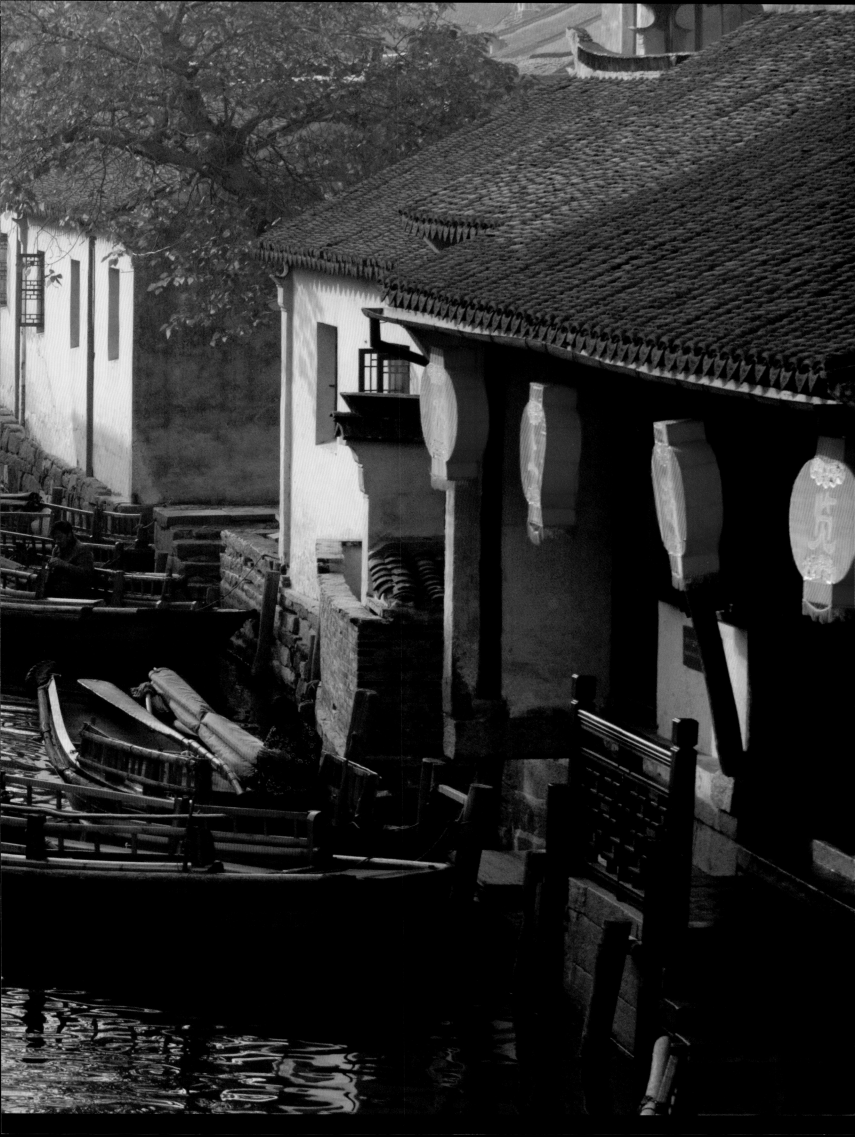

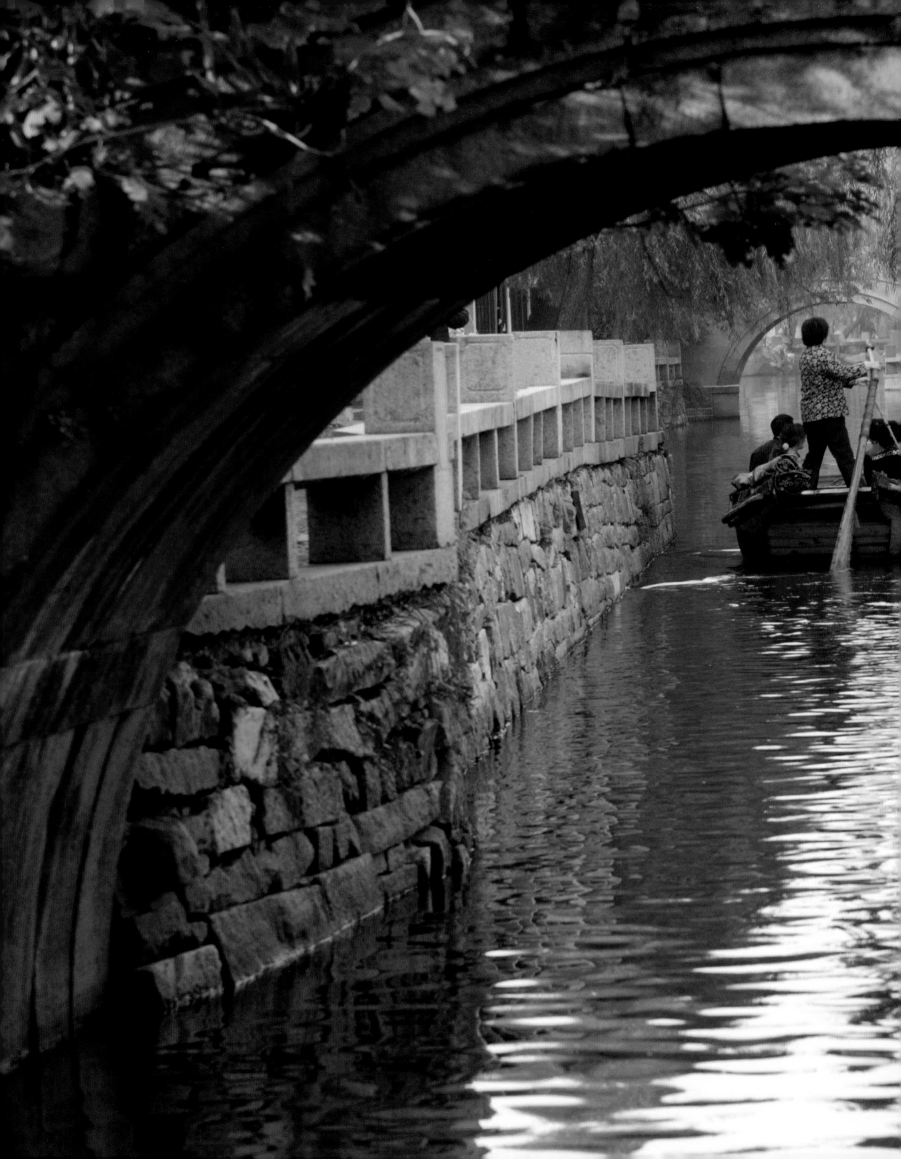

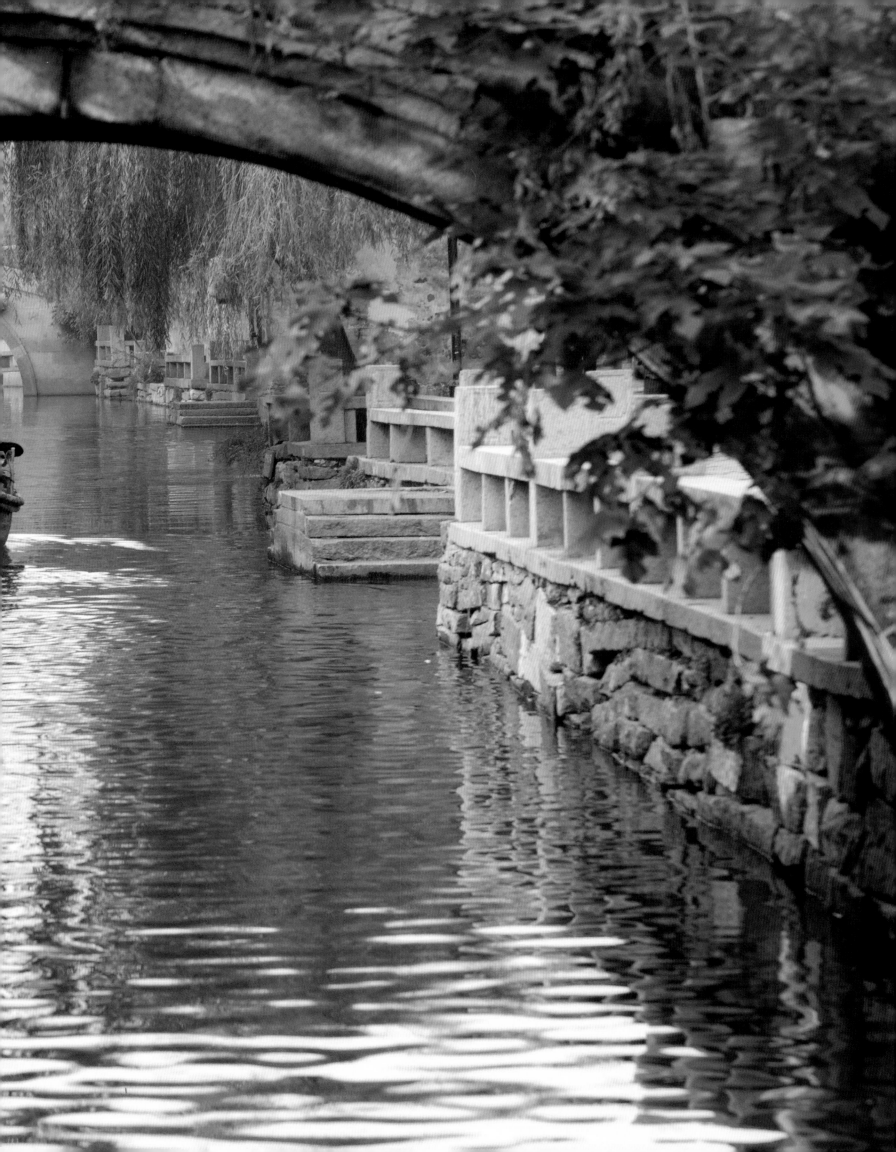

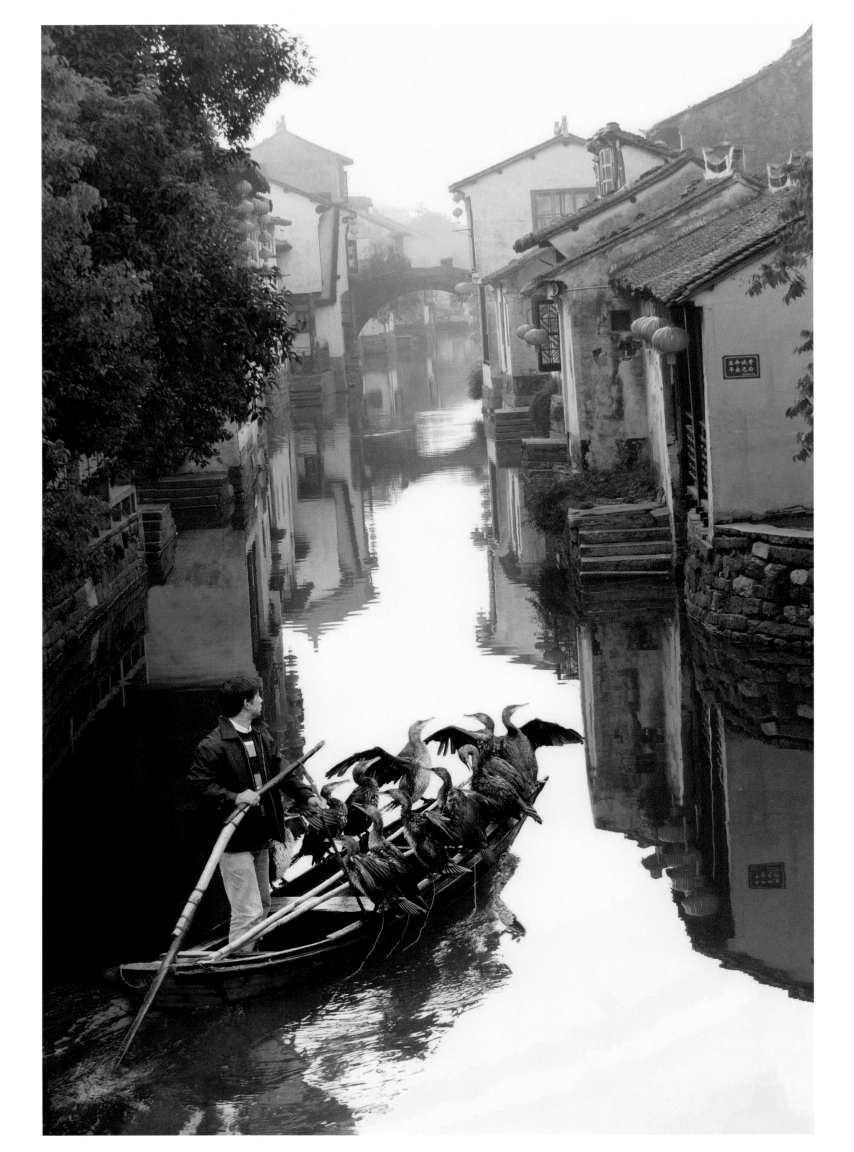

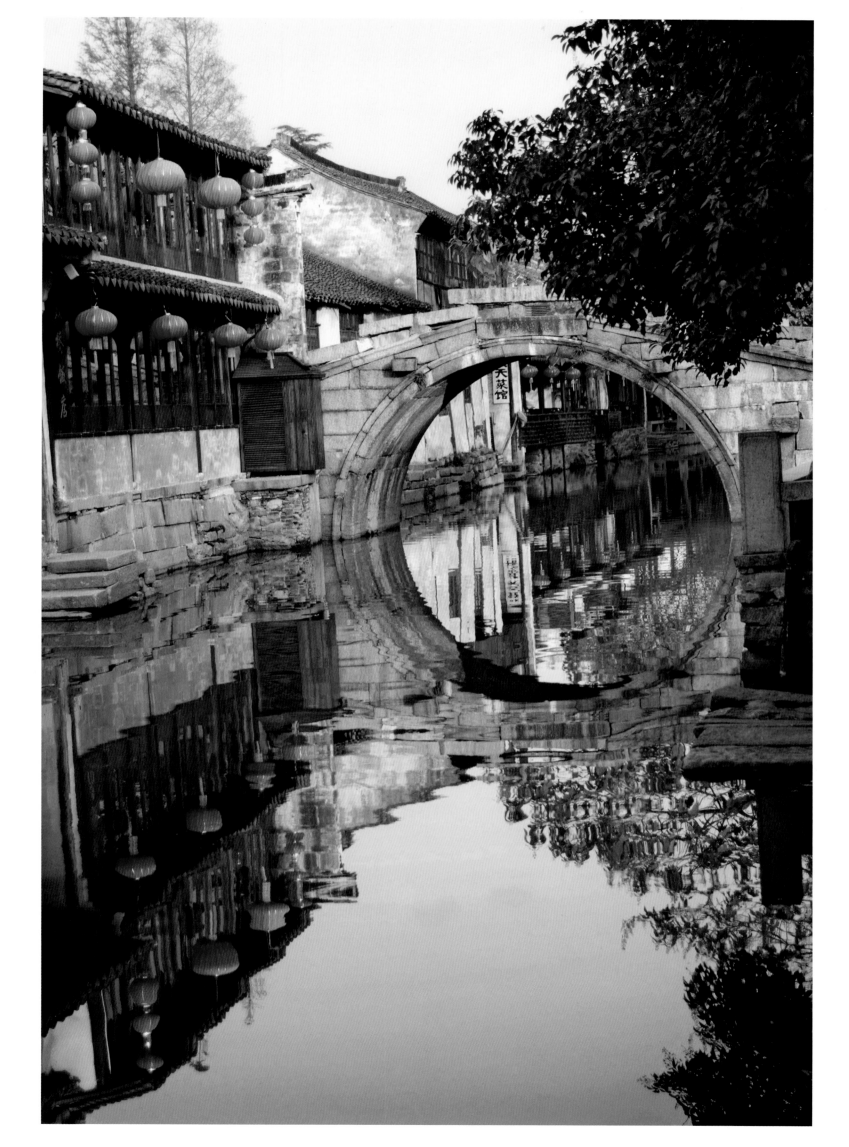

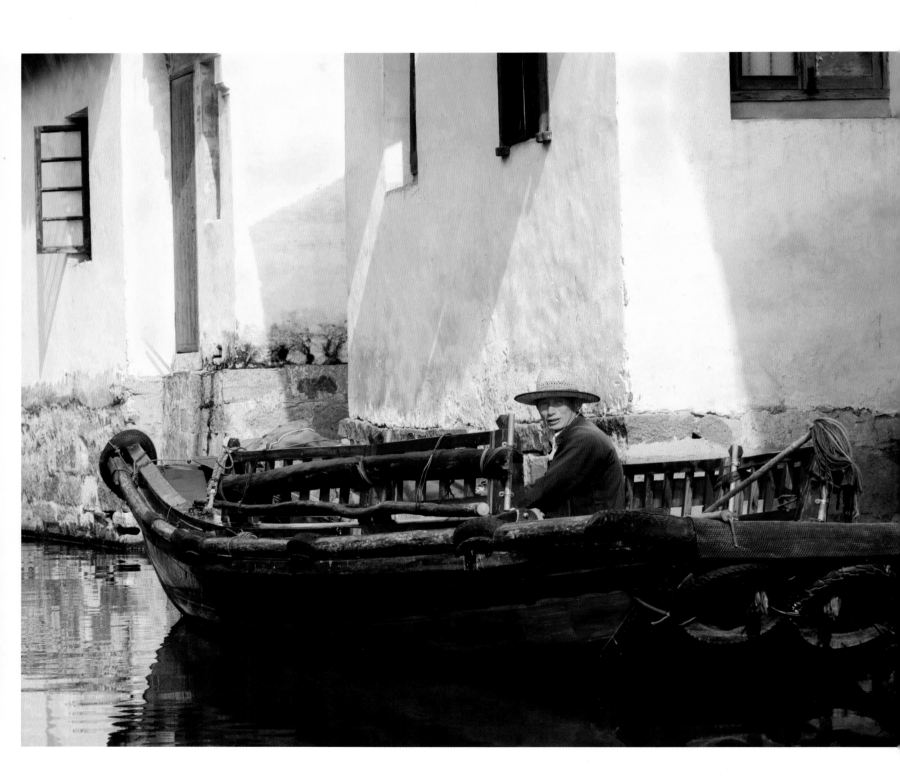

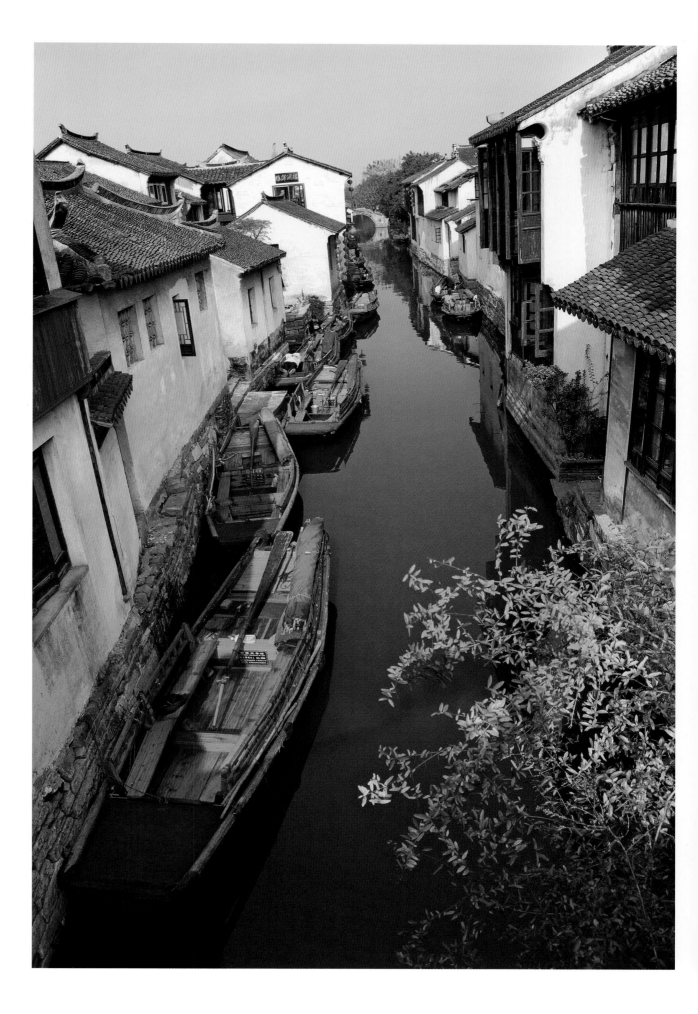

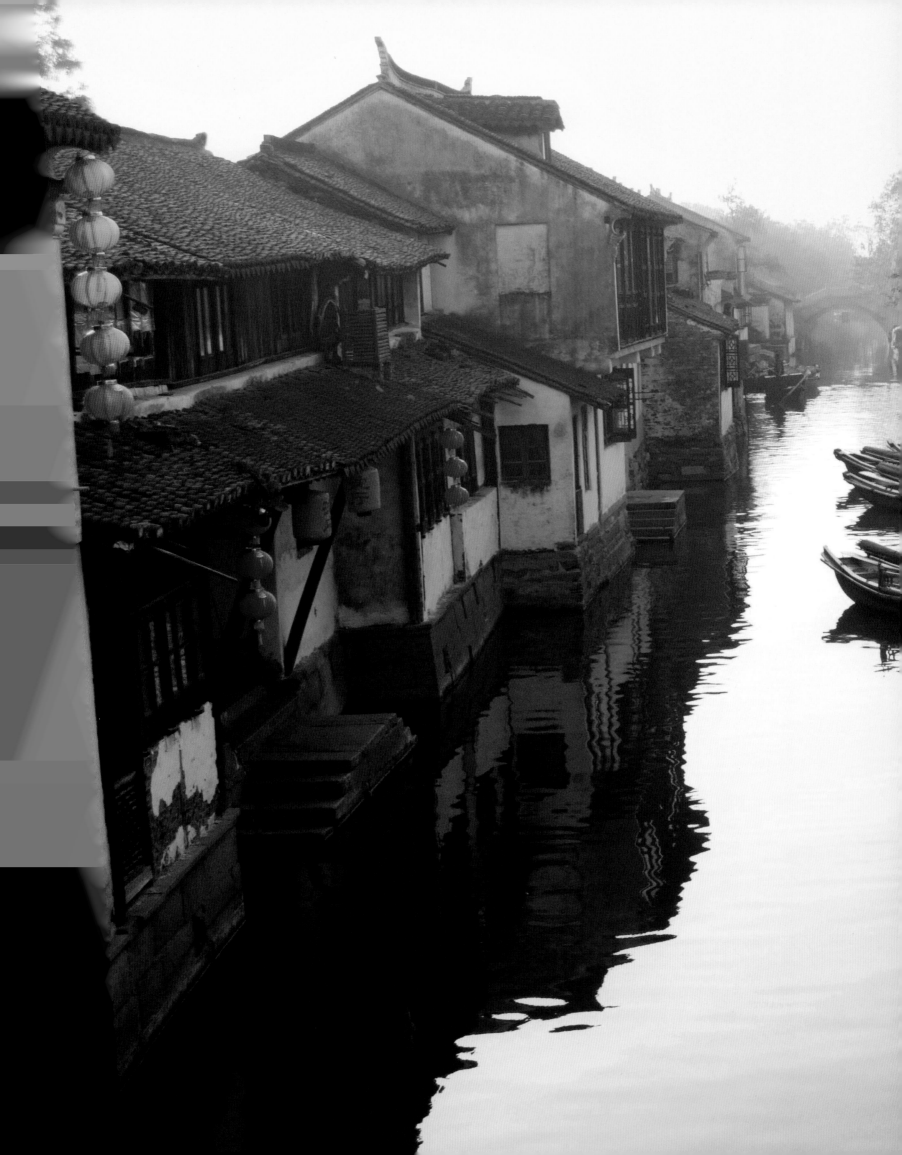

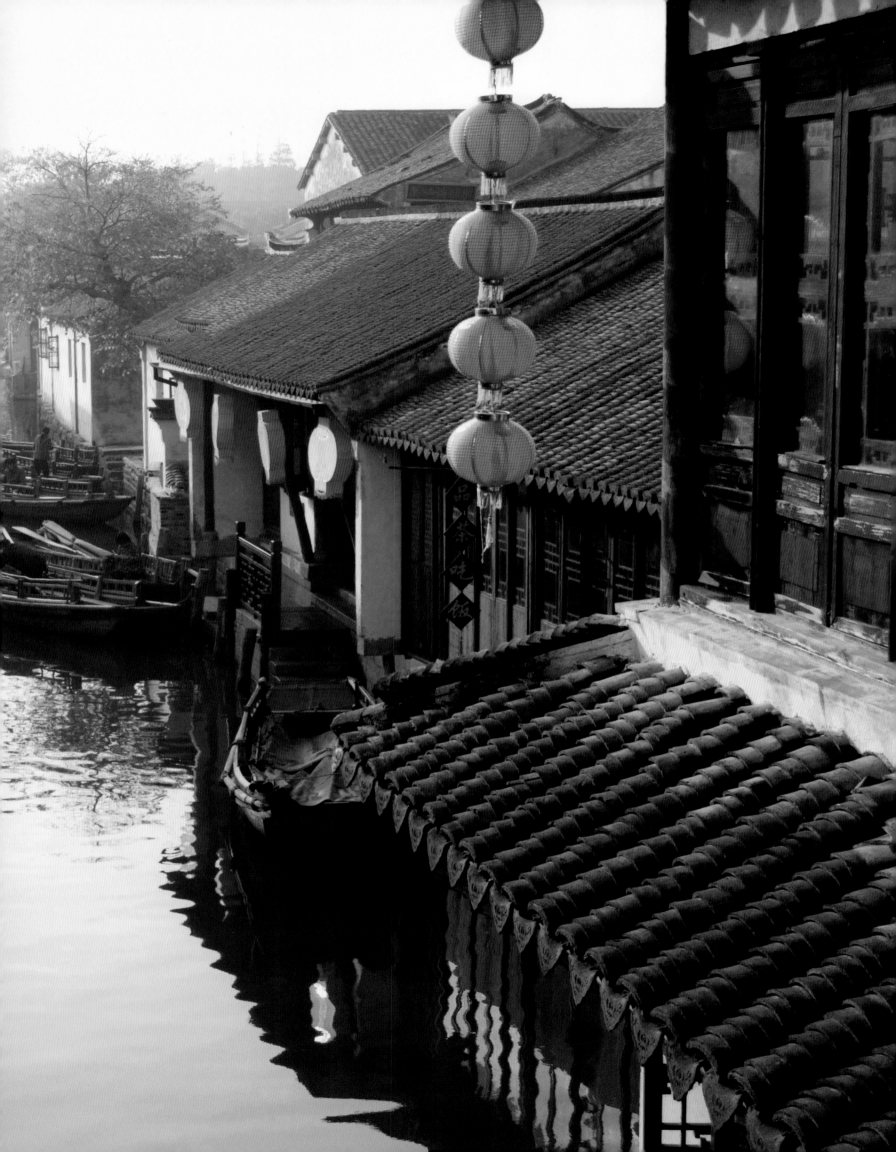

TIBET

西藏

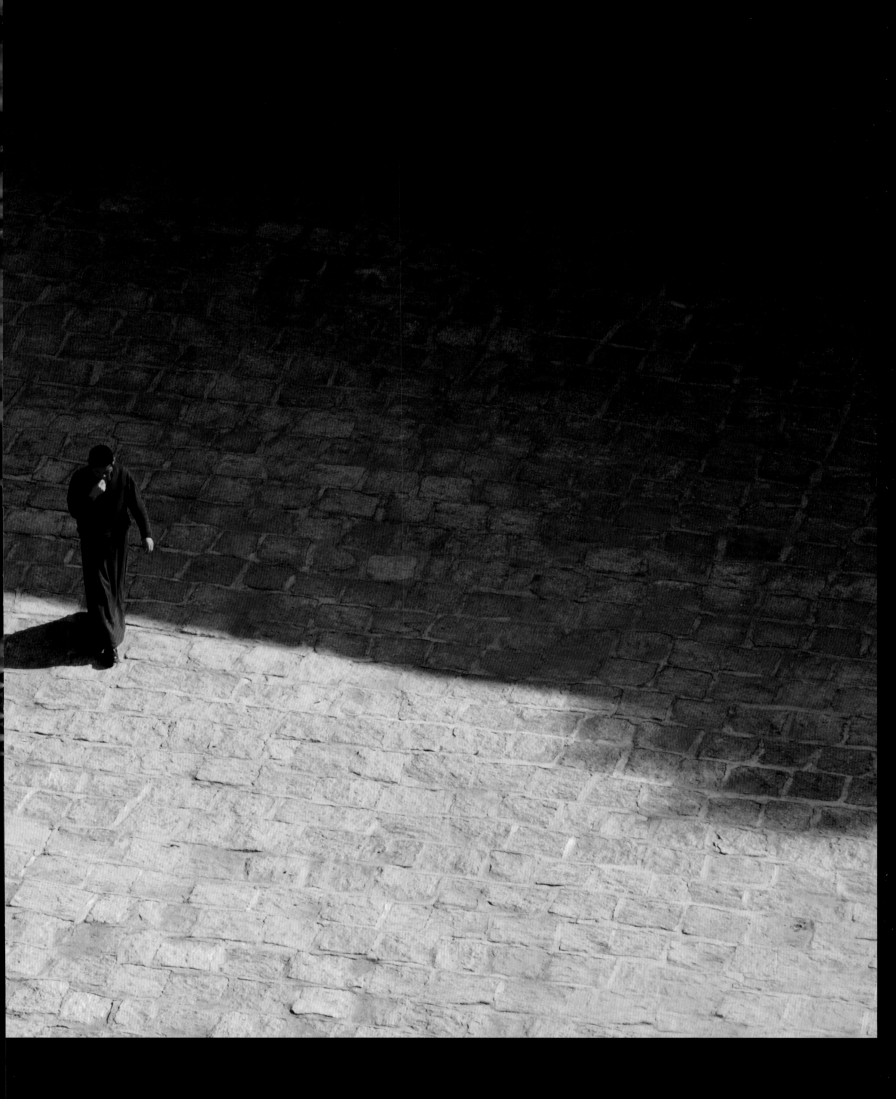

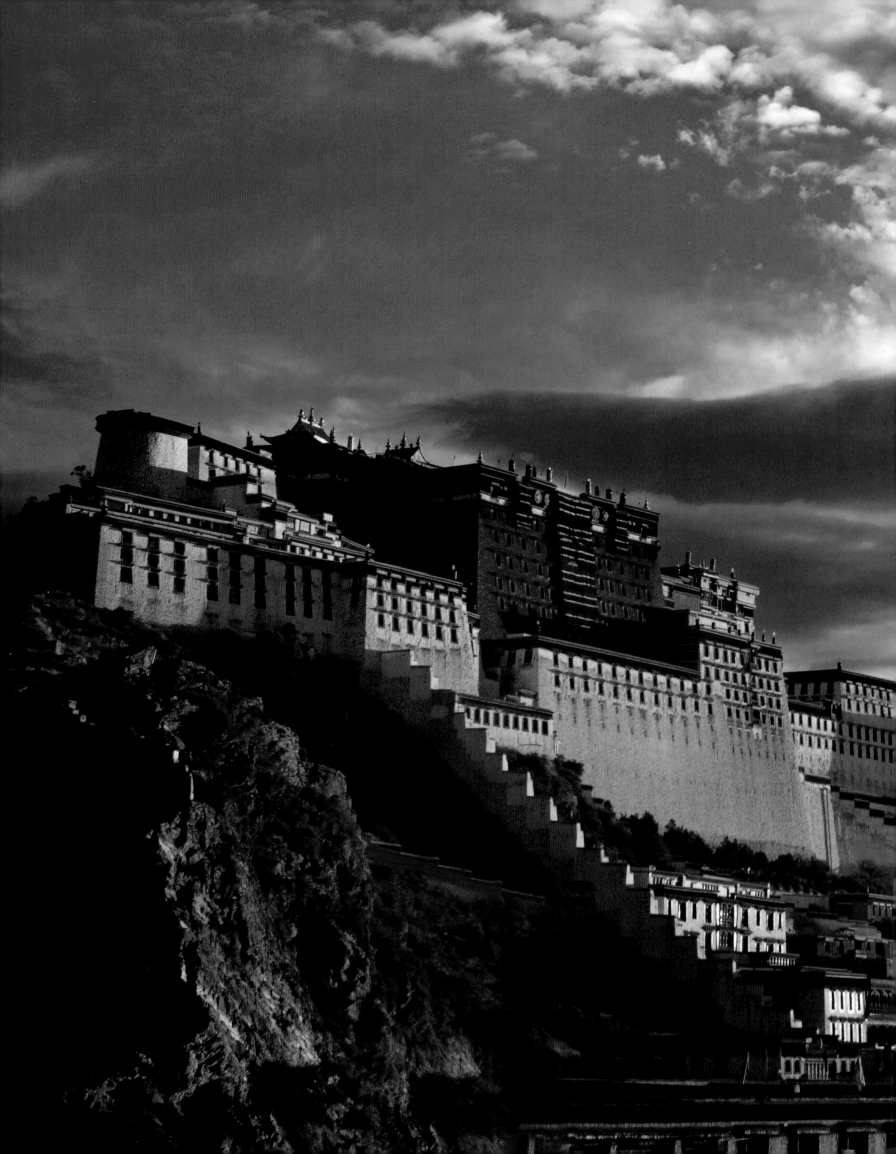

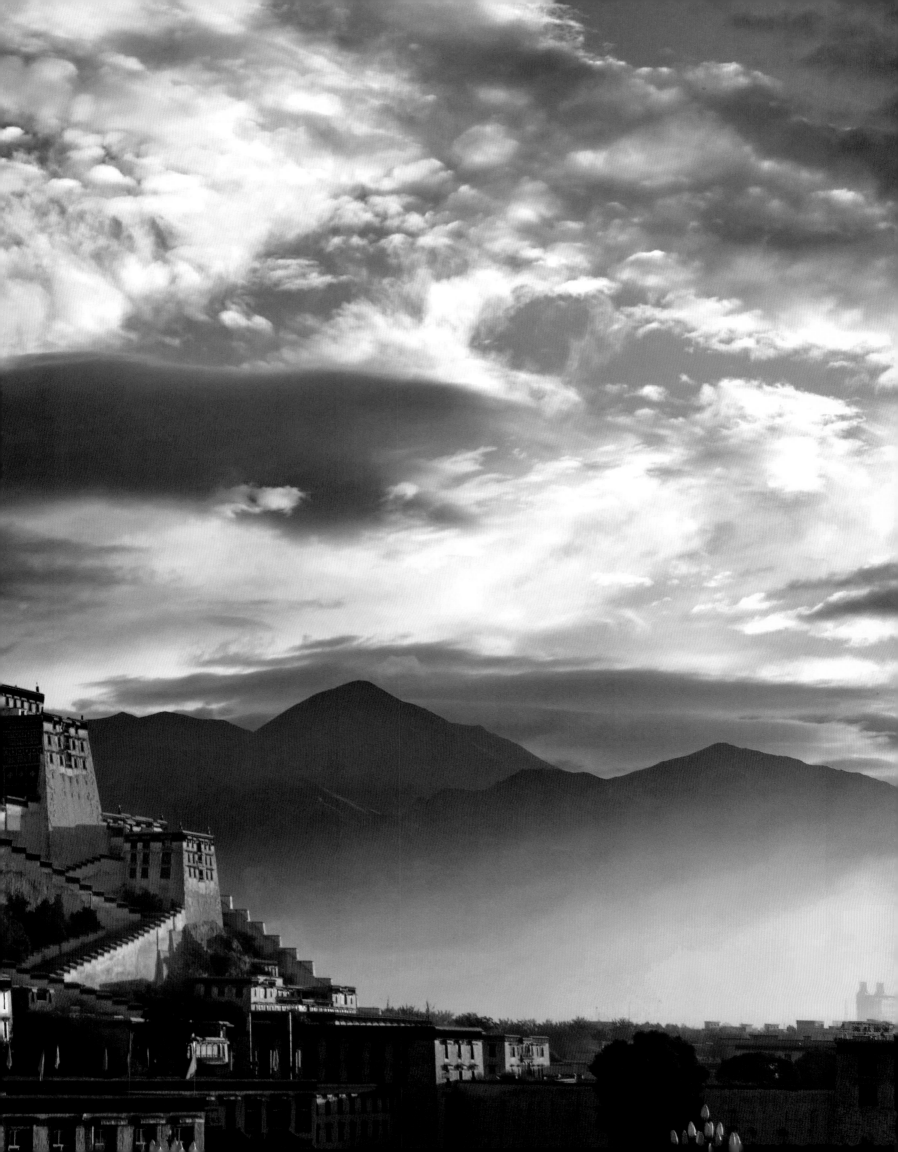

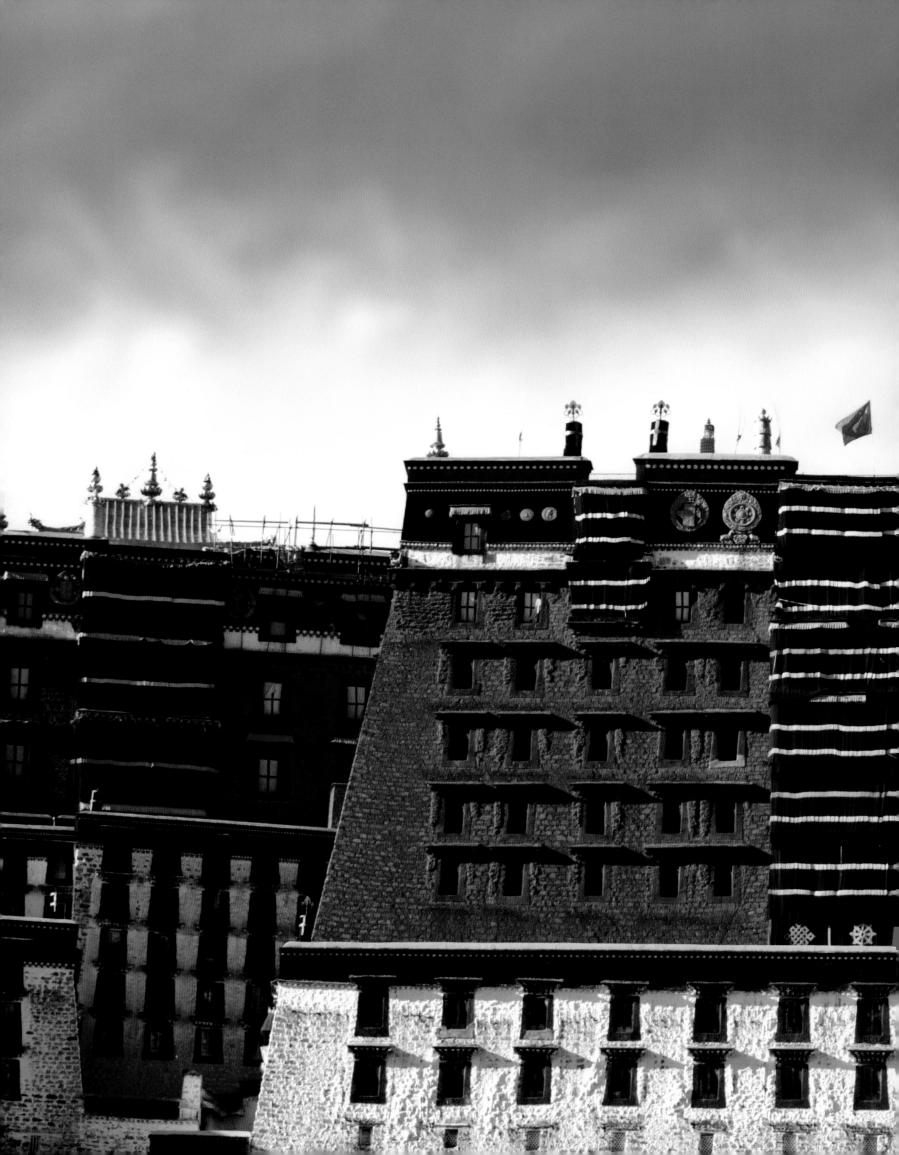

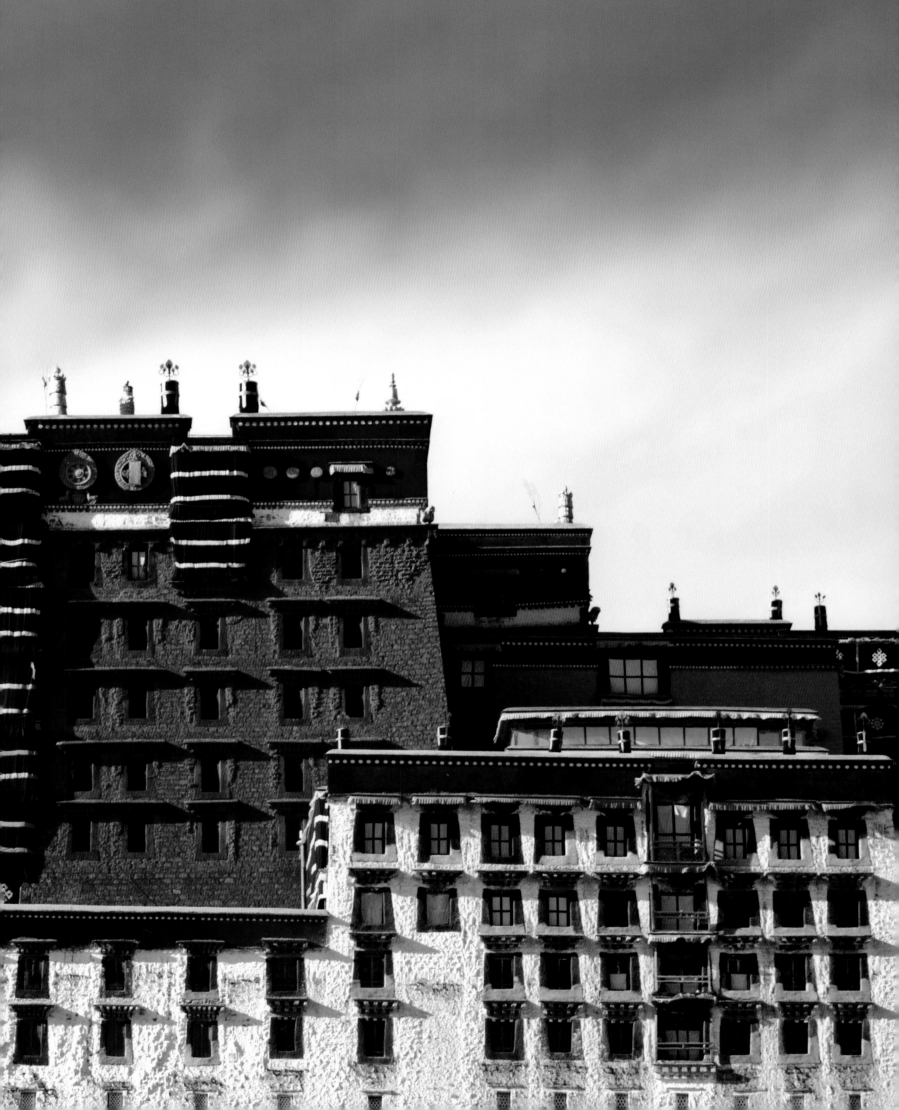

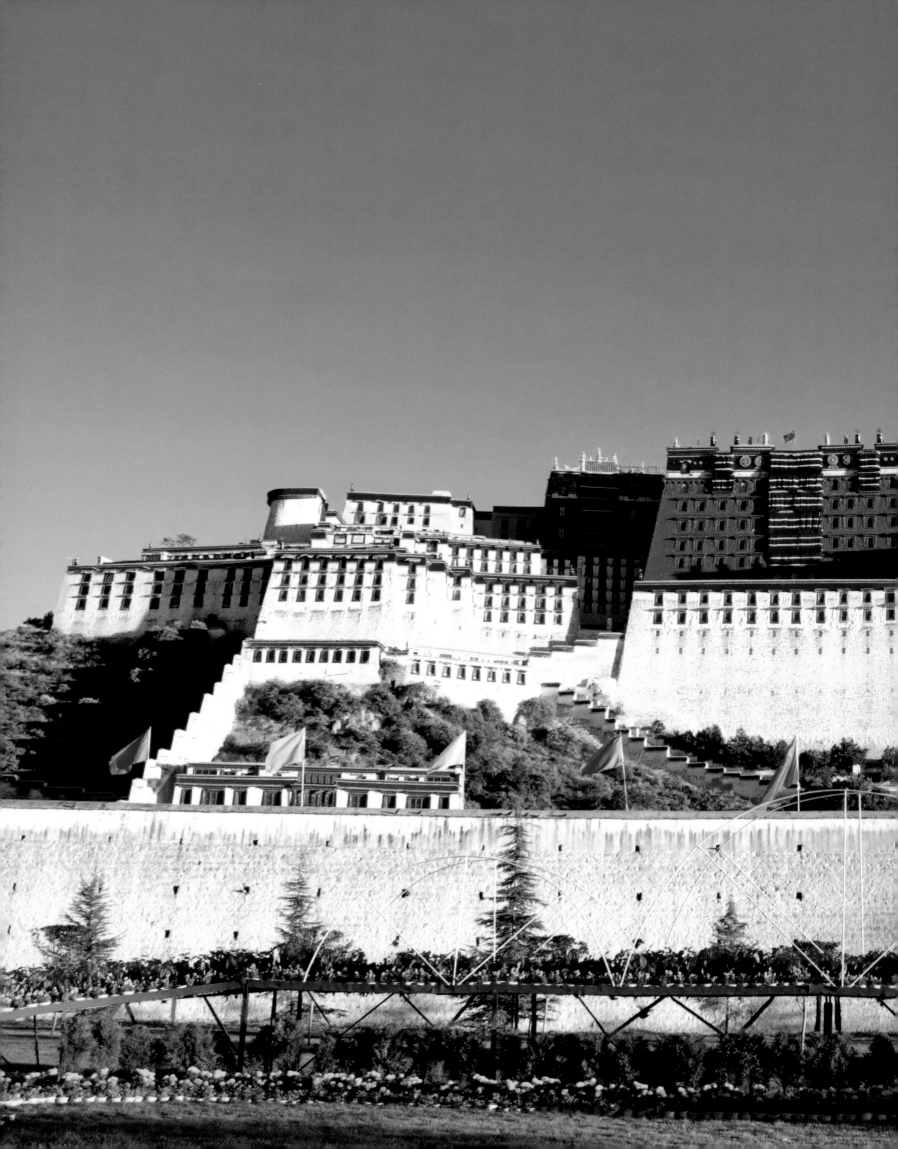

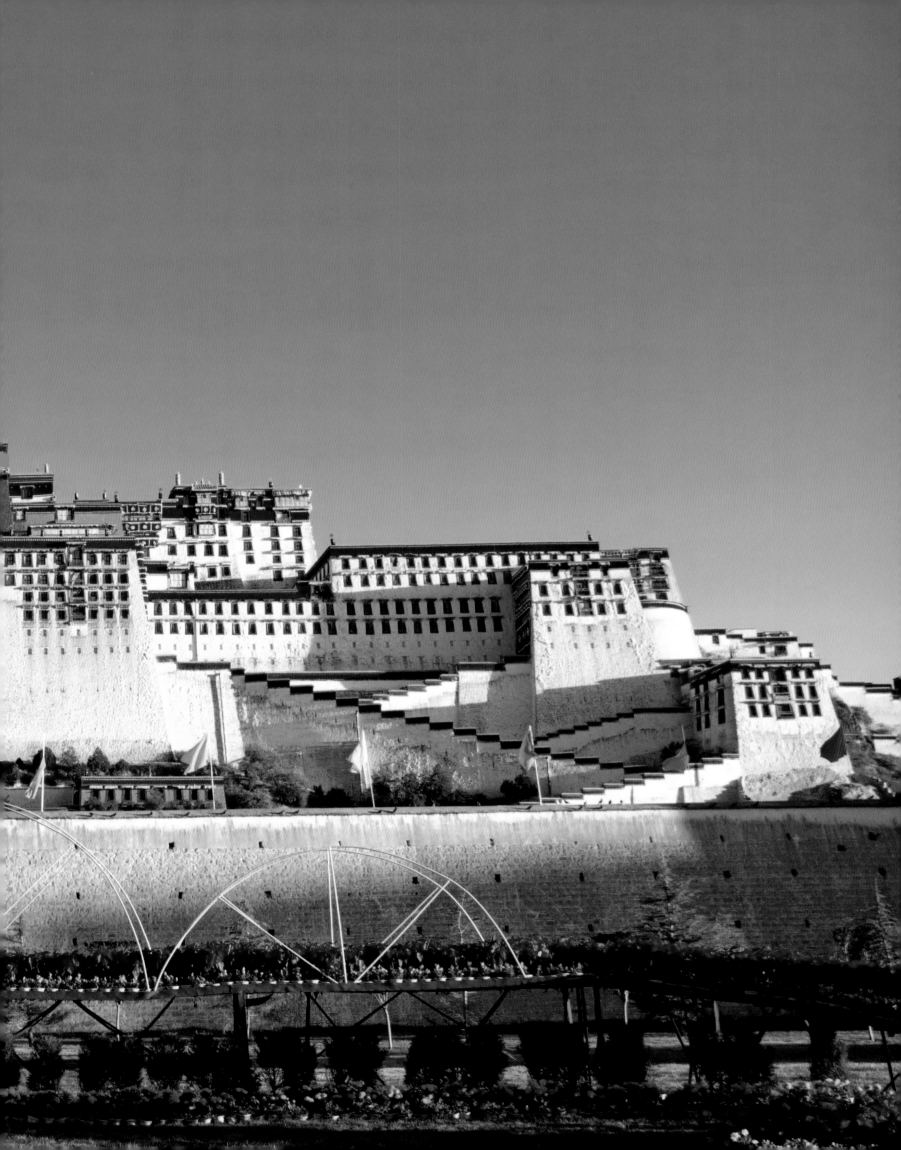

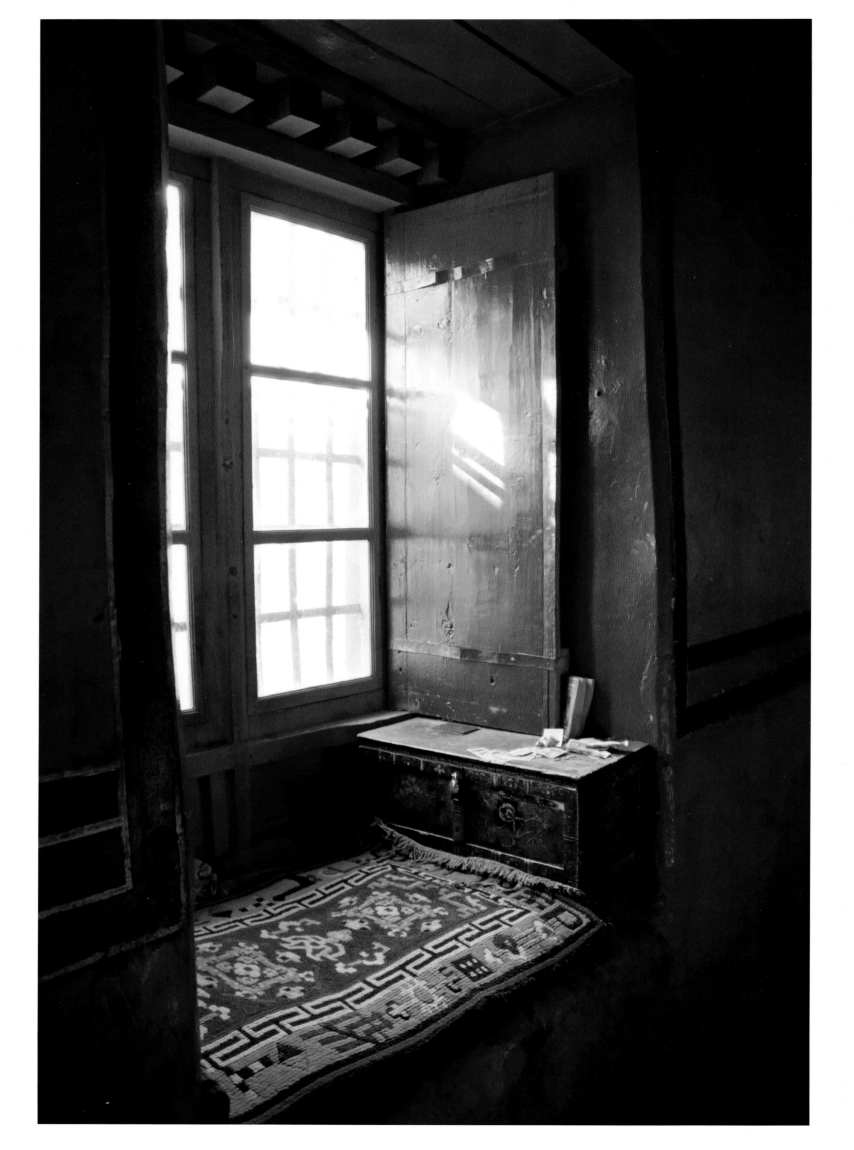

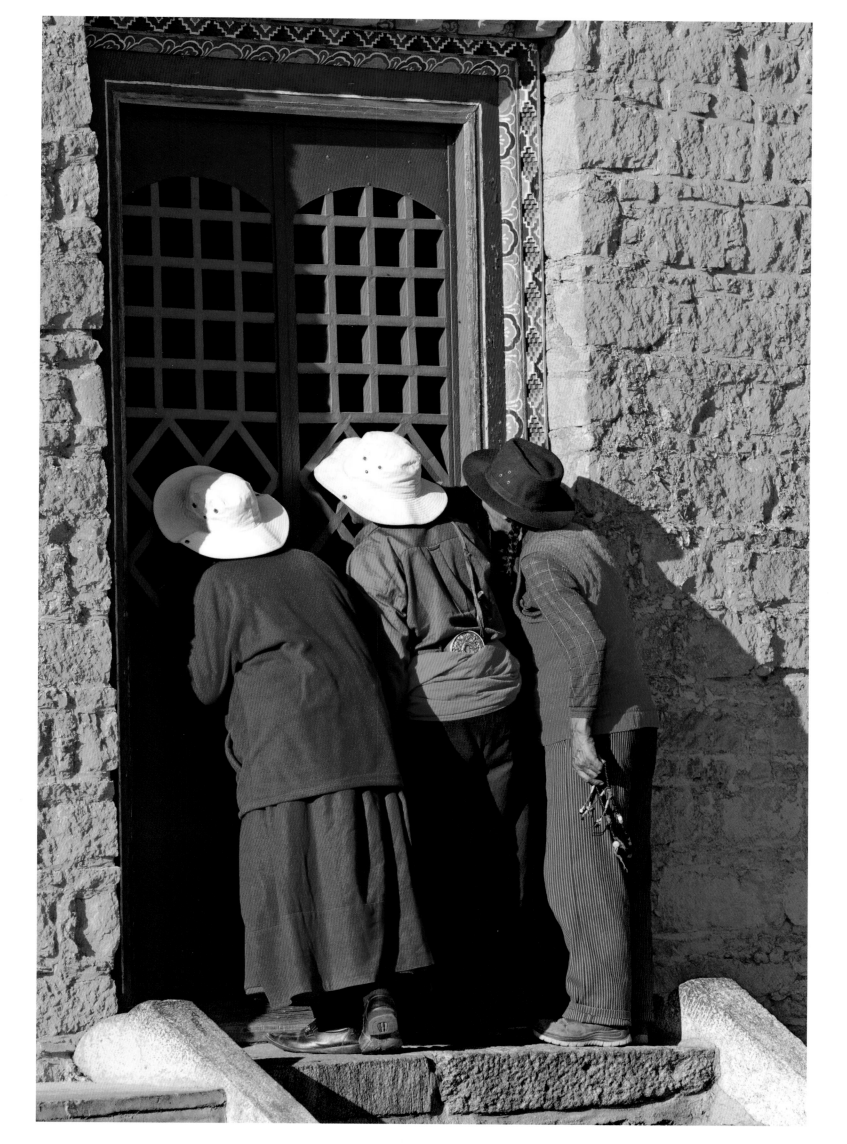

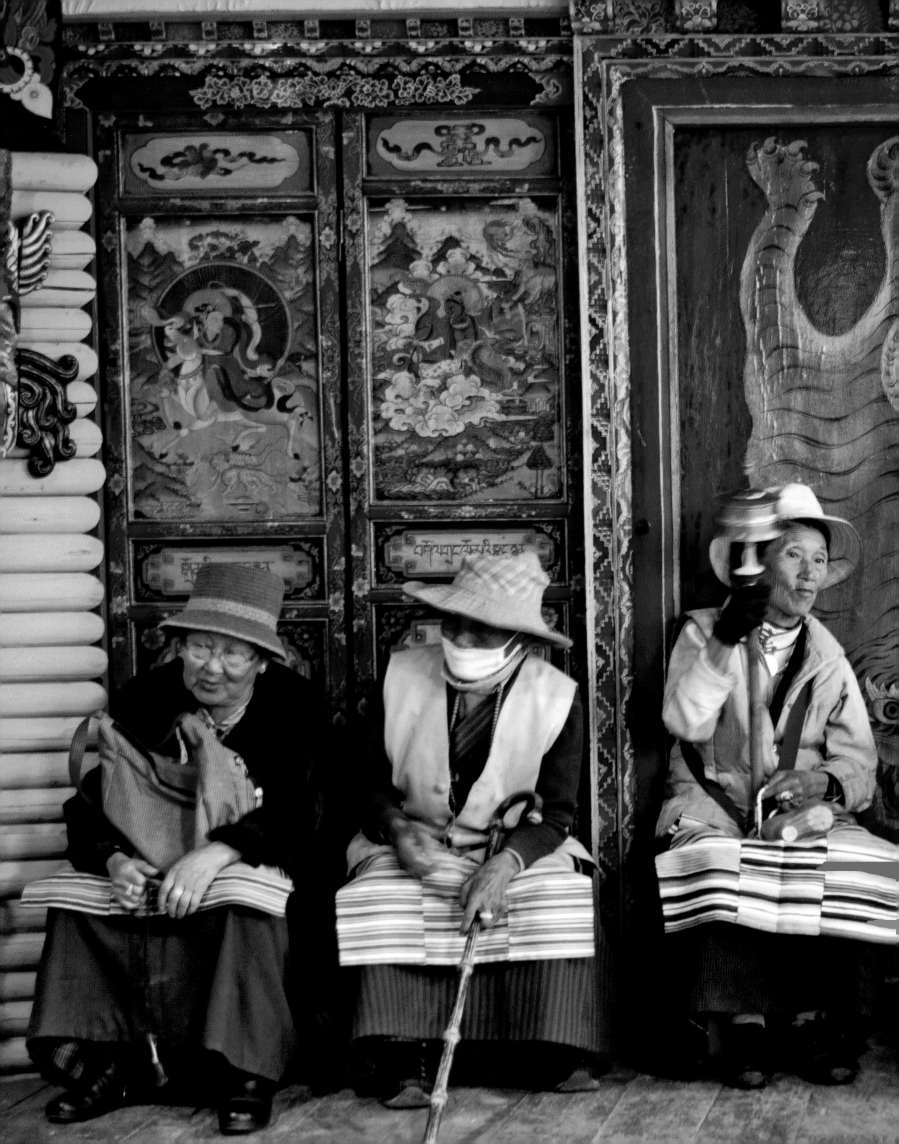

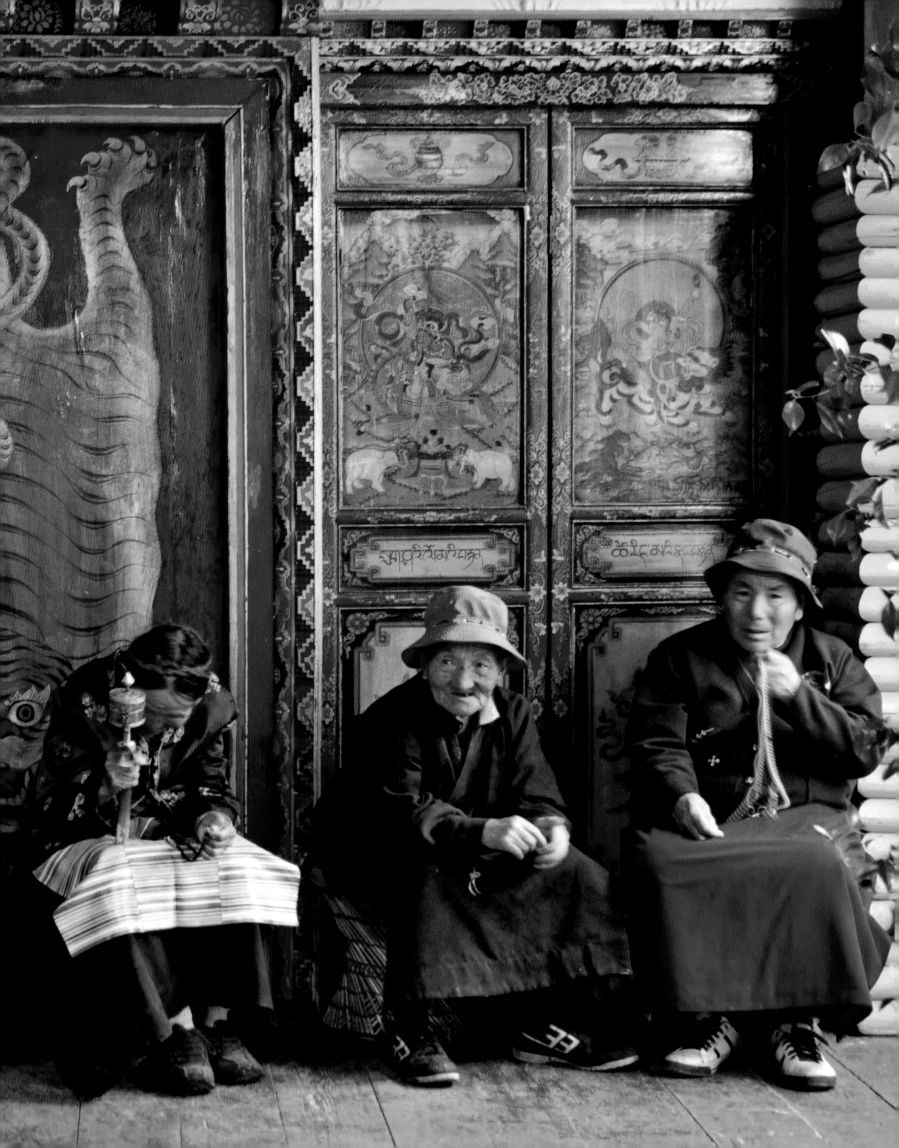

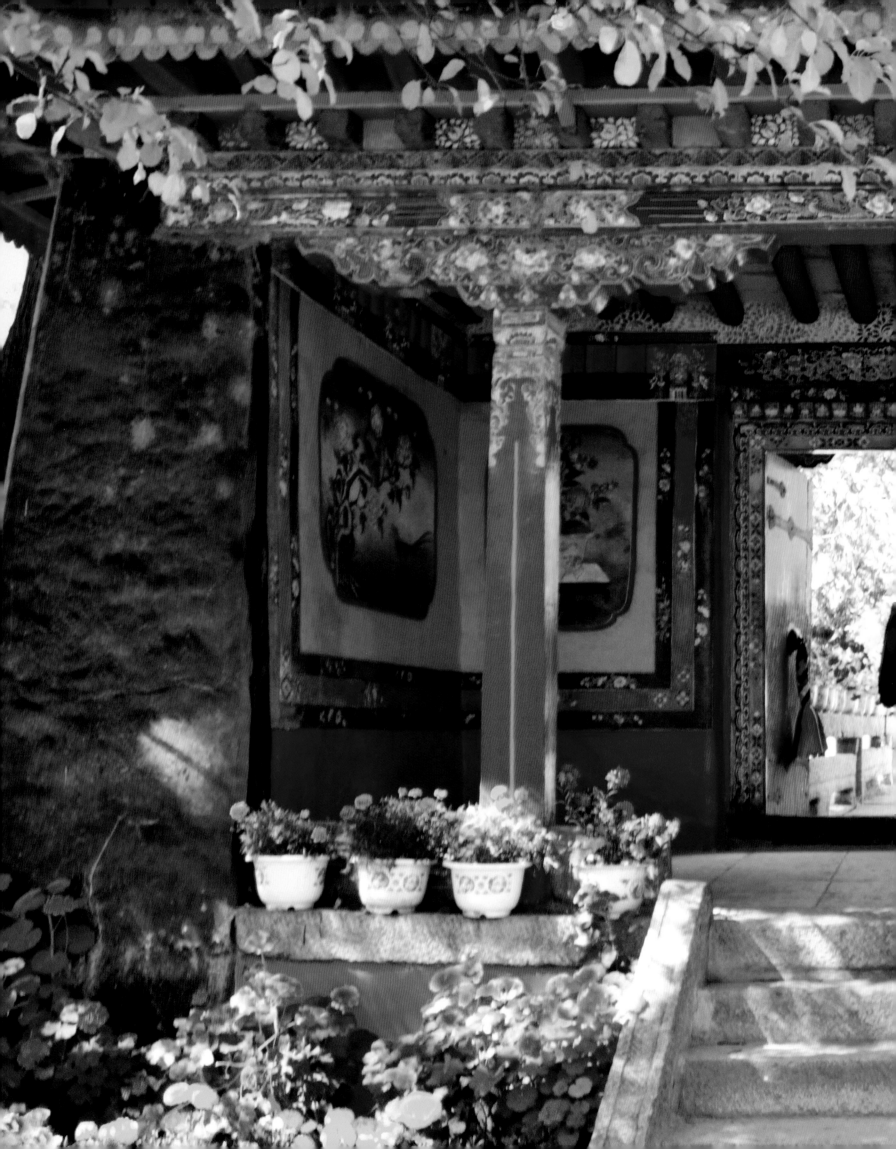

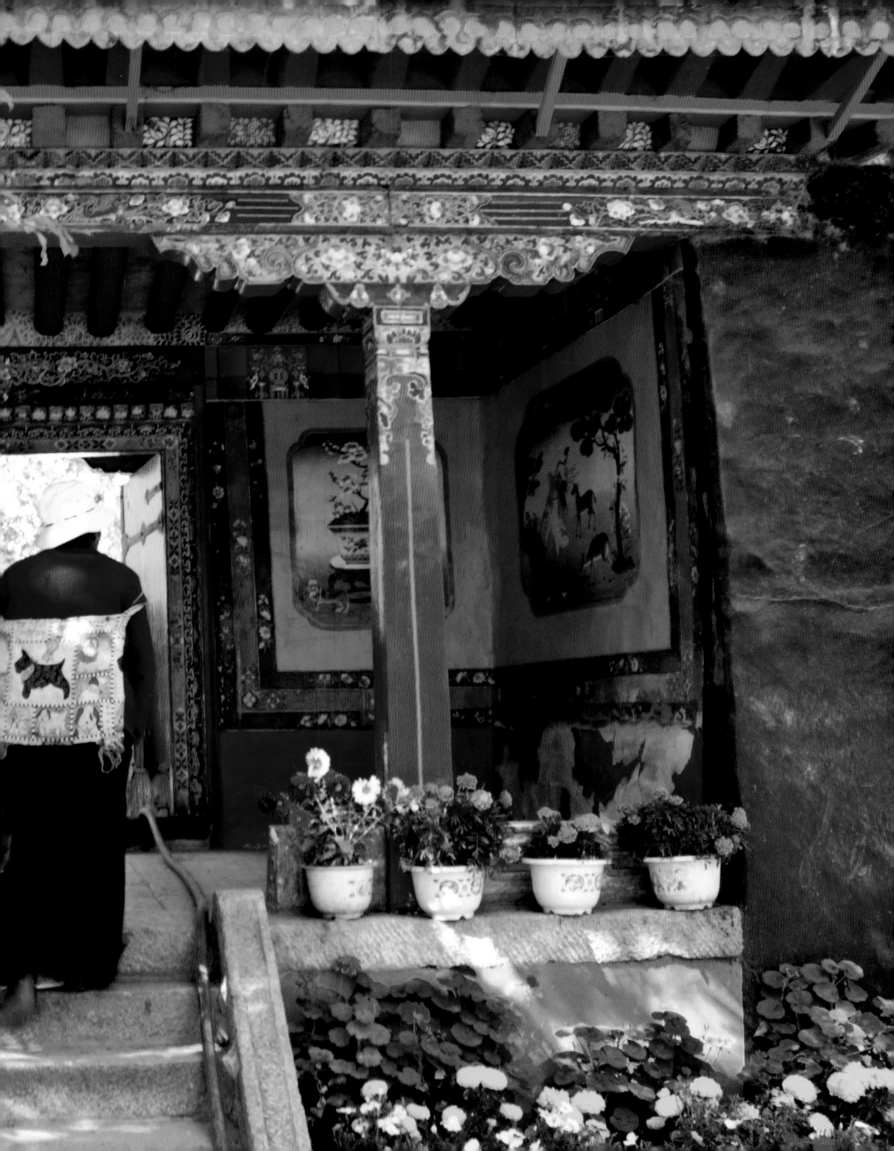

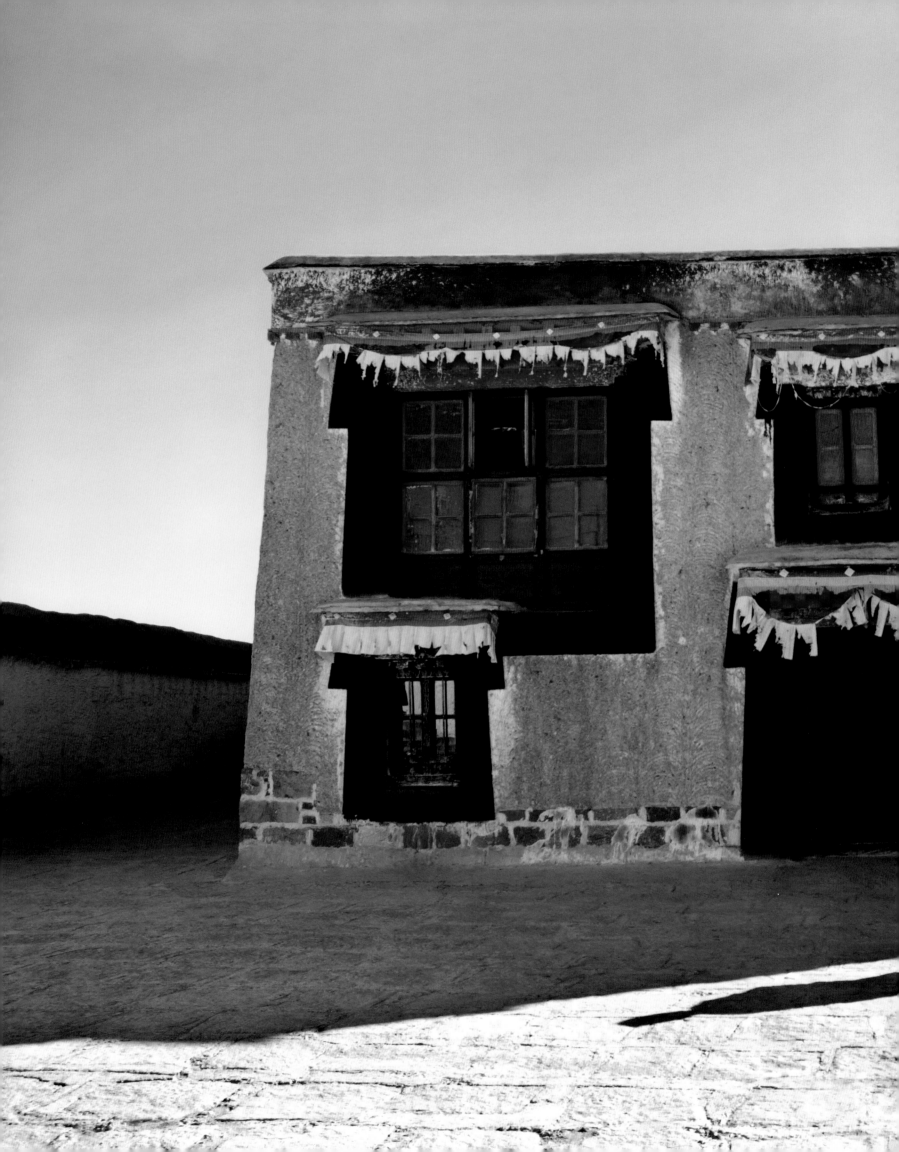

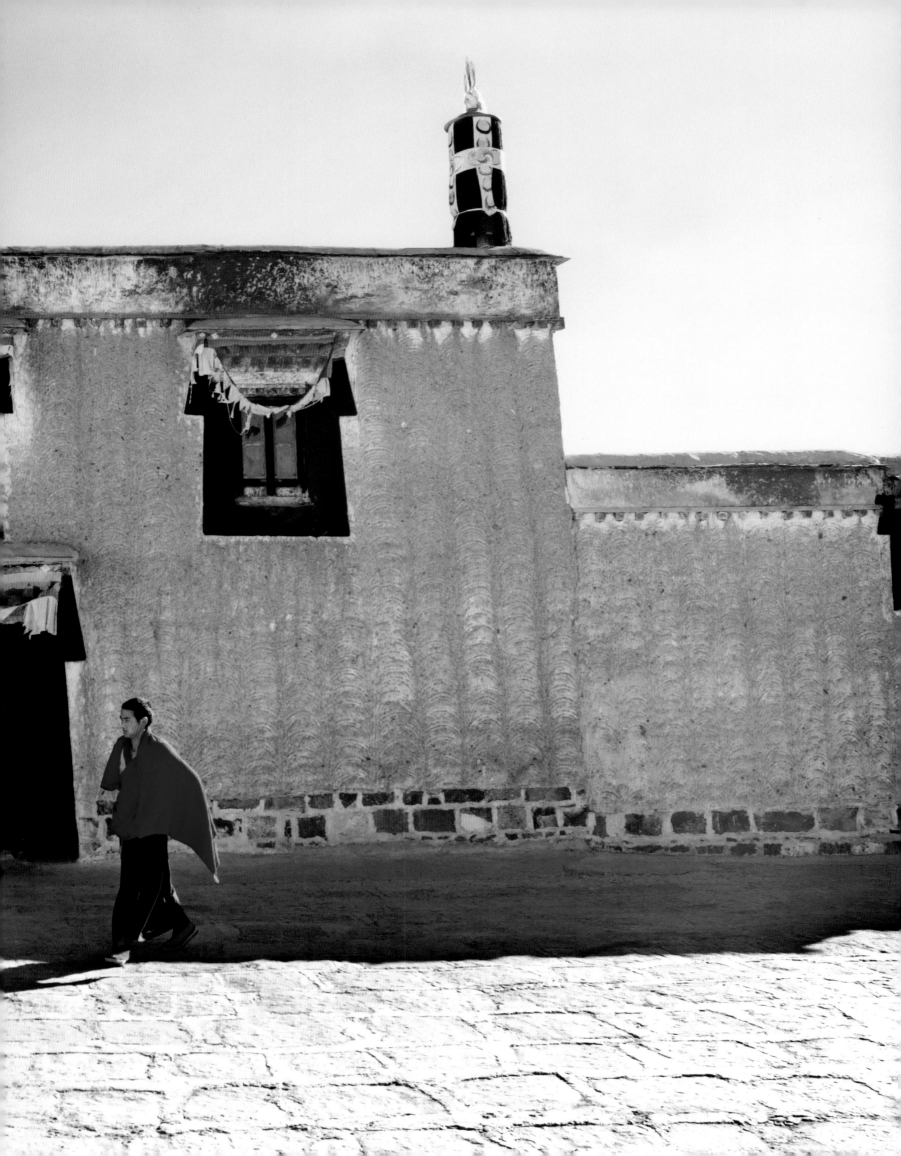

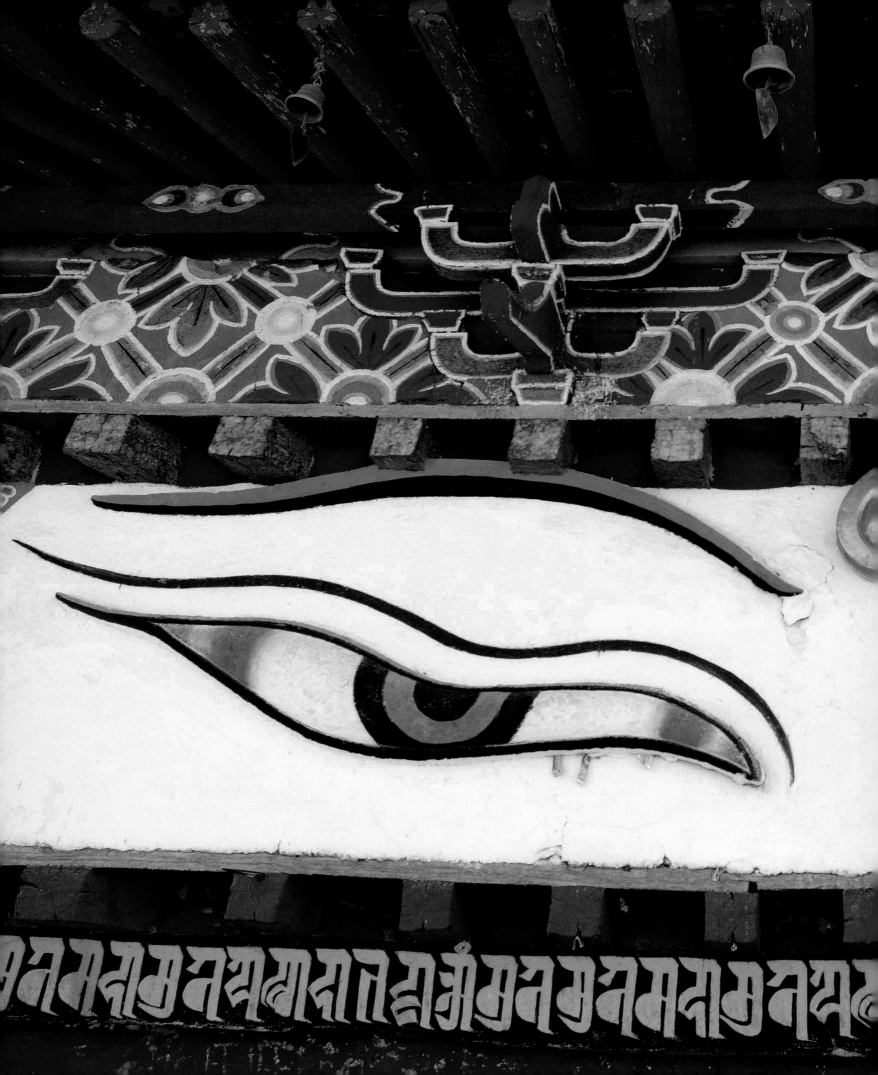

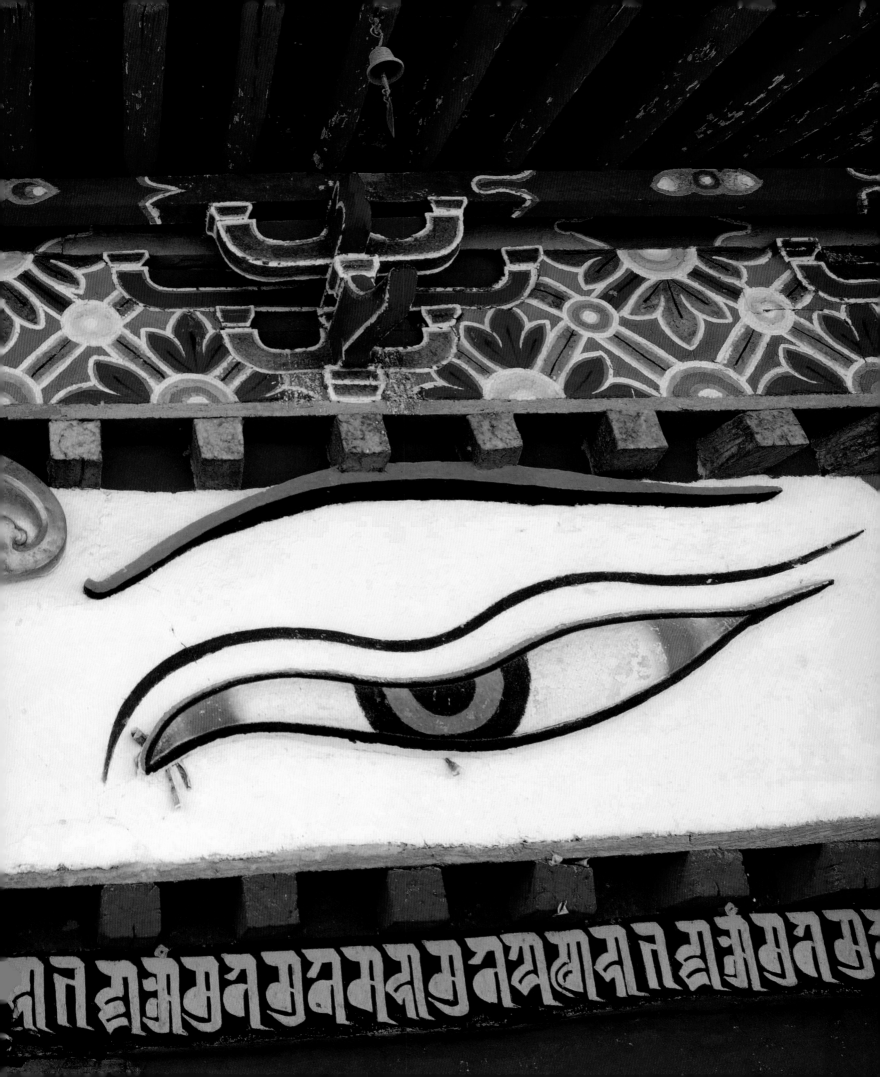

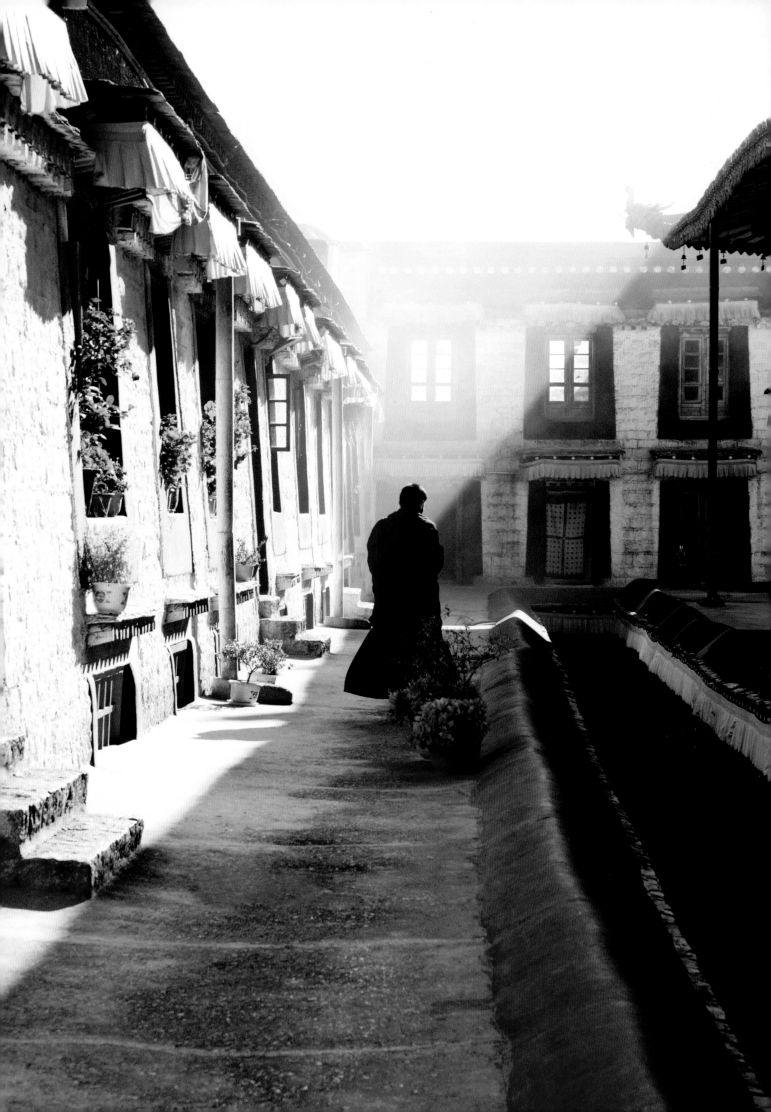

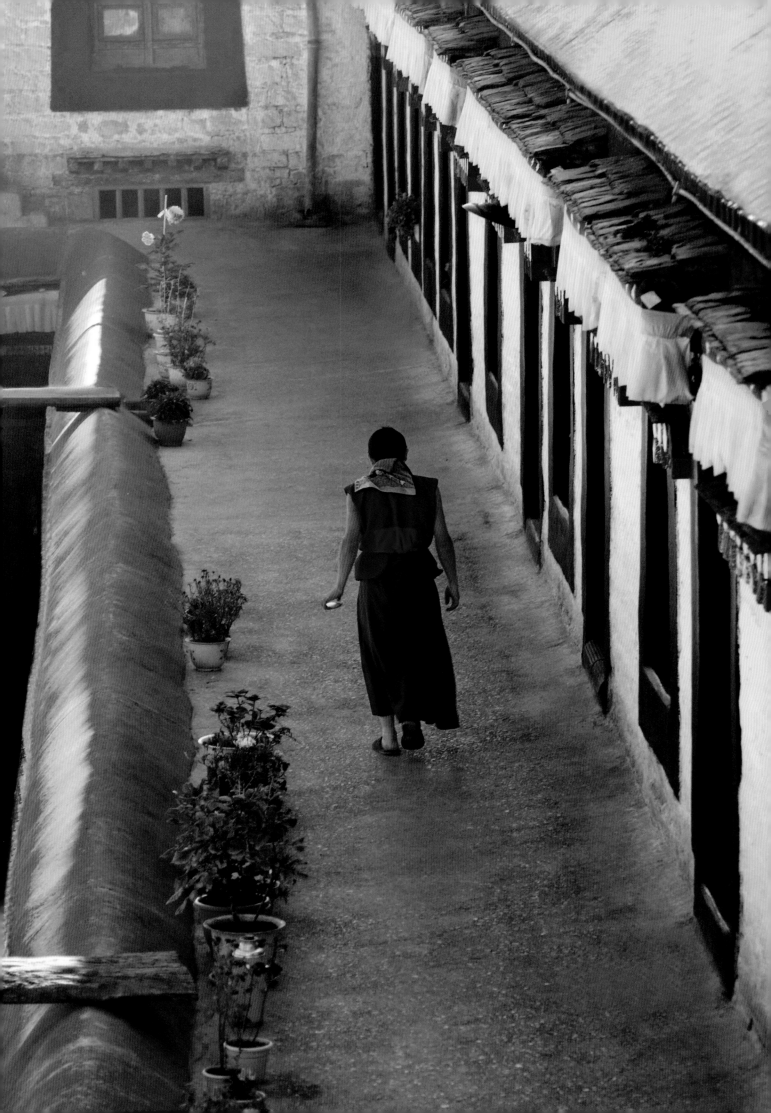

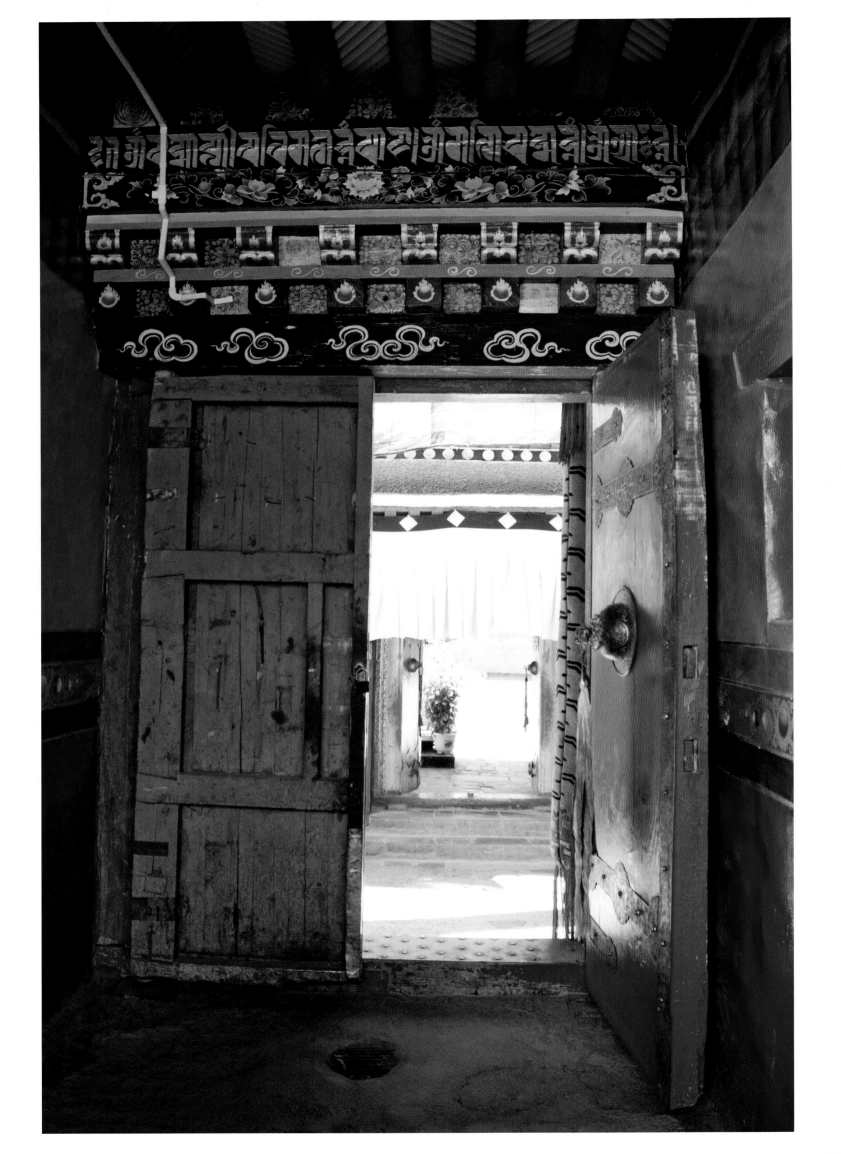

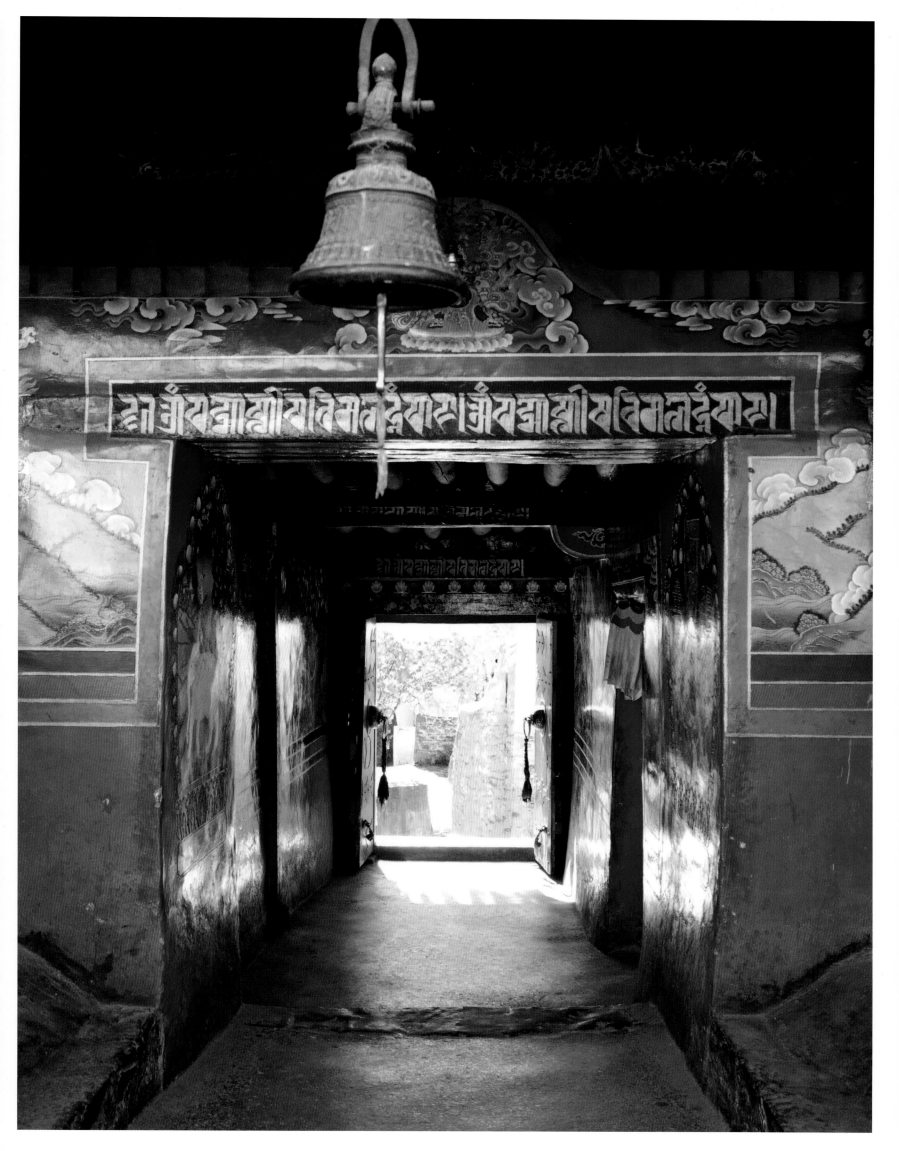

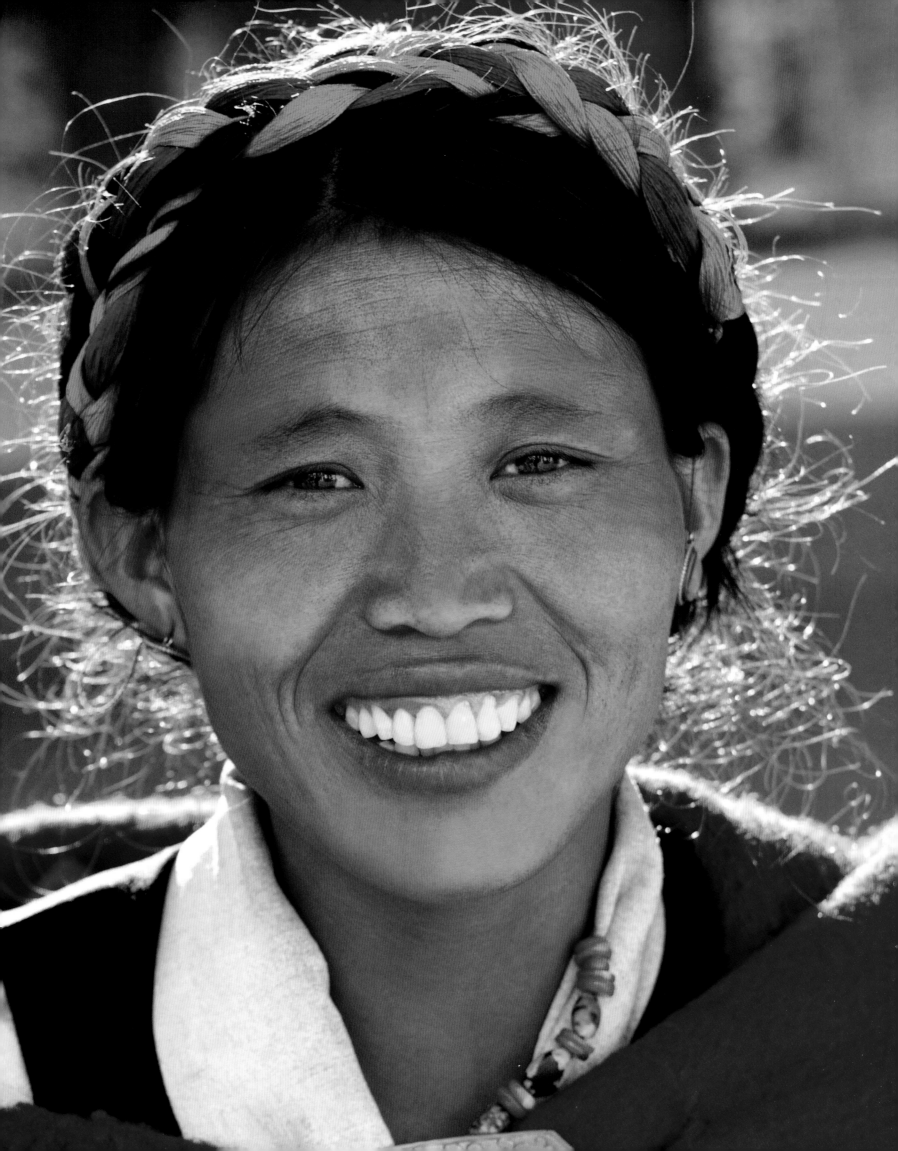

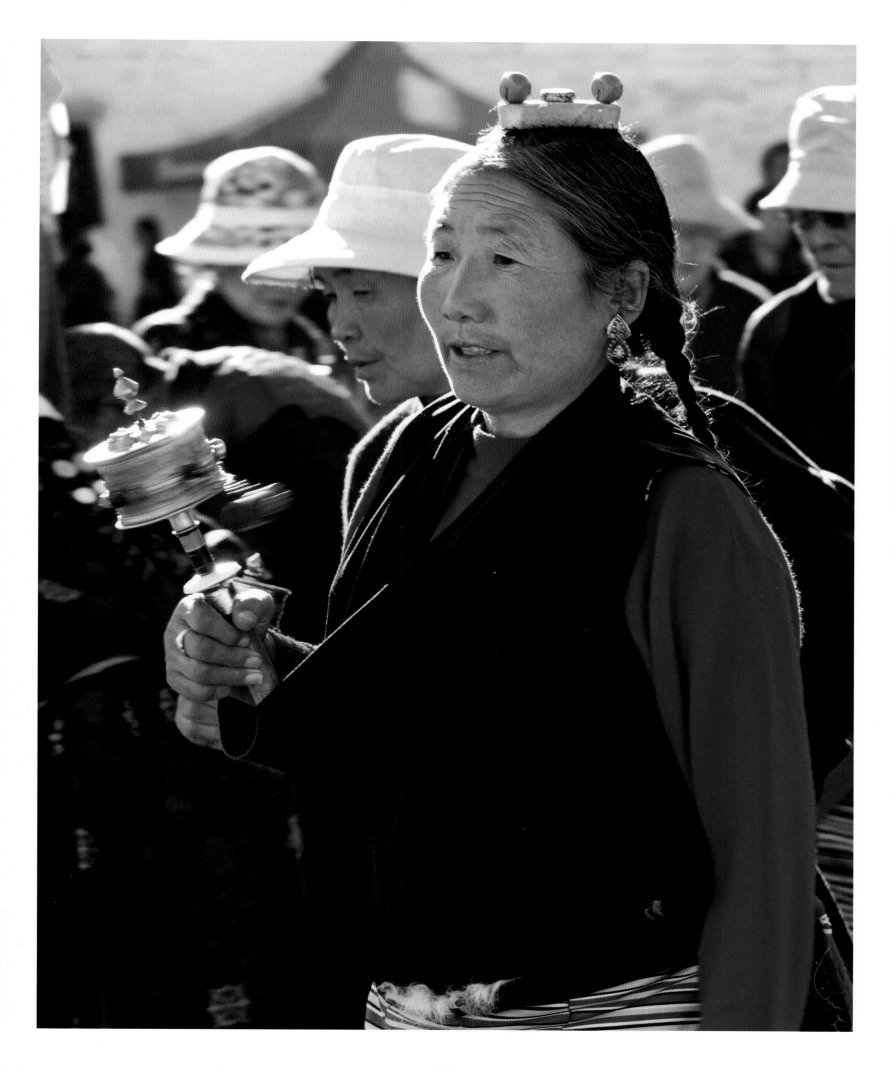

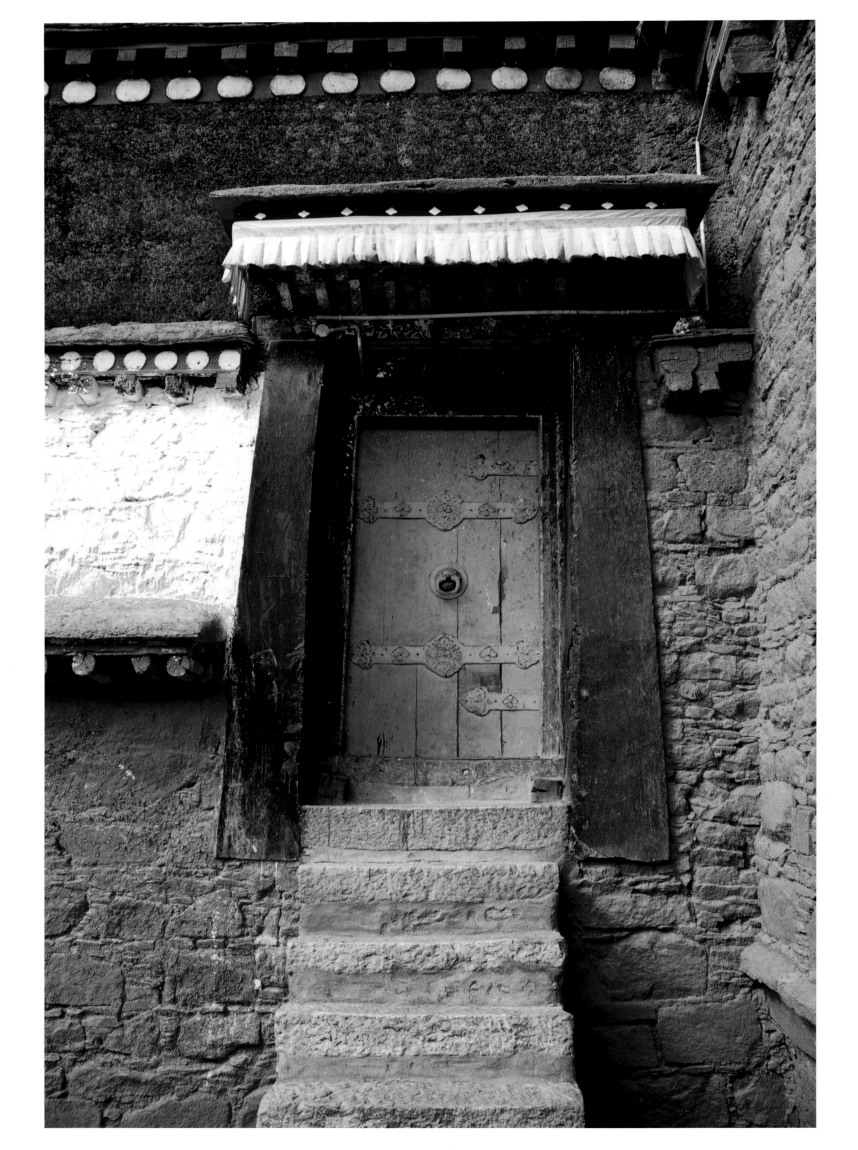

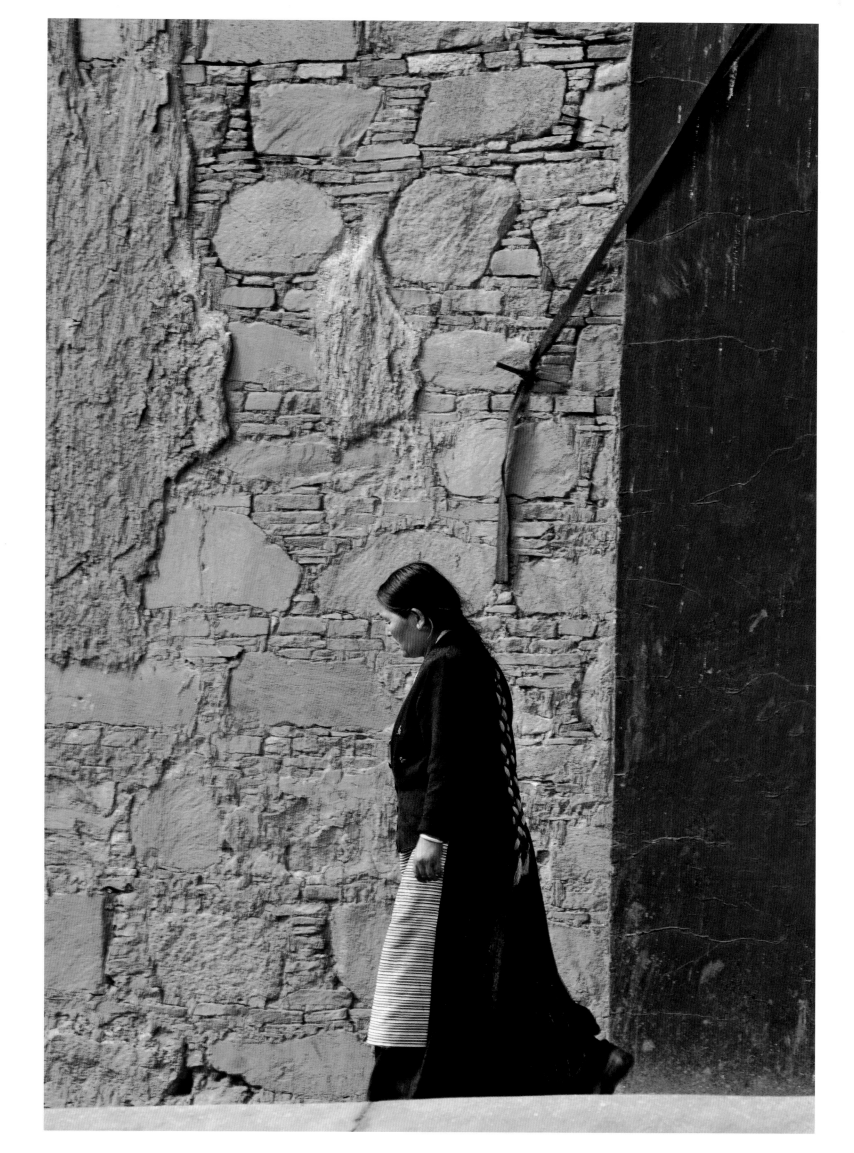

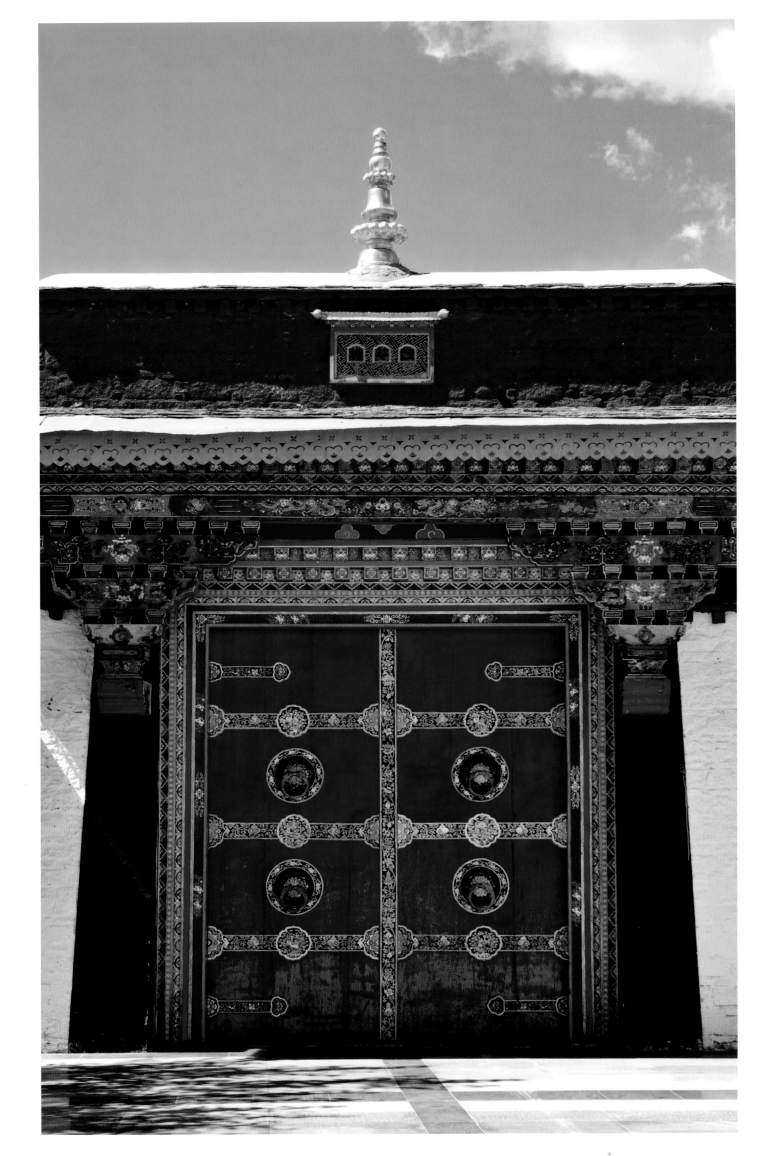

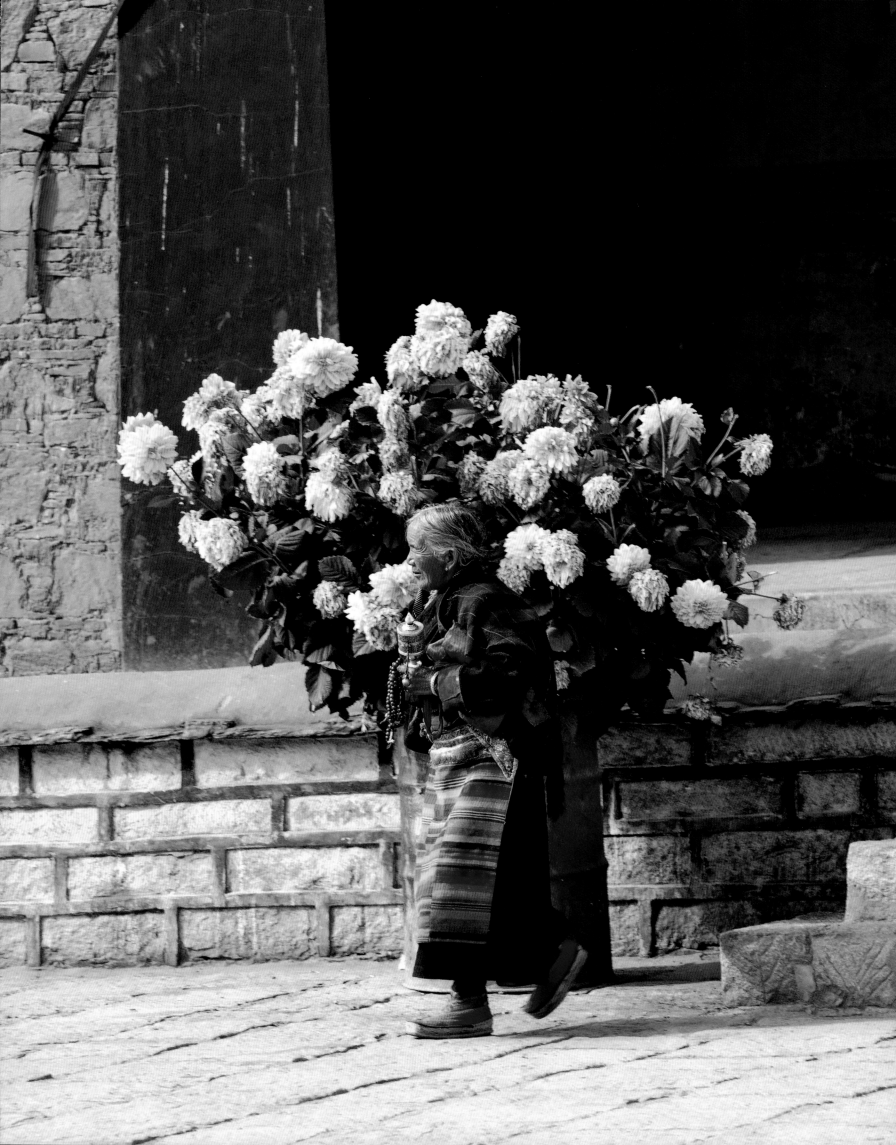

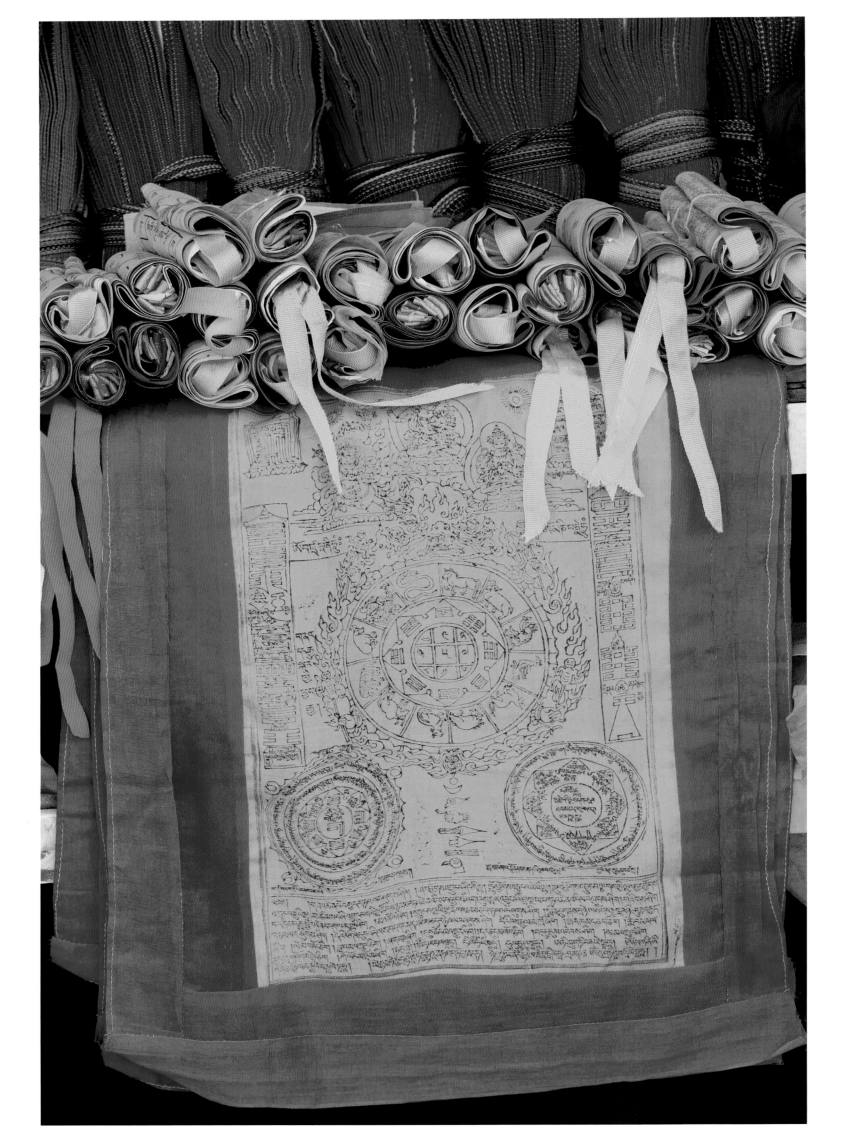

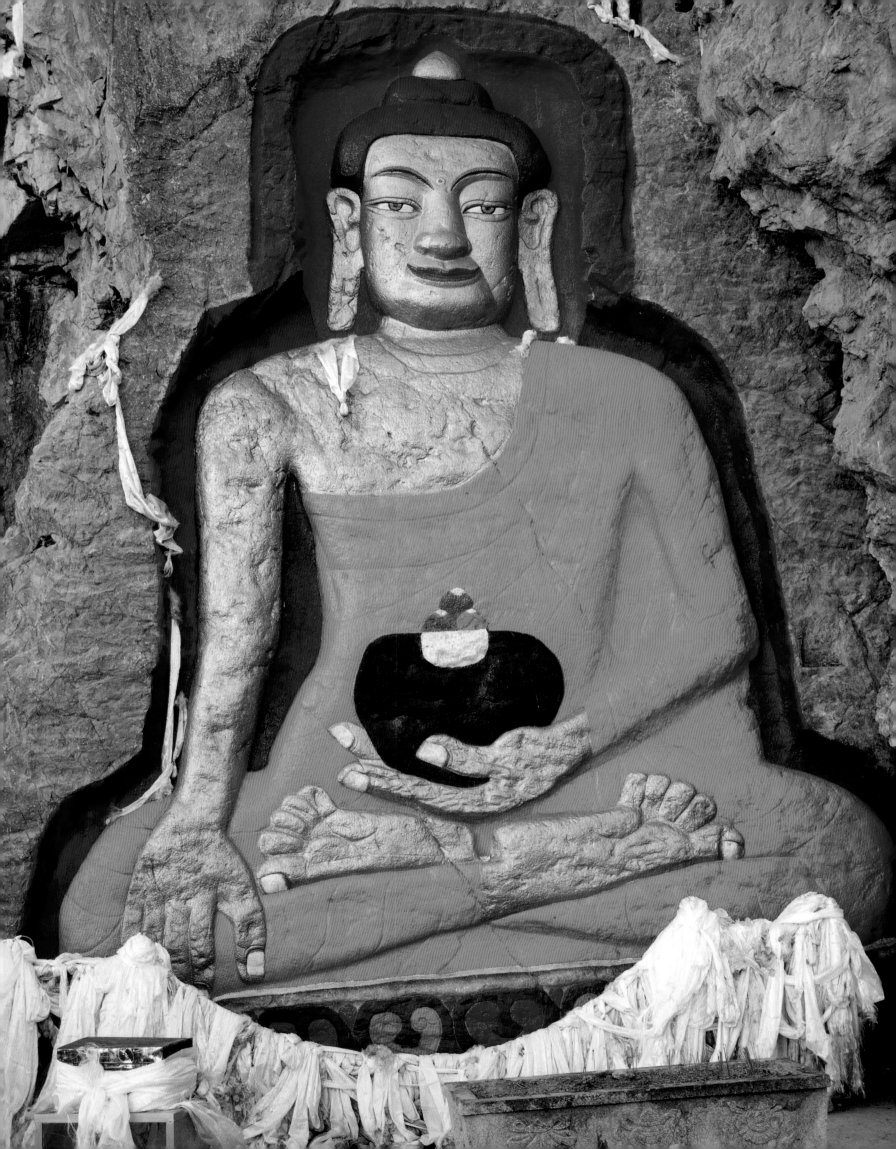

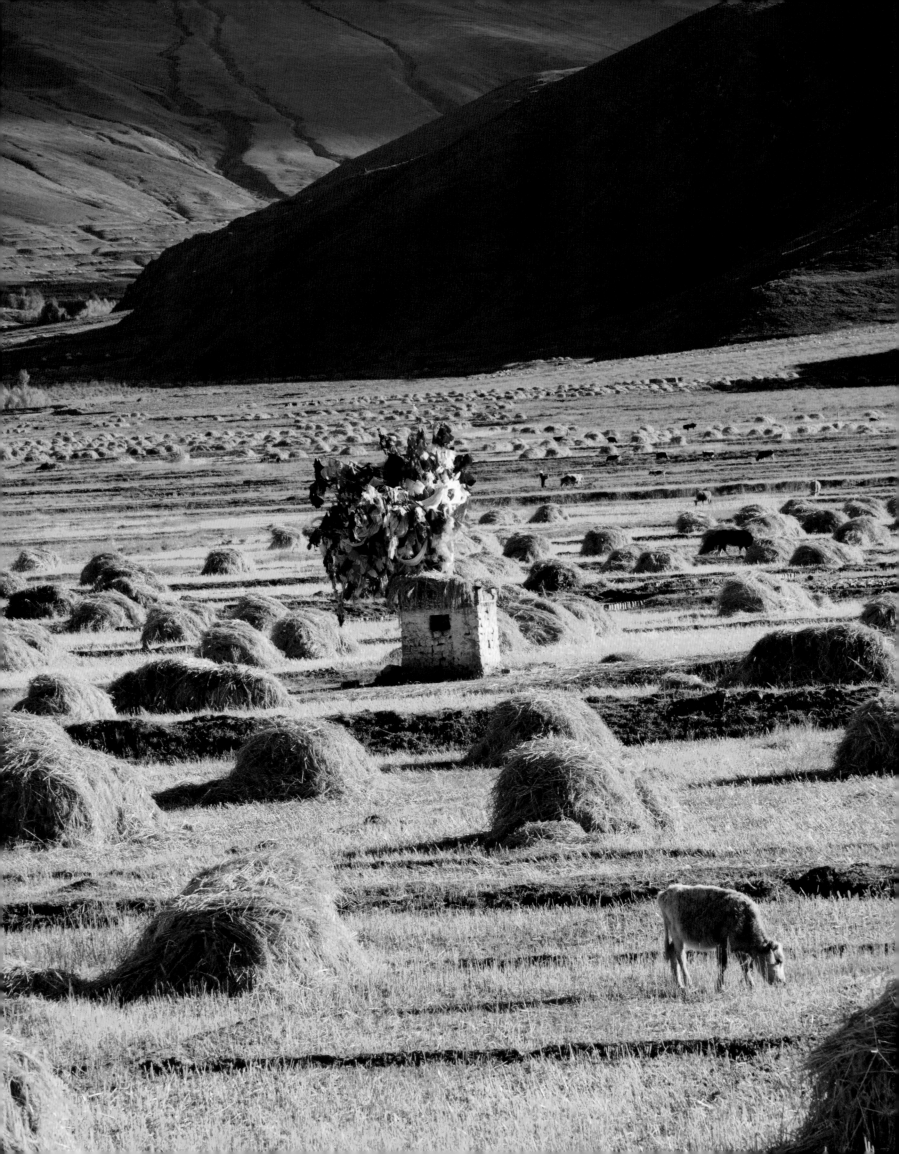

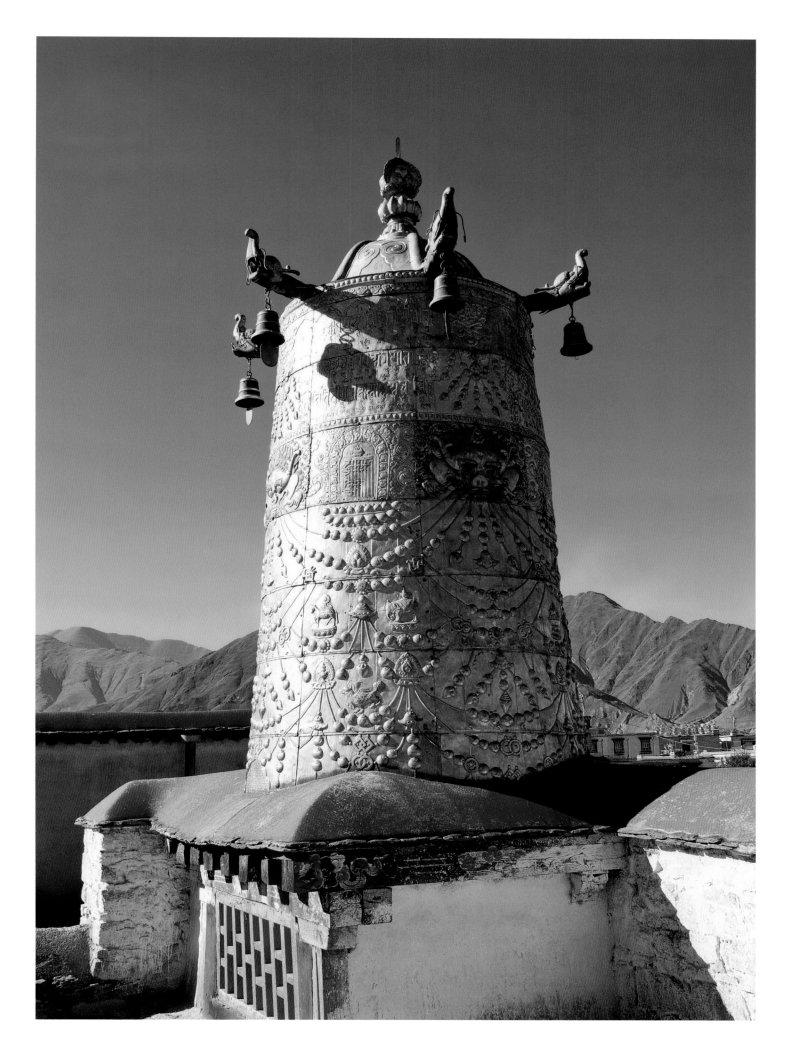

231

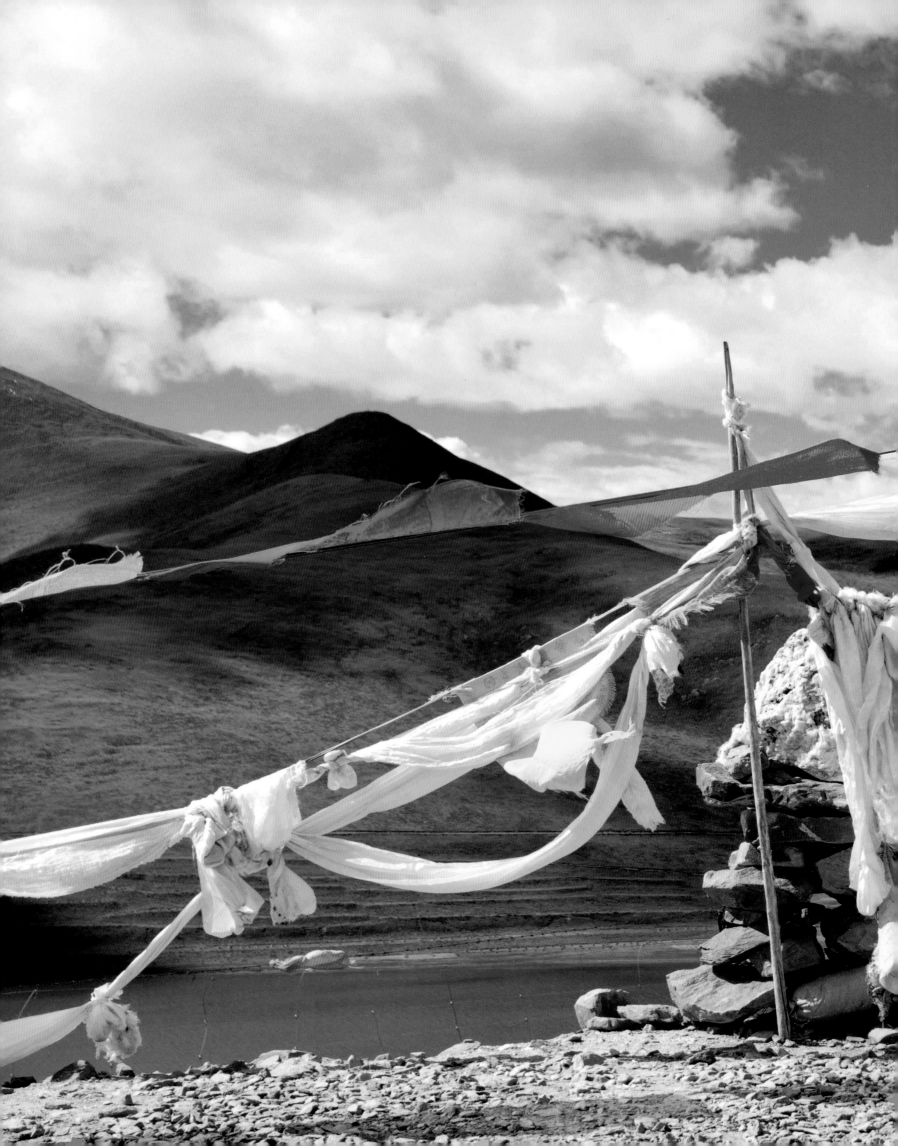

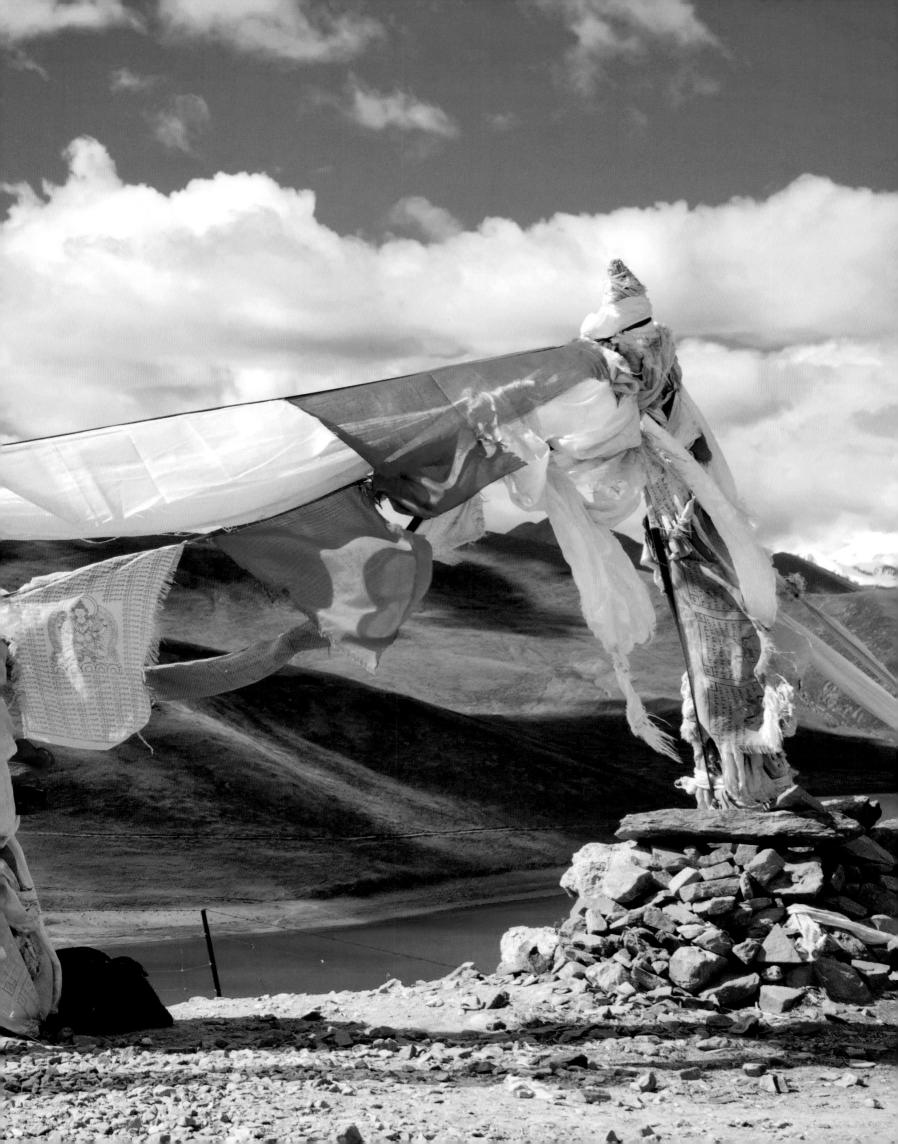

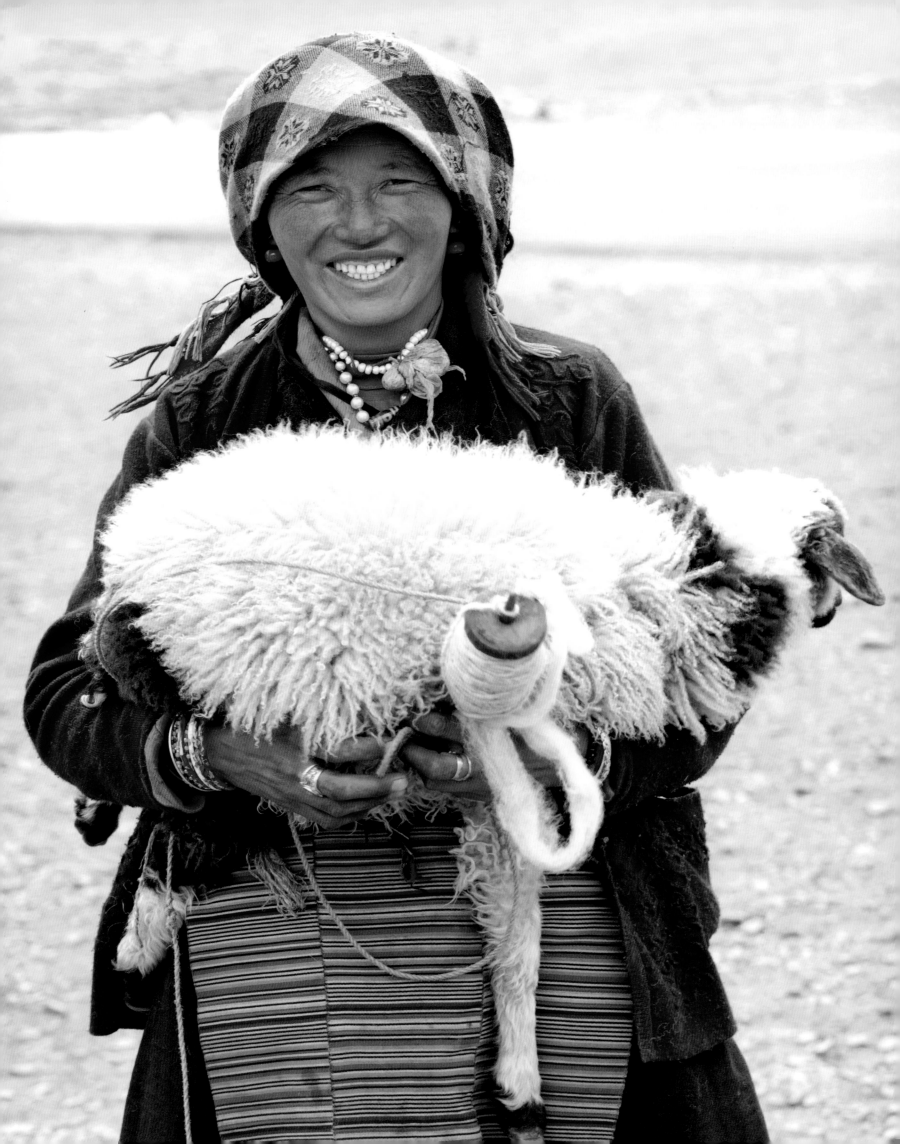

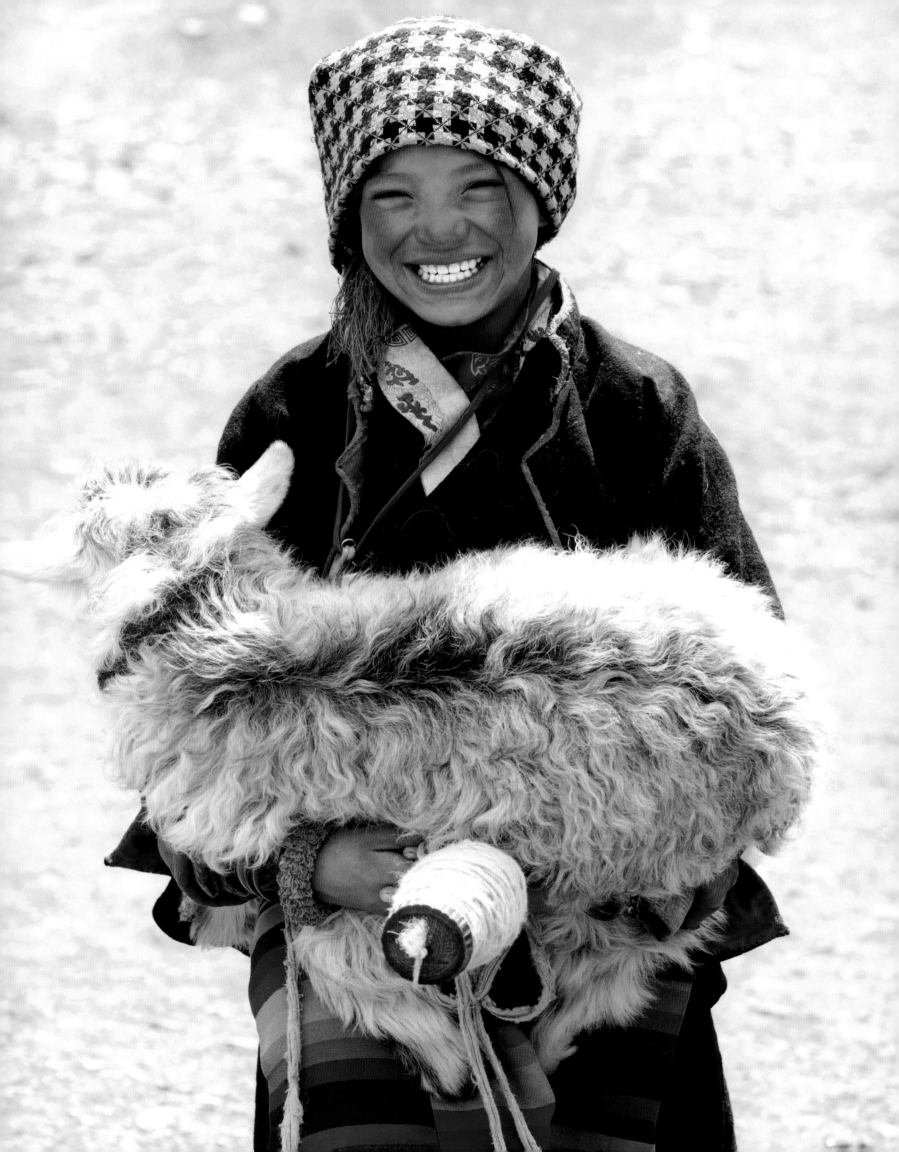

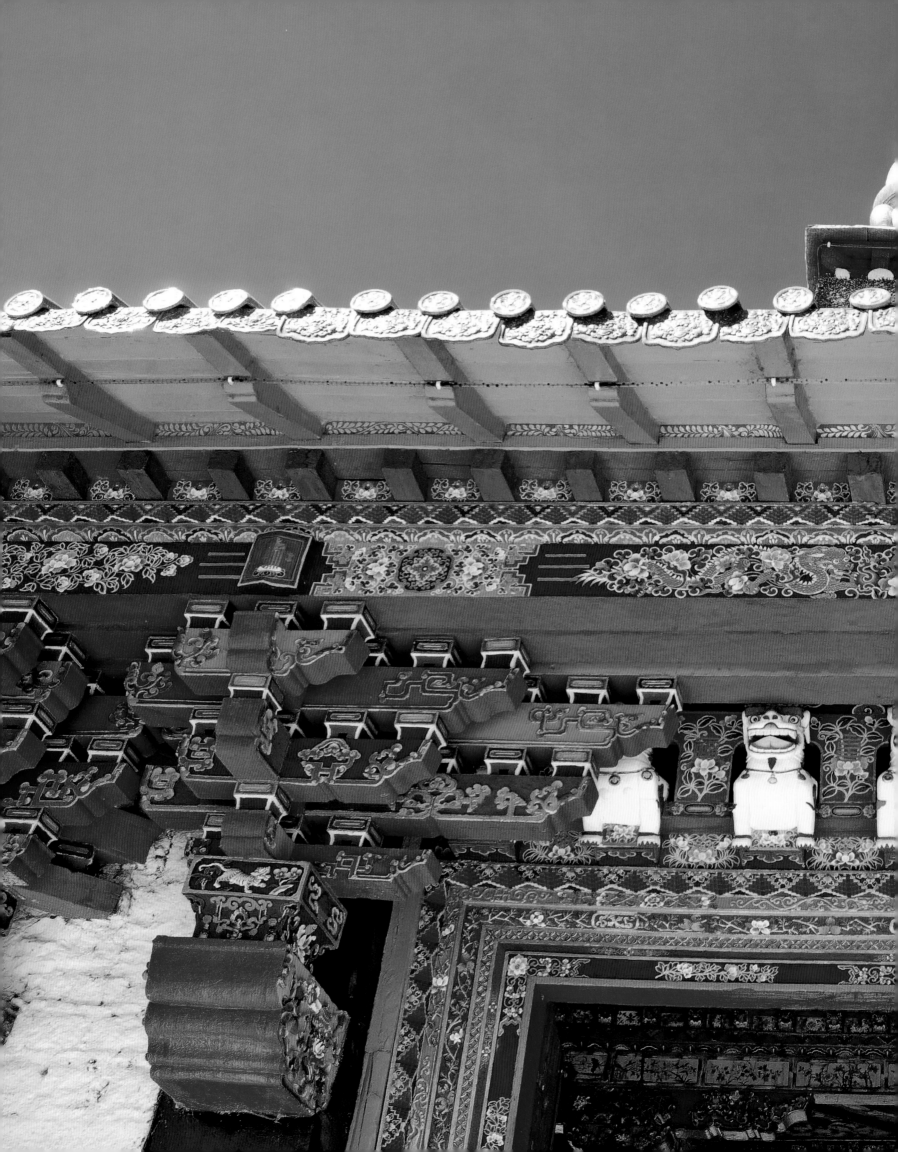

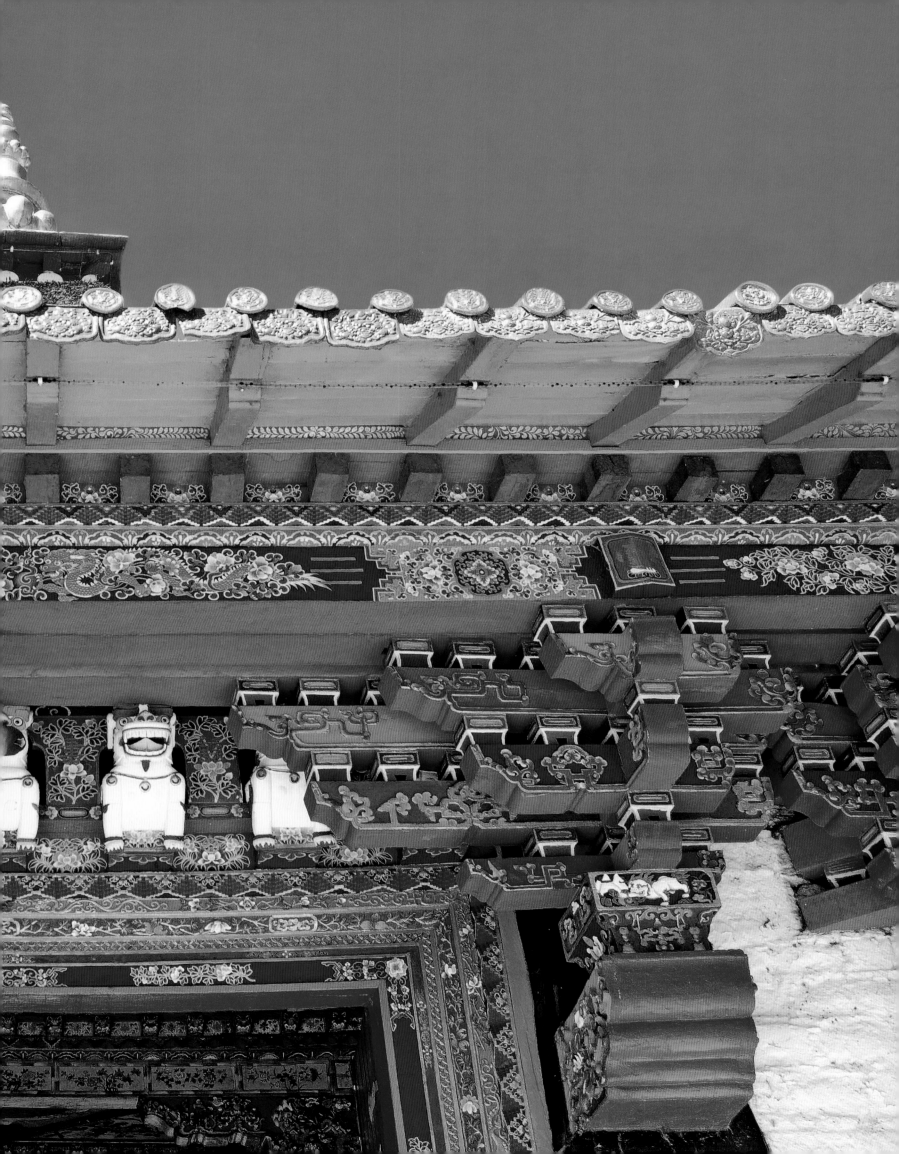

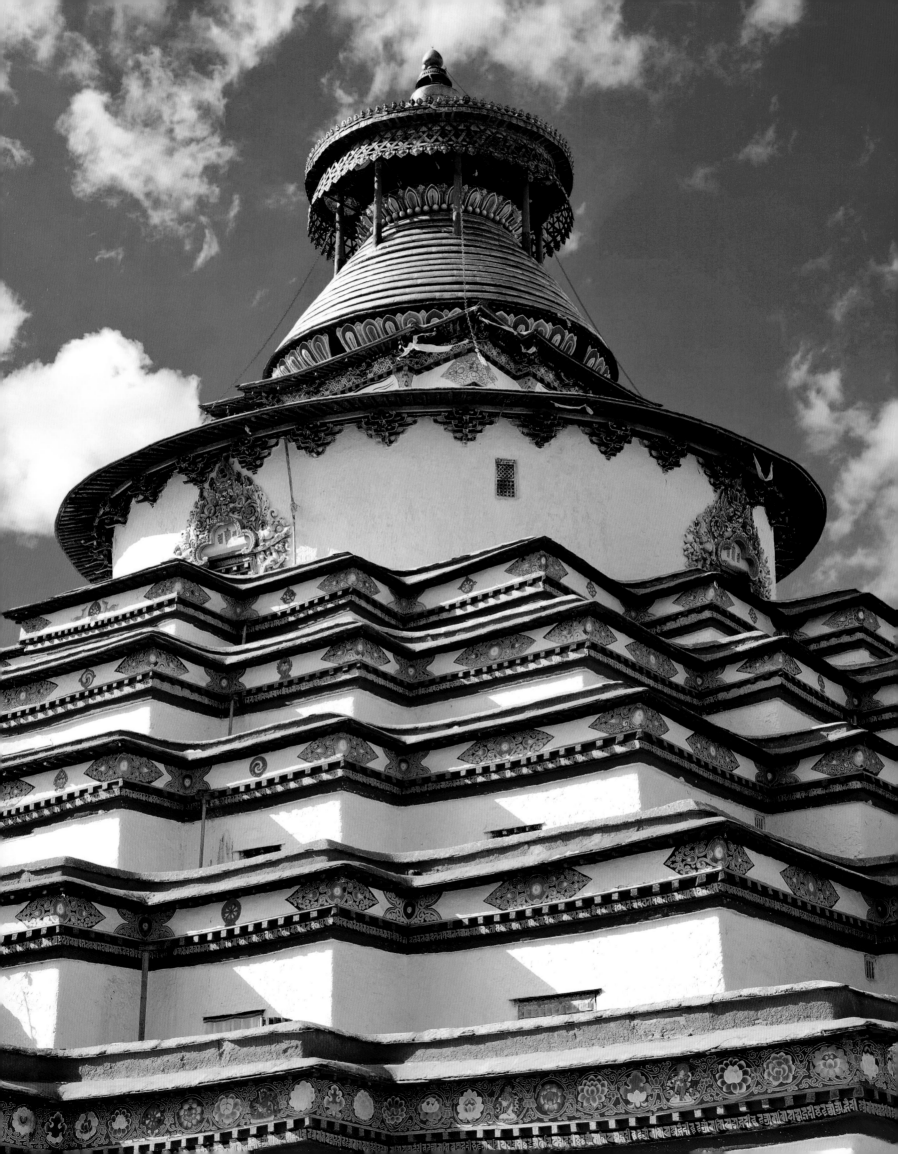

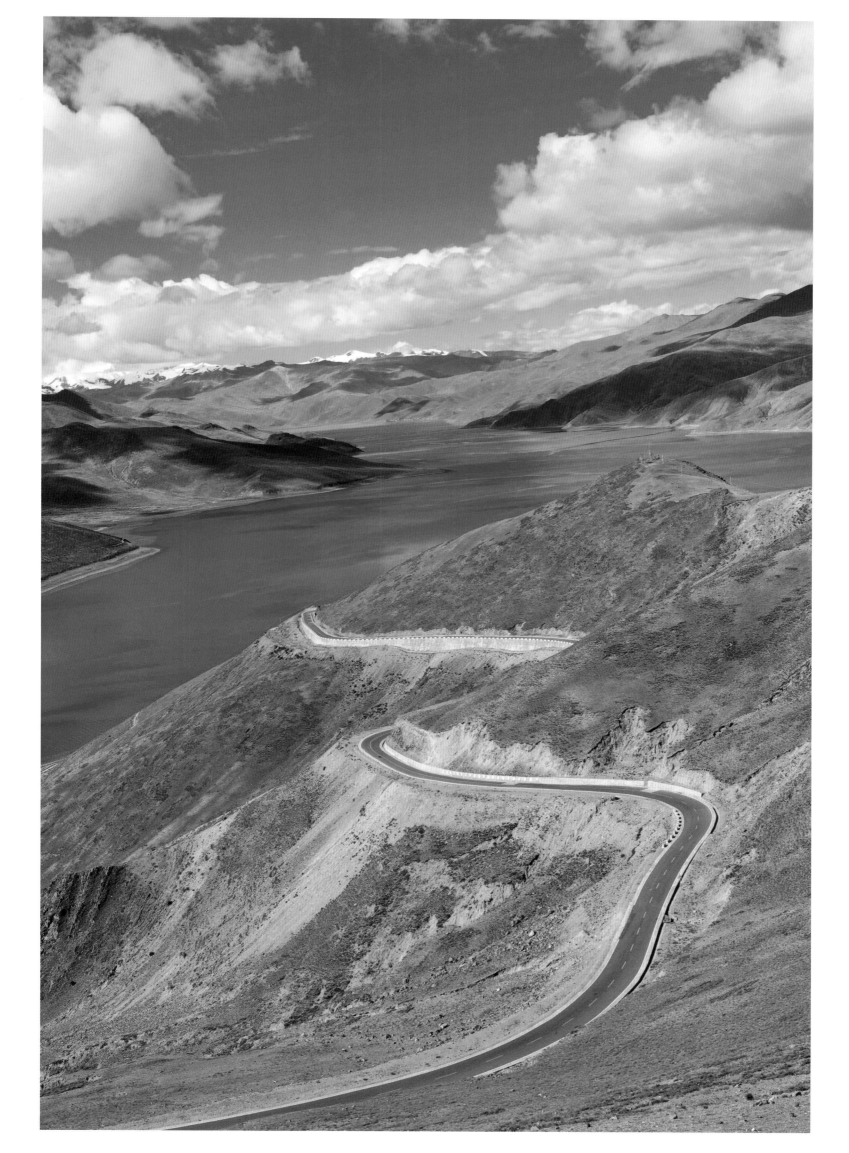

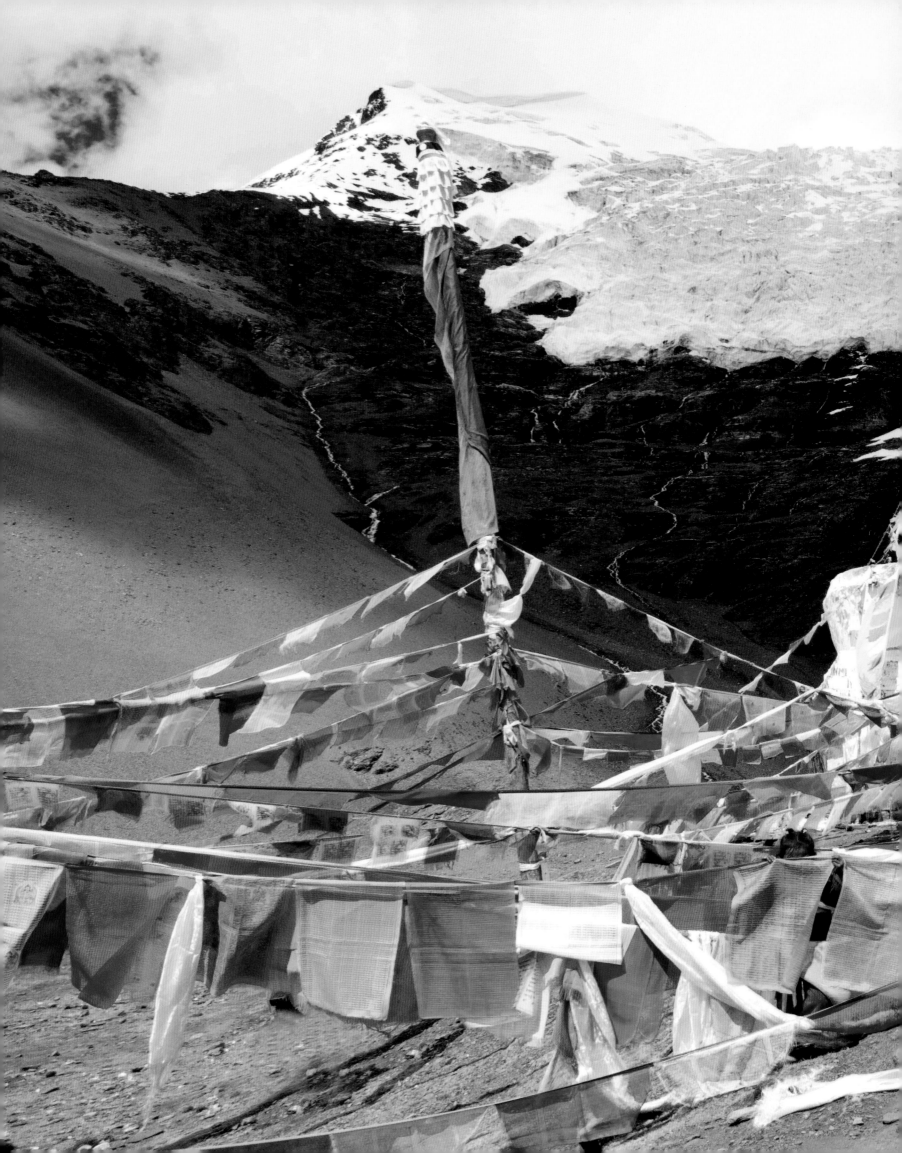

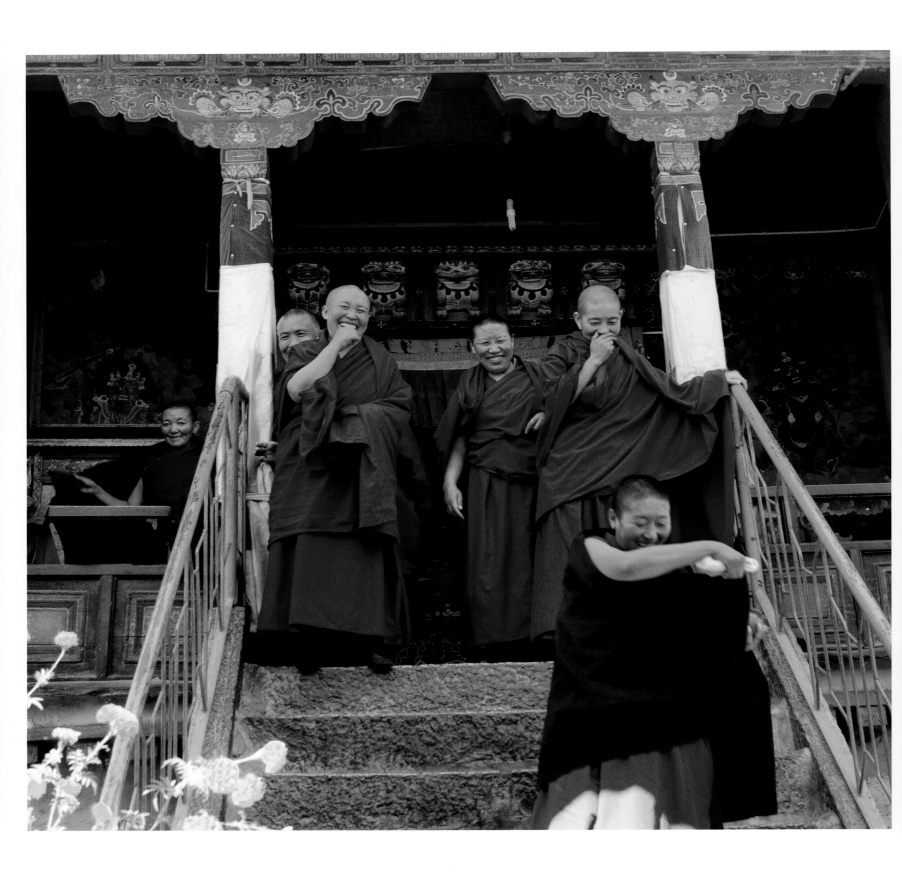

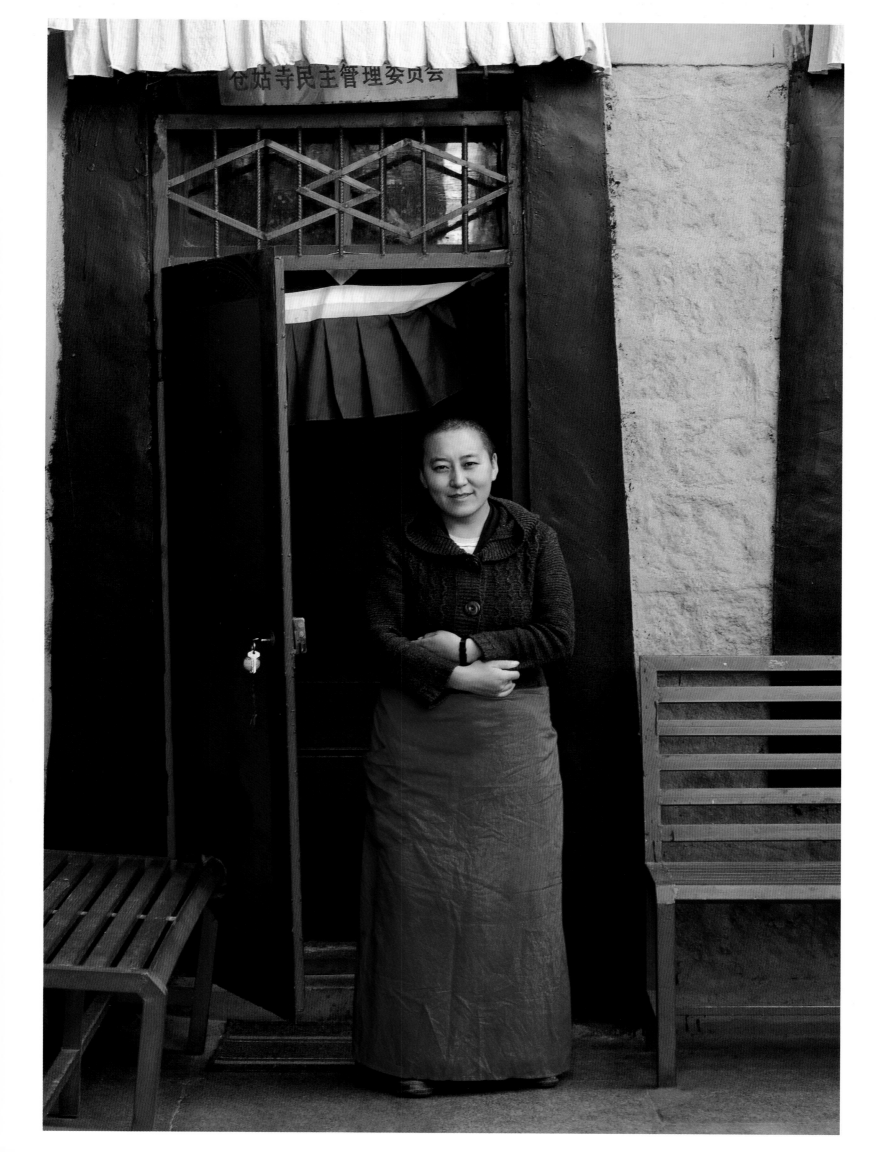

QINGHAI PROVINCE
青海省

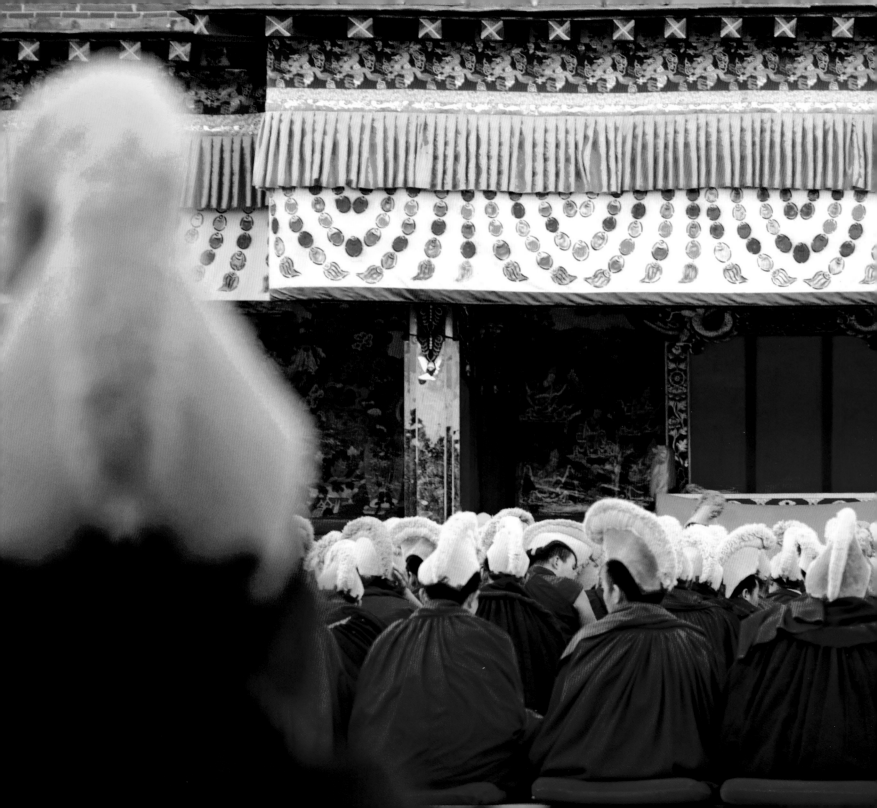

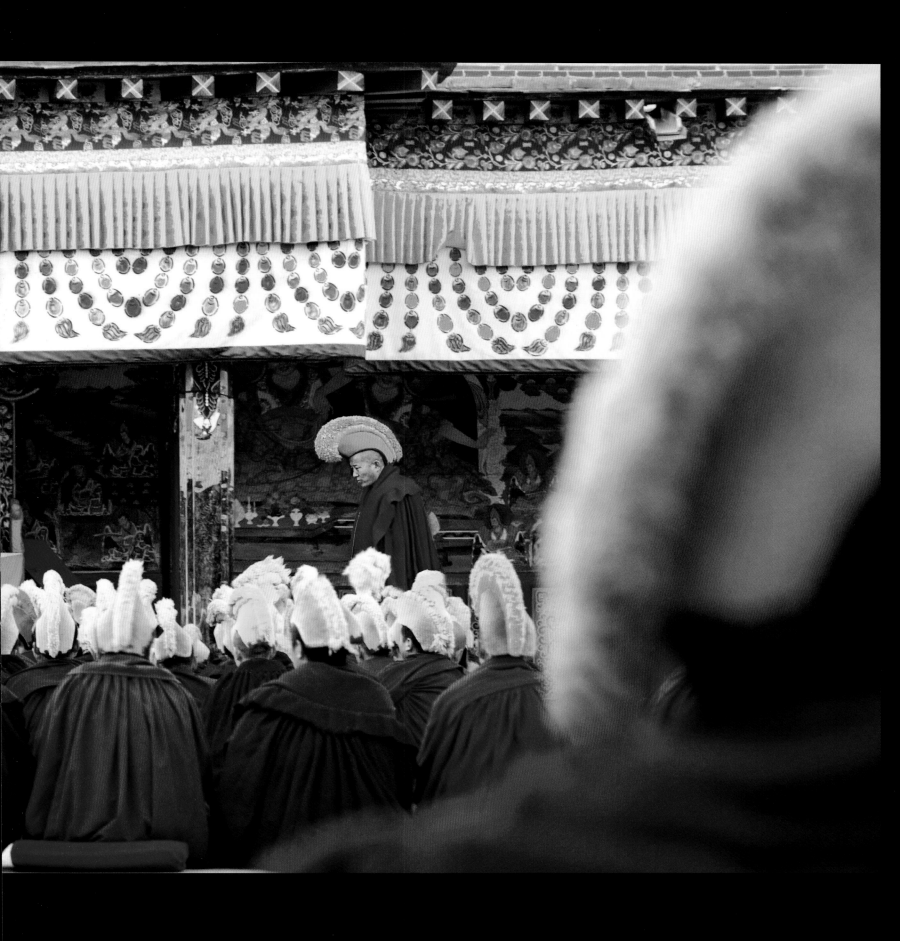

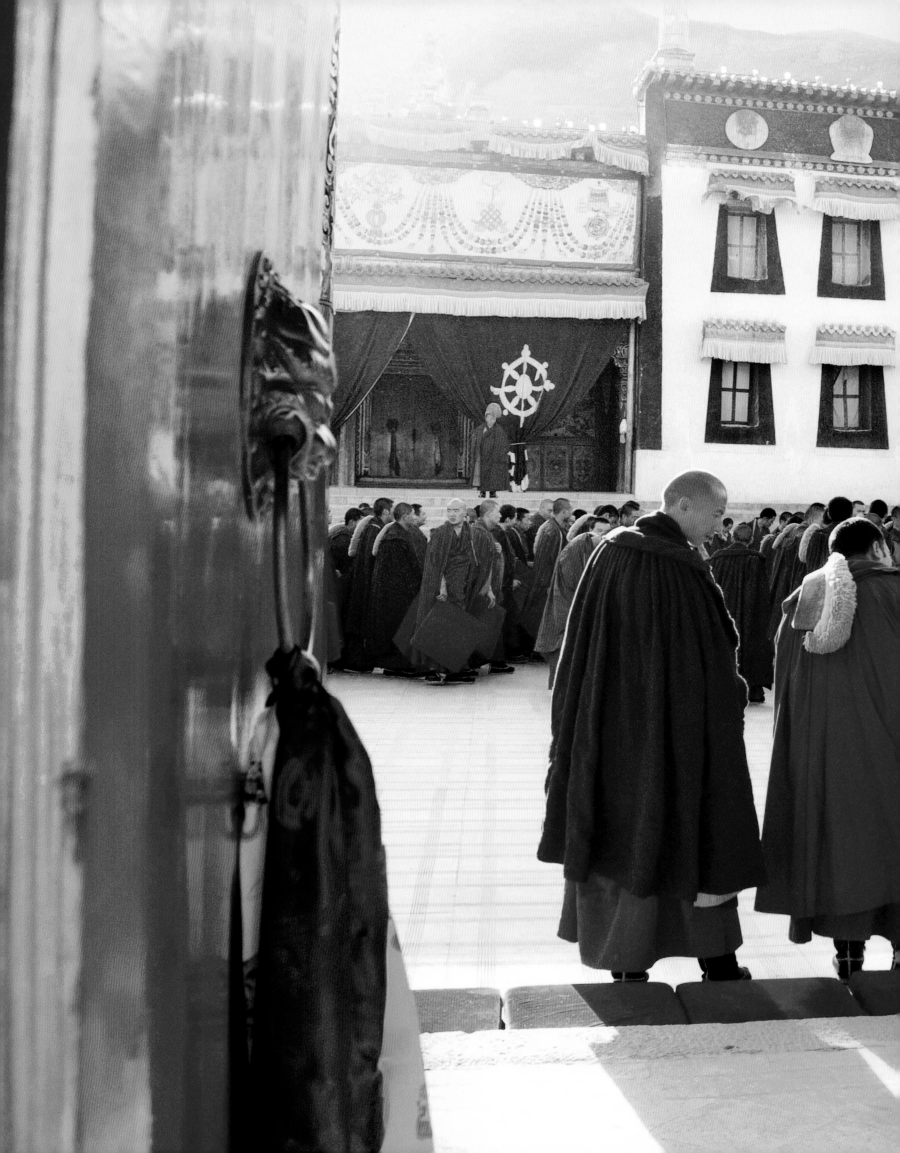

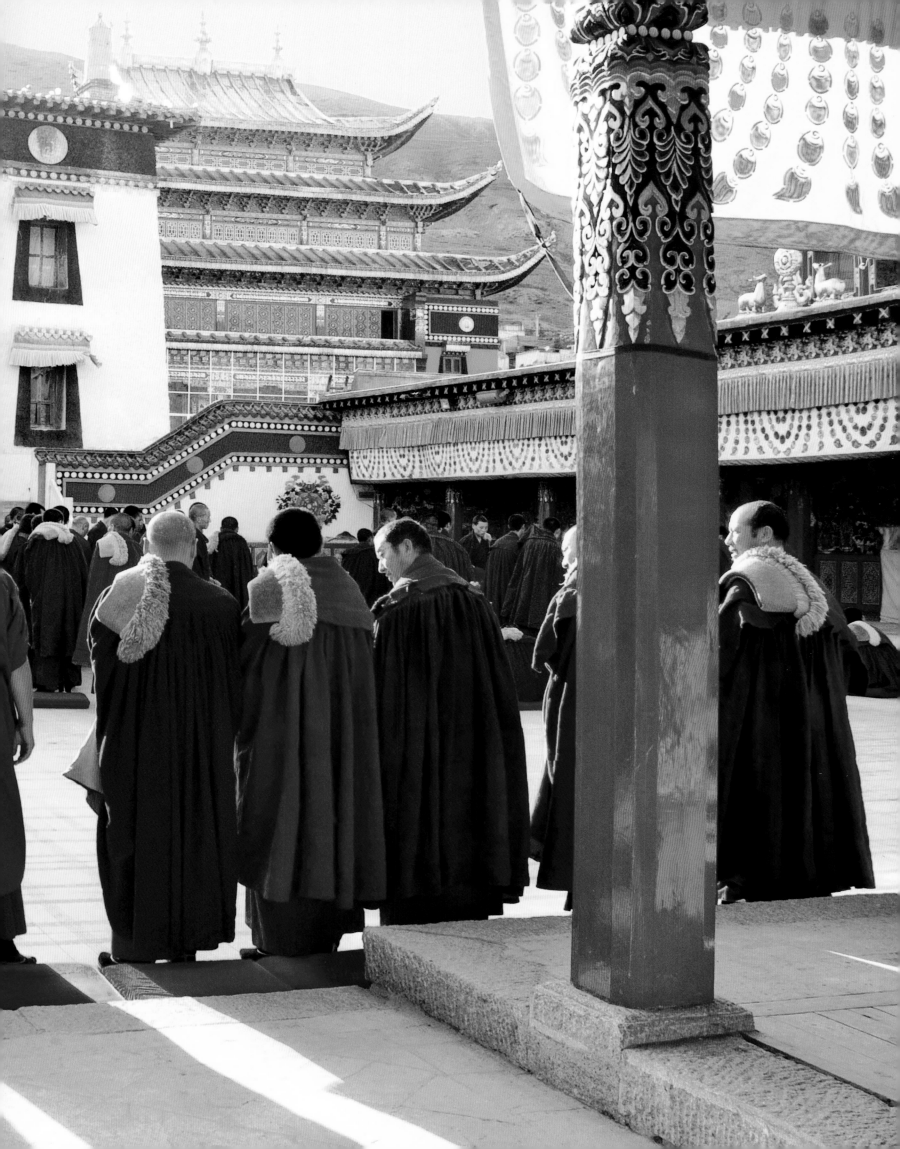

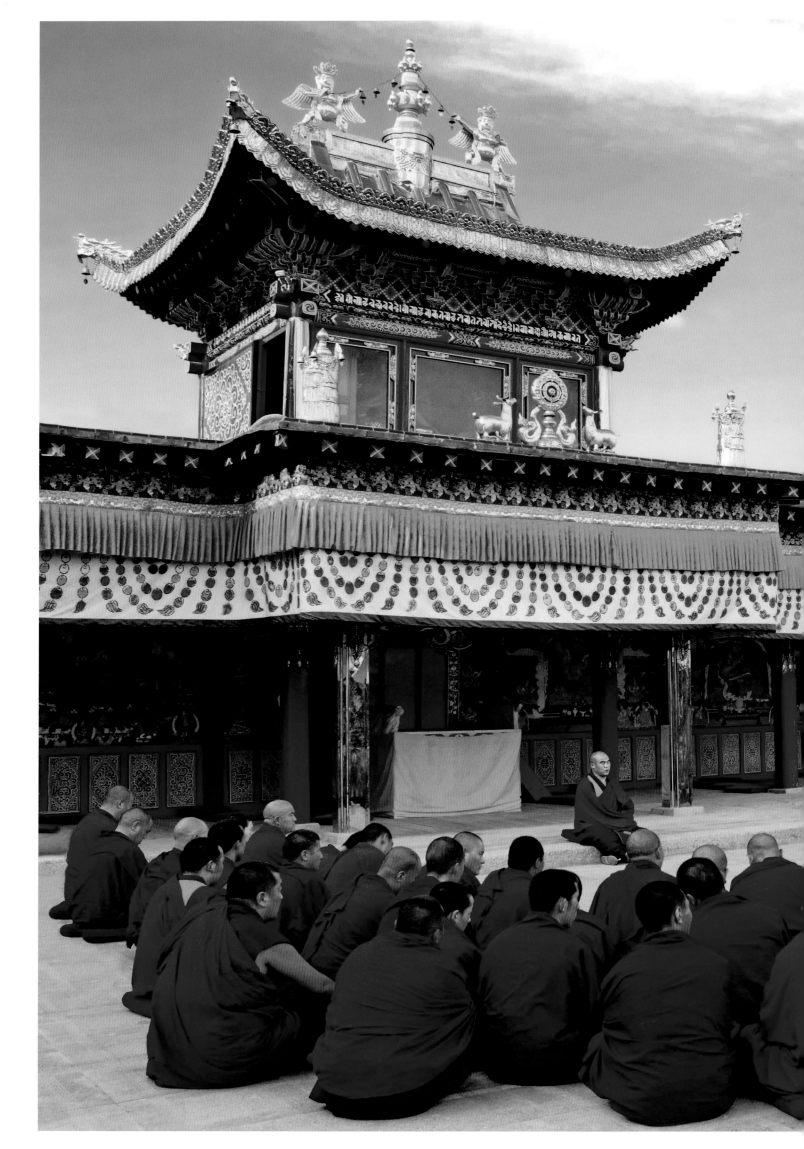

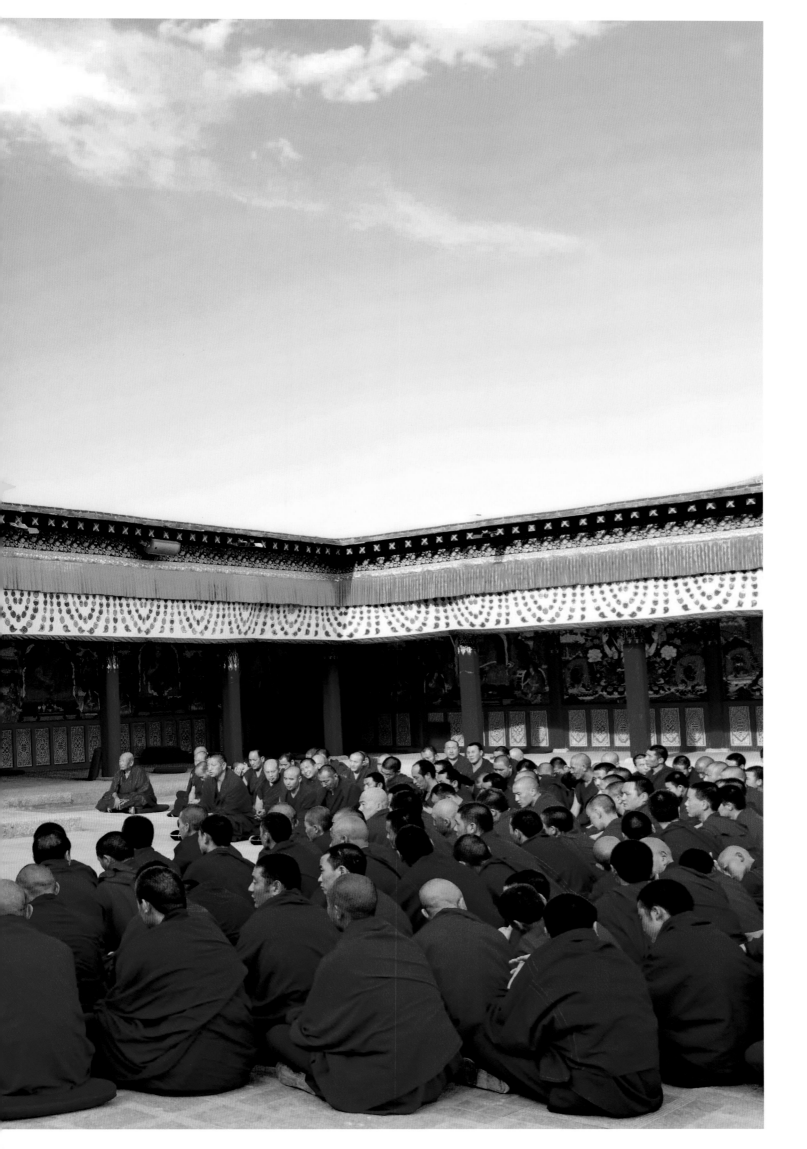

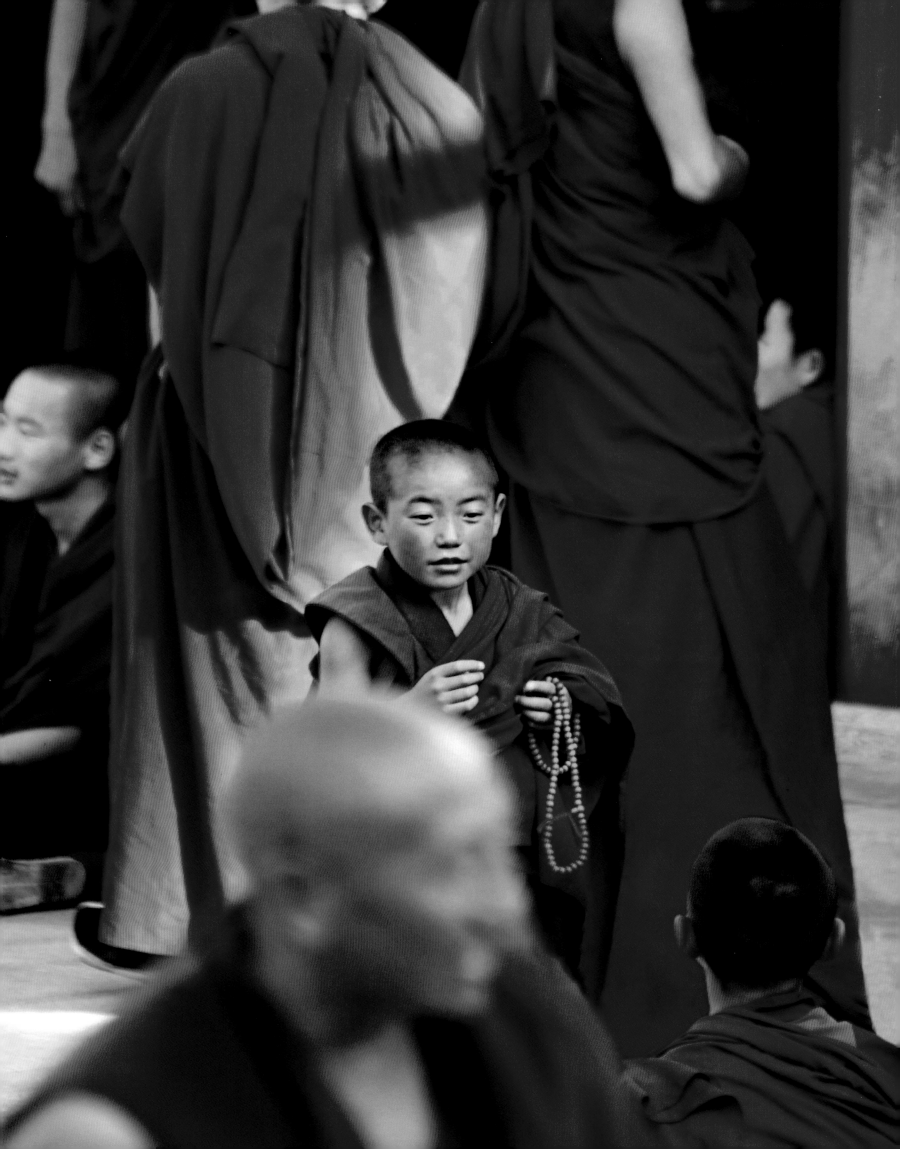

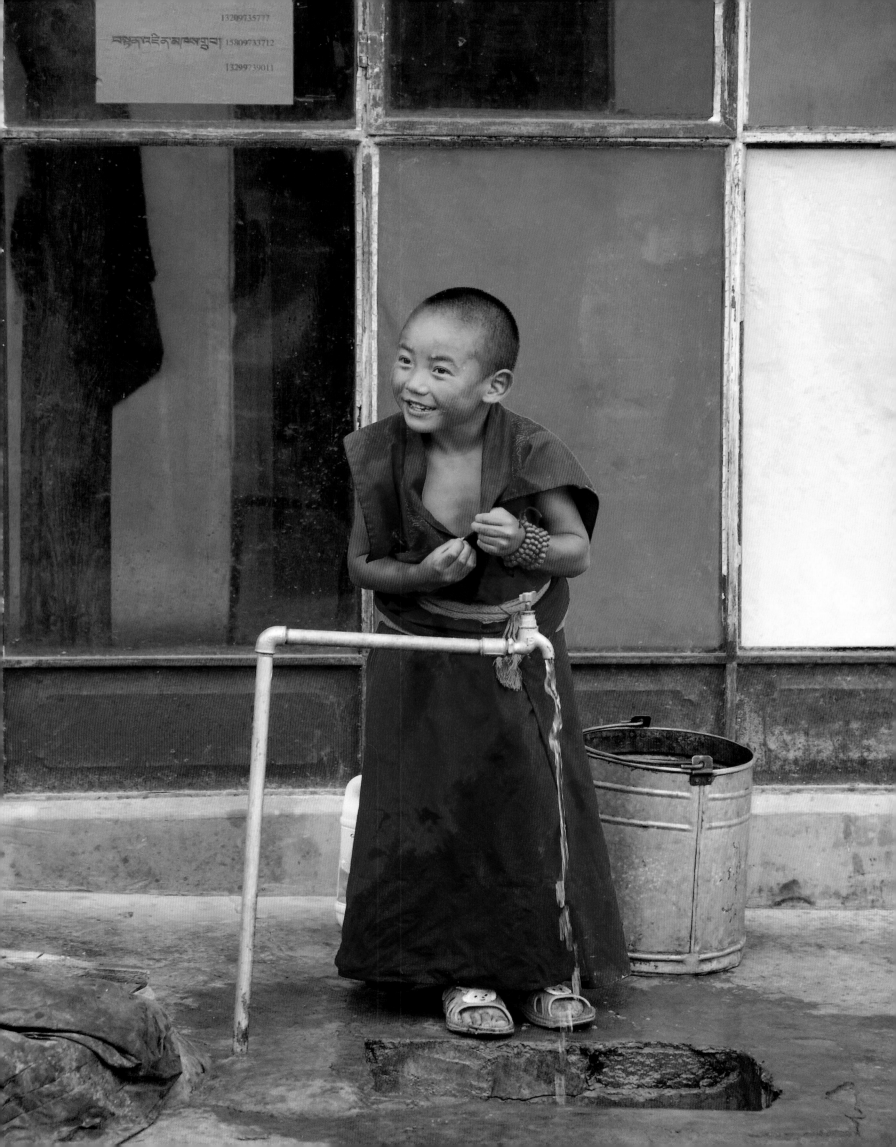

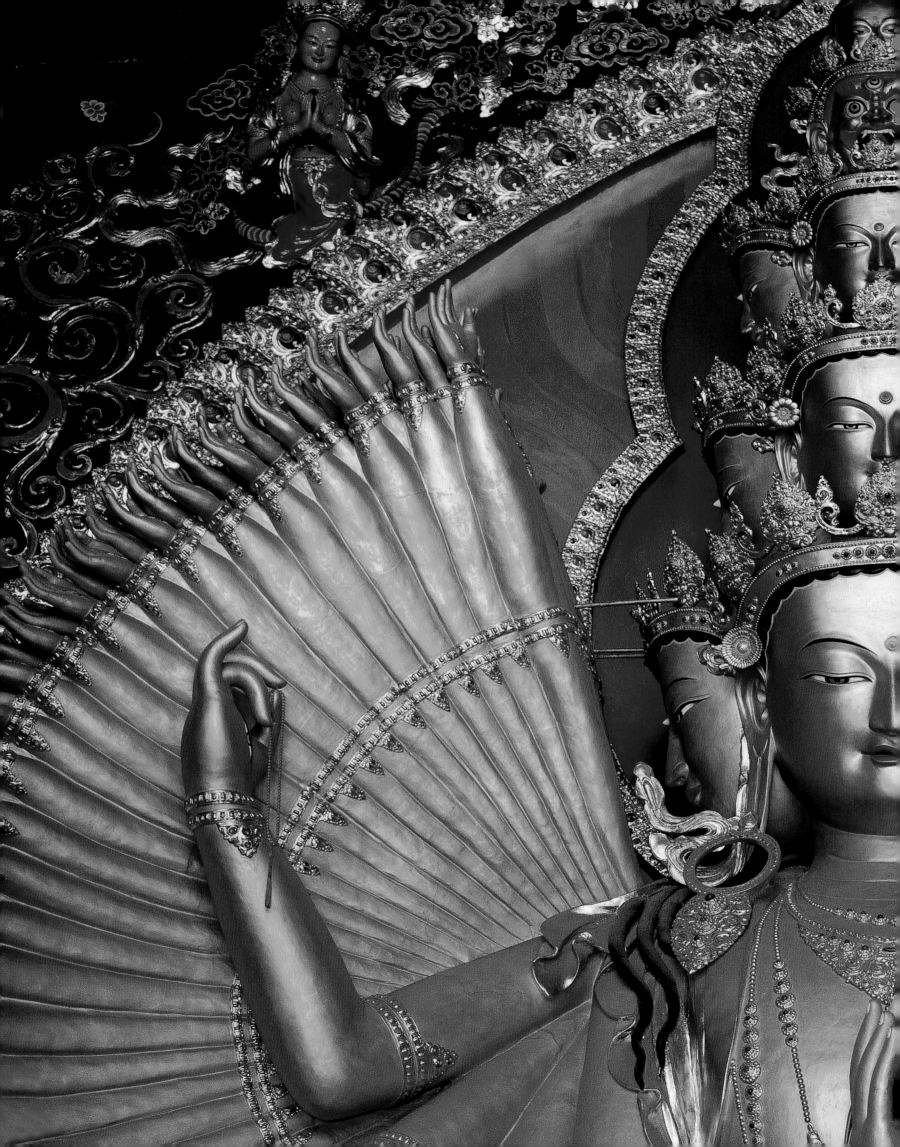

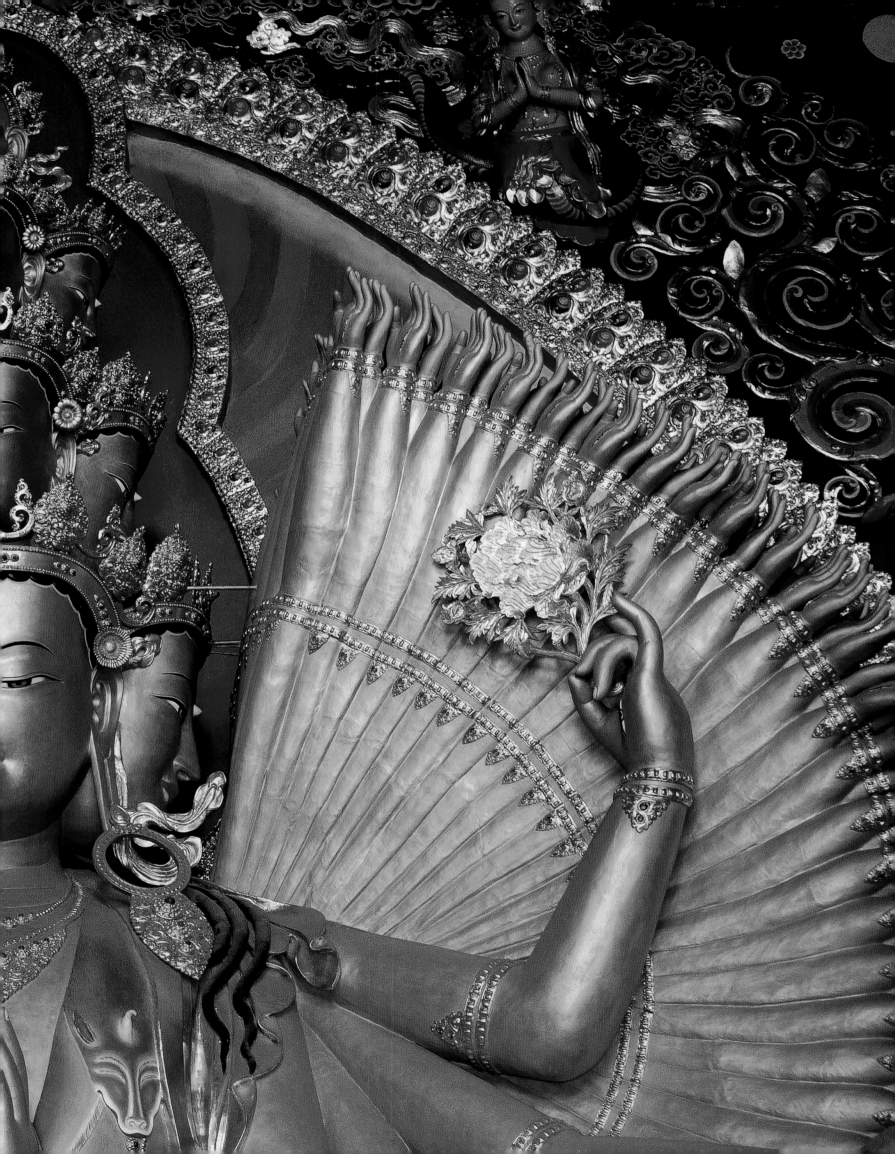

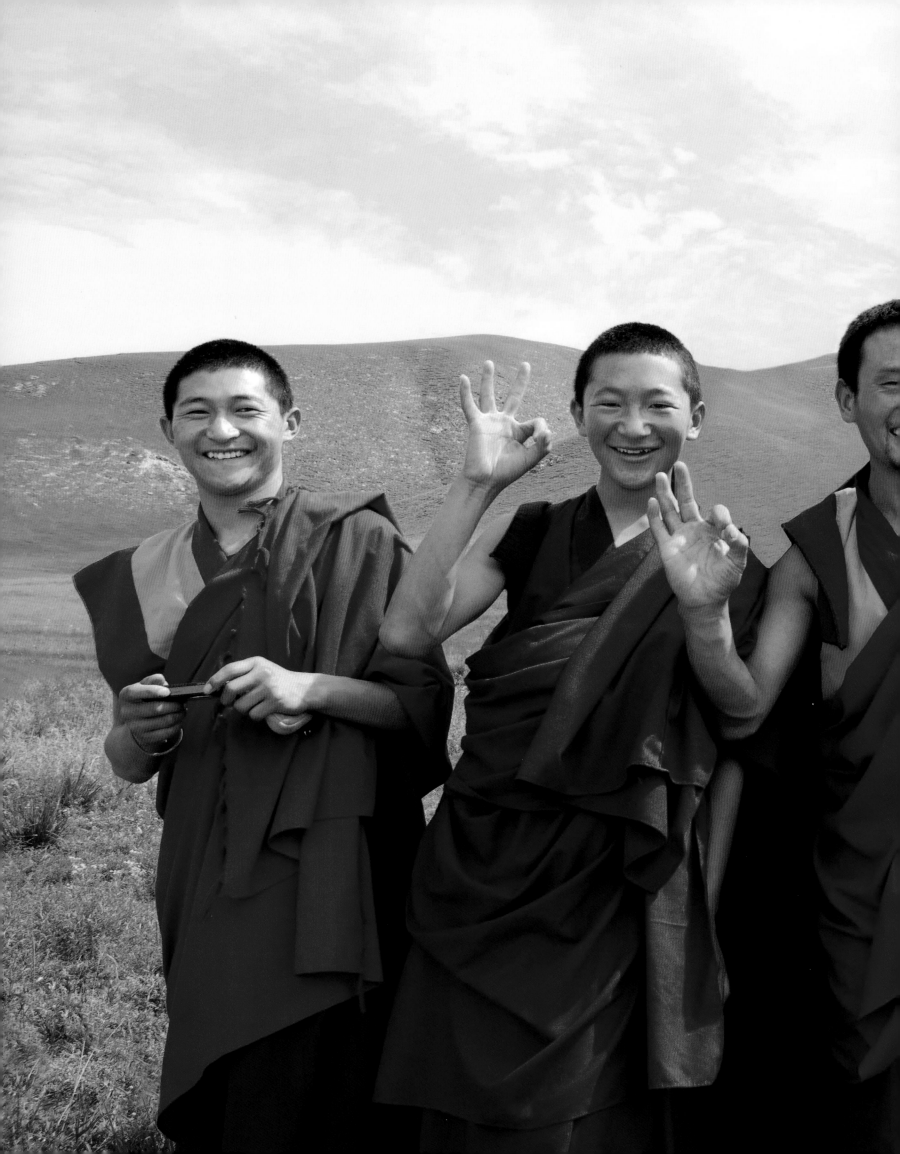

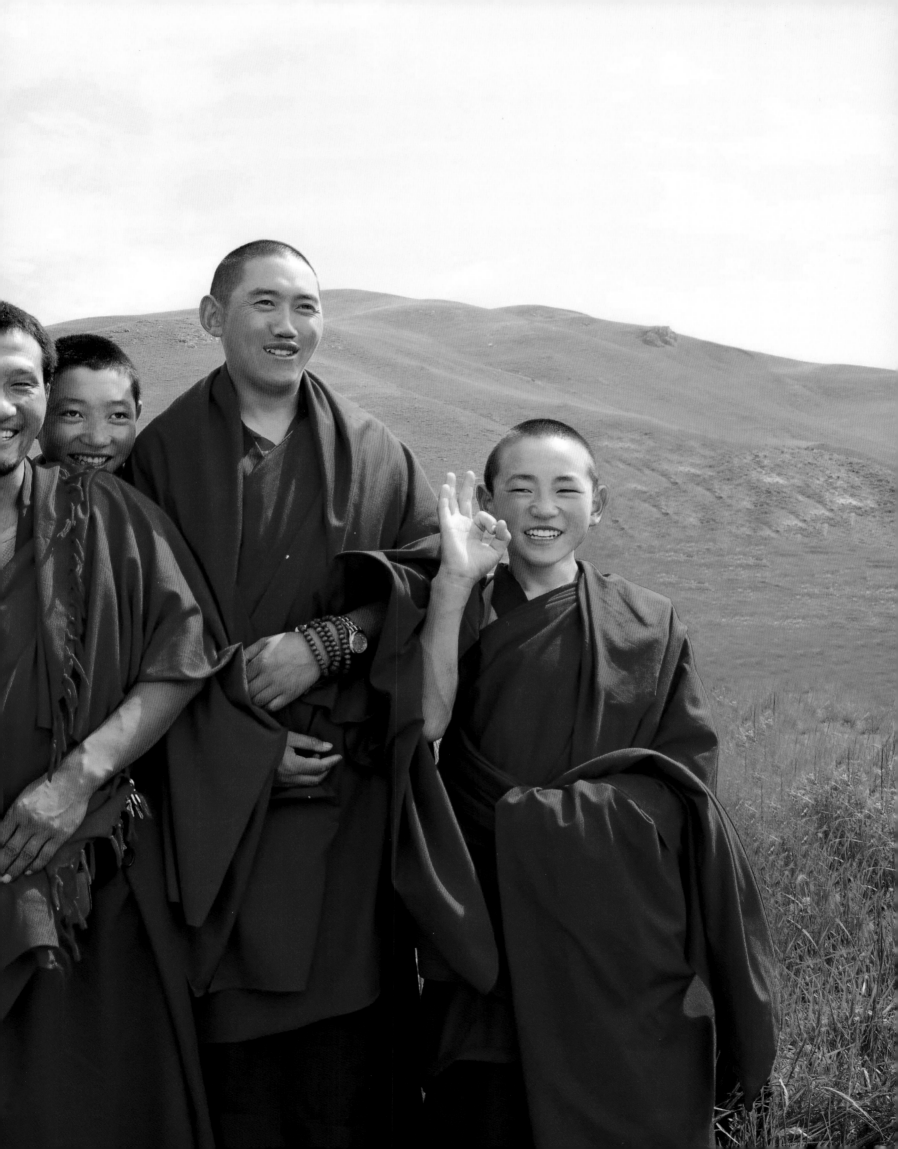

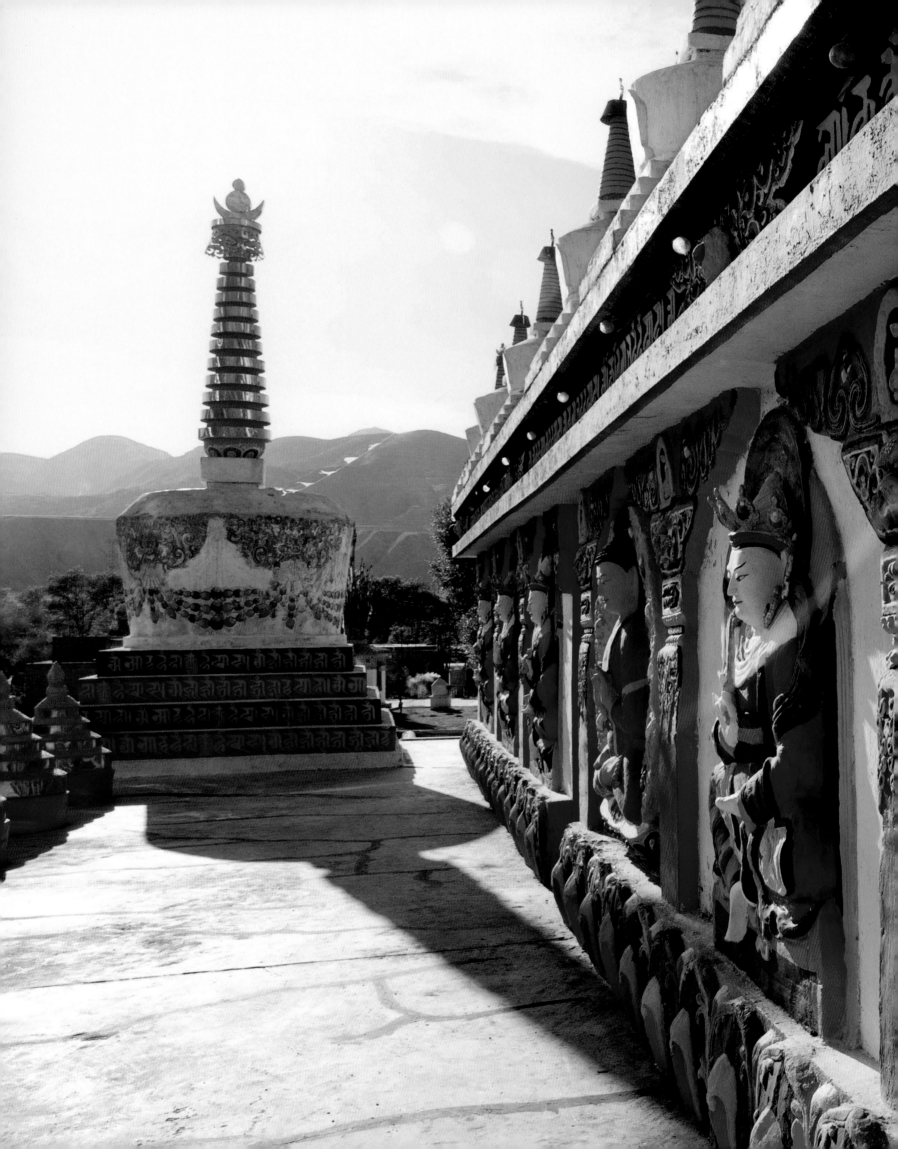

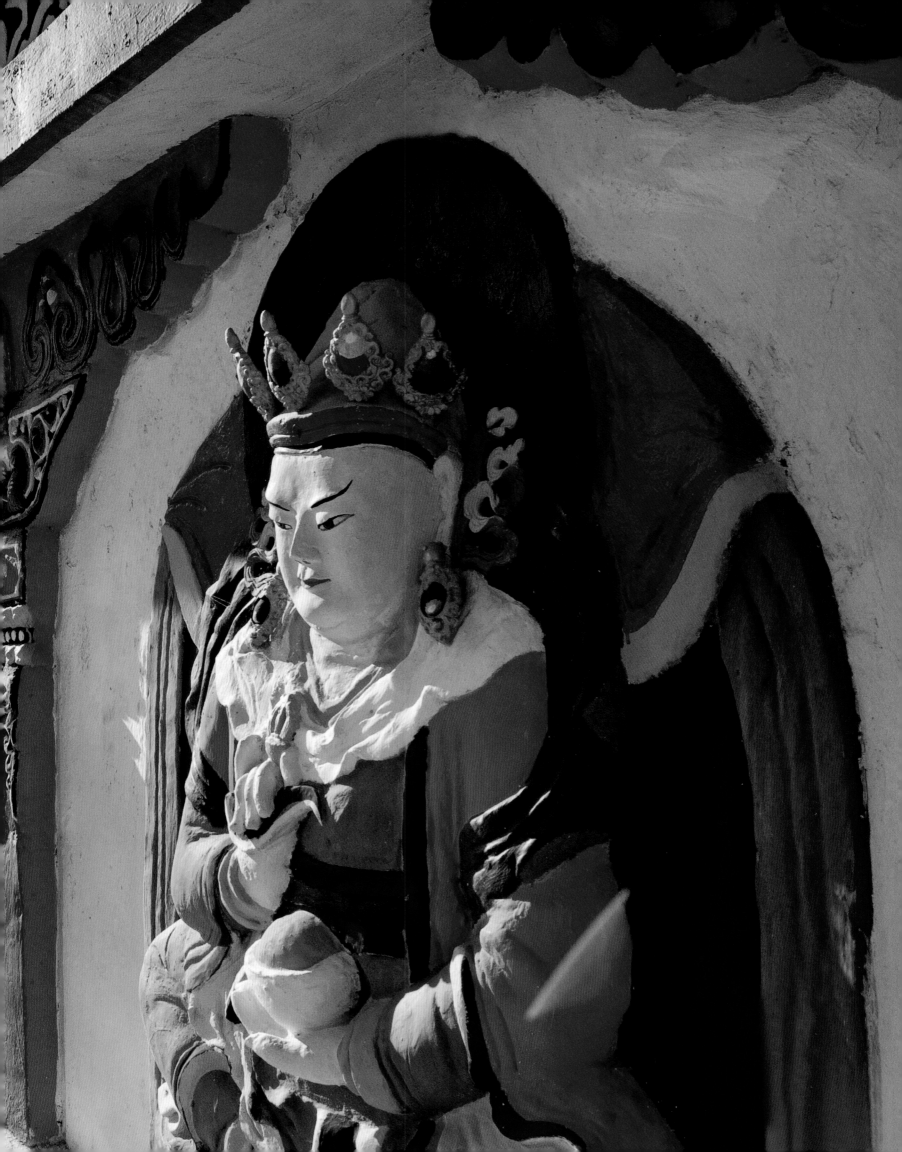

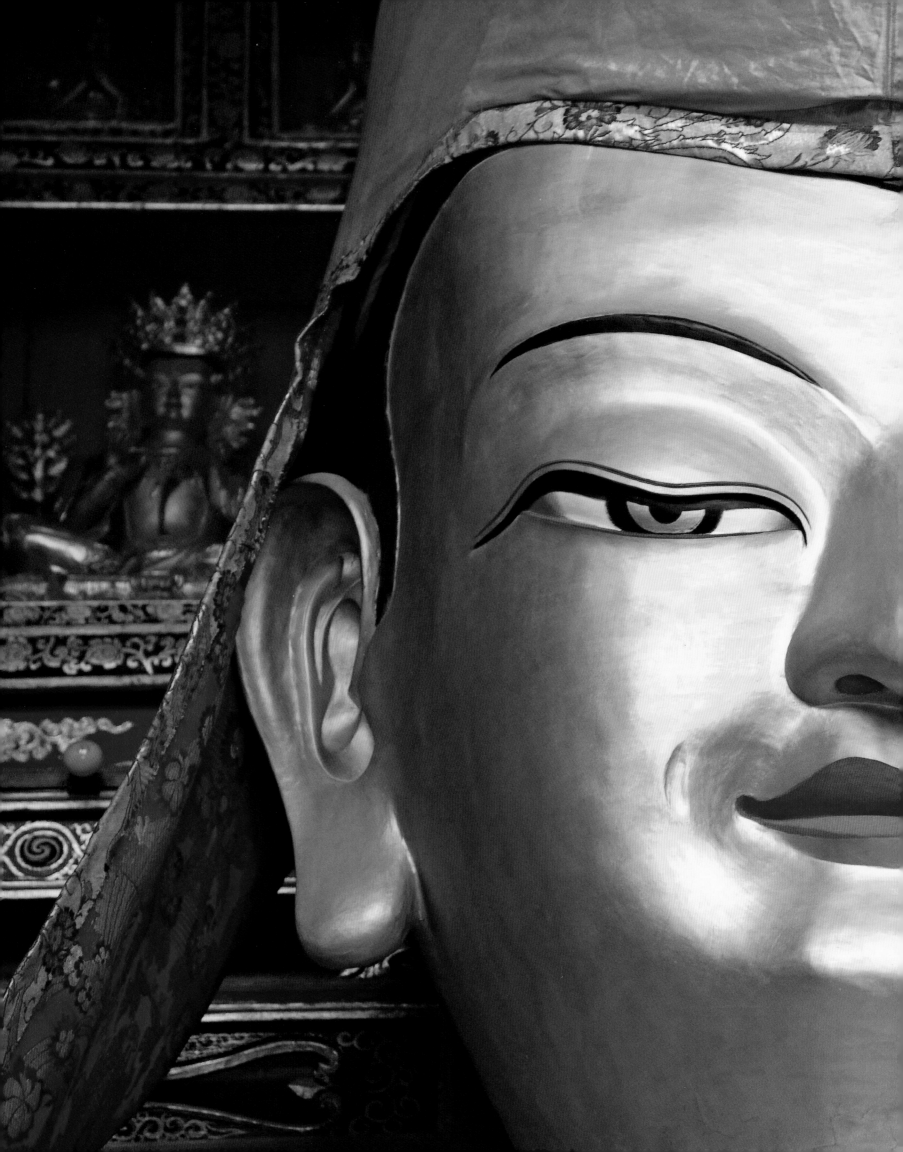

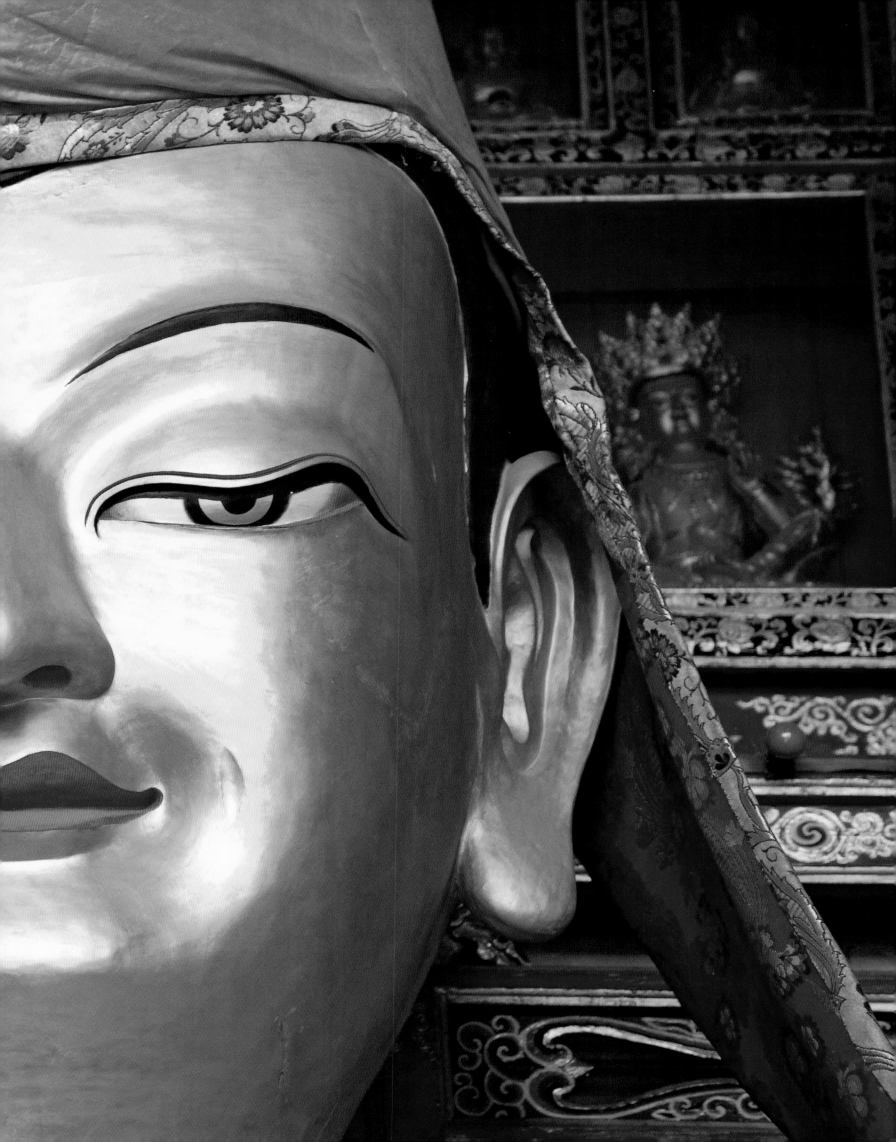

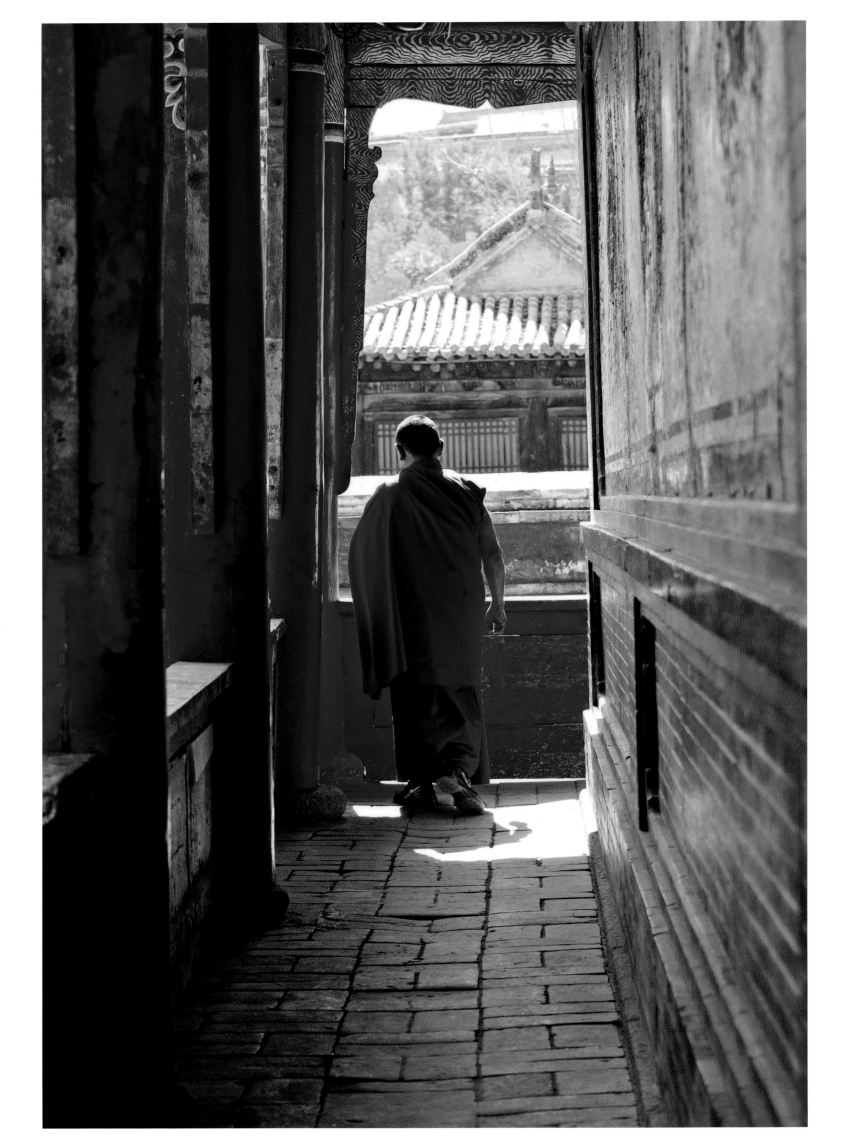

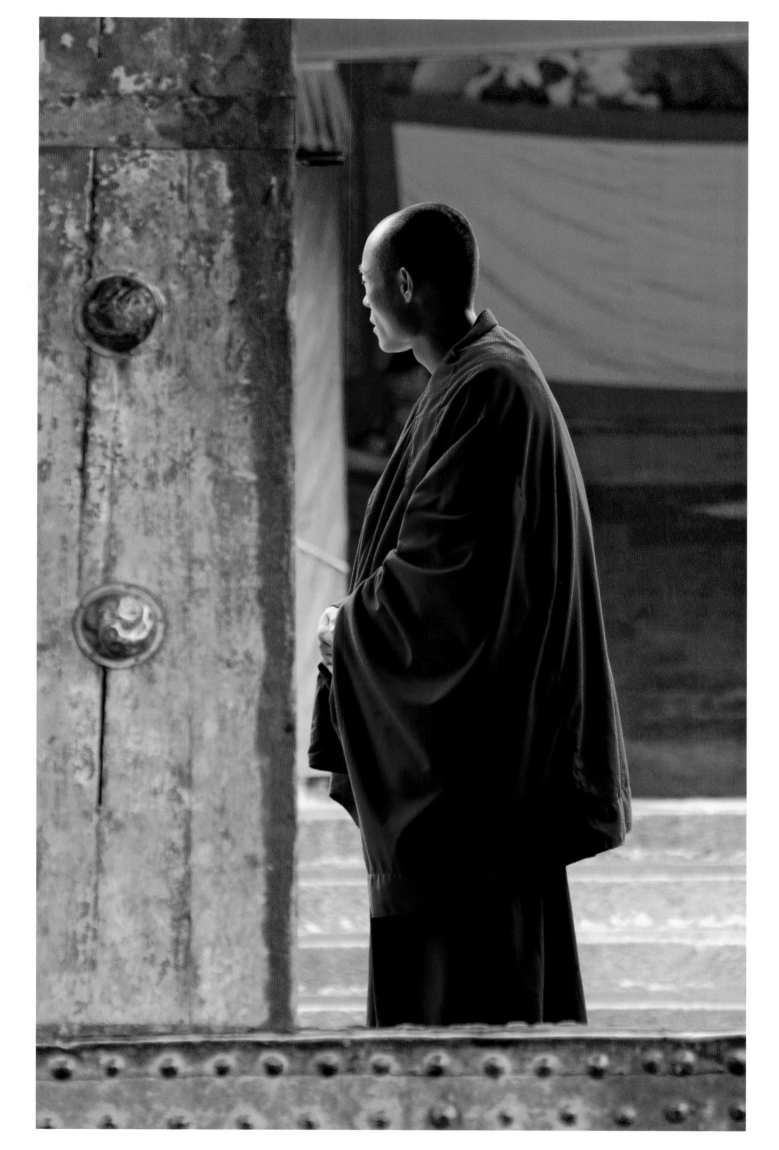

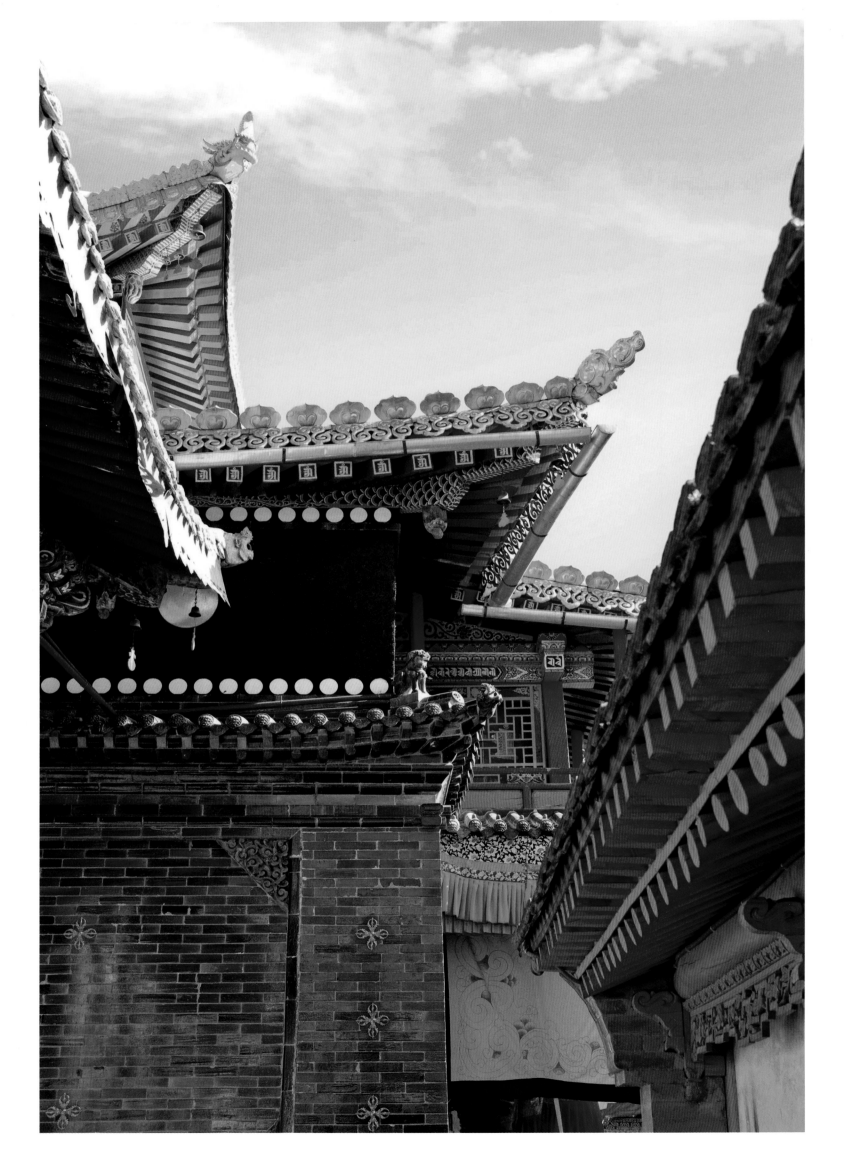

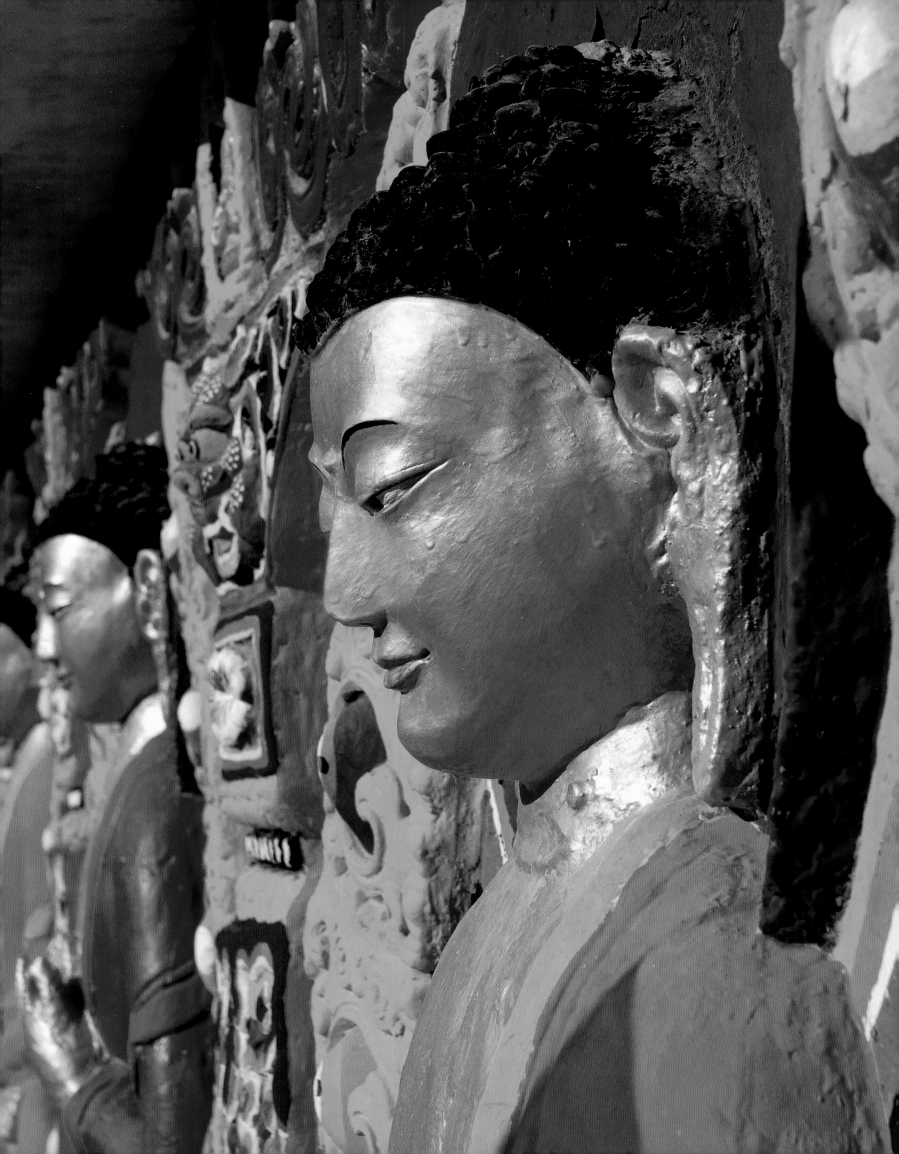

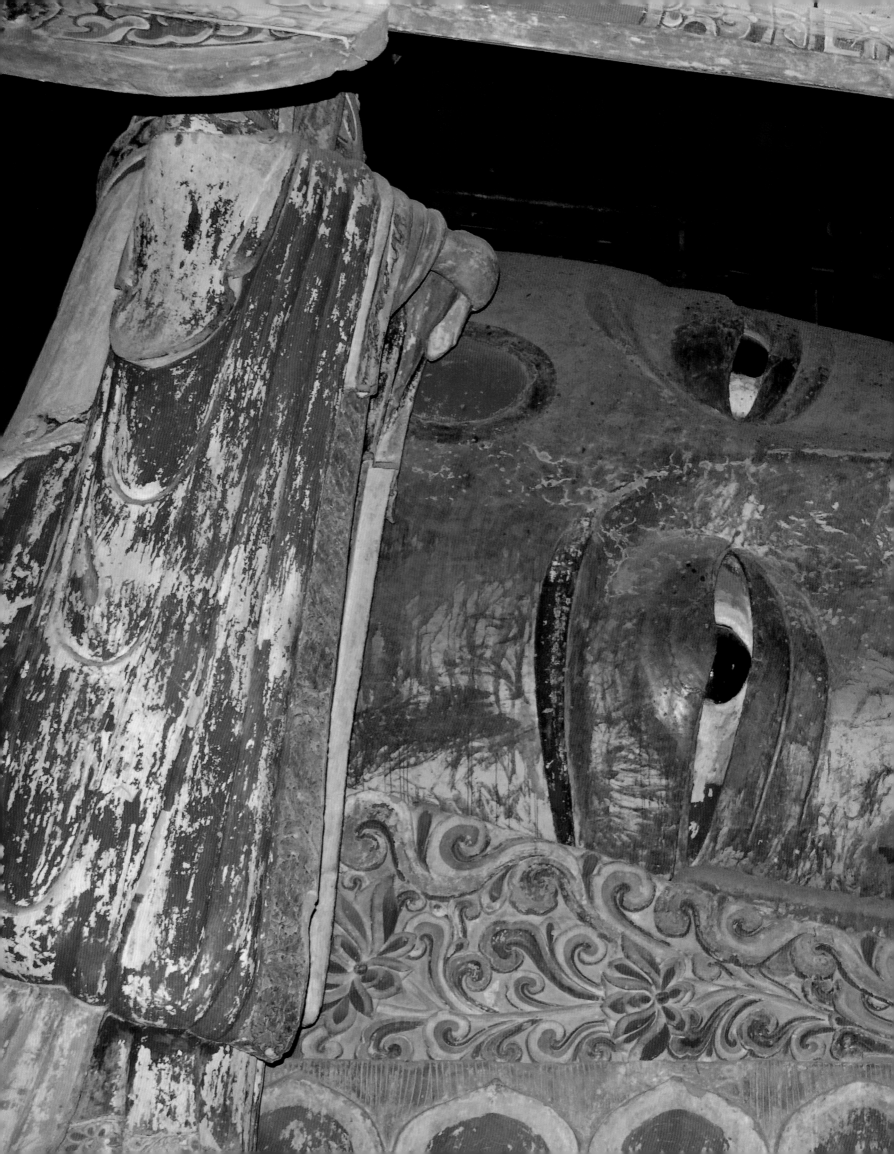

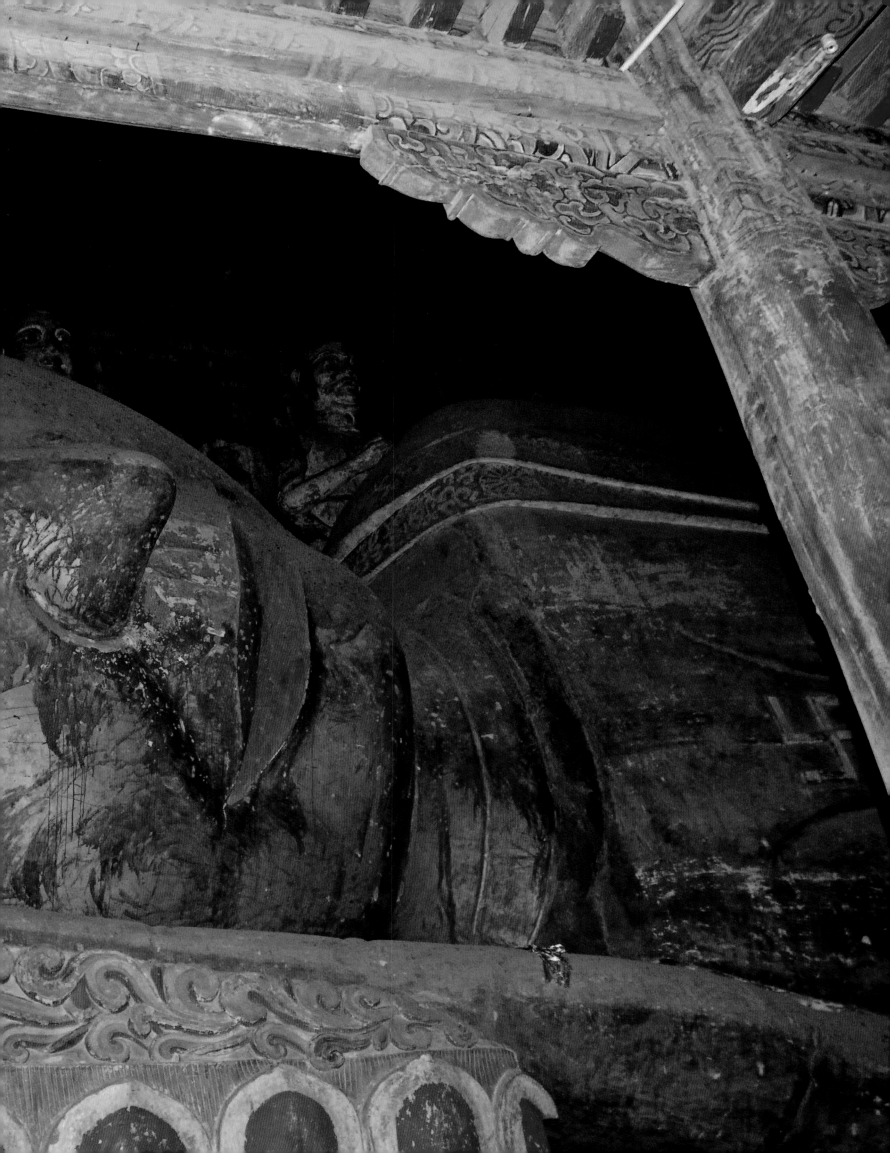

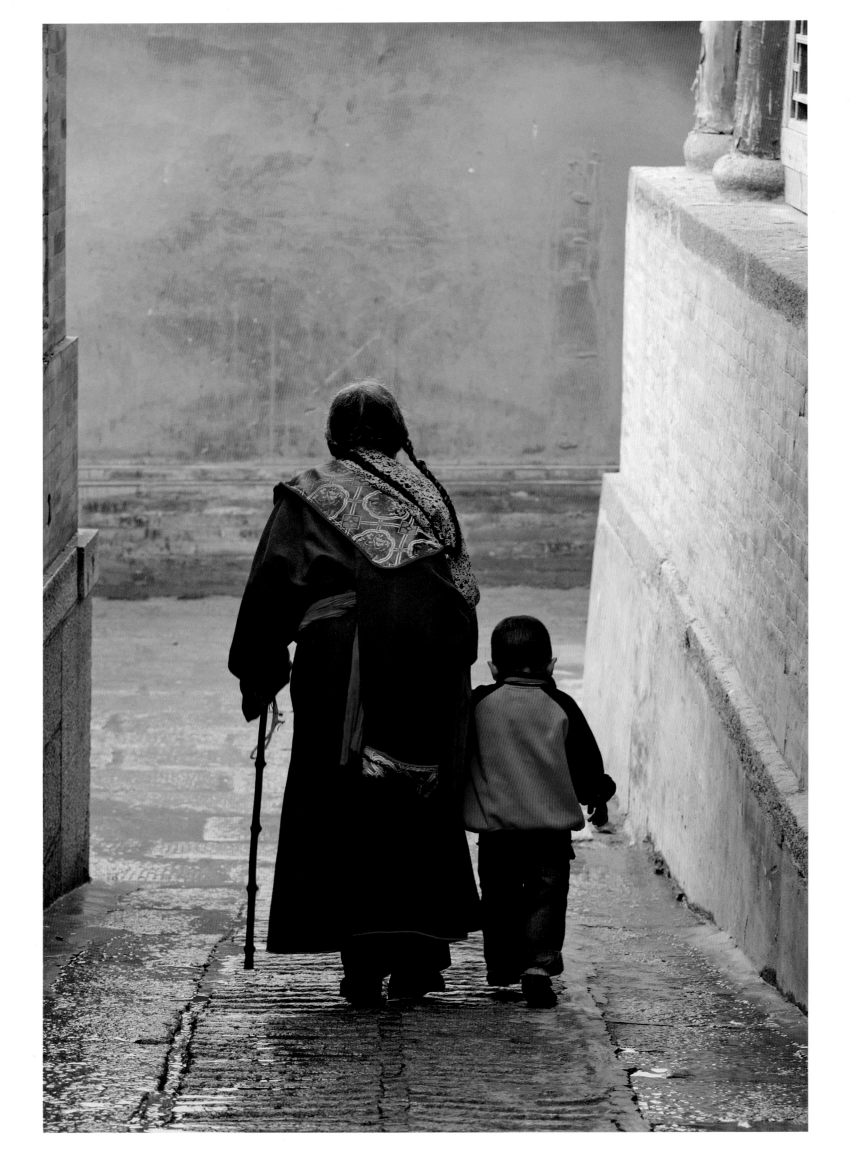

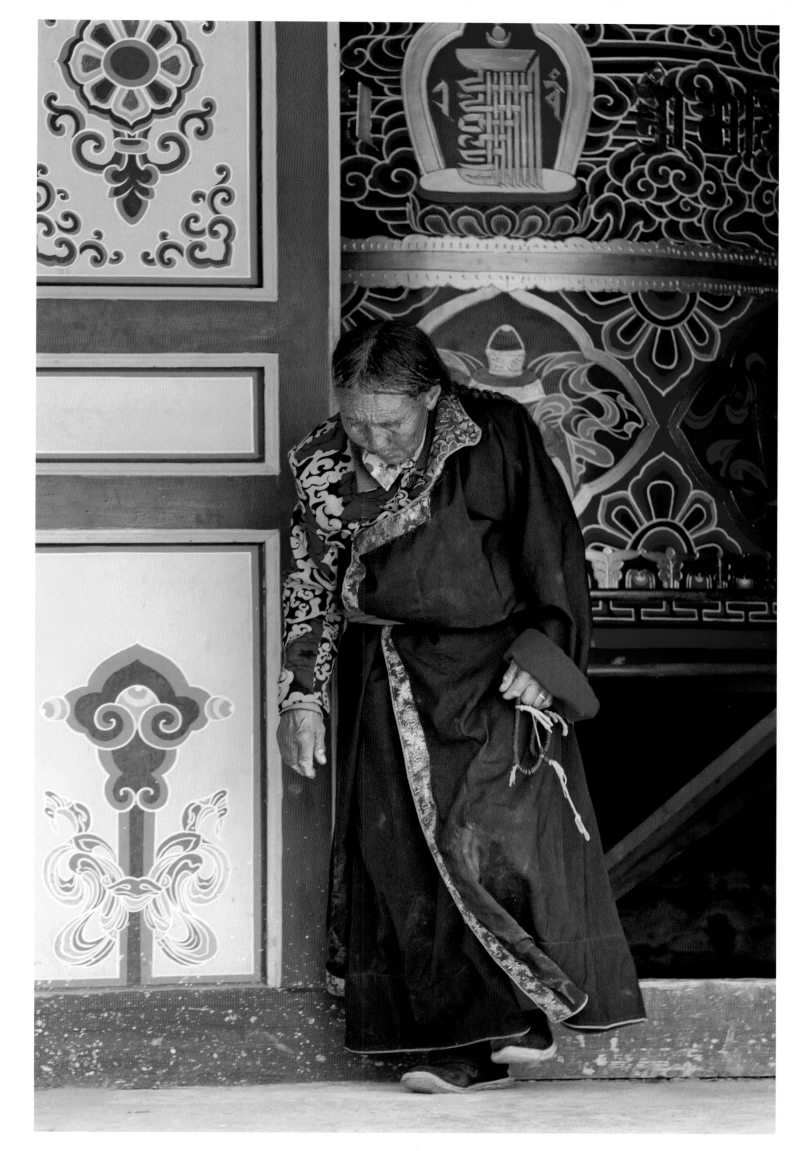

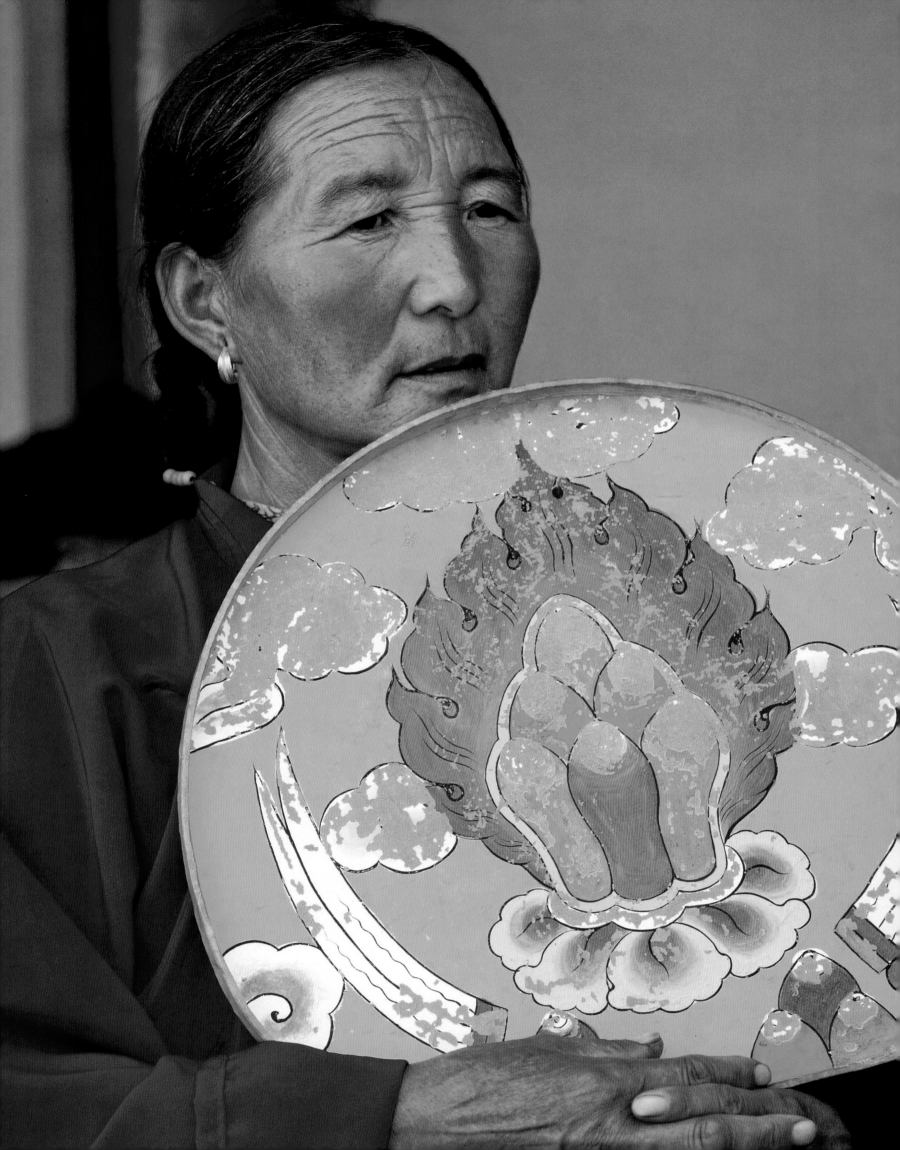

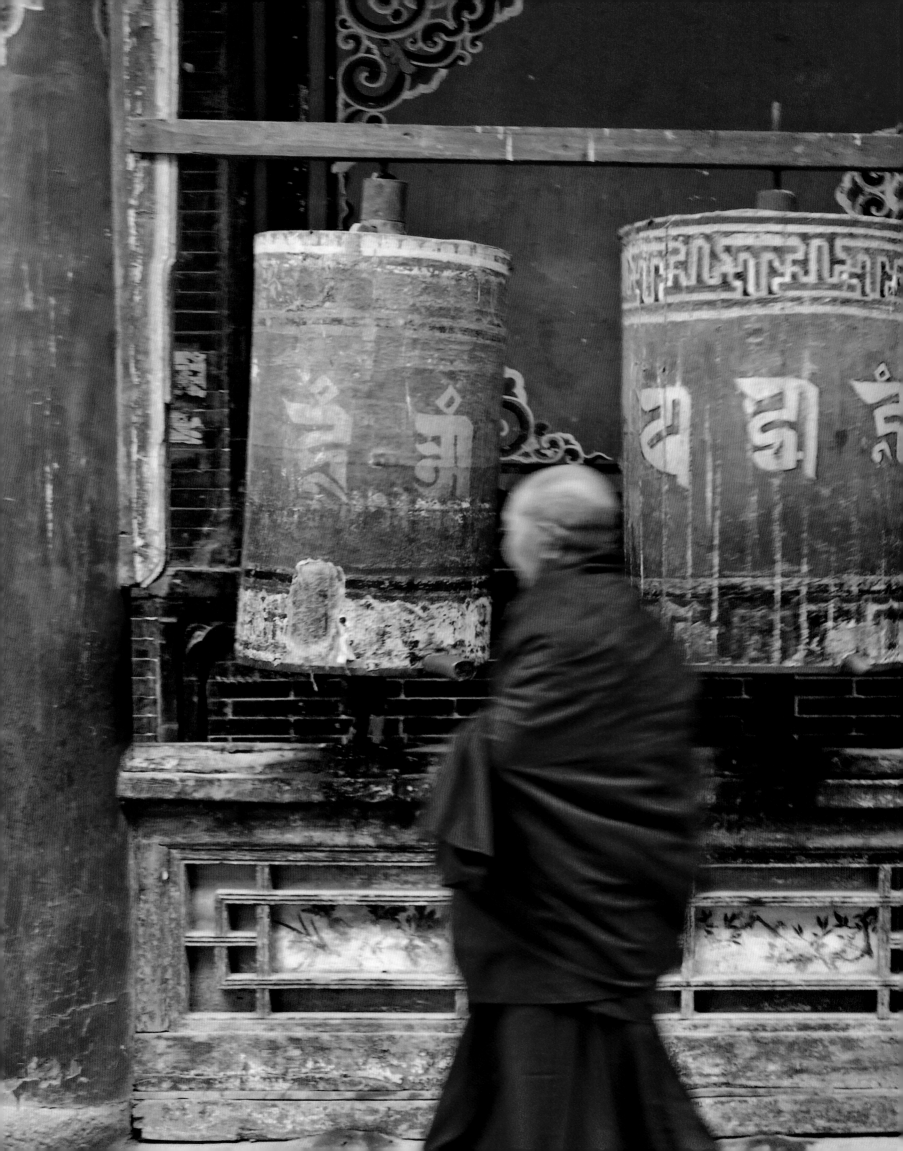

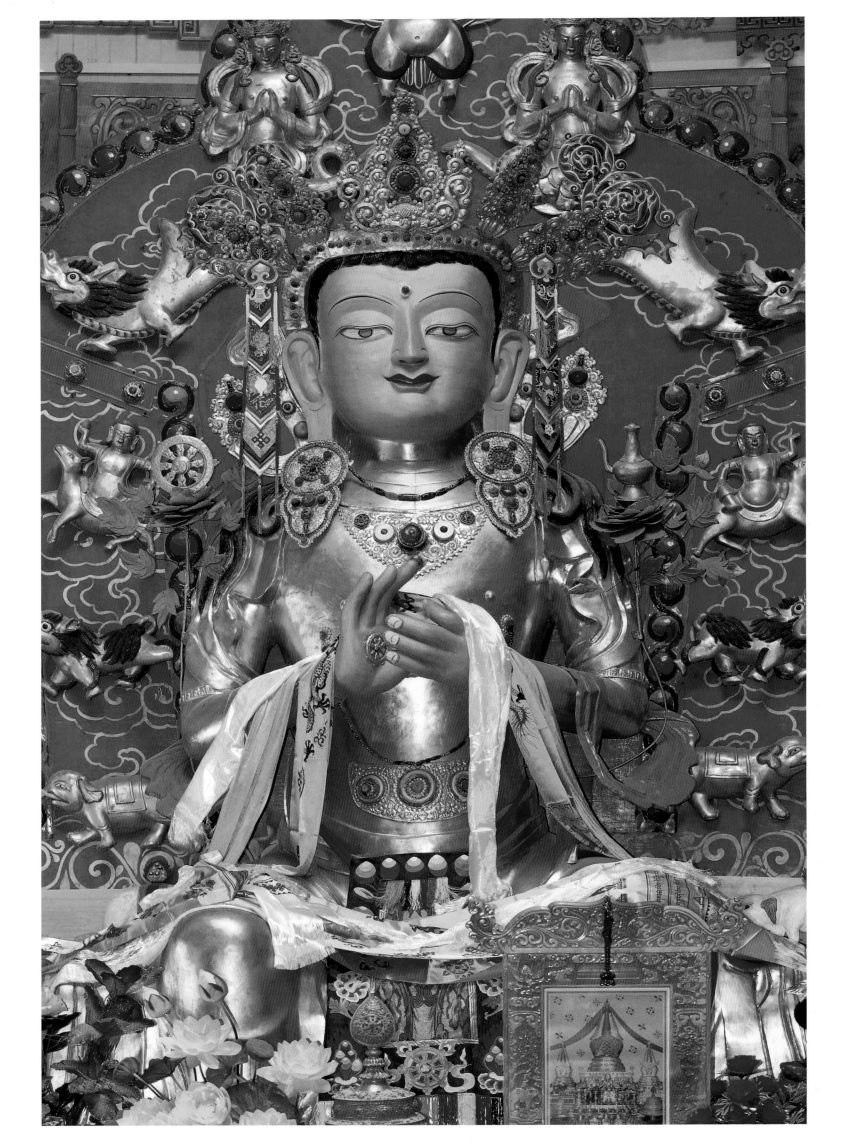

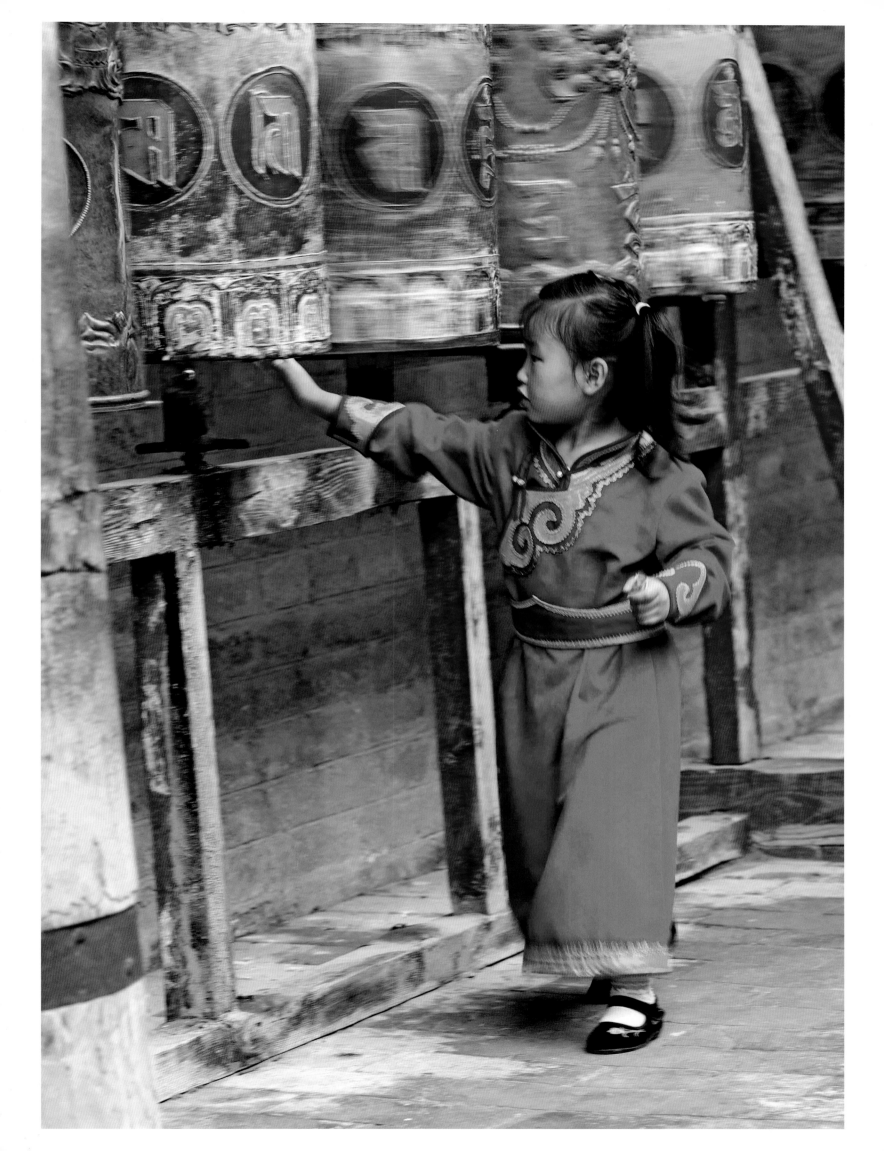

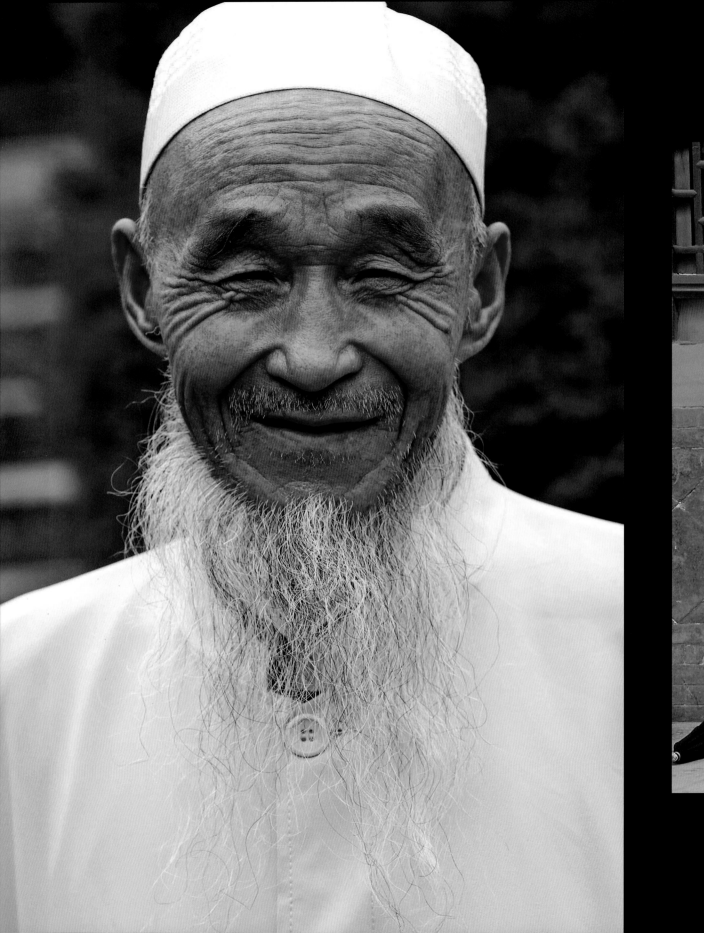

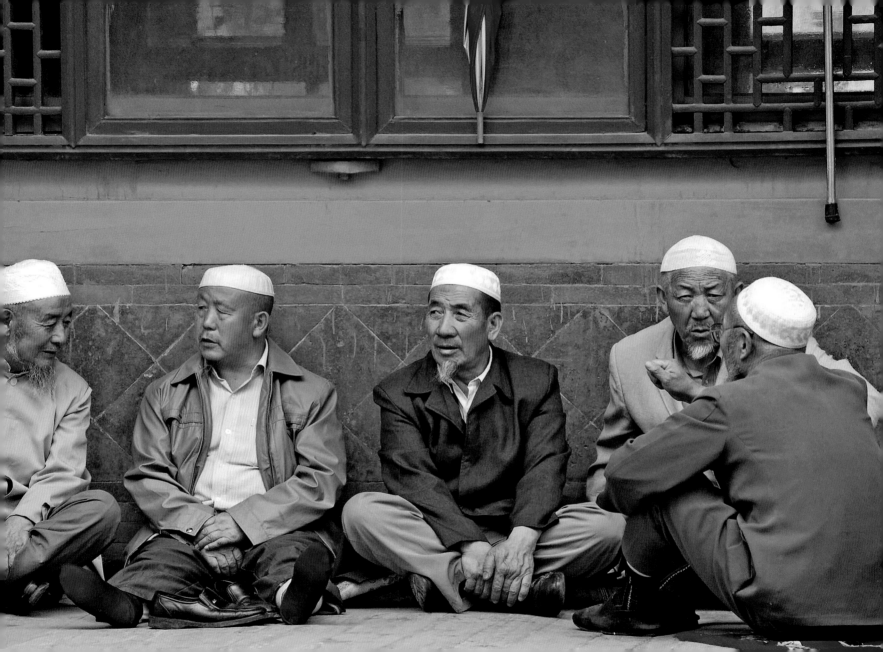

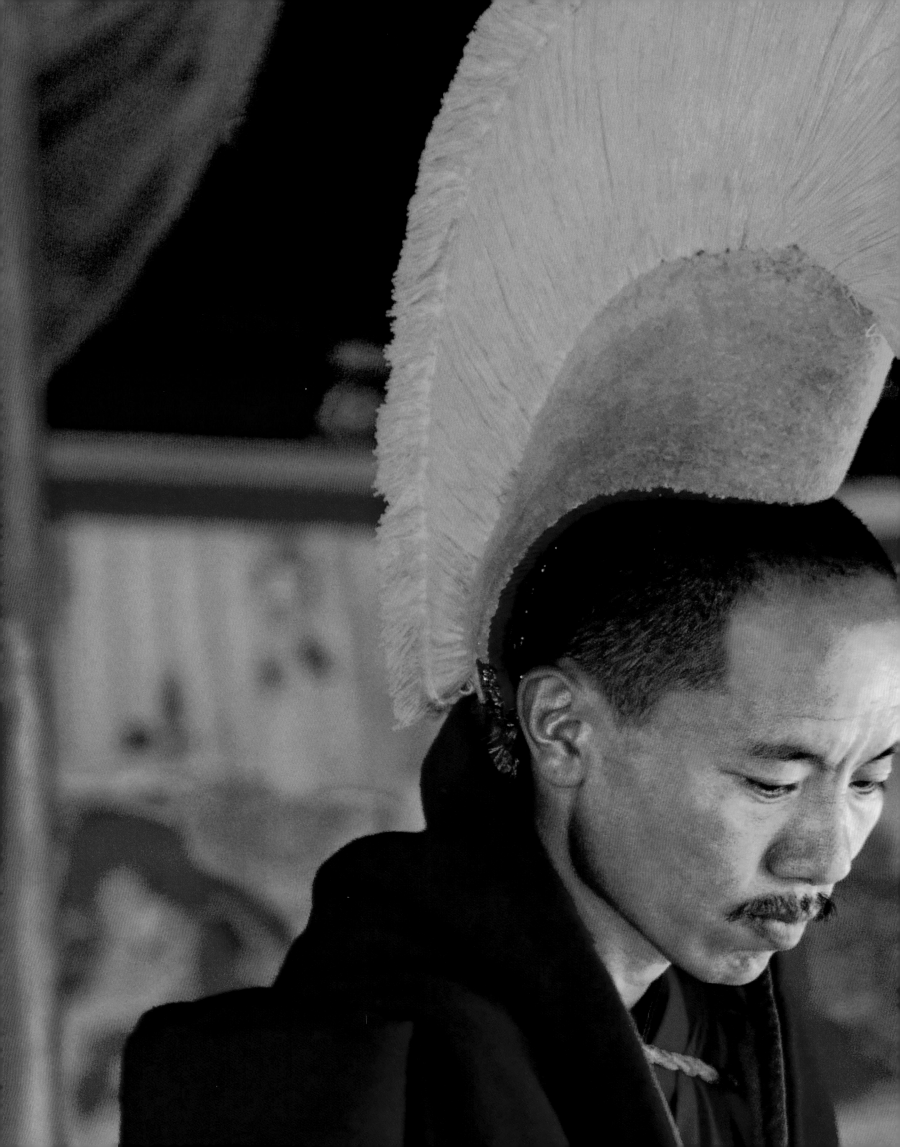

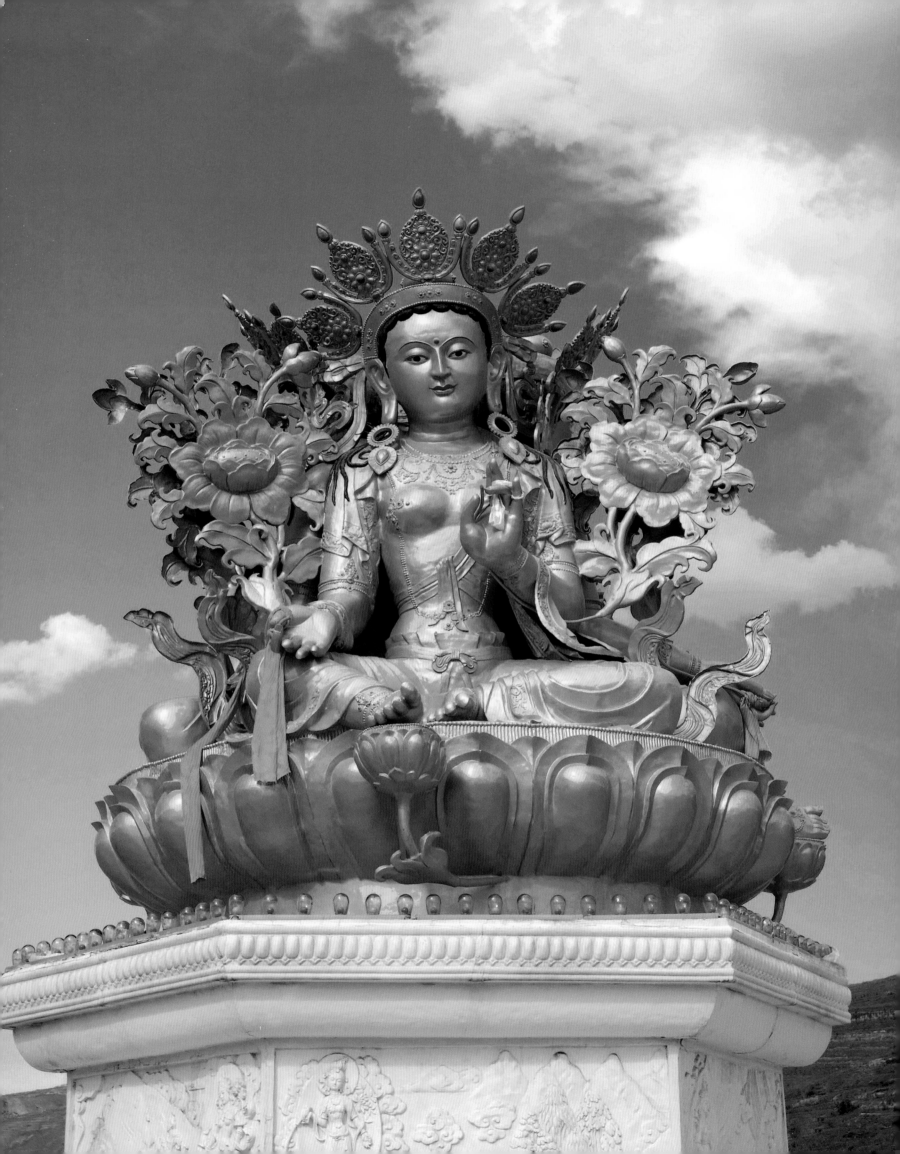

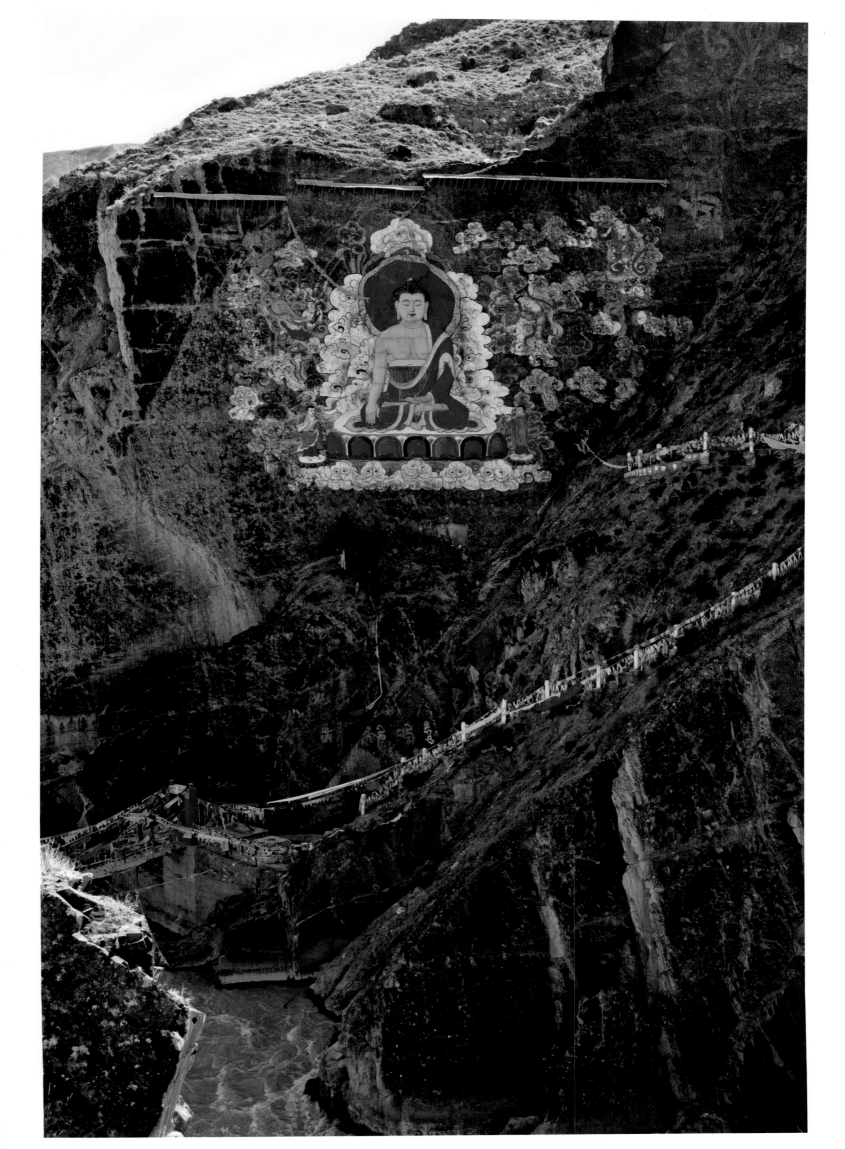